Jennifer Norman

704.393.0786

p59jan@hotmail.com

Race in Cyberspace

Race in Cyberspace

Edited by

Beth E. Kolko

Lisa Nakamura

Gilbert B. Rodman

Routledge
New York and London

Published in 2000 by
Routledge
29 West 35th Street
New York, NY 10001

Published in Great Britain by
Routledge
11 New Fetter Lane
London EC4P 4EE

Library of Congress Cataloging-in-Publication Data

Race in cyberspace / edited by Beth E. Kolko, Lisa Nakamura, and Gilbert B. Rodman.
 p. cm.
 Includes bibliographical references and index.
 ISBN 0–415–92162–7 (hardbound). — ISBN 0–415–92163–5 (pbk.)
 1. Race discrimination—Computer network resources. 2. Computer networks—Social aspects.
3. Cyberspace—Social aspects. 4. Internet (Computer network)—Social aspects. 5. Social
interaction—Computer network resources. I. Kolko, Beth E. II. Nakamura, Lisa. III. Rodman,
Gilbert B., 1965–
HT1523.R252 1999
025.06'3058—dc21 99–29694
 CIP

Contents

v

Acknowledgments

The editors would like to thank Bill Germano at Routledge for supporting and inspiring this project. We would also like to thank Nick Syrett and Liana Fredley for assistance with production and editing. Most of all, thanks to our contributors, without whom this volume would not have been possible.

1. Race in Cyberspace

An Introduction

Beth E. Kolko, Lisa Nakamura, and Gilbert B. Rodman

Cyberspace is an environment comprised entirely of 0's and 1's: simple binary switches that are either off or on. No in-between. No halfway. No shades of gray. All too often, when it comes to virtual culture, the subject of race seems to be one of those binary switches: either it's completely "off" (i.e., race is an invisible concept because it's simultaneously unmarked and undiscussed), or it's completely "on" (i.e., it's a controversial flashpoint for angry debate and overheated rhetoric). While there are similar patterns of silence about race when it comes to interpersonal interaction in "the real world," the presence of visual and aural markers of race (no matter how inaccurate those may be) means that race is rarely (if ever) as invisible offline as it is in cyberspace.

Moreover, those relatively rare moments online when the race switch is "on" are often characterized by a perverse reversal of the notion that "the personal is the political," insofar as they involve the reduction of pressing political issues of race and racism to purely personal arguments and *ad hominem* attacks. For example, a few years ago, one of us inadvertently started a flame war by making a post to a scholarly listserv to the effect that race is a social construct rather than a biological or genetic fact.[1] Significantly, the uproar that

followed wasn't based primarily in disputes over issues of fact (as might have been the case if the posting had claimed the world is flat) or interpretation (as might have been the case if the topic at hand had been whether Hamlet is really mad or not) as much as it was centered around questions of ethics. From the perspective of the "race is biological" crowd, the posting wasn't only inaccurate: it also posed a grave moral threat to Truth, Justice, and the Academic Way. All of which rapidly led the discussion away from the subject at hand (i.e., the nature of racial categorization) and in the direction of the potential harm caused by the propagation of such irresponsible ideas in public. From an initial response claiming that the social constructionist view of race did "severe damage" to "the field of critical inquiry," the discussion degenerated rapidly to a point where the author of the offending posting was denounced as a dangerous relativist who didn't believe in the real world, a politically correct deconstructionist spouting patently false "fringe" theories, and a raving lunatic who thought that a white couple could produce a baby with brown skin and epicanthic folds.

Very briefly, the social constructionist view of race argues that there is no biological or genetic basis for dividing the world's population into distinct racial groups. While we typically see racial difference residing in physical traits that *are* genetically determined (e.g., skin color, hair texture and color, nose and eye shapes, etc.), attempts to map out those traits across the world's population (a) generate patterns that don't match up with the racial categories we already have, and (b) don't add up to coherent patterns that would support *any* model of people as racially distinct from one another. Moreover, there is more genetic variance within allegedly homogenous racial groups than there is between supposedly distinct groups—which simply wouldn't happen were the differences between those groups rooted in biology. It bears emphasizing, however, that the socially constructed nature of race *doesn't* mean that our understanding of race and racial categories isn't somehow real or that it doesn't have real effects: quite the contrary, those categories *do* exist and they have tangible (and all too often deadly) effects on the ways that people are able to live their lives. What it *does* mean, however, is that the systems of racial categorization that permeate our world are derived from culture, not nature. Back to our story.

Part of what was notable about this mini-flame-war was how tenaciously many of the people involved clung to the idea that race simply *must* be rooted in biology, and how any claims to the contrary—no matter how calmly stated, well documented, or logical they might be—had to be thoroughly beaten

down so that they could never surface again. Early in the debate, the author of the original post noted that there are dramatic differences in the ways that different cultures use and understand racial categories. For example, in the United States, the racial category "black" is understood to be limited to people whose ancestry can be traced to Africa, but the "same" category in South Africa *doesn't* include people of mixed African and European ancestry (who are seen as "colored"), while in Britain, the "same" category also includes people with ancestral ties to non-African parts of the former empire (including Pakistan and China). One can find similar shifts in racial categorization over time as well. Terms like "mulatto," "quadroon," and "octoroon" used to be more prominent in U.S. culture, reflecting an understanding of racial "mixing" similar to that embodied in the South African use of "colored." Similarly, turn-of-the-century immigrants to the United States from certain parts of Europe (most notably Ireland and Italy) were often seen to belong to their own (nonwhite) racial groups. What these examples help to demonstrate is that the various ways people conceive of "race" are rooted, not in nature, but in culture: if race were purely a natural thing, there wouldn't be such variation across time and space in people's understanding of racial difference. Somehow, though, in the hurly-burly of the flame war, such examples were magically explained away as *proof* that genetic distinctions between races really existed, as if the existence of racial categories across cultures could only be possible if race transcended culture.

Moreover, citations of both scholarly (e.g., Frankenberg, Gates, Ignatiev and Garvey, Omi and Winant) and popular (e.g., Leslie et al.; Morganthau; Rensberger; Wright) research offered in support of the social constructionist argument were never challenged directly (e.g., "I've read that article by Gates, and this is where I'd say his argument goes astray…"). Instead, in an astoundingly anti-intellectual move for a scholarly listserv, those citations were simply brushed aside on the grounds that lots of "foolish things" get published by irresponsible authors and presses. The tone used to dismiss these articles made it clear that the list members in question felt *compelled* to ignore such texts, because to do otherwise would be to take the social constructionist argument seriously enough to grant it a moral and intellectual status it didn't deserve.

In the end, the vigor and venom with which the social constructionist argument was attacked seemed to represent nothing so much as the desire to turn the binary race switch back to its "off" position. The "race is biological" argument was never presented as a more productive means of wrestling with difficult questions of race, politics, and culture; rather, its proponents seemed

intent on nothing so much as killing off the race thread entirely so that the list could return to safer, less controversial topics. Which, sadly, is exactly what happened: though no one ever officially proclaimed race to be an unacceptable topic for discussion, for months afterward even the most innocent and "safe" references to race were regularly met with snotty asides about how "we don't want to go into all *that* again."[2]

One of the primary rationales behind this book, however, is not only that we *do* want "to go into all that," but that we *need* to do so. To be sure, as many white people point out when faced with questions of racial politics, race shouldn't matter.[3] While we sympathize with the noble belief in egalitarian tolerance at the heart of such a response, we also recognize that the way the world *should* work and the way the world *does* work are two very different things—and that we live in a world that doesn't come anywhere close to that ideal. Whether we like it or not, in the real world, race *does* matter a great deal. As **Tara McPherson** argues in her study of neo-Confederate websites, even deliberate and conscious efforts to elide questions of race online can manage to create unmistakably racialized spaces. While many of these sites make an explicit point of distancing themselves from—and even denouncing—the Klan and other white supremacist groups, McPherson notes that neo-Confederate efforts to preserve and protect Southern heritage invoke a very selective and predominantly white version of that heritage. As her chapter shows, the virtual reality that is cyberspace has often been construed as something that exists in binary opposition to "the real world," but when it comes to questions of power, politics, and structural relations, cyberspace is as real as it gets.

Moreover, in spite of popular utopian rhetoric to the contrary, we believe that race matters no less in cyberspace than it does "IRL" (in real life). One of the most basic reasons for this is that the binary opposition between cyberspace and "the real world" is not nearly as sharp or clean as it's often made out to be. While the mediated nature of cyberspace renders invisible many (and, in some instances, all) of the visual and aural cues that serve to mark people's identities IRL, that invisibility doesn't carry back over into "the real world" in ways that allow people to log in and simply shrug off a lifetime of experiencing the world from specific identity-related perspectives. You may be able to go online and not have anyone know your race or gender—you may even be able to take cyberspace's potential for anonymity a step further and masquerade as a race or gender that doesn't reflect the real, offline you—but neither the invisibility nor the mutability of online identity make it possible for you to escape your "real world" identity completely. Consequently, race matters in cyber-

space precisely because all of us who spend time online are already shaped by the ways in which race matters offline, and we can't help but bring our own knowledge, experiences, and values with us when we log on.

In much the same way that online discourse has typically kept the binary switch of race in the "off" position (or worked very hard to turn that switch back off when it gets turned on), academic work on cyberspace has been surprisingly silent around questions of race and racism. To be sure, part of this has to do with the newness of scholarly work in this area. The critical field of cyberspace studies is still young enough to be uncertain of its name. Variously referred to as "cyberculture," "cyberspace," "online life," or "virtual culture," life with computer technology is still being defined. Ten years ago, there was almost no scholarship that sought to investigate the particular technology of cyberspace and how it affects configurations of community and identity. In the past five years, however, there's been a steadily increasing number of books and articles focusing on cyberspace, both from a broad range of academic perspectives and in more popular venues. Still, for all the diversity to be found in these approaches to virtual culture, the bulk of the growing body of literature in cyberspace studies has focused on only a handful of issues and arguments, in ways that have effectively directed the conversation on cyberculture away from questions of race.

The most prominent of these arguments is the by now familiar assertion that online environments facilitate fragmentation of identity. Mark Poster, Allucquère Rosanne Stone, and Sherry Turkle (to name but a very few) began writing in the early to mid-1990s about the multiple and dispersed self in cyberspace—a fluid subject that traversed the wires of electronic communication venues and embodied, through its virtual disembodiment, postmodern subjectivity. These and other scholars have, through their work, established an intellectual center for cyberspace theory; as researchers from disparate fields approach the question of how communication technologies reconfigure notions of identity and human relations, the disembodied figure is often the starting point.[4]

As the central question regarding subjectivity online becomes more thoroughly explored, the variety of arguments made in the field will increase. Cyberspace is in many ways a semiblank slate upon which users write. Technological artifacts provide us with particular starting points, but within that framework—a blank webpage, an empty chat room, an unformed public policy—individuals are responsible for how they work with the empty space. The interactive environments of cyberspace are particularly notable for the

extent to which a virtual identity is constructed within them. To have a virtual presence means deliberately constructing an identity for yourself, whether it is choosing an e-mail name, putting together a webpage, designing a graphical avatar, or creating a nickname for a chat room or virtual world. Within such a constructivist environment, the construction of identity becomes even more important.

Looking at cyberspace as a constructivist environment has led to research that considers the situatedness of the disembodied cyberself. That is, because the self that exists in cyberspace is the result of purposeful choices, it is possible to trace those decisions back, from the avatar (or virtual projection) to the person who first chose to represent herself in a particular way. Within this area of inquiry there are two questions that are most often examined—that of the cyberself as embodied in language, and of the cyberself situated in gender. Both the language and gender choices of participants hold fruitful possibility for examining the connections between virtual and offline life.

Of the two, the dispersed self is more rarely considered to be a linguistic self—despite the fact that many cyberspace interactions are in some way textual. And while those versions of cyberspace that are more visual provide another set of issues than the text-based venues of e-mail or chat groups, even a website or a graphical virtual world remains a site of communicative exchange, one in which participants are embedded in a rhetorical relationship. Lanita Jacobs-Huey's essay "…BTW, How do YOU Wear Your Hair? Identity, Knowledge and Authority in an Electronic Speech Community" is one of the few works addressing how participants in cyberspace make claims about racial identity in a "discussion, which aside from typed text, provides no visual or audio cues to participants' identities" (1). Jacobs-Huey opens up an important line of inquiry regarding how identity and positionality are communicated via language, and she demonstrates how race and identity are concretely tied to language.

Mark Warschauer and **Joe Lockard** continue this line of inquiry as they examine, in very distinct ways, how ethnicity and language are variously enacted in and constitutive of cyberspace. Warschauer traces some of the roots of how language materially affects ethnic and racial identity in personal and political terms, and he establishes a basis for considering how language affects cyberspace interactions and constructions. In a study of Hawaiian language students at the University of Hawaii, Warschauer investigates the connection between the Hawaiian language and students' sense of identity as Hawaiians, and he examines language revitalization efforts that use the Internet. Lockard

examines some of the more conflicted turns in the development of the Internet. Detailing a techno-universalism that leads to a kind of online nationalism, he also illustrates how cyber-English and the effaced raciality within disembodied virtual communities disregard the material and political identities of participants. Both these essays focus attention on the limits of fragmentation within virtual space by invoking the encasement of the self within language.

In conjunction with considerations of dispersed selves in cyberspace as situated in language, other material elements of identity have been added to the conversation. Participants in cyberspace, it turns out, are not just embedded in language, but tied to gender; in other words, they bring a variety of their real-world identities to bear on cyberspace representation. As Susan Herring's research in the field of linguistics has illustrated, examining electronic discourse communities demonstrates that online communication can be particularly gendered; computer-mediated communication does not exist independent of face-to-face patterns of communication. Placing virtual identities within both language and gender, Herring provides a clear argument for re-embodying the virtual self. She is one of several researchers who have examined the way gender affects online interactions, and in the larger body of such scholarship it becomes clear that a user's gender materially affects the range and kind of experiences within cyberspace.

Such analyses of gender online have significant ties to more generally feminist work that examines the effects of technology and technologized interactions on participants. In contrast to Herring's and others' work that is more grounded in considering how we carry gender relations to technology, another strain of work by feminists has examined how technology provokes us to carry new gender formations into daily life. One of the main starting points for such scholarship has been the concept of the cyborg, popularized for feminists studying gender and technology by Donna Haraway's "Manifesto for Cyborgs."

Haraway's article posits a postgender as well as a posthuman subject in the age of high technology, a formulation that provides fertile ground for politicizing cyberspace. The liberatory and progressive potential of an identity choice that is the cyborg—which is hybrid, fluid, fractured, and above all postmodern—has stimulated much valuable discussion, primarily focused on the nature of gender in cyberspace. If nobody knows your gender in cyberspace, a reading of Haraway seems to tell us, then perhaps while using the Internet you can enact that cyborg identity and be, at least in part, liberated from the constraints of gender.

In their writings about virtual sex, for example, Turkle, Stone, and Shannon McRae have each discussed the cross-dressing facilitated by online interaction. Users can adopt a different gender and purportedly learn what it is like to interact in the face-to-face world within another gender role. But in their tellings of such masquerades these authors subscribe to the schema of the cyborg, and they discuss the cross-dressers as experiencing another gender from *within* their RL (real life) stance; the regendered may be masked, but their online journeys are mapped onto an offline biological (and hormonal) self.

The fact that the cyborg's existence is simultaneously material and political is absolutely crucial to the influence of Haraway's text. And because of this focus on the material, analyses of cyborgian existence have been well adapted to political readings. However, just as first- and second-wave feminists often failed to include race and the issue of third world women in their politics, so too have many cyberfeminists elided the topic of race in cyberspace. This state of things represents the norm rather than an aberration; there is very little scholarly work that deals with how our notions of race are shaped and challenged by new technologies such as the Internet.[5] Haraway situated the cyborg within a complex and broad matrix of identity, but scholarship has focused primarily on the gender of that cyborg rather than other elements of its identity.

Significantly, Haraway's manifesto does present explicitly a politics of race and technology, one that has been little discussed. For the cyborg is not only a hybrid of machine and organism, it is also a racial hybrid. The cover art for Haraway's *Simians, Cyborgs, and Women* depicts a dark-haired woman of indeterminate race sitting at a computer keyboard. This woman, like Gloria Anzaldúa's mestiza, is an avatar of ethnic and racial hybridity, a vision of a racially "queered" utopian future. Her face is framed by a cathode-ray tube depicting whirling models of galaxies and astrological charts, and her torso is represented by an integrated circuit surrounded by pink flesh. Her body is pointedly depicted as a collage of the human and the machine: it represents an integrated circuit of raciality. The cyborg's politics is one of inclusivity, and as we all become cyborgs in the age of high technologies such as the Internet, so too must race be considered as part of the mix of hybrid identities that mark our selves at the end of the millennium.

Jennifer González discusses how, in sites such as Kostya Mitenev's UNDINA and U.S.-based artist Victoria Vesna's Bodies© INCorporated, the body in cyberspace can become an appendage or assemblage of "cultural and racial fusion and fragmentation." Her critique of graphical virtual representa-

tions, or avatars, focuses on how options regarding racial representation elide the history of race and posit a notion of cybercitizenship that is purportedly universal as well as all-consuming.

González's essay is a component in a larger conversation regarding the various ways race is deployed in cyberspace. In cyberspace, users' bodies may be invisible, but, as in all representational media, issues of marking, racial and otherwise, are unavoidably part of its signifying practices. As mentioned earlier, users bring their assumptions and discursive patterns regarding race with them when they log on, and when the medium is interactive, they receive such assumptions and patterns as well. **Lisa Nakamura's** essay analyzes the ways in which advertisements for Compaq, IBM, MCI, and other high-tech corporations depict a "global village" in which racial and ethnic otherness are commodified, fixed, and pictured as antique and anachronistic. These examples of popular media narratives of commercial cyberspace demonstrate how orientalist and other racial stereotypes are reflected and generated in the discourse of marketing that surrounds the Internet.

As the existence of African American, Asian American, Latino, and other ethnic and racially oriented newsgroups and websites exhibits, cyberspace can be a place where ethnic and racial identity are examined, worked through, and reinforced. Cyberspace can provide a powerful coalition building and progressive medium for "minorities" separated from each other by distance and other factors. On the other hand, these nodes of race in cyberspace are marked as being parts of the whole, islands of otherness in a largely white, male, and middle-class cyberspace. **Jonathan Sterne's** essay traces the historical origins of current racial inequities online by examining the effects of technological public policy (in particular, the Technology Act of 1982) on educational infrastructure and funding in computer classrooms. As Sterne argues, the Internet is unlikely to live up to its hype as a democratizing and utopian force until the economic and cultural problems of access are addressed.

David Silver's essay on the Blacksburg, Virginia Electronic Village also focuses on racial inequalities in usage and access, by identifying the ways that community bulletin boards and websites "route around" race. His study shows how decisions regarding interface design can limit the levels of participation and representation available to differently gendered, nonheterosexual, or nonwhite users.

In addition to the impact of policy decisions regarding technology upon the racial composition of the Internet, the representations of cyberspace in popular media highlight an array of ideological attitudes toward race. Almost

a narrative unto themselves, these patterns of representation tell a story in tandem with the surface plot elements of contemporary films. The essays by **Rajani Sudan** and **David Crane** perform close readings of films about high technology, cyberspace, and race. Sudan's essay presents a reading of the film *Rising Sun* and its narrative use of computer-generated imaging techniques. She demonstrates that its depictions of image-enhancement technology are far from racially neutral, as the film's xenophobic paranoia about postindustrial competition between the United States and Japan plays itself out in the theater of cyberspatial racial representation. Crane presents a nuanced analysis of the ways that *Strange Days, Hackers, Virtuosity, Johnny Mnemonic,* and *Jumpin' Jack Flash* depict black characters as mediators between the "real" and the virtual. Crane posits that in these films, blackness is identified with the "street," with lived, as opposed to virtual, experience. The visual and narrative depictions of blackness as somehow authentic, stable, and "real" offset the fluidity and fragmentariness of cyberspace.

Like films, video games can offer representations of race, but only video games offer the user an interactive environment in which one can role-play as a member of a different race. **Jeffrey A. Ow's** essay describes the racial politics and modes of representation that are enacted in the everyday practice of contemporary video games. In particular, Ow analyzes the game *Shadow Warrior* and argues that the game forces the player to occupy a racist, violent, and colonialist subject position.

As the Internet permeates academia, commerce, politics, and other popular media such as film, fiction, advertising, and video games, it becomes increasingly crucial that rigorous inquiry from a variety of disciplinary viewpoints be brought to bear on the intersections between race and cyberspace. Cyberspace does indeed engender new combinations of ethnicity and raciality, and the essays in this volume describe and engage with these new constructions of race and cyberspace.

Cyberspace and race are both constructed cultural phenomena, not products of "nature"; they are made up of ongoing processes of definition, performance, enactment, and identity creation. Just as cyberspace is not a place (as Gertrude Stein might say, there is no there there), but rather a locus around which coalesce a hypertext of texts, modes of social interaction, commercial interests, and other discursive and imaging practices, so too race needs to be understood as a category created through social discourse and performance. Postcolonial theorists such as Kwame Anthony Appiah term race an "illusion," which makes it similar to Gibson's definition of cyberspace as a "consensual hal-

lucination"; both are phantasmatic effects of culture, rather than simple and stable facts of biology (in the case of race) or technology (in the case of cyberspace). **Beth E. Kolko's** essay considers how race is manifested in virtual worlds, and she examines how race, as an element of online identity, came to be eliminated from interactive cyberspaces. While her analysis of virtual world interfaces demonstrates the political power of technology design, her chapter also serves to introduce MOOscape, a virtual world she created to explicitly mark race in an attempt to consider how social interactions might be affected by such an environment.

The status of both race and cyberspace as virtual objects demands that we examine the specific ways and instances in which they inflect and project each other in the realm of cultural representation. Does race "disappear" in cyberspace? How is race visually represented in popular film and advertisements about cyberspace? Do narratives that depict racial and ethnic minorities in cyberspace simply recapitulate the old racist stereotypes, do they challenge them, do they use the medium to sketch out new virtual realities of race?

We have no illusions that this collection addresses all of these and other important questions pertaining to race and cyberspace. For example, important work remains to be done on the racial demographics of the cyber-workforce (from software coders to website designers, from e-commerce start-ups to "traditional" systems administration jobs) and their impact on the ways that race and race-related issues manifest themselves (or don't) online. Similarly, the field would benefit from additional work on patterns of distribution of computer technology and networks across the globe, and how the inequities in those patterns serve to keep the Internet a predominantly white environment.[6] Moreover, even for the questions this volume does address, we make no claims to having exhausted all possible answers: there is much more that remains to be said about access, online (re)presentations of racial identity, and racialized representations of cyberspace. While the essays collected here cover a broad range of important questions about race and cyberspace, we're aware that this volume only begins to scratch the surface of possible work in this area.

What we hope for this collection, then, is that it helps to put questions of race more squarely on the table when it comes to the study of cyberspace—and that it does so in such a way as to help us move beyond the too-restrictive binary choice of keeping silent or engaging in flame wars. Our goal here is not to claim that we have all the answers and thus shut down the discussion; rather, we'd like to see this collection as a modest attempt to open a space where a larger, more extended, and more inclusive conversation about race and cyberspace can take place.

Notes

1. To provide a bit more context here, this particular observation came in response to a post in an ongoing thread about sexual orientation, in which a list member had drawn a distinction between race and sexual orientation on the grounds that the former is a simple matter of biological fact, while the latter involves a more complicated blending of genetics with social and cultural factors.
2. Norma Coates (1997) provides a compelling analysis of the way a similar flame war worked to discourage discussions of gender politics on ROCKLIST (a list formally dedicated to the "academic discussion of popular music").
3. To be fair, the utopian rhetoric of "colorblindness" isn't one exclusively invoked by white people (cf. the prominent role played by African Americans in eliminating affirmative action programs in California), but people of color are far less likely than whites (at least in the United States) to see racial issues as arising irregularly and unexpectedly—and thus as something that might satisfactorily be "solved" with the simple wish that we pretend that race doesn't matter.
4. For writings about cyberspace that discuss subjectivity, see articles in the collections *Cyberspace: First Steps,* edited by Michael Benedikt; *Cultures of Internet,* edited by Rob Shields; *Wired Women,* edited by Lynn Cherny and Elizabeth Reba Weise; *Cyberspace/Cyberbodies/Cyberpunk,* edited by Mike Featherstone and Roger Burrows; *Cybersociety* and *Cybersociety 2.0,* edited by Steve Jones; *Internet Culture,* edited by David Porter. Relevant single-authored books include *The War of Desire and Technology at the Close of the Mechanical Age,* by Allucquère Rosanne Stone, *The Second Self* and *Life on the Screen,* by Sherry Turkle; and *The Second Media Age,* by Mark Poster.
5. For exceptions to this, see Donna Hoffman and Thomas Novak "Bridging the Digital Divide: The Impact of Race on Computer Access and Internet Use"; Cameron Bailey, "Virtual Skin: Articulating Race in Cyberspace"; and Lisa Nakamura, "Race In/For Cyberspace: Identity Tourism and Racial Passing on the Internet."
6. There is some work in this area (eg. the work of William Wresch), but there remains much more to be done.

References

Anzaldúa, Gloria. *Borderlands/La Frontera: The New Mestiza.* San Francisco: Aunt Lute Books, 1987.

Bailey, Cameron. "Virtual Skin: Articulating in Cyberspace," in *Immersed in Technology: Art in Virtual Environments,* Mary Anne Moser, ed. Cambridge, MA: MIT Press, 1996.

Benedikt, Michael, ed. *Cyberspace: First Steps.* Cambridge; MA: MIT Press, 1991.

Cherny, Lynn and Elizabeth Reba Weise, eds. *Wired_Women: Gender and New Realities in Cyberspace.* Seattle: Seal Press, 1996.

Coates, Norma. "Can't We Just Talk About Music?: Rock and Gender on the Internet," in *Mapping the Beat: Popular Music and Contemporary Theory,* Thomas Swiss, Andrew Herman, and John Sloop, eds. Malden, MA: Blackwell, 1997.

Featherstone, Mike and Roger Burrows, eds. *Cyberspace/Cyberbodies/Cyberpunk: Cultures of Technological Embodiment.* London: Sage, 1996.

Frankenberg, Ruth. *White Women, Race Matters: The Social Construction of Whiteness.* Minneapolis: University of Minnesota Press, 1993.

Gates, Henry Louis Jr. "Editor's Introduction: Writing 'Race' and the Difference It Makes," *Critical Inquiry* 12.1 (1985): 1–20.

Haraway, Donna. *Simians, Cyborgs, and Women.* New York: Routledge, 1991.

Herring, Susan. "Politeness in Computer Culture: Why Women Thank and Men Flame," in *Cultural Performances: Proceedings of the Third Berkeley Women and Language Conference*, Mary Bucholtz et al., eds. Berkeley Women and Language Group, 1994.

Hoffman, Donna and Thomas P. Novak. "Bridging the Digital Divide: The Impact of Race on Computer Access and Internet Use." Project 2000, Vanderbilt University. Internet, 29 January 1999. Available: http://www2000.ogsm.vanderbilt.edu/papers/race/science.html.

Ignatiev, Noel, and John Garvey, eds. *Race Traitor*. New York: Routledge, 1996.

Jacobs-Hueys, Lanita. "…BTW, How do YOU Wear Your Hair? Identity, Knowledge and Authority in an Electronic Speech Community." Forthcoming in *Computer-mediated Conversation*. Susan Herring, ed. Manuscript version.

Jones, Steve, ed. *Cybersociety: Computer-Mediated Communication and Community*. London: Sage, 1995.

———. *Cybersociety 2.0: Revisiting Computer-Mediated Communication and Community*. London: Sage, 1998.

Leslie, Connie, et. al. "The Loving Generation: Biracial Children Seek Their Own Place," *Newsweek*, 13 February 1995, 72.

McRae, Shannon. "Coming Apart at the Seams: Sex, Text and the Virtual Body," in *Wired_Women: Gender and New Realities in Cyberspace*, Lynn Cherny and Elizabeth Reba Weise, eds. Seattle: Seal Press, 1996.

Morganthau, Tom. "What Color Is Black?" *Newsweek*, 13 February 1995, 62–65.

Omi, Michael, and Howard Winant. "On the Theoretical Status of the Concept of Race," in *Race, Identity, and Representation in Education*, Cameron McCarthy and Warren Crichlow, eds. New York: Routledge, 1993.

Rensberger, Boyce. "Forget the Old Labels. Here's a New Way to Look at Race." *Washington Post*, 16 November 1994, H1+.

Porter, David, ed. *Internet Culture*. New York: Routledge, 1997.

Poster, Mark. *The Second Media Age*. Cambridge: Polity Press, 1996.

Shields, Rob, ed. *Cultures of the Internet: Virtual Spaces, Real Histories, Living Bodies*. Thousand Oaks, CA: Sage Publications, 1996.

Stone, Allucquère Rosanne. *The War of Desire and Technology at the Close of the Mechanical Age*. Cambridge, MA: MIT Press, 1995.

Turkle, Sherry. *Life on the Screen: Identity in the Age of the Internet*. New York: Simon & Schuster, 1995.

———. *The Second Self: Computers and the Human Spirit*. New York: Simon & Schuster, 1984.

Wresch, William. *Disconnected: Haves and Have-Nots in the Information Age*. New Brunswick, NJ: Rutgers University Press, 1996.

Wright, Lawrence. "One Drop of Blood." *The New Yorker*, 25 July 1994, 46–50, 52–55.

2. "Where Do You Want to Go Today?"

Cybernetic Tourism, the Internet, and Transnationality

Lisa Nakamura

> There is no race. There is no gender. There is no age. There are no infirmities.
> There are only minds. Utopia? No, Internet.
> —"Anthem," television commercial for MCI

The television commercial "Anthem" claims that on the Internet, there are no infirmities, no gender, no age, that there are only minds. This pure, democratic, cerebral form of communication is touted as a utopia, a pure no-place where human interaction can occur, as the voice-over says, "uninfluenced by the rest of it." Yet can the "rest of it" be written out as easily as the word *race* is crossed out on the chalkboard by the hand of an Indian girl in this commercial?

It is "the rest of it," the specter of racial and ethnic difference and its visual and textual representation in print and television advertisements that appeared in 1997 by Compaq, IBM, and Origin, that I will address in this chapter. The ads I will discuss all sell networking and communications technologies that depict racial difference, the "rest of it," as a visual marker. The spectacles of race in these advertising images are designed to stabilize contemporary anxieties that networking technology and access to cyberspace

may break down ethnic and racial differences. These advertisements, which promote the glories of cyberspace, cast the viewer in the position of the tourist, and sketch out a future in which difference is either elided or put in its proper place.

The ironies in "Anthem" exist on several levels. For one, the advertisement positions MCI's commodity —"the largest Internet network in the world"— as a solution to social problems. The advertisement claims to produce a radical form of democracy that refers to and extends an "American" model of social equality and equal access. This patriotic anthem, however, is a paradoxical one: the visual images of diversity (old, young, black, white, deaf, etc.) are displayed and celebrated as spectacles of difference that the narrative simultaneously attempts to erase by claiming that MCI's product will reduce the different bodies that we see to "just minds."

The ad gestures towards a democracy founded upon disembodiment and uncontaminated by physical difference, but it must also showcase a dizzying parade of difference in order to make its point. Diversity is displayed as the sign of what the product will eradicate. Its erasure and elision can only be understood in terms of its presence; like the word "race" on the chalkboard, it can only be crossed out if it is written or displayed. This ad writes race and poses it as both a beautiful spectacle and a vexing question. Its narrative describes a "postethnic America," to use David Hollinger's phrase, where these categories will be made not to count. The supposedly liberal and progressive tone of the ad camouflages its depiction of race as something to be eliminated, or made "not to count," through technology. If computers and networks can help us to communicate without "the rest of it," that residue of difference with its power to disturb, disrupt, and challenge, then we can all exist in a world "without boundaries."

Another television commercial, this one by AT&T, that aired during the 1996 Olympics asks the viewer to "imagine a world without limits—AT&T believes communication can make it happen." Like "Anthem," this narrative posits a connection between networking and a democratic ethos in which differences will be elided. In addition, it resorts to a similar visual strategy—it depicts a black man in track shorts leaping over the Grand Canyon.

Like many of the ads by high tech and communications companies that aired during the Olympics, this one has an "international" or multicultural flavor that seems to celebrate national and ethnic identities. This world without limits is represented by vivid and often sublime images of displayed ethnic and racial difference in order to bracket them off as exotic and irremediably other.

Images of this other as primitive, anachronistic, and picturesque decorate the landscape of these ads.

Microsoft's recent television and print media campaign markets access to personal computing and Internet connectivity by describing these activities as a form of travel. Travel and tourism, like networking technology, are commodities that define the privileged, industrialized first-world subject, and they situate him in the position of the one who looks, the one who has access, the one who communicates. Microsoft's omnipresent slogan "Where do you want to go today?" rhetorically places this consumer in the position of the user with unlimited choice; access to Microsoft's technology and networks promises the consumer a "world without limits" where he can possess an idealized mobility. Microsoft's promise to transport the user to new (cyber)spaces where desire can be fulfilled is enticing in its very vagueness, offering a seemingly open-ended invitation for travel and new experiences. A sort of technologically enabled transnationality is evoked here, but one that directly addresses the first-world user, whose position on the network will allow him to metaphorically go wherever he likes.

This dream or fantasy of ideal travel common to networking advertisements constructs a destination that can look like an African safari, a trip to the Amazonian rain forest, or a camel caravan in the Egyptian desert. The iconography of the travelogue or tourist attraction in these ads places the viewer in the position of the tourist who, in Dean MacCannell's words, "simply collects experiences of difference (different people, different places)" and "emerges as a miniature clone of the old Western philosophical subject, thinking itself unified, central, in control, etc., mastering Otherness and profiting from it" (xv). Networking ads that promise the viewer control and mastery over technology and communications discursively and visually link this power to a vision of the other which, in contrast to the mobile and networked tourist/user, isn't going anywhere. The continued presence of stable signifiers of otherness in telecommunications advertising guarantees the Western subject that his position, wherever he may choose to go today, remains privileged.

An ad from Compaq (see fig. 1) that appeared in the *Chronicle of Higher Education* reads "Introducing a world where the words 'you can't get there from here' are never heard." It depicts a "sandstone mesa" with the inset image of a monitor from which two schoolchildren gaze curiously at the sight. The ad is selling "Compaq networked multimedia. With it, the classroom is no longer a destination, it's a starting point." Like the Microsoft and AT&T slogans, it links networks with privileged forms of travel, and reinforces the

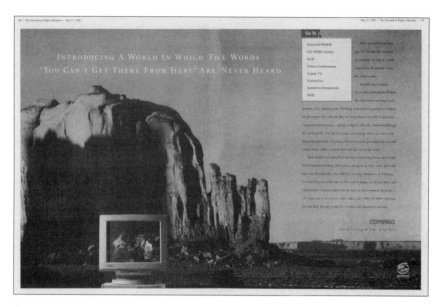

Figure 1 • Grand Canyon—Compaq

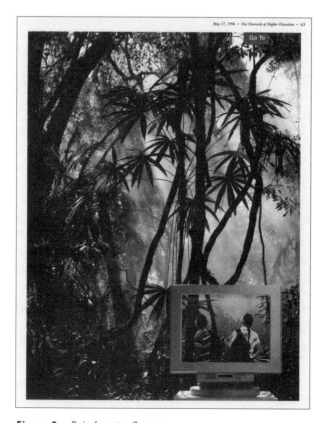

Figure 2 • Rain forest—Compaq

metaphor by visually depicting sights that viewers associate with tourism. The networked classroom is envisioned as a glass window from which networked users can consume the sights of travel as if they were tourists.

Another ad from the Compaq series (fig. 2) shows the same children admiring the networked rain forest from their places inside the networked classroom, signified by the frame of the monitor. The tiny box on the upper-right-hand side of the image evokes the distinctive menu bar of a Windows product, and frames the whole ad for its viewer as a window onto an "other" world.

The sublime beauty of the mesa and the lush pastoral images of the rain forest are nostalgically quoted here in order to assuage an anxiety about the environmental effects of cybertechnology. In a world where sandstone mesas and rain forests are becoming increasingly rare, partly as a result of industrialization, these ads position networking as a benign, "green" type of product that will preserve the beauty of nature, at least as an image on the screen. As John Macgregor Wise puts it, this is part of the modernist discourse that envisioned electricity as "transcendent, pure and clean," unlike mechanical technology. The same structures of metaphor that allow this ad to dub the experience of using networked communications "travel" also enables it to equate an image of a rain forest in Nature (with a capital N). The enraptured American schoolchildren, with their backpacks and French braids, are framed as user-travelers. With the assistance of Compaq, they have found their way to a world that seems to be without limits, one in which the images of nature are as good as or better than reality.

The virtually real rain forest and mesa participate in a postcyberspace paradox of representation—the locution "virtual reality" suggests that the line or "limit" between the authentic sight/site and its simulation has become blurred. This discourse has become familiar, and was anticipated by Jean Baudrillard pre-Internet. Familiar as it is, the Internet and its representations in media such as advertising have refigured the discourse in different contours. The ads that I discuss attempt to stabilize the slippery relationship between the virtual and the real by insisting upon the monolithic visual differences between first- and third-world landscapes and people.

This virtual field trip frames Nature as a tourist sight and figures Compaq as the educational tour guide. In this post-Internet culture of simulation in which we live, it is increasingly necessary for stable, iconic images of Nature and the Other to be evoked in the world of technology advertising. These images guarantee and gesture toward the unthreatened and unproblematic existence of a destination for travel, a place whose beauty and exoticism will

somehow remain intact and attractive. If technology will indeed make everyone, everything, and every place the same, as "Anthem" claims in its ambivalent way, then where is there left to go? What is there left to see? What is the use of being asked where you want to go today if every place is just like here? Difference, in the form of exotic places or exotic people, must be demonstrated iconographically in order to shore up the Western user's identity as himself.

This idyllic image of an Arab on his camel, with the pyramids picturesquely squatting in the background, belongs in a coffee-table book (see fig. 3). The timeless quality of this image of an exotic other untouched by modernity is disrupted by the cartoon dialogue text, which reads "What do you say we head back and download the results of the equestrian finals?" This dissonant use of contemporary vernacular American techoslang is supposed to be read comically; the man is meant to look unlike anyone who would speak these words.

The gap between the exotic Otherness of the image and the familiarity of its American rhetoric can be read as more than an attempt at humor, however. IBM, whose slogan "solution for a small planet" is contained in an icon button in the lower left hand side of the image, is literally putting these incongruous words into the Other's mouth, thus demonstrating the hegemonic power of its "high speed information network" to make the planet smaller by causing every-

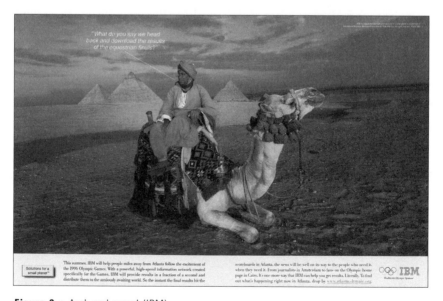

Figure 3 • Arab and camel (IBM)

one to speak the *same* language—computer-speak. His position as the exotic Other must be emphasized and foregrounded in order for this strategy to work, for the image's appeal rests upon its evocation of the exotic. The rider's classical antique "look and feel" atop his Old Testament camel guarantee that his access to a high speed network will not rob us, the tourist/viewer, of the spectacle of his difference. In the phantasmatic world of Internet advertising, he can download all the results he likes, so long as his visual appeal to us, the viewer, reassures us that we are still in the position of the tourist, the Western subject, whose privilege it is to enjoy him in all his anachronistic glory.

These ads claim a world without boundaries for us, their consumers and target audience, and by so doing they show us exactly where and what these boundaries really are. These boundaries are ethnic and racial ones. Rather than being effaced, these dividing lines are evoked over and over again. In addition, the ads sanitize and idealize their depictions of the Other and Otherness by deleting all references that might threaten their status as timeless icons. In the camel image, the sky is an untroubled blue, the pyramids have fresh, clean, sharp outlines, and there are no signs whatsoever of pollution, roadkill, litter, or fighter jets.

Including these "real life" images in the advertisement would disrupt the picture it presents us of an Other whose "unspoiled" qualities are so highly valued by tourists. Indeed, as Trinh Minh-Ha notes, even very sophisticated tourists are quick to reject experiences that challenge their received notions of authentic Otherness. Trinh writes, "the Third World representative the modern sophisticated public ideally seeks is the *unspoiled* African, Asian, or Native American, who remains more preoccupied with his/her image as the *real* native—the *truly different*—than with the issues of hegemony, feminism, and social change" (88). Great pains are taken in this ad to make the camel rider appear real, truly different from us, and "authentic" in order to build an idealized Other whose unspoiled nature shores up the tourist's sense that he is indeed seeing the "real" thing. In the post-Internet world of simulation, "real" things are fixed and preserved in images such as these in order to anchor the Western viewing subject's sense of himself as a privileged and mobile viewer.

Since the conflicts in Mogadishu, Sarajevo, and Zaire (images of which are found elsewhere in the magazines from which these ads came), ethnic difference in the world of Internet advertising is visually "cleansed" of its divisive, problematic, tragic connotations. The ads function as corrective texts for readers deluged with images of racial conflicts and bloodshed both at home and abroad. These advertisements put the world right; their claims for better living (and better

[margin note, handwritten: The western world is provided for granted. White is still supreme b/c whites are not the Others or the appeal for "tourists"]

transnational

boundaries) through technology are graphically acted out in idealized images of Others who miraculously speak like "us" but still look like "them."

The Indian man (pictured in an IBM print advertisment that appeared in *Smithsonian*, January 1996) whose iconic Indian elephant gazes sidelong at the viewer as he affectionately curls his trunk around his owner's neck, has much in common with his Egyptian counterpart in the previous ad. (The ad's text tells us that his name is Sikander, making him somewhat less generic than his counterpart, but not much. Where is the last name?) The thematics of this series produced for IBM plays upon the depiction of ethnic, racial, and linguistic differences, usually all at the same time, in order to highlight the hegemonic power of IBM's technology. IBM's television ads (there were several produced and aired in this same series in 1997) were memorable because they were all subtitled vignettes of Italian nuns, Japanese surgeons, and Norwegian skiers engaged in their quaint and distinctively ethnic pursuits, but united in their use of IBM networking machines. The sounds of foreign languages being spoken in television ads had their own ability to shock and attract attention, all to the same end—the one word that was spoken in English, albeit heavily accented English, was "IBM."

Thus, the transnational language, the one designed to end all barriers between speakers, the speech that everyone can pronounce and that cannot be translated or incorporated into another tongue, turns out not to be Esperanto but rather IBM-speak, the language of American corporate technology. The foreignness of the Other is exploited here to remind the viewer—who may fear that IBM-speak will make the world smaller in undesirable ways (for example, that they might compete for our jobs, move into our neighborhoods, go to our schools)—that the Other is still picturesque. This classically Orientalized Other, such as the camel rider and Sikander, is marked as sufficiently different from us, the projected viewers, in order to encourage us to retain our positions as privileged tourists and users.

Sikander's cartoon-bubble, emblazoned across his face and his elephant's, asks, "How come I keep trashing my hardware every 9 months?!" This question can be read as a rhetorical example of what postcolonial theorist and novelist Salman Rushdie has termed "globalizing Coca-Colonization." Again, the language of technology, with its hacker-dude vernacular, is figured here as the transnational tongue, miraculously emerging from every mouth. Possible fears that the exoticism and heterogeneity of the Other will be siphoned off or eradicated by his use of homogeneous technospeak are eased by the visual impact of the elephant, whose trunk frames Sikander's face. Elephants, rain forests, and unspoiled mesas are all endangered markers of cultural difference that represent

specific stereotyped ways of being Other to Western eyes. If we did not know that Sikander was a "real" Indian (as opposed to Indian-American, Indian-Canadian, or Indo-Anglian) the presence of his elephant, as well as the text's reference to "Nirvana," proves to us, through the power of familiar images, that he is. We are meant to assume that even after Sikander's hardware problems are solved by IBM's "consultants who consider where you are as well are where you're headed" he will still look as picturesque, as "Indian" as he did pre-IBM.

Two other ads, part of the same series produced by IBM, feature more ambiguously ethnic figures. The first one of these depicts a Latina girl who is asking her teacher, Mrs. Alvarez, how to telnet to a remote server. She wears a straw hat, which makes reference to the Southwest. Though she is only eight or ten years old, her speech has already acquired the distinctive sounds of technospeak—for example, she uses "telnet" as a verb. The man in the second advertisement, an antique-looking fellow with old fashioned glasses, a dark tunic, dark skin, and an untidy beard proclaims that "you're hosed when a virus sneaks into your hard drive." He, too, speaks the transnational vernacular—the diction of Wayne and Garth from *Wayne's World* has sneaked into *his* hard drive like a rhetorical virus. These images, like the preceding ones, enact a sort of cultural ventriloquism that demonstrates the hegemonic power of American technospeak. The identifiably ethnic faces, with their distinctive props and costumes, that utter these words, however, attest to the importance of Otherness as a marker of a difference that the ads strive to preserve.

This Origin ad appeared in *Wired* magazine, which, like *Time, Smithsonian,* the *New Yorker,* and *The Chronicle of Higher Education* directs its advertising toward upper-middle-class, mainly white readers (see fig. 4). In addition, *Wired* is read mainly by men, it has an unabashedly libertarian bias, and its stance toward technology is generally utopian. Unlike the other ads, this one directly and overtly poses ethnicity and cultural difference as part of a political and commercial dilemma that Origin networks can solve. The text reads, in part,

> [W]e believe that wiring machines is the job, but connecting people the art. Which means besides skills you also need wisdom and understanding. An understanding of how people think and communicate. And the wisdom to respect the knowledge and cultures of others. Because only then can you create systems and standards they can work with. And common goals which all involved are willing to achieve.

The image of an African boy, surrounded by his tribe, seemingly performing a *Star Trek* Vulcan mind meld with a red-haired and extremely pale boy, cen-

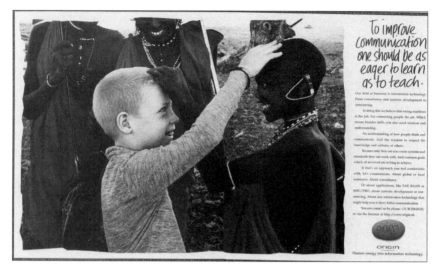

Figure 4 • Black boy and white boy: Origin

trally situates the white child, whose arm is visible in an unbroken line, as the figure who is supposedly as willing to learn as he is to teach.

However, the text implies that the purpose of the white boy's encounter with an African boy and his tribe is for him to learn just enough about them to create the "systems and standards that THEY can work with." The producer of marketable knowledge, the setter of networking and software-language standards, is still defined here as the Western subject. This image, which could have come out of *National Geographic* any time in the last hundred years, participates in the familiar iconography of colonialism and its contemporary cousin, tourism. And in keeping with this association, it depicts the African as unspoiled and authentic. Its appeal to travel across national and geographical borders as a means of understanding the Other, "the art of connecting people," is defined as a commodity which this ad and others produced by networking companies sell along *with* their fiber optics and consulting services.

The notion of the computer-enabled "global village" envisioned by Marshall McLuhan also participates in this rhetoric that links exotic travel and tourism with technology. The Origin image comments on the nature of the global village by making it quite clear to the viewer that despite technology's claims to radically and instantly level cultural and racial differences (or in a more extreme statement, such as that made by "Anthem," to literally cross

them out) there will always be villages full of "real" Africans, looking just as they always have.

It is part of the business of advertising to depict utopias: ideal depictions of being that correctively reenvision the world and prescribe a solution to its ills in the form of a commodity of some sort. And like tourist pamphlets, they often propose that their products will produce, in Dean MacCannell's phrase, a "utopia of difference," such as has been pictured in many Benetton and Coca-Cola advertising campaigns.

Coca-Cola's slogan from the seventies and eighties, "I'd like to teach the world to sing," both predates and prefigures these ads by IBM, Compaq, Origin, and MCI . The Coca-Cola ads picture black, white, young, old, and so on holding hands and forming a veritable Rainbow Coalition of human diversity. These singers are united by their shared song and, most important, their consumption of bottles of Coke. The viewer, meant to infer that the beverage was the direct cause of these diverse Coke drinkers overcoming their ethnic and racial differences, was given the same message then that many Internet-related advertisements give us today. The message is that cybertechnology, like Coke, will magically strip users down to "just minds," all singing the same corporate anthem.

And what of the "rest of it," the raced and ethnic body that cyberspace's "Anthem" claims to leave behind? It seems that the fantasy terrain of advertising is loath to leave out this marked body because it represents the exotic Other which both attracts us with its beauty and picturesqueness and reassures us of our own identities as "*not* Other." The "rest of it" is visually quoted in these images and then pointedly marginalized and established *as Other*. The iconography of these advertising images demonstrates that the corporate image factory *needs* images of the Other in order to depict its product: a technological utopia of difference. It is not, however, a utopia *for* the Other or one that includes it in any meaningful or progressive way. Rather, it proposes an ideal world of virtual social and cultural reality based on specific methods of "Othering," a project that I would term "the globalizing Coca-Colonization of cyberspace and the media complex within which it is embedded."

Acknowledgments

I would like to thank the members of the Sonoma State University Faculty Writing Group: Kathy Charmaz, Richard Senghas, Dorothy Freidel, Elaine McHugh, and Virginia Lea for their encouragement and suggestions for revi-

sion. I would also like to thank my research assistant and independent study advisee at Sonoma State, Dean Klotz, for his assistance with permissions, research, and all things cyber. And a very special thanks to Amelie Hastie and Martin Burns, who continue to provide support and advice during all stages of my work on this topic.

References

Hollinger, David. *Postethnic America: Beyond Multiculturalism*. New York: Basic Books, 1995.

McCannell, Dean. *The Tourist: A New Theory of the Leisure Class*. New York: Schocken Books, 1989.

McLuhan, Marshall. *Understanding Media: The Extensions of Man*. Cambridge: MIT Press, 1994.

Rushdie, Salman. "Damme, This Is the Oriental Scene For You!" *New Yorker*, 23 and 30 June 1997, 50–61.

Trinh Minh-ha. *Woman, Native, Other: Writing Postcoloniality and Feminism*. Bloomington: University of Indiana Press, 1989.

Wise, John Macgregor. "The Virtual Community: Politics and Affect in Cyberspace." Paper delivered at the American Studies Association Conference, Washington D.C., 1997.

3. The Appended Subject

Race and Identity as Digital Assemblage

Jennifer González

To append is to attach or fix something onto something else. The Latin root *pendere* means *to hang*—to hang something (an arm, a leg, a text) onto something else. In an uncanny way, an appendage is always considered integral to the object to which it is also an addition. The simultaneous necessity and marginality of the appendange also characterizes many of those material practices, objects and signs that are said to construct forms of social and cultural identification. Signs grafted onto the human subject—such as clothing or names, projections of others based upon historical circumstances, location, language—enunciate both defining elements of that subject and part of an external, changing narrative into which that subject is drawn—voluntarily or involuntarily—as a participant. The "appended subject" has several connotations here: that of a subject that is comprised of appendages, of parts put together, of supplementary materials, or that of a subject or person who is defined by a relation of supplementarity, added to some other principal body—as the colonized subject might be perceived by an imperial nation as an appendage to a centralized state. Finally, the appended subject describes an object constituted by electronic elements serving as a psychic or bodily appendage, an artificial

subjectivity that is attached to a supposed original or unitary being, an online persona understood as somehow appended to a real person who resides elsewhere, in front of a keyboard. In each case a body is constructed or assembled in order to stand in for, or become an extension of, a subject in an artificial but nevertheless inhabited world.

The concept of an appended subject is used in this essay in order to account for contemporary artists' representations of utopic spaces on the World Wide Web and the visible models of embodied subjects produced therein. This relatively new domain for the phantasmatic projection of subjectivity (new in comparison to other media such as film, television, advertising and forms of cultural spectacle that produce patterns of identification) has also been championed as an innovative space for the reinscription or redefinition of social relations, as well as the reconceptualization of the traditional markers of race and ethnicity, sexuality and gender. There are currently thousands of online spaces that allow users to experiment with identity in an artificial world. The original form of such sites—MUDs or MOOs—are collaborative writing projects in which people describe or define a physical presence, contribute to a textual architecture, and converse with other online participants. Media theorists and communications scholars have provided the most sophisticated and extensive readings of this social collective practice. Much has already been written about the agony and ecstasy of gender swapping, virtual sex, passing, and politics on these sites.[1] As computer monitors and Internet interfaces have increased in their capacity to display visual information over the last decade, online sites with image and sound components have become popular. In these "habitats" or "palaces" a textual description of the user is superseded or supplemented by a visual icon—usually called an avatar.

Even a superficial glance at online sites that distribute or sell avatars is instructive, revealing a common set of identificatory fantasies created by individual whim as well as popular demand. Simple grids of images (scanned photographs, drawings, cartoons) are arranged thematically (as movie stars or "avamarks," soft-porn models or "avatarts," muscular men or "avahunks," trouble-makers or "avapunks," cats, dogs, Native Americans, blondes, brunettes, happy faces, Hula dancers, space aliens, medieval knights, and corporate logos) apparently following an internal logic of demand but tacitly referencing a social typology in which such categories mark out a hierarchy of social relations and stereotypes. The availability of these images for sale makes literal a public circulation of ego ideals while simultaneously naturalizing the market-

place as the privileged domain—beyond family, church or state—of contemporary identity construction and consumption.

The enactment of racial identity in online sites takes a variety of forms. In some cases users will self-identify (as white, black, Latino) in chats that solicit discussion on the topic of race. In other cases, race or ethinicity will be a defining feature of a website to which users send photographs of themselves, such as sites that function as support groups for mixed-race couples. My focus here, however, is on the phantasmatic representation of race or ethnicity and in particular on models of hybrid racial identity that take the form of avatars or other visual assemblages of human bodies. Insofar as racial and ethnic identity are conceived in many cases to be limited to visible signs such as skin color, eye color, or bone structure, they are also conceived as decorative features to be attached or detached at will in the so-called artificial or virtual context of cyberspace. Such play with racial identity nevertheless can and does have concrete consequences as real as those occuring in other cultural domains of social exchange such as literature, film or music. Because "passing" (or pretending to be what one is not) in cyberspace has become a norm rather than an exception, the representation of race in this space is complicated by the fact that much of the activity online is about becoming the fantasy of a racial other.

Homi Bhabha's 1986 essay "The Other Question" has been useful to my own work for its elaboration of the link between racial stereotyping and the structural disavowal that characterizes fetishism. Stereotypes are created by colonizing cultures, Bhabha asserts, in order to mask real cultural difference. In order to disavow this difference, as well as the complex subjecthood of the colonized population, the stereotype presents itself as a fetish—in the form of literature, images, speech—by which the possible threat of the "other's" difference is transformed into a safe fantasy for the colonizer. Thus "the recognition and disavowal of difference is always disturbed by the question of its representation or construction."[2] Bhabha's analysis succeeds in drawing out the relations of power that underlie the colonialist enterprise and that become manifest in social and material practices. Something on the same order of analysis is required, I believe, to address the fantasy utopias or dystopias of the Web that reproduce stereotypes (particularly of race and gender) at an impressive pace.

My brief analysis here is motivated largely by a curiosity concerning representations of human bodies online. How do such visual representations extend or challenge current conceptions of racial and cultural identity and relations of power? In what ways is human identity equated with the notion of

a bodily assemblage? What are the possible ramifications of such an equation for conceptions of cultural hybridity on the one hand, or a revived eugenics on the other?

Two provocative sites will serve as a point of discussion, though there are many others appearing daily. UNDINA, by the Russian artist Kostya Mitenev, and Bodies© INCorporated, by U.S.-based artist Victoria Vesna, appear inspired, at least in part, by the contemporary phenomenon of avatar production. Both websites deviate somewhat from the norm, putting an unusual spin on the production of "appended subjects," particularly as those subjects are conceived as assembled from disparate iconic elements. Each site offers the user the opportunity to construct or "submit" visual images of a body or of body parts, and to examine other bodies that have been put on display. These two sites were chosen for comparison because the human body is their primary focus and race or ethnicity as elements of identity are conspicuous in their presence or absence in each case. Both sites use the space of the computer screen to depict bodies in pieces, either as photographic images or three-dimensional renditions of corporeal fragments (arms, legs, heads, torsos) that can be selected from a menu or reassembled. I am particularly interested in the ramifications of such artistic projects for thinking about the interpellation of individuals as embodied subjects and the political, ethical, and aesthetic notions of choice that they imply.

Identity as Bodily Assemblage: Parts and Proximate Relations

The title of Kostya Mitenev's website, UNDINA, is an acronym for United Digital Nations. Linked to a collective webpage for a group of Russian artists and scholars who identify themselves as Digital Body and who participate in exhibitions held in the Bionet Gallery, as well as to the home page for the city of St. Petersburg, the site has an international, cosmopolitan, and diplomatic feel. At the same time, UNDINA is clearly positioned as a work of contemporary art, sited within its own electronic gallery and addressing an audience of other artists and designers. Indeed, the line between so-called high art and the visual culture that pervades the World Wide Web has long been institutionally crossed insofar as museums of art (ICA London, the Guggenheim Museum, the Museum of Modern Art, and so on) regularly display online art projects; institutions of art education in industrialized nations offer computer graphics as a central component of their curricula; and art critics produce many online

and offline publications that address exclusively online art practice. At the same time, the work is not unlike other sites that are presented for entertainment, commerce, or information. The space is electronic, the vernacular is based on standards of hardware and software, and the audience is unpredictable. To study works of art in this context thus invites comparison to a broader field of visual culture (i.e. avatar production) as well as to parallels in other fine art practices and performances.

On the opening page of Kostya Mitenev's UNDINA appears the familiar figure of Leonardo Da Vinci's fifteenth-century Vitruvian Man, with arms and legs outstretched, floating in geometric perfection (see fig. 1). An ironic gesture on the part of Mitenev, the Vitruvian Man situates his work within and against a tradition of figurative normativity. Leonardo's geometry becomes a sign of the standard against which the artist develops his own model of contemporary human form and being, while at the same time the body of man is read as the central axis in a futurology of body archetypes. Mitenev accuses this standard (here renamed Xyman) of having dominated European cultural representations of the body "for half a millennium."[3] Part of the goal of the UNDINA website, according to the artist, is to de-center this traditional form with a set of collectively constructed new future bodies.

Comprised of three separate domains, the UNDINA site includes a virtual gallery space that can be navigated with VRML technology, a planetary system "populated" by cultural archetypes, and, the central focus of the work, what might be called a future-body table of new physical types. This last consists of a screen space divided into a grid of nine squares, depicting the head, torso, and legs of three vertical figures (see fig. 2). Body or body-part images that have been submitted by users or that the artist has included himself are joined or stacked together to form a monstrous or fantastical mixing of sex, age and race into a single body. The artist comments, "In the project of UNDINA the intrigue of the collective modeling of the body of the future is maintained." His plan is to make "a wide range catalog of visual delirium of future images of the body and to create a model or space of international foresight of artistic images of future bodies." In the process, he suggests that "you can choose your own model of a body, alternatively you can create it yourself with your computer. The bodies are timeless and anonymous, that frees the self in the space of the meta-world." He adds in conclusion that "Artists of non-European traditions of conceptualizing and visualizing of the body are specially invited."[4] Mitenev's project appears progressive in so far as it aims to undermine narrow conceptions of human being; to shift European standards of

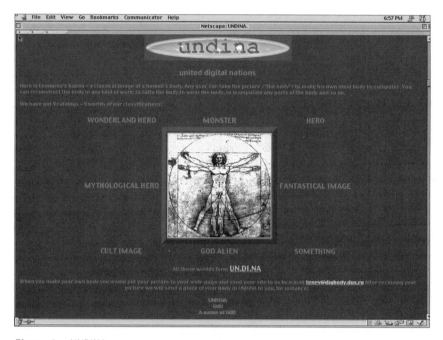

Figure 1 • UNDINA

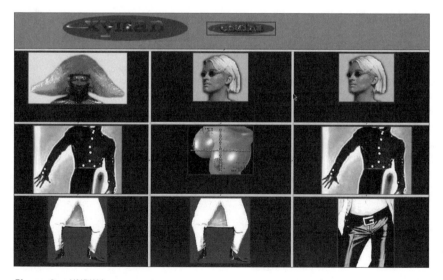

Figure 2 • UNDINA

body normativity from center to margin; to offer a United Digital Nations of diverse international membership as a model for future cultural contact, perhaps even a "global" village. But UNDINA's effort to escape the culture of the stereotype oddly reinscribes its narrow confines. The result is more akin to what might be a fantasy in the form of the surrealist game Exquisite Corpse.

The bodies in Mitenev's body grid are "timeless" or perhaps more precisely, heterochronic, insofar as they are comprised of both historical and contemporary images that are also constantly shifting, the mix-and-match elements recurring or transforming into new configurations. Along the row of heads, for example, one might see a portrait by Archimboldo or Rosetti, a 1940s photograph of a beautiful black woman's face, or the head of a white male fashion model; at torso level there might appear the bare breasts of a pornography model, a scantily clad dark-skinned woman or a white man in a suit and tie; and for legs a pair of combat boots, a photograph of female—or in the rare instance, male—genitalia and bare legs, or the tender feet of an infant. These and many other images flash continually on and off in this imaginary game of human exhibition and hybridization. Fantasies of undressing and connecting with cultural "others" are expressed in a painfully awkward montage, resulting in a strange dysplasia.

Leaving behind this screen of automated flesh, the user can travel to the planetary realm of UNDINA populated by selected archetypal figures of the artist's futurology. Rather than dissecting these bodies into a set of interchangeable parts, the artist presents them within categories of his own devising. One can visit, for example, the planet of the gods, the aliens, the heroes, the mythological heroes, the wonderland heroes, the cult images, the fantastical images, or the monsters. Here, future bodies are not so much hybrids as characters within an almost literary taxonomy, and there seems to be little distinction between Mitenev's work and the cultural stereotypes provided by other avatar sites. For example, aliens are either black men or blue space creatures; heroes are white men with blond hair; killers wear African headdresses; and cult images include nude women of color.

Mitenev's work, perhaps unconsciously, perpetuates damaging racial and sexual stereotypes—in itself nothing new in art or visual culture; yet, UNDINA is all the more insidious because of its utopic and inclusive rhetoric. Indeed, I would probably not address this work if it were not for its supposed attempt to picture a progressive model of future subjectivity. In this context, the most interesting aspect of the site is the series of images that comprise the automatic body table, those future bodies exemplified in a nonunitary, hybrid form. This

ambitious attempt to reproduce a model of cultural mixing through an inter-
section of photographic images appears in an equally insidious way in *Time*
magazine, in an article entitled "The New Face of America" (1993). Donna
Haraway has commented, "*Time* magazine's matrix of morphed racial mix-
tures induces amnesia about what it costs, and what might be possible when
flesh-and-blood people confront the racialized structure of desire and/or
reproduction collectively and individually."[5] Evelynn M. Hammonds com-
ments that

> Morphing, with its facile device of shape-changing, interchangeability,
> equivalency, and feigned horizontality in superficial ways elides its simi-
> larity with older hierarchical theories of human variation. [...] With the
> *Time* cover we wind up not with a true composite, but a preferred or fil-
> tered composite of mixed figures with no discussion of the assumptions
> or implications underlying the choices.[6]

What both UNDINA and *Time* magazine offer in the form of a visual repre-
sentation is a dissection of a fantasy subject along the gross criteria of bodily
appendages or genotype, with little or no consideration of other cultural fac-
tors such as language, economic class, or political practice. It is similar to the
process that Margaret Morse sees operating in the morphing of human faces
in Michael Jackson's *Black or White* music video: "Ideologically, the work of
achieving harmony among different people disappears along with the space in
between them."[7] The artist's desire to produce timeless and anonymous bod-
ies creates precisely the kind of historical elision that erases any complex
notion of cultural identity. Here a hybrid identity is presumed to reside in or
on the visible markers of the body, the flesh. In a sense, Mitenev beautifully
illustrates the projective power of stereotyping. Here the *subject* is distilled
from the assembled components (appendages) of the *body*.

This reading of the body as a coded form, a visible map, of the subject is
as familiar as the idea of the symptom, as basic to visual culture as the process
of photographic mimesis that followed painting in a long line of efforts to cap-
ture the subject through a record, an imprint of the body. But it is not this his-
tory that is of greatest importance here. Mitenev's work has less in common
with the history of portraiture than with the experiments enacted in the name
of modernity, the split and divided corporeality of twentieth-century visual
collage, photomontage, and assemblage that attempts to map an unstable sub-
jectivity with the collection or appropriation of disparate images and objects.
I have already suggested a parallel with the surrealist game Exquisite Corpse,

here played out electronically. It is also clear that this site derives its formal structures from photomontage. Indeed, an oblique reference to Hannah Höch's work can be found in Mitenev's use of an African headdress that bears a remarkable resemblance to *Denkmal II: Eitelkeit (Monument II: Vanity)* from the series *Aus einem ethnographischen Museum (From an Ethnographic Museum)* of 1926.

Insofar as Kostya Mitenev's project relies upon, or at least gestures toward, these artistic precedents, it is tempting to read UNDINA as simply an electronic extension of a familiar formal practice, but is also something more. The site might be read as a progressive recognition of the *fact* of cultural hybridity, a recognition that humans are all produced through genetic and linguistic mixes. Yet, as I note above, the mix in Mitenev's universe depends upon cultural stereotypes for its model of the future. I have written elsewhere that the very concept of hybridity is haunted by its assumption of original purity.[8] UNDINA, finally, does little to subvert the racial or cultural hierarchies that underlie its playful, monstrous hybrids.

Mary Shelley's *Frankenstein* was an exploration of psychological and moral transformation, but it is remembered best in popular culture as the story of the reanimation of dead flesh, the production of a monstrosity out of parts of human bodies. The monstrous, as Barbara Maria Stafford reminds us, derives etymologically from the Latin *monstrare* "to show," from *monere*, "to warn," and has come to mean the unnatural mixing of elements that do not belong together—a mixing of elements most often read as a tragic accident.[9] While Frankenstein's monster was no accident, Shelley's novel implies that the monstrous is nevertheless a product of tragedy. It is as if the various parts of the beast, acting in disunion or disharmony, create his inability to cohere as a subject.

The step from the tragic monster to the tragic mulatto or mestizo was a short one in the nineteenth century. The hybrid subject is never considered immune from the vicissitudes of fate or of the repercussions of unnatural union. Here there is also a notion of the body in pieces, somehow unable to become accurately assembled into a properly functioning subject or citizen—hence the laws banning miscegenation that were only repealed in the United States in 1968. Thirty years later, the once forbidden has become an unlikely ideal. What is the appeal of such a subject position (still presented as monstrous) at the end of the twentieth century?

In the context of post-Soviet Russia, it may be a radical act to suggest or visually represent racial and cultural hybridity. This gesture may have some

impact on contemporary political activism. At the same time, the work does little to undo the essentializing tendency common in many well-intentioned efforts to populate the World Wide Web with a variety of human types. Instead, the body fragment is used as a fetish to make cultural difference palatable, as an element of desire, of consumption. The synecdochic quality of the fetish, its status as a part object that allows pleasure, appears in UNDINA's formal, visual dissection and literal truncation of corporeal signs. Even the body as a whole, represented in parts, reproduces a fetishistic structure of disavowal, an occlusion of both the original subject and of the *historical relations between concrete bodies*, of enforced racial mixing, of colonialism. Yet, Mitenev's future bodies are presented as part of a new archetypal architecture of diplomacy. If the artist wishes his audience to play out the metaphor of a United Digital Nations, then what kind of diplomacy, dialog or action can take place in this context? Is the lack of a fixed subject position, a shifting set of bodily apparatus, enough to constitute or provoke, as the artist seems to hope, a new international consciousness? In short, what set of relations is being offered to the audience as the model of future global interchange? Despite its claims of collaborative construction UNDINA perpetuates a unidirectional, uncritical reiteration of precisely the hegemony it claims to critique, and it does so using racial mixing as its model.

In a different way, shifting from an imagined global community to a corporate one, artist Victoria Vesna also takes up the visual metaphor of the body-in-pieces to figure a new elemental species. Bodies© INCorporated is an art project based at the University of California at Santa Barbara, created by Victoria Vesna and a team of collaborators including Robert Nideffer, Nathanial Freitas, Kenneth Fields, Jason Schleifer and others (see fig. 3). The site is designed to allow users to "build out bodies in 3-D space, graphically visualizing what were previously bodies generated as text-only."[10] Bodies© INC clearly situates its origins within the world of avatar manufacturers, yet it also foregrounds the manner in which bodies can be conceived as part of a corporate or institutional structure in contemporary capitalist culture. It hovers in its own liminal space, a pun on the term "incorporated" that becomes a simultaneous critique of corporate culture and a capitulation to its terms of enunciation. For example, as with many other websites, visitors to the site must agree to recognize and abide by various copyright restrictions, legal disclaimers, and limits of liability— including liability for *disappointment* in the outcome of the body one constructs. This witty, self-conscious irony runs throughout the text of the site, drawing upon the rhetoric of advertising as well as making subtle and often satirical gestures toward the politics of identity and, in this case, the very notion

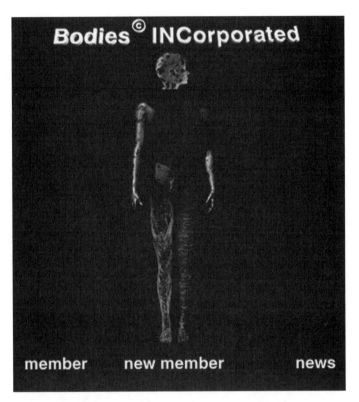

Figure 3 • Bodies© INC

of satisfaction guarantees or the lack thereof in the complex construction of a bodily identity. For here, as in Mitenev's world, the construction of a body is expressly linked to the construction of identity. The opening page of the site welcomes the new visitor, who is informed that the site "functions as an institution through which your body gets shaped in the process of identity construction that occurs in, and mutually implicates, both the symbolic and material realms."[11] The important relation between the material and the symbolic for Vesna is that between the shaping of the body and the construction of identity (the former being the apparent process by which the latter is achieved). While this equation echoes the assumptions of eugenics, it also can be read, alternatively, as a progressive assertion that identities are always inseparable from corporeal encounters and the symbolic inscription of bodily signs. The corporate rhetoric continues in the assertion that the body created "becomes the personal property" of the person who assembled it. The notion of the body

as property also has its own historical connotations, not only in the traditional examples of prostitution and slavery, but also in a contemporary moment when body parts, organs, and vital tissue are bought and sold on a black market.[13] Body parts are also for sale in Bodies© INC, and the more shares the user accrues, the more parts he or she can buy.

Bodies© INC aptly reconstructs the bureaucracy that inspired its inception, drawing attention to bodies threaded through the paperwork of birth and death certificates, census forms, and medical records, and simultaneously emphasizing the necessity and ludicrous limits of creating selfhood through the apparatus of checked boxes and a narrow range of multiple choices. Birth and death are reduced to nothing but the mechanical act of filling out a form—accompanied by the frustration of waiting indefinitely to see the body-object one has created to appear as a visual model in 3D graphics. The process of constructing a body for Bodies© INC sensitizes the user to the categories of identity and identification already standardized in the culture at large.

The administrative forms are a simple black and white, divided into various subsections beginning with a "personal validation" in the form of a name, e-mail address, and password. One must next choose a name for the body to be constructed, then a sex assignment (choices include: female, male, hermaphrodite, other), then a sexual preference (choices include: heterosexual, homosexual, bisexual, transsexual, asexual, other), then an age group (any number with three digits or fewer), then body parts. One arrives at the construction of the body after already declaring its attributes. Continuing with the reductionist model maintained throughout, the body is conceived as an object composed of six essential components: a head, torso, left arm, right arm, left leg, and right leg. No logic is given for this decomposition, though it is likely that the design is dependent upon a number of technical constraints as well as conceptual focus. Each body part can be masculine, feminine, infantile, or nonexistent. One could produce a body without a head, for example. Each part can be sized either small, medium, or large, and is finally surfaced by one of twelve textures: black rubber, blue plastic, bronze, clay, concrete, lava, pumice, water, chocolate, glass, or wood (see fig. 4). Vesna contends that the bodies are "constructed from textures, in order to shift the tendency to perceive the project from a strictly sexualized one (as frequently indicated by people's orders and comments) to a more psychological one (where matters of the mind are actively contemplated and encouraged). Before long, each of the textures is given detailed symbolic meaning."[14]

Bodies© INC thus establishes its own community of bodies with symbolic meaning intimately tied to a surface texture. Given the kinds of images

Figure 4 • Bodies© INC

available on the Web, this gesture is probably groundbreaking, though it remains to be seen how successful it is in desexualizing the body, as the representative forms in Bodies© INC are tall and slim and decidedly reflect the Euro-American ideal. Indeed, to construct a fat body or to produce an unusual or monstrous body in this context requires more shares and expertise. Textures are also a convenient solution to the problem of skin color(s). Yet, the progressive potential of a rejection of racial typology falls into its own essentialism when character traits are equated with physical attributes, and limited to a prescribed system of behaviors. Black rubber is hot and dry, sublimates at a relatively low temperature and is a fashion and style element; bronze is hot and cold, hard and wet, very reactive when heated with most substances and is a corporate leader element; clay is cold, dry, and melancholy, it works on subliminal levels to bring out the feminine and is an organizational element; concrete is cold and wet, a powerful desiccating agent that reacts strongly with water and is a business element; lava is hot and dry, conceived as light trapped in matter or perpetual fire and represents a team leader sense; chocolate is sweet and moist, an integrative force that interweaves and balances and is a marketing element, and so on. What emerges from this list is a set of corpo-

rate typologies—the fiery team leader; the melancholy feminine organizer; the dry diplomat; the black, stylish sublimator—that are simultaneously humorous and disturbingly familiar. Familiar because they combine traits that are already linked in the popular preconscious of the culture at large (the melancholy female, the reactive corporate leader) in the form of archetypes or stereotypes. Hybrid figures may also be composed of different elements, perhaps even a schizophrenic set of surfaces that may implicate the body in a set of conflicting power relations. More ironic and sophisticated than those produced in UNDINA, these body textures are still problematic for those who may already be identified as black or bronze.

In addition to a visual body, the user is able to choose from one of twelve sounds that will provide an otherwise mute figure with a kind of vocal presence: breath, geiger, history, nuclear, sine, and voice for example. The sound components are clearly conceived as conceptual signs that function evocatively rather than mimetically. Finally, the user can mark whether the newly designed body functions as an alter ego, a significant other, a desired sexual partner, or "other," and may add special handling instructions or body descriptions and general comments.

Unlike Mitenev's UNDINA, Vesna's Bodies© INC has extensive written documentation on the website that creates a metadiscourse for the user. An essay by Christopher Newfield defines Bodies© INC as a specific kind of corporate structure that

> establishes a virtual corporation as an 'active community' of participants
> who choose their own bodily form. The primary activity is the creation
> of a body in exchange for which the creator is given a share of stock.
> Corporation B thus exists to express each member's desire about his or
> her physical shape. Production serves self-creation. Firm membership for-
> mally ratifies expression. These expressions have none of the usual limits:
> men become women; black becomes white and white becomes brown;
> flesh turns to clay, plastic, air; clay, plastic, air are attached on one body.
> Bodies need be neither whole nor have parts that fit.[15]

Indeed, this work clearly produces what I have called an appended subject whose limbs and flesh are accessorized, linked to personality traits, and used as values of exchange. The miscegenation of this world is one of hot and cold, wet and dry, mind over matter. But the underlying notion of easily transformed gender and skin color—"men become women; black becomes white and white becomes brown"—more accurately denotes the fantasies inherent in the project.

To her credit Vesna writes, "There is a need for alternate worlds to be built with more complex renditions of identity and community building and not simply replicating the existing physical structures or hierarchies."[16] She also comments that Bodies© INC is conceived "with the intention of shifting the discourse of the body from the usual idea of flesh and identity. Every member's body represented is the locus of the contradictions of functioning in the hi-tech environment, while being in the Meta-Body, the Entity in the business of service."[17] Vesna here maps the internal logic of her own work, criticizing and at the same time reproducing a corporate ontology. Unfortunately, the users of the site do not seem to share her self-conscious take on the function of bodily representations. Lucy Hernandez, quoted in the discussion section of Bodies© INC, writes in May 1997, "I am very pleased to have found your site. I am looking for avatars that can be used in any VRML world. Can my new body leave this site and visit other places? How can I get my new body code? Thanks for making 'real' people. I'm tired of being a bird!" What happens to these real people when they are no longer needed? Like the leftover packaging of mass-produced commodities, the bodies created in Bodies© INC are sent to the wasteland of "Necropolis" after their creators chose a method for their death. Never really gone, they haunt the floating world in cold rows of gray geometric blocks. Other bodies circulate and purchase parts at the "Marketplace" (where a *Star Trek* Vulcan head might currently be on sale), or exercise their exhibitionism in "Showplace," return "Home," or loiter in "Limbo". Each domain is a separate VRML world within Bodies© INC that can be navigated with the proper software (see fig. 5).

Sardonic, slick and beautiful, Bodies© INC offers a critical response to a corporate structure and hierarchy—a hierarchy it maintains, despite its claims to the contrary. Its irony is also part of its complicity. And for this group of artists, complicity seems to be the primary mode by which any kind of cultural transformation and critique will take place. Christopher Newfield writes,

> There's no more important change right now than culture recapturing technology—recapturing technology not to reject it but to make culture its partner again as we invent our future, our society, our redemptions. An excellent place to begin is the [corporate] B-form's recolonization of business power for the artist's mode of continuous invention business now says it seeks. You will know the recolonization is working when you say, paraphrasing Louis Massiah, "it makes revolution irresistible."[18]

This unlikely mix of neo-Marxist and marketing rhetoric suggests a new critical form for art production. Bodies© INC's financial sponsors include, among

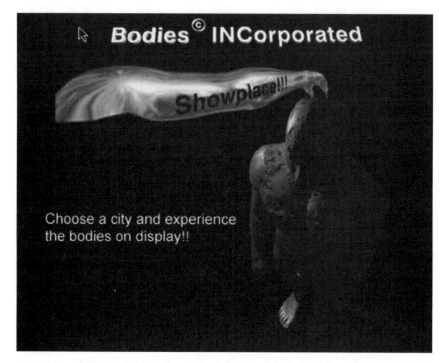

Figure 5 • Bodies© INC

others, Viewpoint Data Labs, Netscape, alias/Wavefront, Silicon Graphics, MetaTools, and Siggraph. It remains to be seen whether a "recolonization" of business power is the most effective method for its critique. Bodies© INC suceeds at least in foregrounding relations among bodies, bureaucracy, and power in a culture based on consumption.

The Global Ideological Apparatus and Getting a Head

The bodies under construction in UNDINA and Bodies© INC populate a built environment of supposedly global proportions. The Internet, when seen as an infinite realm of marketing and promotion, primarily interpellates subjects as consuming bodies, or as subjects in need of appending. Victoria Vesna writes, "One thing is certain—the avatar business is booming. Major companies are investing in creation of online communities and placing their bets on this becoming a 'virtual entertainment ground.'"[19] She sites Rich Abel, president and CEO of Worlds INC who declares, "Consider this:

a virtual trade show that never closes, complete with booths, displays, product demonstrations, and shows. Or a showroom with operating products on display. Or a virtual visit to a theater, a hotel, or cruise ship. There is no more powerful way to market and promote. What kind of world would you like us to build for you?"[20]

In writing about the World Wide Web, scholar Joseba Gabilando turns to Louis Althusser's concept of ideological state apparatuses—conceived as those laws and social institutions that produce concrete individuals *as subjects* through nonrepressive means (church, family, advertising)—in order to elaborate the concept of an ideological global apparatus. Gabilando comments that just as individuals are interpellated as national subjects by the state, cyberspace interpellates individuals as global subjects, hence "cyborg" subjects. But what is the nature of this subjectivity? For Gabilando the interface of cyberspace (as in much of the rest of the world) interpellates the subject primarily as a consumer—not as a citizen, a voter, or a worker. But this new kind of subject position, which at first seems free of cultural specificity, is in fact contingent upon the very differences it appears to overcome. As Gabilando comments,

> Postcolonial subject positions are necessary in order to create the outsideness that cyberspace and consumer culture need to constitute themselves as the new hegemonic inner spaces of postmodernism. [...] In a time when multinational capitalism can simulate multiculturalism, nevertheless race, gender, ethnicity and sexuality still function as forms of discrimination and oppression.[21]

Indeed, it is often argued that the problems of racial discrimination are miraculously overcome in the process of the creation of new subjects and new bodies online. In a tone similar to that taken by Christopher Newfield, Bruce Damer in his recent book *Avatars!* writes, "One of the best features about life in digital space it that your skin color, race, sex, size, religion or age does not matter; neither...[do] academic degrees you have."[22] This naive yet pervasive notion that subjects who are online are able to leave behind the very social categories that define them in the "real world" misunderstands the complexity of human subjects who inevitably enact and perform their new identities through the sign systems they already inhabit, and through which they are already interpellated. It would be equally naive to suggest that subjects are somehow not also powerfully *shaped by* the images and activities that take place for them online. Indeed, the distinction between real and artificial is not

in the least useful when attempting to address the kind of subjects that are cre-
ated in the "interfacial" moment of body/avatar construction. Althusser's
claim that ideology interpellates subjects by mimesis or mirroring (we identify
with those who look like, or otherwise reflect, us) is replaced in Gabilando's
account with interpellation by subject position.

> The postmodern Ideological Apparatuses do not interpellate individuals
> through a process of mimetic reflection in which individuals identify
> themselves as subjects but rather as through a process of interfacing in
> which individuals identify their subject positions. The individual is inter-
> pellated only as the subject who takes part in a specific interfacing.[23]

Since the "global condition" does not exist as such (we do not *function* globally
but only locally, always defined through an interface with a machine that *seems*
to be spatially infinite) the subject becomes conceived as a subject *position*
within a matrix of other signs of exchange, a location within cybersapce, in short
an e-mail address, a URL, a credit card number. Yet Gabilando also ignores the
possibility that, with online visual representations of bodies (not to mention the
complexity of textual exchange), there continues to be a mimetic element to the
interface and to ideology. I am interested in this slippage between the idea of
interpellation through *mimesis* and by location or *position*. For it seems that
these are both at stake in online virtual worlds and in the kind of play with bod-
ily assemblage inherent in UNDINA and Bodies© INC. The user is called upon
to identify with bodies visually presented, to find a reflection of subjectivity
there, as well as to retain a position outside of this body, a kind of transcendent
position that guarantees the meaning of this electronic appendage.

In a section entitled "Gender-bending, Race-shifting, and Generally Not
Being Yourself" Bruce Damer continues, "Part of the most thrilling and enticing
aspect of the virtual experience is to live the fantasy of being another person."[24]
That there is power in such fantasy is undeniable. Psychoanalysis offers the most
nuanced vocabulary for understanding the relations between identification and
desire, and in particular the states of mind through which the subject assembles
the fragmented material and linguistic elements that comprise an identity. While
I do not attempt to offer a psychoanalytic or symptomatic reading here, I will
note that the fantasy of being an "Other" person, represented in a visual form, is
a scenario familiar to those scholars who find in the Lacanian mirror stage a
model for the formation of subjectivity and the production of ego ideals. The
process of bodily construction, of being an Other, in the context of UNDINA or
Bodies© INC or some of the other avatar construction sites, has the function of

a secondary revision, a reversal of narrative, a double reconstruction. Rather than an infantile body-in-pieces searching for a unifying device in an external, mimetic reflection, the supposedly unified subject (at the keyboard) seeks to reconstruct subjectivity through a new fragmentation and reconstitution of body parts. Once again, the body becomes the site where identity is reshaped— all the elements of cultural difference, of individual character are assumed to be imbedded in visual signs that stand for flesh. In his essay entitled "Chance Encounters," Victor Burgin cites Sandor Ferenczi's observations concerning the function of the body as an apparatus for understanding the world:

> Thus arise those intimate connections, which remain throughout life, between the human body and the objective world that we call *symbolic*. On the one hand the child in this stage sees in the world nothing but images of his corporeality, on the other he learns to represent by means of his body the whole multifariousness of the outer world.[25]

If such forms of representation in childhood shape the symbolic construction of the world in adulthood, then reconstruction of the body as an adulthood rite is hardly an insignificant event in the course of subject formation. True, in the case of UNDINA and Bodies© INC the end result is still a fantasy of coherence, but a coherence borrowed from a variety of sources. Moreover, the threat of difference (cultural, sexual) is, once again, overcome, not only as a fetish in the form of a stereotype, but now in the projection of one's own subjectivity into or onto that very difference. Race is understood not to "matter" precisely because the conditions of power that produce racism are not, in this online domain, perceived as under any kind of threat from the material realm cyberspace supposedly escapes. Bodies are conceived as products of bureaucracy, and hence largely as property, and the idea of not being oneself is intimately tied to the conditions of leisure and the activity of consumption. The fantasy of an "outside" of the system, the multicultural or postcolonial bodies that Gabilando identifies as the boundaries to a privileged cyberspace, are brought inside literally for the sake of appearances. That the ability to consume and dissect these very bodies, that to have a fantasy of the body in pieces, might be an activity of privilege is never addressed. Only in the absence of history and with a blindness to those cultural contexts where bodies are already dismembered through political torture, and in which racial identities are fraught with a history of violent, forced miscegenation can one imagine such fantasies operating freely. And, of course, they do operate in the neocolonial rhetoric of a global interface.

Randy Farmer, one of the creators of the early virtual world *Habitat*, writes,

> In *Habitat* the primary way to change your appearance is by changing your head. You can buy new styles of head from a vending machine in the local "Head Shop", or you might win a unique head in a contest sponsored by the service administrator.... [eventually] there is nothing left to buy except the special one-of-a-kind prize heads. As a result, these rare heads trade for hundreds of times the price of the others. Without a doubt, the dominant symbol of wealth and stature in the Habitats is a large collection of unique heads, proudly on display in your virtual living room.[26]

The consumption of identity is here made explicit in the form of a competitive trophy exhibition. The more identities one displays, the more status one accrues. An individual user becomes identified with multiple subject positions through collecting and disguise. Given the interdependent histories of colonialism and collecting (especially for museums of anthropology), it is worth asking *who* is collecting *whom* online, and whose bodies are on display.

Transcendental Subjects Embodied

Embedded in fantasies of collecting body specimens and creating hybrid subjects is a matrix of desire that seeks to absorb or orchestrate cultural differences. The racial, ethnic, or gender hybrid is usually read as a break with the traditional Enlightenment concept of the unified individual.

Joseph Nechvatal writes that in Bodies© INC "[t]he digit-body is a motif—a trope—of the entirety of the self, and in its numericalization of the body is the site of and metaphor for the disintegration of the modern notion of the self."[27] By offering an image of a body in pieces and made up of pieces, the Bodies© INC site, Nechvatal suggests, rejects the transcendental, universal, timeless self of modern European philosophy.[28] Instead, a postmodern subject is expressly evoked, a subject able to be represented by discontinuous elements, entirely present in electronic form. The model of a subject, somehow not essentialized into fixed categories such as male/female, black/white, natural/artificial—is, in the works discussed here, given a utopian status as a kind of miscegenation of elements that—legitimate or illegitimate—stands as a figure of possible future identification. At the same time, however, a narrow or ahistorical conception of hybridity (found in UNDINA and Bodies© INC)

threatens to reproduce a new "transcendental" subject that floats through cyberspace, supposedly free from social contraints while nevertheless perpetuating a familiar social hierarchy. Because it is refreshing and exciting to see an effort on the part of artists and theorists to move beyond essentializing notions of subjectivity, and because there is a progressive element in efforts to map cultural hybridity, it is all the more imperative that such important efforts be examined for the ways in which they unwittingly perpetuate the very stereotypes they may be attempting to subvert.

Problems arise primarily when cultural identity or self-representation is equated with a configuration of body parts. Each appendage becomes the sign of a different race, ethnicity, natural element, character trait. The assumption that this electronic body might somehow inhabit a privileged space because of this multiplicity—a universal translator with interchangeable parts—reenacts an equally romantic notion of the mulatto or mestizo as someone able to inhabit more than one cultural paradigm as a result of phenotype. Here hybridity is a matter of visible traits or stereotyped morphologies, not, as in Homi Bhabha's analysis, "inscribed as a historical narrative of alterity that explores forms of social antagonism and contradiction that are not yet properly represented, political identities in the process of being formed, cultural enunciations in the act of hybridity, in the process of translating and transvaluing cultural differences."[29] Other scholars have also emphasized the importance of dissociating the conception of a complex, transcultural politics, with a reduction to corporal signifiers. Chela Sandoval suggests that a "cyborg consciousness" is able to avoid the forms of control that plague the reified or immobile subject by taking steps such as deconstruction, appropriation, and differential movement to disrupt the hold of a hegemonic culture over individual subjects. For Sandoval this model of an oppositional or differential position, akin to "U.S. third world feminism" and "*mestizaje*" is produced through a series of concrete *practices* that can never be reduced to a type of *body*. Instead, the nonessentialized subject for her becomes identifiable through a map of possible *action*.[30]

For Bodies© INC it is the construction of a body that performs the process of identity formation. The different appendages and their accompanying bureaucratic data are what constitute the character of the subject depicted. In UNDINA the process is even more simple, as it relies on a simple grid of interchangeable parts, without even the pretense of action or choice. By representing a shifting locus for a distributed subject—radical in the sense that it is perhaps shifting and changing, living, dying and nonessentialized—the

appended subject in the form of an online body also defines a relation to a so-called global interface as primarily one of consumption, not opposition.

Nestor Garcia-Canclini has written,

> For my part, I think that the fragmentary and scattered view of the experimentalists or postmodernists appears with a double meaning. It can be an opening, an occasion for again feeling uncertainties, when it maintains the critical preoccupation with social process, with artistic languages and with the relations that these weave with society. On the other hand, if this is lost, the postmodern fragmentation is converted into an artistic imitation of the simulacra of atomization that a mar-ket—in fact monopolistic and centralized—plays with dispersed con-sumers.[31]

As works of art, UNDINA and Bodies© INC fall somewhere between these two models of postmodernism. If the transcendental subject of an enlighten-ment reason was a unified, predictable subject that could only be imagined because of a homogeneous cultural context, and if the postmodern subject emerged from a recognition of, among other things, a complex heterogeneous cultural context, then these two art works enact the *return* of a transcendental subject as an *endlessly appendable subject.* What the creation of this appended subject presupposes is the possibility of a new cosmopolitanism constituting all the necessary requirements for a global citizen who speaks multiple lan-guages, inhabits multiple cultures, wears whatever skin color or body part desired, elaborates a language of romantic union with technology or nature, and moves easily between positions of identification with movie stars, action heroes, and other ethnicities or races. It is precisely through an experimenta-tion with cultural and racial fusion and fragmentation, combined with a lack of attention to social process, a lack of attention to history, and a strange atom-ization of visual elements that a new transcendental, universal, and, above all, consuming subject is offered as the model of future cyber-citizenship.

Political or ethical choice is reduced to the consumption and incorpora-tion of new appendages to the body. When these appendages are "racialized" a new form of colonization takes place on the level of symbolic exchange. UNDINA and Bodies© INC offer one view into this global ideological appa-ratus and serve as a reminder that human bodies continue to be the material and visible form through which human subjectivities are defined and con-tested today, despite the now popular belief in cyberspace as the ultimate realm of disembodiment.

Notes

1. See the writings of Allucquère Rosanne Stone, Julian Dibbell, Steven Jones, Anne Balsamo, Mark Dery, and others.
2. Homi Bhabha, "The Other Question."
3. Written e-mail comments to the author, January, 1998.
4. Ibid.
5. Donna Haraway, "Monkey Puzzle," 42.
6. Evelynn M. Hammonds, "New Technologies of Race," 109, 118.
7. Margaret Morse, *Virtualities: Television, Media Art and Cyberculture*, 96.
8. Jennifer González, "Envisioning Cyborg Bodies."
9. Barbara Maria Stafford, *Body Criticism*, 264.
10. Victoria Vesna, Bodies© INCorporated.
11. Ibid.
12. Some theorists of cyberspace see a new philosophical potential in the ability of computers to convert symbols into deeds. However, I would side with Mark Dery in his observation that "while the disembodied sociology of BBSs may treat descriptions as actions, the most significant exchange of symbols in cyberspace—the global, often computer-assisted traffic in currency, junk bonds, information, and other immaterial commodities—*accentuates* rather than eliminates the 'division of the world into the symbolic and the real.'" (emphasis original) Mark Dery, *Escape Velocity*, 68–69. The division is, of course, always an artificial one, as the "real" is always also symbolic.
13. See Anthony Beadie, "Body-Parts Black Market on Rise, Film Says." Cited in Dery.
14. Vesna, Bodies© INCorporated.
15. Christopher Newfield, Essay, Bodies© INCorporated.
16. Victoria Vesna, Genealogy, Bodies© INCorporated.
17. Ibid.
18. Newfield.
19. Vesna, Bodies© INCorporated.
20. Rich Abel, Worlds INC, 1996, cited in Vesna, Ibid.
21. Joseba Gabilando, "Postcolonial Cyborgs," 424, 429.
22. Bruce Damer, *Avatars!* 136.
23. Gabilando, "Cyborgs," 428.
24. Ibid., 132.
25. Sandor Ferenczi, cited in Victor Burgin, *In/Different Spaces*, 97–98.
26. F. Randall Famer, *Habitat Citizenry.*
27. Joseph Nechvatal, Genealogy, Bodies© INCorporated.
28. Nechvatal writes, quoting Robert C. Solomon, "'The self in question is no ordinary self, no individual personality, nor even one of the many heroic or mock-heroic personalities of the early nineteenth century. The self that became the star performer in modern European philosophy is the transcendental self, or transcendental ego, whose nature and ambitions were unprecedentedly arrogant, presumptuously cosmic, and consequently mysterious. The transcendental self was the self—timeless, universal, and in each one of us around the globe and throughout history.'" (Robert C. Solomon, *Continental Philosophy since 1750*, 4). The body in Bodies© INCorporated then is a negative space denoting the bodies former presence."
29. Homi Bhabha, *The Location of Culture.*
30. See Chela Sandoval, "New Sciences."
31. Nestor Garcia-Canclini, *Hybrid Cultures*, 280.

References

The two URLs for the sites are Bodies© INCorporated: *http://www.arts.ucsb.edu/bodiesinc.* and UNDINA: *http://www.dux.ru/virtual/digbody/undina/!undina.htm*

Balsamo, Anne. *Technologies of the Gendered Body: Reading Cyborg Women.* Durham, NC: Duke University Press, 1996.

Beadie, Anthony. "Body-Parts Black Market on Rise, Film Says," *Arizona Republic,* 12 November, 1993.

Bhabha, Homi. "The Other Question: Difference, Discrimination and the Discourse of Colonialism," in *Literature, Politics and Theory,* F. Barker et al., eds. New York: Methuen, 1986.
———. (1994) *The Location of Culture.* London; New York: Routledge.

Burgin, Victor. *In/Different Spaces.* Berkeley: University of California Press, 1996.

Damer, Bruce. *Avatars!* Berkeley, CA: Peachpit Press, 1998.

Mark Dery, *Escape Velocity.* New York: Grove Press, 1996.

Dibbell, Julian. *My Tiny Life : Crime and Passion in a Virtual World.* London: Fourth Estate, 1999.

Farmer, F. Randall. *Habitat Citizenry, http://www.communities.com/people/crock/habitat.html,* 1993.

Gabilando, Joseba. "Postcolonial Cyborgs," in *The Cyborg Handbook,* Chris H. Gray, ed. New York: Routledge, 1995.

Garcia-Canclini, Nestor. *Hybrid Cultures.* Minneapolis: University of Minnesota Press, 1995.

González, Jennifer. "Envisioning Cyborg Bodies: Notes from Current Research," in *The Cyborg Handbook,* Chris H. Gray, ed. New York: Routledge, 1995.

Hammonds, Evelynn M. "New Technologies of Race," in *Processed Lives: Gender and Technology in Everyday Life,* Jennifer Terry and Melodie Calvert, eds. New York: Routledge, 1997.

Haraway, Donna. "Monkey Puzzle." *World Art* 1 (1996), 42.

Jones, Steven. *CyberSociety 2.0 : Revisiting Computer-Mediated Communication and Community,* Thousand Oaks, Calif. : Sage, 1998.

Morse, Margaret. *Virtualities: Television, Media Art and Cyberculture.* Bloomington: Indiana University Press, 1998.

Nechvatal, Joseph. Genealogy, Bodies© INCorporated, *http://www.arts.ucsb.edu/bodiesinc.* (1997).

Newfield, Christopher. Essay, Bodies© INCorporated, *http://www.arts.ucsb.edu/bodiesinc.* (1997).

Sandoval, Chela. "New Sciences: Cyborg Feminism and the Methodology of the Oppressed," in *The Cyborg Handbook,* Chris H. Gray, ed. New York: Routledge, 1995

Robert C. Solomon. *Continental Philosophy since 1750: The Rise and Fall of the Self,* Oxford: Oxford University Press, 1988.

Stafford, Barbara Maria. *Body Criticism: Imagining the Unseen in Enlightenment Art and Medicine.* Cambridge, MA: MIT Press.

Stone, Allucquere Rosanne. *The War of Desire and Technology at the Close of the Mechanical Age,* Cambridge, MA: MIT Press, 1995.

Vesna, Victoria. Genealogy, Bodies© INCorporated, *http://www.arts.ucsb.edu/bodiesinc.* (1997).

4. The Revenge of the Yellowfaced Cyborg Terminator

The Rape of Digital Geishas and the Colonization of Cyber-Coolies in 3D Realms' Shadow Warrior

Jeffrey A. Ow

> Listen. Understand. That Terminator is out there. It can't be reasoned with, it can't be bargained with…it feels no pity or remorse or fear… and it absolutely will not stop. Ever. Until you are dead.
>
> Reese, *The Terminator,* 1984

In the Orwellian-prophesied year 1984, a foreboding *The Terminator* propelled Arnold Schwarzenegger to superstardom. Super Mario soldiers began their Asian invasion in 1986, as their 8-bit video game console implanted Nintendo narratives within the minds of red-blooded American youth. Yet neither by movie nor game, constructed neither of masculine metal nor transnational marketing, Donna Haraway's seminal *Cyborg Manifesto: Science, Technology and Socialist Feminism in the 1980s,* crafted in 1985, heralded the age of the (academic) cyborg. Writing in the temporal center of an American Reaganism, where technology-laden militarized buildups resurrected binary paradigms of good and evil, Haraway built a theoretical cyborg capable of navigating the domestic Evil Empire. She explained,

> Cyborg imagery can help express two crucial arguments in this essay:
> first the production of universal, totalizing theory is a major mistake
> that misses most of reality, probably always, but certainly now; and sec-
> ond, taking responsibility for the social relations of science and technol-
> ogy means refusing an anti-science metaphysics, a demonology of tech-
> nology, and so means embracing the skillful task of reconstructing the
> boundaries of daily life, in partial connection with others, in communi-
> cation with all of our parts. (181)

Haraway asserts that cyborgs are not born, but constructed by the hands of
others, and as a result are neither entirely innocent nor guilty of their actions.
The constructs fracture existing myths of a naturalized "universal woman-
hood" adverse to science and technology by embracing a hybridized politic of
shifting boundaries. In her words,

> Cyborg politics is the struggle for language and the struggle against per-
> fect communication, against the one code that translates all meaning
> perfectly, the central dogma of phallogocentrism. That is why cyborg
> politics insist on noise and advocate pollution, rejoicing in the illegiti-
> mate effusions of animal and machine. (176)

Despite Haraway's call for a complex feminist project, her work has often
been reduced to the closing "I would rather be a cyborg than a goddess"
(181) by many second-generation cyborg works. These works celebrate the
freedom that technology affords women with the newly developed spaces in
computer-mediated communication—gender bending, lesbian e-mail lists,
playful netsex liasions within MUDs, and other social investigations focus-
ing upon the importance of identity on the Internet.[1] Nowhere is this cele-
bration more apparant than within the following quote taken from a bio-
graphical article on Haraway from *Wired* magazine online: "Feminists
around the world have seized on this possibility. Cyberfeminism—not a
term Haraway uses—is based on the idea that, in conjunction with technol-
ogy, it's possible to construct your identity, your sexuality, even your gender,
just as you please" (Kunzru, n.p.).

 Why would Haraway not use the term *cyberfeminism* in this manner?
While her manifesto indeed embraces the feminist implementations of tech-
nology, it also critically questions "devastating assumptions of master narra-
tives deeply indebted to racism and colonialism" located within Euro-American
feminism to marginalize the bodies and thoughts of women of color (1). Chela

Sandoval (411) observes that cyborg politics, "run parallel to those of U.S. third world feminist criticism" (411), stressing oppositional consciousness to hegemonic feminisms. She further realizes that Haraway's position as an established white feminist theorist gives her a racialized authority to be listened to within intellectual communities, commenting, "when uttered through the lips of a feminist theorist of color, [similar theories] can be indicted and even dismissed as 'undermining the movement' or as 'an example of separatist politics.'"

In further revisions of her manifesto, Haraway first refines her analysis to better include issues of race and later begins to examine issues of masculinity. In "Cyborgs at Large: Interview with Donna Haraway," she admitted the problematic usage of "we" in "We are all cyborgs," which did not embrace impoverished women, often third-world women with little choice but to serve as workers in electronic sweatshops. As a corrective, she suggests an expanded "family of displaced figures, of which the cyborg is one" (Penley and Ross 12, 13), yet of which men are none. Believing men to possess unbelievable amounts of privilege, she wanted to avoid any avenue for a masculinist response in her work.[2]

Haraway finally recognized the dangers of the male cyborg warrior in 1995 in "Cyborgs and Symbionts: Living Together in the New World Order," an order dominated by this very same male cyborg warrior, the Terminator. She explained that "the Terminator is much more than the morphed body of a virile film star in the 1990s: the Terminator is the sign of the beast on the face of postmodern culture, the sign of the Sacred Image of the Same" (xiv). Unlike her female-gendered cyborg, who utilizes her hybridity to negotiate dangerous superstructures, the "male" cyborg continues to march on preestablished pathways of colonization, domination, and destruction through his militarized versions of video games and Nintendo wars.

Nowhere is the terror of the male cyborg more apparent than in 3D Realms' 1997 computer action game Shadow Warrior, where yet another male monster rampages through a city, raping, colonizing, terminating all within his path. Yet this monster is not the muscle-bound Aryan Schwarzenegger cyborg, but instead wears the digital makeup made famous by fellow monsters Warner Orland who played Charlie Chan, David Carradine of Kung Fu fame, and Jonathan Pryce, the Engineer in Miss Saigon: yellowface. Yes, the tale I will tell is The Revenge of the Yellowfaced Cyborg Terminator! (Insert anguished scream here!) This Yellowfaced Cyborg Terminator, amalgam of middle-class white man and digital ninja, revels in the material hybridity between human and

machine, using this positionality to reinscribe master narratives based on racism and colonialism.

While the Terminator may represent the apocalyptic future as viewed in its namesake movie, my Yellowfaced Cyborg Terminator possesses strange hybridizations that potentialize fatal flaws. Similar to common notions of race-neutral "cyberfeminism," Yellowfaced Cyborg Terminators perceive and revel in the material hybridity between human and machine, but they utilize this celebrated space to assert common narratives of racial domination, sexual abuse, and capitalist consumption. Yet the Yellowfaced Cyborg Terminator little realizes the changing contours of cyberspace—the significant role of Asian-owned transnational corporations, the growing role of female gamers, and the need to remain technologically competitive on the electronic entertainment marketplace—and this rigidity suggests his growing obsolescence.

My interest in the naming and the racializing of one masculine Terminator that has been "yellowfaced" stems from a recent controversy surrounding *Shadow Warrior,* which will center this discussion of its digital terrorization of the Asian body. After the release of a demonstration version of the game, Elliot Chin, columnist for *Computer Gaming World* magazine, castigated the game's creators for producing "a game that is patently offensive in its racial humor and, even worse, shows great ignorance about its very own subject matter: East Asia and ninjas" (221). Proud of its ability to ignite conflict, 3D Realms continued to promote its racist and sexist agendas, expressing their distaste of "politically correct" wars against multiculturalists, explaining their product is only a parody/homage of '70s chop-socky movies, and essentializing their argument to, "If this game offends you or anyone, go play another game. We won't mind" (Miller, Broussard).

As an Asian male cyborg in my own right, I choose to play my own intellectual game with the *Shadow Warrior* controversy, acknowledging the perverse pleasures of weaving an oppositional read of the controversy, creating much more horrid creatures of the game designers and gaming public than the digital entities on the computer screen. In each level of my game, the Yellowfaced Cyborg Terminator morphs into different entities, from the individual gamer, to company representatives, ending with the corporate entities. Level 1 examines the battle of cultural representation between Yellowfaced Cyborg Terminator's gamers and its critics. Within this level, I will unmask the Yellowfaced Cyborg Terminator from his ascribed position as a postmodern parody to reveal his true identity as a white male, middle-class, cultural colonizer. In Level 2, the contestants grow larger, as the

Yellowfaced Cyborg Terminator, in the embodiment of 3D Realms, battles its Pacific Rim opponents over domination in the video game marketplace within the arena of global capitalism. Here I will *terminate* the Terminator by exposing his powerlessness when facing a larger, Japanese popular cultural juggernaut that understands the pulse of the international popular economy much better. Each level will examine how the Yellowfaced Cyborg Terminator aspires to amalgamate aspects of Oriental aesthetics and Asian power to be Asian/Oriental, but it neither knows nor cares how to pursue an "authentic" path. It is unwilling to truly transform itself, but it only wears the digital skin to become superficially Oriental. Digitized Yellowface: the new makeup of the millennium.

Level 1—The Fantasies of White Male Cyborgs

> Guy (interviewer)—Although I think it's a wise marketing move to position Lo Wang as having an eclectic Asian background, there have been some questions as to whether Lo Wang is Chinese or Japanese? Your thoughts?

> George Broussard—Our thoughts are "who cares"? ;) We intentionally mixed the nationalities, not out of ignorance, but because we knew it would generate mass amounts of flames and email debates online. We just wanted to give people something to talk about. ;) In the end Lo Wang is who you want him to be, and since "you" sort of become him in the game, we think it's good to have a fuzzy background, so you can assume his role more easily. (Smiley)

In the spirit of propagating a "virtual reality," George Broussard asserts that the malleability of Asian ethnicity surrounding the main character in Shadow Warrior allows the video gamer added comfort within a digital body. The digital body with which one can interface and become is that of Lo Wang, a racist and misogynist Yellowfaced Cyborg Terminator, on his solitary quest to rape, pillage, and claim the Asian continent, leaving nothing but carnage. Or, as the Yellowfaced Cyborg Terminator prefers to read himself, as a "wacky blend of all things Asian."[3] In this level, I closely examine how the hybrid Yellowfaced Cyborg Terminator of Lo Wang as gamer plays the roles of movie star, tourist, and colonizer, unsuccessfully negotiating through these contradictory perspectives.

As Lo Wang, the gamer situates himself within a flimsy plot that has little bearing on the action of the game. Lo Wang's background is that of a former henchman for a Japanese conglomerate, Zilla Enterprises, who, as "a man of honor," resigns from the company upon discovery of a "demonic scheme to rule Japan, using creatures summoned from the dark side" (Shadow Warrior). Master Zilla subsequently sends his loyal henchman to Lo Wang's studio in an assassination attempt, and thus the game begins, unfolding like many other "one-man-versus-corrupt-capitalists" narratives such as *Blade Runner* and *RoboCop*.[4]

Within the four-level demonstration game offered for free on the Internet, two levels occur in a techno-Tokyo, designed and populated with anachronistic and geographically displaced beings.[5] Bamboo sliding doors open to allow access to the Bullet Train station, revealing hoards of bare-chested yellow ninjas hefting Uzis and throwing stars in the company of green kamikaze coolies carrying explosives, all waiting to die by Lo Wang's sword, Uzis, or nuclear weaponry. If injured, the gamer searches for fortune cookies to refresh his health levels. In frustration, Elliott Chin (222) castigates the ignorance of 3D Realms, arguing that *Shadow Warrior* is "a game that caters to the stereotypes of Americans as to what a Japanese adventure should be…but 3D Realms can't even get their own stereotypes right".

3D Realms' official response, written in an open letter distributed on the Internet, claims,

> We designed the game this way on purpose. In fact, we thought
> that our mixing of Asian cultures was so outright obvious that no
> one could possibly mistakenly think it was done from ignorance.…
> We are having fun with the whole Asian culture, and we blatantly
> mixed up all the elements and cultures to make a fun game. (Miller
> and Broussard)

In another statement, they clarify, "Our intent was not to make a racist game, but a parody of all the bad kung-fu movies on the 60's–80's. We wanted to make a 'fun' game that didn't take itself too seriously." Rather than interrogating each sentence he utters, I choose to construct and examine an amalgamation of his statements, "We are having fun with the whole Asian culture…Lo Wang is who you want him to be…a parody of bad kung-fu movies." According to this statement, the gamer should enjoy the game as an "Asian" actor, but I argue that he ultimately finds more enjoyment as a tourist/colonizer/rapist Terminator cyborg…in yellowface, of course.

The digitized yellowfacing of the Yellowfaced Cyborg Terminator gamer as an actor is both subtle and overt. Lo Wang is rendered virtually bodiless in the game. Unlike many video games where the gamer controls the character from the third-person perspective (e.g., Pac Man directing small, iconic character through a maze, avoiding ghosts and eating dots), *Shadow Warrior* is a three-dimensional game (actually, to be technically accurate, 2.5D) from the first-person perspective. That is, the computer screen represents both the gamer's line of vision and body, with only weapon-carrying limbs exposed "in view." Thus, the gamer does not see his appearance in the game, enabling, as Broussard explained in the epigraph, the gamer to imagine himself as anyone he prefers. Thus, the gamer could *potentially* assume the role of the bald, goateed Lo Wang depicted on the product box, a white warrior from a James Clavell novel, or himself transported into a mythical Asian society. Preferably, Broussard suggests the gamer take an Oriental filmic role. Thus, wearing the body of Lo Wang, the gamer can pretend to be a chop-socky martial artist like Bruce Lee when he kills an enemy with his bare fists, pretend to be slick gangster extraordinaire Chow Yun Fat when he mows down screaming hoards with two-fisted Uzi gunplay, or pretend to be faithful student Caine of the television show *Kung Fu* conversing with Master Leep high on the mountaintop.

Yet sound effects confine the gamer to act as the inscribed character of Lo Wang rather than any other imaginary characters. As the gamer interacts with the virtual world, certain canned digitized quotes will emanate from the computer speakers. Voice actor "John Galt" (an eerie pseudonym perhaps referring to Ayn Rand's "superman" character in *Atlas Shrugged*), an expert at the stereotypical pidgin-English inflection spoken by all yellowfaced performers, gives Lo Wang the voice to shout such profanity as the phallocentric "Who wanta some Wang?" and "Howza that for kung-fu fighting, you chickenshit?" Clearly, any type of "honor" afforded to Lo Wang's characterization in the plot blurb is forsaken for childish, bawdy humor geared for giggling adolescent guys.

Thus, the gamer is forced to view the game in the constricted "parody" script written by Broussard and company. As a parody of Asian films, the game fails miserably. While many of the Asian movies popular in the United States focus on heavy action and light plots, the action invariably emphasizes intricate choreography. Both well-produced and "bad" kung-fu movies showcase awesome physical flexibility, speed, and artistry in the performer's martial arts skills. Through many innovative film techniques, director John Woo trans-

formed gory gunfights into an art form, inspiring such upstart filmmakers as Quentin Tarantino to follow in his path. In contrast, having Lo Wang throw open bamboo doors, throw down a nuclear bomb, throw forward the phrase, "Just like Hiroshima," parodies a wisecracking Arnold Schwarzenegger *Terminator* flick rather than anything typifying an "Asian" film aesthetic. The Lo Wang wisecracks prevail so heavily within the game that they eliminate any suspenseful moments, neutralizing the immersive action that should be the game's central selling point.

Whereas the advancement through the levels can be read as the ascribed plot progression of the heroic story of a just Asian warrior battling the hoards of corporate demons, the journey of the Yellowfaced Cyborg Terminator can also be read as a colonizing narrative where conquest and exploration, rather than upholding justice, become the primary goals. Mary Fuller and Henry Jenkins trace the threads of colonial domination in the more simplistic, linear games on Nintendo home-console-based video games, comparing the games to the journals of new world explorers. They state,

> We want to argue that the *movement* [italics mine] in space that the rescue plot seems to motivate is itself the point, the topic, and the goal and this shift in emphasis from narrativity to geography produces features that make Nintendo and New World narratives in some ways strikingly similar to each other and different from many other kinds of texts." (Fuller and Jenkins 58)

They explain that character development in many video games consists of the acquisition of advanced weaponry and pointed avoidance of life-depleting dangers rather than psychological development. The experiential enjoyment the gamers receive is not from plot twists, but from their own constructed narrative of exploration. The on-screen character serves as a vehicle in the exploration of different levels of this visibly complex virtual world. Only after the complete exploration of one level, which includes finding all the secret passages and hidden weapons, will the gamer complete his pre-established goal, opening the gilded door with the jeweled key for example, to see what world the next level will bring.

This exploration narrative connects well with the popularity of American tourism in Asia. Christopher Connery examines a subgenre in literature he coins "the Japanese Wanderjahre," where "young American men go to Japan for a year or two and either find themselves or muse on the confusion of life reflected in the odd juxtapositions that surround them" (49). Yet since the importing of Japanese Anime and Hong Kong gangster flicks continues to

influence "American" popular culture, and Oriental porn and Asian mail-order brides are readily available on the Internet, does one really need to travel to Asia for an enlightenment that can be achieved through virtual vacations?

Playing Shadow Warrior becomes an escape from white, middle-class (sub)urban drudgeries to exotic Asian worlds where racialized problems of cultures clashing are subsumed by a canned plot. Within this fictional Tokyo, the Yellowfaced Cyborg Terminator is indeed the target of Master Zilla's Oriental minions, yet he is not the *gaijin* white foreigner victimized by inquisitive, reproachful stares as he walks down the street, because he possesses digital skin that hides his whiteness (as well as his high-tech weaponry). With this perfect disguise, the gamer battles through the train station, terminating all the Orientals within, not fearing that any enemy alive will further advance Zilla's domination of the world, but so he can leisurely eye the detail of this gaming world—riding the bullet train, climbing Mt. Fuji, enjoying Japanese bathhouses and bathing beauties. His only true interaction with this culture is to appreciate it before he destroys it. Realistically rendered Buddhist statues can be demolished with a well-placed bazooka blast, while Pachinko machines can be slashed to release yen.

To rearticulate in ghastly detail words all too familiar, the Yellowfaced Cyborg Terminator commits genocide in a territory in order to enjoy the goods available there, while native bodies lie bloodied. When bored by the current territory, he will travel to the new world/next level to once again violently wrest that area away from the natives.

A specific example brings this colonizing narrative into focus. 3D Realms situates all female characters nude in contrived conditions, such as bathing underneath a waterfall in the midst of a battlefield or sitting on a toilet in Master Leep's temple. The limited interactivity of the game allows the gamer two options. First, he can "talk" by pressing the key that denotes "action," resulting in lewd questions and comments that are hardwired into the game: "Those real tits?" "Ha ha! You go poo poo! I leave room." Susan Clerc notes that "boys online seem to have an obsession with actresses' breasts and their compulsion for discussing them in public," what she calls the "big tits" thread; the games' comments cater to this crowd (82). Beyond verbally molesting the female characters, the gamer is compelled to kill these stationary women in "self-defense," which is actually a thinly veiled reactionary response to "liberated women." After Lo Wang's lewd comment, the woman replies with a dismissive comment of her own, "You jerk," accompanied by her own machine gun, which rattles off a burst of bullets. Thus, under the guise of self-defense,

Lo Wang can execute the Asian woman who just spurned his advances with a few bullets cast in her direction, and walk away with a giggle as the woman explodes with a shriek into a mist of blood.

The constraints of the game force the gamer into the role of the cold blooded colonizer who rapes, pillages and kills like a digitized reenactment of the My Lai massacre. Passing off any type of problematics as entertainment, the Yellowfaced Cyborg Terminator does not care to interpret these meanings. If anything, because of the controversy, the Yellowfaced Cyborg Terminator revels in the carnage, playing the game as a political statement for antiintellectualism. Fred Snyder writes a letter to the editors of *Computer Gaming World* in response to the controversy, stating, "If I seek cultural education, I'll see *Farewell My Concubine* again. If I want to play an ultraviolent computer game, I will do so without regard for any bruised egos on the part of those who might associate themselves with the game's subject matter" (30). Alas, Snyder expects to be educated from a movie, in contrast to a parody of a movie, never realizing that both products are representations of a culture, and whether authentic or not, would always be in question.

Level 2—Corporate Warfare: The Battle of the Big Bosses

> "All in all, *Shadow Warrior* will not be getting my (and this half of the world's) support." (Ong 30, written from Singapore)

Despite the bravado 3D Realms assumes in the cultural wars they instigate, their mantra "if you don't like it, don't buy it" may become their death knell if they choose to incorporate the phrase in their international marketing strategy. The video gaming industry is a highly competitive and profitable global industry and should not be approached with such a cavalier attitude. Although the video game originated in the United States, Japanese manufacturers dominate the console unit and coin-operated marketplaces globally. Can the Yellowfaced Cyborg Terminator survive with a strategy that denigrates the Asian market? This level will examine the marketplace for video games, both domestically and internationally, again from a colonizing paradigm. Only here it is the virtual dragons of the Orient that impinge on the assumed territory of the Yellowfaced Cyborg Terminator.

In "alt.civilizations.faq: Cyberspace as the Darker Side of the West," Ziauddin Sardar exposes the vocabulary describing cyberspace as one fraught

with colonialist overtones, revealing another Western advancement toward claims of new spaces. Comparable to *Star Trek's* Captain James T. Kirk's argument of space as the "final frontier," Sardar (17) notes that the Internet has been likened by media voices to an electronic frontier. Quoting from a British magazine, he explains that it is "one of those mythical places, like the American West or the African Interior, that excites the passions of explorers and carpetbaggers in equal measures." The full title of Howard Rheingold's book, *The Virtual Community: Homesteading on the Electronic Frontier*, further reflects the romantic aspect of civilizing this space. Yet these romantic views of colonization are, of course, those of the privileged colonizer who invokes Manifest Destiny in an unconscious or uncaring possession of spaces.

The continuous modernization of this Internet frontier can be seen further in Vice President Al Gore Jr.'s popularization of the Internet as the "information superhighway." Steven G. Jones parallels this analogy with the federal highway system, in which former Senator Al Gore Sr. played an instrumental role. Both were designed to facilitate transport of militarized operations, and any benefits the citizenry may enjoy are secondary. Furthermore, although the "highway" metaphor is viewed as one that connects communities, highways often disrupt and disperse the communities through and over which they are built, namely communities of color (Jones 10–11). Yet it is this elision of race that is ignored, whether passively or actively, within this modernization/civilizing-utopian paradigm. Julian Bleecker finds that race takes a formidable presence as racial tension in dystopic films like *Blade Runner* and *Demolition Man*, yet a close analysis of the utopian city simulation, *SimCity 2000*, reveals "raceless" urban uprisings blamed instead on "high heat, high crime, and high unemployment, all desperate allusions to life in the inner-city ghetto. Through the disaggregation of race, the gamer can construct a more 'benign' narrative justification while the specter of a racial context remains implicit" (Bleecker 210).

Metaphors of colonization prevail in video games. A casual perusal of the January 1998 issue of *Computer Gaming World* magazine, the self-proclaimed "#1 Computer Game Magazine," reveals the popularity of strategy/wargames as the magazine reviews eleven new games, with titles such as *Age of Empires, Conquest Earth,* and *Prelude to Waterloo.* Running second are "action" games with seven reviews, including a lackluster review of *Shadow Warrior,* while only one "puzzle" game made it to the review board. In the same issue, the magazine hails "Sid Meier's *Civilization* [as the] #1-rated game of all time," as an "indescribably addictive world conquest/exploration game" (370).

Haraway describes how the potential and real alliances between the military and gaming companies represent her Terminator cyborg of male colonization and domination:

> The Terminator is the self-sufficient, self-generated Tool in all of its infinite but self-identical variations. It can be the transfused blood fraternity of information machine and human warrior in the cyber-enhanced airforce cockpit, those pilot projects for the equally—or maybe more—profitable cyborg theme parks and virtual reality arcades to follow in the great technology transfer game from military practices to the civilian economy that has characterized cyborg worlds. (Haraway, "Cyborgs," xv)

Sardar also finds the relationship between computer wargames and actual warfare unsurprising, due to the military origins of the computer, both hardware- and software-related. He argues that the defense industry invests in the entertainment arena to reap further profits from its technology originally built for war: "Once the military has opened up the new frontier, the settlers can move in to play their games, to explore, colonize, and exploit the new territory taking us back to mythic times when there were other worlds (Islam, China, India, Africa, America) with resources beyond imagination and riches without limits" (21). Yet two stark examples show that technology is coming of age beyond its military origins—the privatization of war works both ways. At the request of the U.S. Army, video game manufacturer Atari converted the popular *Battlezone* video arcade game into a computerized military tank simulator. More frightening, the U.S. Marine Corps reprogrammed an inexpensive popular computer game, *Doom II* (originally retailing for $50) to serve as a Marine infantry training simulation (Riddell). Have video games advanced to the point that they are accurate simulators of war?

While patterns of Western colonizing narratives such as *The Terminator* deserve continued reflection, colonization should not be pinned on Western civilization exclusively. Although Japan may no longer send air combat troops over the Pacific, their cars, consumer electronics, and media icons have infiltrated every corner of the earth. No longer does Santa bring Lionel Train Sets and Cabbage Patch Kids to the excited children of the Western world. Instead, video game consoles named Sega, Sony, and Nintendo top Christmas lists, with Bandai Tamagotchi "virtual pets" as stocking stuffers. Even the hot-rodding Asian-American teenagers of the Silicon and San Gabriel Valleys dream of four-banging four-cylinder Acura Integras rather than the V-8 Chevys and Mustangs of 1950s Milwaukee *Happy Days* lore.

Christopher Connery chronicles the rise (and decline) of a "Pacific Rim Discourse," noting an equivalent relationship between Asia and America that sounds suspiciously cyborgian: "Its world is an interpenetrating complex of inter-relationships with no center: neither the center of a hegemonic power nor the imagined fulcrum of a 'balance of power'" (32). Based partially upon the rise of an economically strong Japan and an economically weakening America, this discourse examines the exchanging and punctured absorption of culture. According to Connery, his idea of the Pacific Rim discourse weakens in the late 1980s, and he notes how another period of economic uncertainty in the United States results in Japan bashing. If these two aspects signal the decline of his discourse, I would argue that the decline began in the early 1980s, with the murder in Detroit of the Chinese American engineer Vincent Chin by two unemployed auto workers looking (mistakenly) for a Japanese scapegoat. Indeed, I propose that material products and culture continue to be amalgamated into the cyborg consciousness of America, always creating disruptions, but nevertheless continuing unabated.

Super Mario, a portly Italian plumber, and Hello Kitty, a white cat with no mouth, have much more in common with a certain black mouse than the red color of their overalls/blouse/shorts. All three are squeaky-clean childhood icons, seen internationally on cartoons, video games, clothing, lunchboxes, and practically any other product with a merchandizing license. Yet of these three, only Mickey Mouse is not a Japanese immigrant. Nintendo's flagship icon, Super Mario, appears on over 120 million video game cartridges world-wide, with the best-selling game of all time, Super Mario Bros. 3 grossing $500 million (Herz 21, 133). With Nintendo wielding this amount of popularity and monetary power, Fuller and Jenkins carefully remind readers that the belief that cultural imperialism only flows in an Eastern direction has its Orientalized flaws. They note Japan's ability to manipulate, repackage, and resell aspects of Western culture, and subsequently ask,

> Does Nintendo's recycling of the myth of the American New World, combined with its own indigenous myths of global conquest and empire building, represent Asia's absorption of our national imaginary, or does it participate in a dialogic relationship with the West, an intermixing of different cultural traditions that insures their broader circulation and consumption? In this new rediscovery of the New World, who is the colonizer and who the colonist? (Fuller and Jenkins 71–72)

In the past decade, America has bristled at Japanese purchases of American cultural icons such as the Pebble Beach golf course and the Seattle Mariners

baseball team, but recent American commercials for Japanese products reflect a definite, if not Orientalized, Asian association. Sega game commercials of the past ended with a figure in their commercial, a teenager or video game character for example, shouting "Sega" in a brash, masculine onomatopoetic form, yet current Sony Playstation commercials end with a feminine enunciation of "Playstation" pronounced with a distinctly Japanese accent. A Japanese man and his dog recently hawked Nissan trucks nationwide in a country that demonized Asian Americans fifteen years previously. And despite the destabilization of the Asian economy in the late 1990s, Colonel Sanders has been seen distributing Japanese video-game inspired Pokémon beanie toys with his buckets of Kentucky Fried Chicken! ("Pokémon").

Given the hegemonic power that Nintendo, and to a lesser extent Sony and Sega, have in the international gaming community, the Yellowfaced Cyborg Terminator named 3D Realms finds itself in a problematic position. While 3D Realms may (rightly) believe that their IBM-PC based game will sell well to the primarily American and European markets that own IBM-PCs, can they successfully market, let alone license, *Shadow Warrior* in its entirety to the strictly regulated yet more profitable video game console industry? A $150 video game console is ten times less expensive than a $1500 mid-ranged computer, and thus a much more affordable present purchased by lower and middle class families acquiescing to their whining children.

Despite its "bad boy" position, 3D Realms has indeed already compromised its reactionary vision with the recent release of *Duke Nukem 3D* for the Nintendo console. Gone are the demeaning female strippers in a bawdy nightclub, replaced by an inoffensive warehouse. No longer is the gamer forced to kill the women trapped in cocoon casing; here they can be rescued. Yet the content of *Shadow Warrior* is not as easily correctable. Can they fix a game whose central selling aspect is the trivialization of Asian cultures and peddle it to overwhelmingly Asian-owned multinational companies that sell products to a large Asian market? These questions would not have to be answered if 3D Realms actively considered the Asian market rather than using Asian products as gags.

On the other hand, *Shadow Warrior* might indeed gain approval by the Japanese companies. First, according to Sandra Buckley, pornography and other fetishizations are more openly accepted in Japan, so the "parodic" nature of *Shadow Warrior* could be profitable if marketed to those specific subcultures. Yet Nintendo markets itself as a "family oriented" company, like Disney, and closely regulates and rates its licensees to prevent parental/consumer backlash over inappropriate products. Second, and more important, the transnational entities

of the video game manufacturers may permit 3D Realms to produce an offensive *Shadow Warrior* to sell primarily to the American and European markets, as Masao Miyoshi asserts that true multinational/transnational corporations show little allegiance to their originating country and will eschew "morals" in lieu of hefty profits. Yet the fear of this particular Yellowfaced Cyborg Terminator marching through a worldwide marketplace can be junked. Despite the controversial publicity surrounding the game, consumer data obtained from software marketing firm PCData reveals that, unlike its predecessor, *Duke Nukem 3D*, *Shadow Warrior* failed to sell. During its first year of availability, never once did it become a monthly top-20-selling game. No console game manufacturer has opted to translate *Shadow Warrior*, and the 3D Realms website does not indicate any further activity with the game. Did Lo Wang, *Shadow Warrior*, and 3D Realms die a dishonorable death?

Endgame

Because of the construction of the Yellowfaced Cyborg Terminator and the accompanied milieu in *Shadow Warrior*, female cyborgs and cyborgs of color can create few, if any sensible narratives in a game oriented around their own destruction. Yet, ultimately, 3D Realms will not profit much from *Shadow Warrior* because of its reliance on gimmickry to cover its technological obsolescence. Game manufacturer Id Software created the first widely popular first-person perspective "shooter," *Doom* (1993), and the company continues to lead the industry with *Quake* (1996) and *Quake II* (1997). Id's games showcase more advanced graphics and gameplay within the same "3-D shooter" genre in which 3D Realms publishes titles. Furthermore, Id pays careful attention to the needs of their consumer base. A growing number of women "cyborgs" play the militaristic *Quake* (an essentially "plotless" game where a soldier runs through a beautifully Gothic world shooting demonic creatures), enough to warrant the inclusion of nonstereotypical gender and ethnicity choices for the militaristic main character in *Quake II*. 3D Realms' decision to be, in the words of its head Scott Miller, "a controversial company choice," one that doesn't "shrink away from issues that would send PC-anal companies running with their tails tucked between their legs," suggests that its market is primarily the white, middle-class conservative male who enjoys demeaning portrayals of women and people of color. 3D Realms sells controversy, not gaming content, and will fail to reach the prosperous levels of Nintendo or Id if the company fails to expand their market beyond the Yellowfaced Cyborg Terminators.

The Yellowfaced Cyborg Terminator, trapped behind the seemingly contradictory bars of cultural appreciation and cultural imperialism, marches disjointedly on colonial paths well worn by the steps of men before him. Yet a motley crew of other cyborg renegades threatens the ways of the white imperialist: Asian-American keyboard critics, female Quakers, and a *Super Mario* hegemony. Unlike the faceless enemy hoards in *Shadow Warrior*, this heterogeneous group can divide and conquer their yellowfaced enemy, dismantling the cyborg mind and body, rendering their forms of racism, sexism, and colonialism obsolete. Like a bad movie, *Shadow Warrior* has been all but forgotten within the fast-paced gaming community, left to linger in the ghettoized bargain software bins. That is, until a new entity picks up these discarded vestiges, reworks them to incorporate a newer, nigh-invincible cyborg to resume the race for world conquest. Will the Yellowfaced Cyborg Terminator rise again?

Acknowledgments

An incredible amount of thanks goes to Sau-ling Wong, who has always supported my interest in Asian-American Cyborgology from my early days as a young undergraduate through my latter days as a harried grad student; without her words of wisdom and advice, I would not be pursuing a career in academia. Lisa Nakamura deserves most, if not all the credit, for this paper seeing print here: from her sage words as discussant at the Techno-Orientalism panel at the Discipline and Deviance: Genders, Technologies, & Machines conference at Duke University, October 1998, to her editorial acumen for this collection. Greta Niu has been an invaluable friend and colleague, organizing the aforementioned panel as well as being an excellent sounding board to talk techno with. I thank Laura Verallo Rowell and Masha Raskolnikov for the excellent editing skills, helping me boil down this paper into a six-paragraph review of *Shadow Warrior* for *Critical Sense* 6:1 (Spring 1998), and Beth Kolko and Gil Rodman for further tinkering on the cyborg project that you read here. Lastly, Slantgirl (http://www.worsethanqueer.com), Malinchista (http://members.tripod.com/~malinchista), and Melty (http://www.melty.com), deserve everlasting honors for all of our online dialogues.

Notes

1. See Nina Wakeford, "Sexualized Bodies in Cyberspace," in Warren Chernaik, Marilyn Deegan, and Andrew Gibson, eds., *Beyond the Book: Theory, Culture, and the Politics of Cyberspace,* Oxford: University of London, 1996; Shannon McRae, "Coming Apart at the

Seams: Sex, Text and the Virtual Body," in *Wired_Women: Gender and New Realities in Cyberspace,* Lynn Cherny and Elizabeth Reba Wise, eds., Seattle: Seal Press, 1996; and Anne Balsamo, *Technologies of the Gendered Body,* Durham: Duke University Press, 1996, for these specific examples of cyberfeminism.

2. Surprisingly, she admitted in this interview published six years after her manifesto that, "This really is the first time [she had] to imagine that line being read by people—not just male people—in a masculine subject position." Constance Penley and Andrew Ross. "Cyborgs at Large: Interviews with Donna Haraway" in *Technoculture,* Constance Penley and Andrew Ross, eds., Minneapolis: University of Minnesota Press, 1991, 19.

3. Irony prevails as 3D Realms takes the company line of berating and belittling the individual critics who have issues with their own attempts at gaming domination.

4. Software manufacturers often offer abbreviated "demos" or time-limited "shareware" versions of their products for consumer sampling. My *Shadow Warrior* analysis is based on this four-level demo game, and ongoing debate and research in computer trade magazines and Internet web pages. Thus, none of the author's dollars have been exchanged with 3D Realms!

References

Balsamo, Anne. *Technologies of the Gendered Body.* Durham: Duke University Press, 1996.

Bleecker, Julian. "Urban Crises: Past, Present, and Virtual." *Socialist Review* 24:1/2 (1995): 189–221.

Broussard, George. "Plan file," *Quakefinger.* 7 September 1997. Online. http://finger.planetquake.com/plan.asp?userid=georgeb&id=4720.

Buckley, Sandra. "'Penguin in Bondage': A Graphic Tale of Japanese Comic Books," in *Technoculture,* Constance Penley and Andrew Ross, eds. Minneapolis: University of Minnesota Press, 1991.

Chin, Elliot. "3DRealms' Folly: *Shadow Warrior's* Ignorant Stereotypes Are too Offensive to Stomach," *Computer Gaming World* 157 (1997): 221–22.

Clerc, Susan. "Estrogen Brigades and 'Big Tits' Threads: Media Fandom Online and Off," in *Wired_Women: Gender and New Realities in Cyberspace,* Lynn Cherny and Elizabeth Reba Weise, eds. Seattle: Seal Press, 1996.

Connery, Christopher. "Pacific Rim Discourse: The U.S. Global Imaginary in the Late Cold War Years," *Boundary 2,* 21:1 (1994): 30–56.

Fuller, Mary and Henry Jenkins. "Nintendo and New World Travel Writing: A Dialogue," in Steven G. Jones, ed., *Cybersociety: Computer-Mediated Communication and Community,* Thousand Oaks, CA: Sage Publications, 1995.

"Hall of Fame," *Computer Gaming World,* 162 (1998): 370.

Haraway, Donna. "Cyborgs and Symbionts: Living Together in the New World Order," in *The Cyborg Handbook,* Chris Hables Gray, ed. New York: Routledge, 1995.

———. "A Cyborg Manifesto: Science, Technology and Socialist Feminism in the 1980s." In *Simians, Cyborgs, and Women.* New York: Routledge, 1991.

Herz, J. C. *Joystick Nation.* New York: Little, Brown and Company, 1997.

Jones, Steven G. "Understanding Community in the Information Age," in *Cybersociety: Computer-Mediated Communication and Community,* Steven G. Jones, ed. Thousand Oaks, CA: Sage, 1995.

Kunzru, Hari. "You Are Cyborg," *Wired* 5.02 (February 1997) Online. http://www.wired.com/wired/5.02/features/ffharaway.html.

Mc Rae, Shannon. "Coming Apart at the Seams: Sex, Text and the Virtual Body," in *Wired_Women: Gender and New Realities in Cyberspace,* Lynn Cherny and Elizabeth Reba Weise, eds. Seattle: Seal Press, 1996.

Miller, Scott. "Plan File," *Quakefinger.* 26 August 1997. Online.
 http://finger.planetquake.com/plan.asp?useid=scottm&is=1413.
Miller, Scott and George Broussard. "An Open Letter to Elliott Chin, 'Action' Columnist of
 Computer Gaming World" PC World Online, 30 June 1997: Online.
 http://www.pcworld.com/annex/games/articles/game_beat/jul97/beat071697b.html.
Miyoshi, Masao. "A Borderless World? From Colonialism to Transnationalism and the Decline of
 the Nation-State," *Critical Inquiry* 19:4 (Summer 1993): 726–51.
Ong, Rick. "Letters to the Editor," 159 (1997): 28–32.
"PC Data Hits List of Top-Selling Software: Top Selling Games," *PC Data. May 1997–May1998.*
 Online. http://www.pcdata.com.
Penley, Constance and Andrew Ross. "Cyborgs at Large: Interview with Donna Haraway," in
 Technoculture, Constance Penley and Andrew Ross, eds., Minneapolis: University of
 Minnesota, 1991.
"Pokémon World News Story" *Pokémon World.* Online. http://www.pokemon.com/news/
 nw-kfc.html. 20 January 1999.
Riddell, Rob. "Doom Goes to War," *Wired* 5.04 (April 1997) Online.
 http://www.hotwired.com/collections/future_of_war/5.04_doom1.html.
Sandoval, Chela. "New Sciences: Cyborg Feminism and the Methodology of the Oppressed," in
 The Cyborg Handbook, Chris Hables Gray, ed. New York: Routledge, 1995.
Sardar, Ziauddin. "alt.civilizations.faq: Cyberspace as the Darker Side of the West," in
 Cyberfutures: Culture and Politics on the Information Superhighway, Ziauddin Sardar and
 Jerome R. Ravetz, eds. New York: New York University Press, 1996.
"7 Dirty Words You Can't Say on a Website: Duke Nukem 64 Review," *Game Revolution,* December
 1997: Online. http://www.gamerevolution.com/games/n64/duke.htm.
"Shadow Warrior v1.1 On-Disk Technical Support Manual," Shadow Warrior Game, 3D Realms,
 26 May 1997.
Smiley, Guy. "Exclusive Interview with SW creator, George Broussard" *Shuriken Times.* 4 June
 1997: n. pag. Online. http://www.shadowwarrior.com/times.html.
Snyder, Fred. "Letters to the Editor," *Computer Gaming World* 159 (1997): 28–32.
Wakeford, Nina. "Sexualized Bodies in Cyberspace," in *Beyond the Book: Theory, Culture, and the
 Politics of Cyberspace,* Warren Chernaik, Marilyn Deegan, and Andrew Gibson, eds. Oxford:
 University of London, 1996.

5. Sexy SIMS, Racy SIMMS

Rajani Sudan

It doesn't take a rocket scientist to figure out that as a culture we are obsessed with almost every aspect of technology. In fact, a rocket scientist would probably *not* recognize quite so immediately the multifarious ways in which "high" scientific theory and engineering get disseminated as technological wizardry in the artifacts of everyday life. I am not a rocket scientist, nor do I play one in academic settings that encourage interdisciplinary exchanges between the sciences and humanities.[1] I am, however, interested in the varied representations of technologies in popular culture, particularly as they reflect ideological formations. I admit that my familiarity with the technical aspects of electronic discourse is lamentable. As an interloper in the field, however, my poaching on these territories may prove useful if only to help identify and articulate how those of us not belonging to the rarefied group of rocket scientists—or other such assemblies of cultural privilege—read technology.

The contestations between the revolutionary possibilities and cultural representations that technology promises and the ideological structures of social identity in which its production is entrenched have been admirably argued by cultural critics from a number of different academic fields.[2]

Particularly from the standpoint of gender studies, such work has been crucial to the development of a discourse that addresses technological innovations. Not surprisingly, however, attention to the issue of race has been at best understated in this discourse except as something that can be rendered "invisible" or less debilitating by such innovations. I claim "not surprisingly" because even if we can attest to the ways that race has developed as an ideological position in Western culture, we are still coming to terms with the *history* of a racialized body: separating tags of color from the production of race, disentangling the histories of racial difference as discrete states of being and knowing.[3]

It seems that the place "race"[4] has occupied in the postindustrial technological "revolution" is simultaneously rendered invisible because we eradicate the histories that determine its parameters, and also excessively visible because we depend on the putatively material effects of those parameters. For example, technological experiments for the "general" public are more often than not tailored to specifically gendered, raced, and sexualized bodies. These specifications, however, are never made visible because their bodies—primarily white, male, and heterosexual—represent cultural authority: they are, in Jacques Lacan's terms, operating as master signifiers. The current debate over airbags in cars (or medical research on diseases and cures) is an example of how this white, male, heterosexual body is conjured in the cultural psyche as the "representative" body, consciously or not; it is, therefore, not acknowledged either as a body in the first place or one that requires visible definition.

Whether such invisibility happens on the drawing table or in the tabloids is not really important; the fact is that we *consume* the eradication of visibly corporeal markers as somehow legitimate, as part and parcel of technological evolution. The research and testing of technological invention uses the unmarked body as its empirical model.[5] The *invisibility* of the model body, however, obfuscates *other* issues of difference—for example, the fact that drivers do not always share the heights, weights, sexes, of the model body, nor do diseases always metabolize the same way in all bodies—that may determine their radical inadequacies as "test cases." I want to examine the question of how this model gets established and situated in popular discursive practices. But I also want to investigate the more crucial concern of how bodies get cast as racially marked in the first place, and where in popular cultural discourse that happens.

The freedom promised by cyberspace is apocalyptic. I should clarify, however, that when I use the word *cyberspace*—especially in the context of popular culture—I am referring to the spaces open to discursive, primarily

visual representation. I hasten to add that though the focus of this essay is on the visual, our understanding and judgment of visual imagery and visual culture has developed from the laws governing textual culture. In this sense, it is difficult to situate the visual and the discursive as radically different from one another. Some discussions of cyberspace (by this definition) ostensibly allow for an infinite capacity for representation. No longer hampered by the corporeal demands of race, sex, gender, or other ideologically marked obfuscations, cyberspace offers "pure" discourse as a leveling playing field. But, in a curious repetition of the problems that have plagued print culture, do we, as authored subjectivities, bring our cultural baggage of marking to contaminate the playing field even before the games begin? In what ways does the endless capacity for representation invoke the need for older cartographies of territorialization that crucially depend on histories of marking to make visible an invisible expanse?

Perhaps more powerful for this millennium culture, however, is the place of the visual. Developing from the popularization of cameras in the earlier part of the century, our uses of visual images have changed quite dramatically from centuries past. According to art historian John Berger, the visual arts "have always existed within a certain preserve; originally this preserve was magical or sacred. But it was also physical: it was the place, the cave, the building, in which, or for which, the work was made." Yet with the invention and popularization of the camera (and in particular the moving camera), images "surround us in the same way as a language surrounds us. They have entered the mainstream of life over which they no longer, in themselves, have power."[6] Dislodging the image from its human production and making the visual image capable of infinite reproduction through mechanical/technological innovation has brought us face to face with what we consider "truth." The camera, then, has supplied us with a Cartesian objectivity that grants absolute truth to the image it reveals, both in social, cultural, economic and juridical law.

Given our reliance on the technology of camera representation to furnish us with "truth," what happens when we develop ways to disengage the mythic veracity from the photographic image? Pixels are used to generate and manipulate most computer-produced images, but they may or may not be representational, unlike what we believe to be the case with a photograph. It seems that we have a philosophical quandary on our hands: Do we return to the "preserves" of image production—and the laws governing those preserves—in order to regulate visual authenticity?

According to representations of cyberspace in popular Hollywood film, it seems as if we are more concerned with the "dangers" of a fenceless expanse rather than with the possibilities of limitless invention. But the ways in which issues of visibility and invisibility get worked out in this venue are enormously complicated. Issues of visibility and invisibility collapse into questions of *choices*; "we" choose whether or not to see something determined by its ideological parameters. I mark "we" in scare quotes here because often such choices and such sights do not issue from an objective standpoint of personal freedom (or free will): our choices are as determined by dominant ideologies as the sights we see. The common saying, therefore, that "seeing is believing" makes more sense when we switch the terms to "believing is seeing."

SIMS, or simulations, are complicated programs for simulating complex activities. Unlike photographs or film, they allow the user a certain amount of leeway in order to establish her paths. The use of simulations in Hollywood film is often diluted and conflated with the use of virtual representation; what appears to be a *program* that is set to reproduce a simulation of activity is often represented as a *picture* (or virtual simulation) of that program. It seems, then, if we can read the machinery of SIMS metaphorically, that Hollywood itself may operate as a SIM: as a program or template for simulated activity that allows a certain latitude in its implementation. I'm interested in the ways that SIMS and their "simulations" get deployed and manipulated as ideological machinery that produce materialized "evidence" of race in popular Hollywood film.

The postmodern fluidity that SIMS and their simulations provide may be too flexible for the comfort of a dominant ideology, and the materiality of "hardware"-like single in-line memory modules, or SIMMS, solidifies this flexibility. Regardless of the limitless expanse cyberspace offers in terms of representation, I argue that we still depend ideologically on *concrete* proof such as SIMMS to establish shifting categories of representation like race promised by SIMS.

I want to return to the idea Berger raises about the production of visual images within the sanctuary of a "preserve," and to the question I raised about our need to reinstate this notion. Perhaps one way we can chart our reliance on physical or material "spaces" for representation is in our obsession with hard copy. In this sense the freedom of representation promised by SIMS, unhinged from its historical ideological boundaries, once more gets metaphorically corralled by the limits of the hardware, by SIMMS. Berger suggests that the "art of the past no longer exists as it once did. It has lost its authority." Such a loss entails a remapping of ownership—the tangled circuits

of ownership and copyright—that depends on the physical evidence of the artistic work's originality. In Berger's words, "A people or a class which is cut off from its own past is far less free to choose and to act as a people or class than one that has been able to situate itself in history."[7] I argue that our (the dominant "we") renewed interest in hardware, hard copy, and material evidence is in response to the cutting-off of a new postmodern cyberculture— one that could radically shift hegemonic ideas about economy, race, sexuality, gender, disability and more—from its historical roots that have established and maintained social marginalization.

I will focus on Philip Kaufman's 1993 thriller, *Rising Sun*, as a film that is especially engaged in the production of the concrete proof SIMMS provide. I am primarily interested in how this film reflects cultural *anxieties* about redressing historical boundaries defining race, class, gender, sexuality, and nationality in a postmodern, postindustrial climate that aggressively promotes the erasure of those boundaries through technological development. In fact, the very technologies that make such erasures possible are ironically invoked in *Rising Sun* in order to make the necessity for a traditional hegemony clearly visible.

There have been many films depicting the horrors of virtual identity over the past few years. From *Videodrome* and *Strange Days* to *The Net*, most of them have engaged constructions and contestations of gendered and racialized identity. However, their operative paradigms have insisted upon a Cartesian subjectivity that "knows" itself *as* a self. *Rising Sun* capitalizes on this knowledge with an added fillip: it illustrates in immensely paranoid detail a compulsion for marking a racial body through the medium of simulations.[8]

Rising Sun, a film based on Michael Crichton's novel, renders the neo-noir American whodunit as a narrative about corporate competition across nationalities. The Japanese Nakamoto corporation vies with other competing firms, most prominently the Yakamoto corporation, for the acquisition of the American company Microcom. In the midst of their inaugural celebration of the newly purchased building, the unwelcome body of an American woman, Cheryl Austin (Tatjana Patitz), lying on a boardroom table forces the Nakamoto corporation to call into action, against their will, the LAPD. Together with the Special Services Liaison officer, Webster Smith (Wesley Snipes), the police proceed with an investigation of the woman's murder. This task is, however, complicated both by the cultural obstacles the Japanese corporations throw in their way and the supplementary help of a former liaison officer, the cultural renegade, John Connor (Sean Connery), whose legendary

preference for the tactics of Japanese business culture has caused many an officer to doubt his institutional loyalty both to the force and to his country.

The discovery of Austin's killer affords structure to the plot but is in fact incidental to the other kinds of discoveries of nationality, race, and the problems with the globalization of capitalism that Smith and some of his counterparts make.

Basically, the film capitalizes on the postindustrial anxieties that the United States faces in the wake of its lucrative exploitation of third-world labor, among them the dissemination of industrial secrets and the possible decimation of their economic integrity. The film insistently and chillingly reminds us how "technology," long the fiefdom of a pioneering and imperial economy, is moving away from "first"-world control and establishing itself as the unmistakable province of a long-reviled "third" world culture. The national integrity of American enterprise is at stake, and this is demonstrated most dramatically across the bodies of sexually transgressive women who move between successive masters.

The film opens with visual problems of cultural assimilation. With the tune "Don't Fence Me In" playing in the background, the camera focuses on an ant colony that's destroyed when a horse steps on it. Moving away from the ants in a slow backward pan, the camera reveals the horses themselves and the Japanese "cowboys" that ride them, and finally the screen onto which this Western has been projected. It's in the middle of a karaoke bar, and the Japanese man singing "Don't Fence Me In" addresses his song to a sultry blonde woman who is plainly bored by his attentions. The dynamic between the Japanese man, Eddie Sakamura (Cary-Hiroyuki Tagawa), and the American woman, Cheryl Austin, is clearly vexed by the many complications of paid companionship. Austin's boredom with Sakamura's antics, stridently staged by her sudden departure from the karaoke lounge, indicates that her personal social preferences—and perhaps even sexual ones—are not congruent with the amusements the film determines as typically Japanese. Sakamura's reaction to Austin's egress is equally dramatic: he quickly abandons his microphone and runs after her, forces her into his red Delorean and reminds her that she is his property by exhorting her to "never do that again." What this scene dramatizes is Sakamura's uneasy possession of America's "natural resources," to use the LAPD investigating officer Tom Graham's (Harvey Keitel) sexist term.

This opening scene establishes several important issues for the film. The renowned American movie genre, the Western, having historically represented

(however problematically) the pioneering spirit of American freedom is now inhabited by foreign bodies. The Japanese figures that pose in the film seem to have usurped the maverick role the United States has played in shaping world politics and world economies. Even the conflation—or is it an imposition?—of karaoke, a form of Japanese entertainment technology, within American pleasure palaces that are now inhabited almost exclusively by young Japanese professionals lugubriously attests to the ways in which we have invited our own demise: "The Japanese are not our saviors. They are our competitors. We should not forget it."⁹ Eddie Sakamura's rendition of "Don't Fence Me In" may therefore be read as an ironic assault on a number of different fronts. As a lilting cowboy ballad, the song's melancholy refrain, sung by Sakamura and his associates, may bear witness to the confines of an island culture that seeks new purchase for its dominion, especially in the postindustrial technological marketplace. Equally transparent is the fact that the song describes the plight of an American economy held hostage—by its own initiative—to a foreign invasion. The Americans can't sell their "freedom" fast enough, according to the film's logic. Though it *seems* clear that this is the case, what's enacted for us is precisely the opposite. Sakamura's warblings are in fact only a ventriloquization, scripted by a master ideological discourse that "knows" about liberty. He is obviously held captive to Austin's charms, witnessed by his excessive distress when she leaves the bar without bothering to hear him out. Her abrupt departure also suggests that she is experiencing a similar distress. She is plainly straining to maintain her end of the economic bargain struck with Sakamura (to be his paid mistress), but her native American intrepidity battles with her economic interest to wrest control over her actions.

"Don't Fence Me In" functions, therefore, as an ideological metacommentary. The technological access to virtual simulation is particularly complicated by the location of "truth" in photographic representation versus computer-generated simulation that I pointed out earlier. Karaoke offers a program for reinventing original artistry (the songs) according to the limitations of the personal user, but this new form of technological simulation in fact laments a bygone time when hegemonic first world "fences" established a recognizable hierarchy. Such a lament is demonstrated by *both* the marginalized bodies of Sakamura and Austin. As racial and gendered subjectivities, Sakamura's uneasy assumption of power and Austin's disdain for it situates the position of the Japanese as cultural interlopers. Despite the moral high ground on which their business superiority may situate them, their pursuit of assimilation into American popular culture is abject. The ludicrous juxtaposition of

Japanese actors on an American stage—the Western—only points to the radical fissures between these national identities. The dangers of American incorporation into Japanese culture are, therefore, warded off from the start. After all, the ant colony that may allude to racist Western representations of Asian cultures gets obliterated by the generic signifier of freedom in Western films: the horse.

However comforting this initial scene may be, it's still quite clear that the threat posed to the coherence of American economic enterprise takes shape as problems with Japanese surveillance. The next scene takes place in the security office of the Nakamoto building, where negotiations for the Microcom sale are taking place. The camera reveals a Nakamoto employee, eavesdropping via sophisticated equipment on the private, whispered conversations that Microcom representatives are having with each other, and feeding their conversations, verbatim, into the listening ears of members of the competing Japanese firm. Other camera shots establish that this room is—like all rooms in the building—completely covered by surveillance cameras from all possible angles, and that the boardroom in particular has tapes recording all activity taking place. From these shots the camera cuts to a hotel bedroom where Austin is seated in front of a mirror, covering scars on her neck with make-up while Sakamura watches her. What these particular shots illustrate is the putative vulnerability of the American cultural body. Watched from all angles, their business transactions and even private conversations aren't their own property anymore: everything is recorded by the silent but watchful machinery of Japanese technological expertise. Cheryl Austin's pathetic efforts to cover her vulnerability—the scars that are testimony to her sexual habits—are on display for the delectation of a Japanese audience. These surveillance techniques, however, give way to a dramatic turning of the tables.

It is as if the film's imaginary encodes the American white body with the same discursively subordinate position reserved for racial, sexual, gendered difference under the guise of competing nationalities. I say the film's *imaginary* because the logic of the symbolic—Lacan's term for the register that establishes language and phallic law—steps in at the eleventh hour to resituate hegemonic (national) positions. The American body, mostly signified by Austin's flaws, is wrongfully on display for a relatively invisible "Asian" public, but it gets its chance for revenge.

This revenge takes shape on many levels. First, there are simulations manipulated by characters that alter the circumstances rendering the American body visible: the surveillance video cameras used in Japanese cor-

porations and, later, the computer graphics hardware that reveal video manipulation. But far more insidious—and important—is *Hollywood's* simulation of the film that conflates racial difference with national difference. It is Hollywood's simulation, here signified by the very film the camera produces, that chooses what to make visible or render invisible, whether it is Austin's body or the body of Japanese hedonism. Like the pixels used in simulation, these shots reveal the "truth" that we unconsciously grant the camera. These shots may, however, be just as fabricated and nonrepresentational as the pixels used to alter video images.

Midway through the film transpires one of the more improbable representations of computer detection in recent Hollywood cinema. This scene takes place in a basement under a university ice rink that houses—implausibly, as we are meant to think—the most sophisticated computer graphics classrooms in the United States and the source of the SIMS that will enable us to see for ourselves the necessity for making visible unshaded "gray" areas of racial representation. We see a crucial moment of detective work appear before us on the video screen. The first crack in an inscrutable armor of Oriental cover-up, the first sign of an acclimating thaw, is signified by the sounds of melted ice dropping in buckets which allude, no doubt, to the leaky, problematic status of American institutions, prone to takeovers, in sharp contrast to their sleek, coherent, comprehensive, and self-contained Japanese counterparts.

In fact, the leaky distinctions that inform much of postmodern identity are at issue here: how does one understand "truth" in a world of simulations? Embedded in this scene is a very clearly understood idea of the things that designate difference between Western and "Asian" cultures; that is, what counts as "Japanese" is a smoothly technophilic yet minimalist interior decor that hides or masks the full capacities of its machinery, while "American" culture is *perceived* as contrastingly chaotic, less seamless, more disruptive and crude, represented most strikingly by the American police force and the vulgar, crude figure of Detective Graham. While the former depends on notions of deception, the latter, though unrefined, is, nevertheless, unnervingly "honest." What's interesting about this specific scene, however, is not the differences it ostensibly manifests but rather the ways in which the notion of authenticity is produced through the representation of race.

Connor and Smith are reviewing a disk that has recorded, they think, Austin's murder. Curiously, this scene, so crucial to the plot developments for the Americans, revolves on the dynamic between women. Jingo Asakuma (Tia

Carrere) is the half African American, half Japanese student of computer technology introduced to Smith and Connor by her professor, and she establishes her status as a brilliant student by analyzing the disk in question.

More important, however, she negotiates several different cultural positions between the two detectives and the dead woman. Asakuma is substantially more marked than Austin, and yet it is her very visibility—the fact that she can only be perceived as racially coded—that "buys" her loyalty to American nationalism. Austin, on the other hand, though identified as a sexual deviant, is able to slide between cultural standpoints (though, of course, she can only remain as the property of whatever culture "buys" her) because her whiteness makes her relatively invisible. What this suggests is that "race" marks itself, but it also remains as a supplement to the master signifier, embodied most fully by Connor, whose "ownership" of Asakuma is represented unproblematically. This is primarily because it's only in the film's final moment that we realize Asakuma has a sexual relationship with Connor.

From the film's inception, it's clear that Connor has a comprehension of Japanese culture that Smith, despite his status as a special services liaison officer, cannot share. As an African American, Smith seems locked into a specific mode of understanding and reaction based, one can only conclude, on the fact of his skin color. Connor, on the contrary, is able to mediate between the enormous cultural differences in Japan and the United States and, more important, make sensible to us the workings of an "inscrutable," unknowable society. As a "part" of both "cultures"—that is, as a material embodiment of the two "racial" standpoints the men represent—Asakuma uses cyborgian technology in order to authenticate and guarantee the kinds of "physical" evidence for cultural difference requisite to uncovering the film's detective plot.

Curiously, as an audience, we seem to be in Smith's position: like the apt pupil Asakuma is and Smith will soon become, we need to be similarly taught by a master about the "natural" hierarchies of race and nationality, and we do so by becoming good consumers of Hollywood film. *Rising Sun* demonstrates how the representational process seeks to undermine positions occupied by the socially marginalized by the *fact* of representation itself: Smith and Asakuma acknowledge the stain of *kokujin* (the Japanese term for black) origins, but they "blame" that fact on Japanese racism and *not* American codes of color. The film exploits representations of African-American poverty—the random shots of ghetto life Smith and Connor see while driving—by attributing its cause to Japanese greed. In order to "see" Asians as a "race," it seems that we have to be "raced" ourselves.

Asakuma proceeds to disclose the fact that the disk is a SIM masquerading as reality. Her first comment has to do with "shadows." She displays the apparent inconsistencies between a "real" video representation and its copy, which we are now seeing: there is "something in the edge collars...look at shadow lines," she says. We notice immediately the awkwardness of her halting, nonidiomatic language; while her facility with computer graphics may identify her as "Japanese" in this film—that is, "naturally" endowed with a technophilic capacity—she still is subordinated, like Smith, by her lack of mastery over language that would signify her cultural fluency and fluidity. The object of our gaze, however, is not this woman; her presence is only a marginal one, serving to define the parameters of our understanding of the power relations in this film. Instead, we are watching a video camera recording a "murder" whose presence is in fact virtually invisible without the aid of a maverick U.S. computer technology.

Asakuma only *facilitates* our comprehension of the ways in which race is deployed in this film. Her first remark concerning "something there in the edge collars" points us to the image of a Japanese man; "they've added shadows," she says and then, with finality, "the pixels have been altered...this disk is a copy." Of course, it is precisely at the edges of something—the collars of comprehension—that ambiguity about identity occurs. What makes identity have an "edge," so to speak, is what marks it as specifically different from others. To "add shadows" is to further mystify the moment. In this disk, the blue "edge collars" reveal that the disk is a copy. The figure that has replaced the "original" is presumably the one that gets shadowed. Interestingly, the figure on the original disk is a white man; in the copy, the white man is shadowed by the body of an Asian one, thus producing an extremely loaded representation of the identification and marking of race. Shadowing also implies a kind of masking. In the case of *Rising Sun*, the masks over the "truth" of the investigation are cast most visibly by the Japanese, who seem to erect obstacle after illogical obstacle for the American detectives. The shadows that outline the figure of the "Asian" carrying the same history of subordination granted "colored" races turn out, therefore, to be deserved.

Shadows contrast with reflections, most particularly the reflection the video "ghost" has carelessly left on the disk. The shadowy presence of the Japanese is abundantly clear. They have already doctored the disk and displayed their contempt for American technical prowess by leaving the ghost on the disk for discovery in the first place: "They expect us to be sloppy Americans," Asakuma explains, "in Japan the ghost would remain invisible."

This "mistake" insinuates that the notion of reflection is something more than a simple afterthought.

Lacan's formulations of the mirror stage are critical to this moment of discovery. The self-recognition that happens the moment the *trotte-bébé* sees himself in the mirror is constructed not only through a field of external signifiers but on the apparatus that sustains the infant in front of the mirror, usually the mother.[10] In other words, the reflection the "ghost" leaves, later (through SIMS) shaded in by shadows and disclosed as the newly colored "Asian," may be one that is sustained by the ideological apparatus constructing race as a visible entity that we as an audience bring to the film. Connor, in fact, refers to Japan's presence in the United States as a "shadow world."

The rest of the scene involves a series of quick cuts between the computer screen, Smith's face, Asakuma's face, and, most interesting, her mutilated hand, which is shown isolating the image on the screen, honing it, filtering out all the "noise...picked up along the way," and finally revealing the face of a Japanese man, Eddie Sakamura, as the material origin of the "ghost." Interestingly, at no point during this segment do we see a shot of Connor's face until the end of the computer sequence. The scene begins with a shot of the backs of Connor, Smith, the computer graphics professor, and Asakuma, but later focuses on the faces of Smith and Asakuma. Though the roles of both the professor and Connor appear marginal, their presences, unlike Asakuma and Smith, insures a disembodied authority—they are ghosts of power that remain invisible on screen: the directors, so to speak, behind the scenes. In contrast, Smith and Asakuma function as a set of pupils learning their ideological lessons.

Cheryl Austin, the putative subject of the disk and the murder investigation, has an entirely different function. Her body, though white and therefore presumably outside the scope of racial investigation, is marked by gender and scarred from the marks of her ostensibly perverted sexual practices. She's a "gasper," the medical examiner declares—she enjoys being nearly asphyxiated in order to achieve heightened orgasms—but as the examiner reminds Smith, "it's easy to make a mistake." The simulated version of her sex scene—the disk is a "copy" of the "real" one—represents the ways in which sex gets racy. Her mistakes are altogether too clearly manifested by both the kinkiness of her sexual and racial preferences and her complicity with a raced group who, according to the LAPD, are well known as "world-class perversion freaks" and only want to "fuck the Rosebowl Queen." These mistakes, too easily made and too readily identified by institutions that police gendered and raced boundaries,

crop up at the seamless coherence of her whiteness and reveal the cracks in the armor of race to be the fissures created by gender.

Rising Sun's mystery is ostensibly represented as a whodunit—identifying Austin's killer allegedly constitutes the film's drama, sustains its plot, and affords a coherent closure. What's at stake *ideologically*, however, is another mystery. I want to suggest that at issue in this film is the more insidious mystification of racial representation: how conventions of race, produced in all sorts of discursive practices—discrimination, segregation, integration, theory—get reinscribed in the language of Western hegemony.[11] "Adding shadows" to the face of the "Asian" duplicates the ways in which racial identification and difference get filled in, so to speak, by skin color. The continual cuts the camera makes between the image produced on the screen and the faces of Smith and Asakuma suture examples of "Asian" (Asakuma) together with Western-created notions of differences based on color (Smith). Asakuma's hand, replicating these ideological positions by reinscribing the image of the Japanese man—making the "ghost" visible—negotiates and mediates between cultural and racial standpoints, reminding us by its mutilated state that even her capacity for disembodiment as a computer genius is confined by her bodily disability. In addition, she is a woman colored by race, which, in turn, guarantees the unmarked, hegemonic position of white heterosexual masculinity that Connor prominently wields.

What's curious about the act of marking, however, is that while we assume—and while the film assumes—that the unmarked category is going to be the white heterosexual male, it turns out that what has remained radically unmarked and therefore in dire necessity of marking is the status of the "Asian."[12] The one "Asian" with whom we are able to identify is Asakuma, whose overdetermined role more than adequately marks her body in a system of Western hegemonic discourse: gendered, sexualized, colored, and disabled. The position of the "Asian" male, however, needs to be as fundamentally marked for the sake of the narrative's coherence as for the detective plot, as this film makes obvious. Thus the figure of Eddie Sakamura, the itinerant Japanese playboy infamous for the diversity of his sexual tastes, needs to have parameters drawn: shadowed, colored, identified as different, foreign, threatening to the integrity of a teleological representation of Western history.

It turns out, however, that though Sakamura makes an admirable suspect, easily embodying the "perversion freak" so dear to the heart of the LAPD, he is innocent. In fact, what has happened is that the white aide to Senator John Morton (Ray Wise), a prominent figure in the Microcom negotiations, has cov-

ered up for his boss's transgressions. Morton's infamous sexual indulgences have led him to an entanglement with Cheryl Austin, the prized property of Japanese corporate executives. Together with the young Ishiguro, another Japanese assistant to the head of the Yakamoto corporation (the firm that is competing with Nakamoto for the Microcom sale), this aide has plotted to remove the complications Morton's sexual liaison may cause by murdering Austin. Sakamura has been both framed and absolved by a technology that is able to alter the apparent "truth" of technological representation and reproduce what we're led to believe is the lie of simulacra. Yet I would argue this lie functions as an ideological truth; that is, it is not "an illusion masking the real state of things but…an (unconscious) fantasy structuring our social reality itself."[13]

The task of unmasking the "real" culprit never in fact materializes within a SIM: *his* face and body don't get projected onto the boardroom screen. Rather, the camera focuses on the face of the young male *Japanese* aide associated with the Yakamoto corporation, to uncover *his* mark of guilt in terms of his complicity with this murder. The camera makes him masquerade as the criminal body. The white male aide to the slippery Senator Morton (who earlier in the film has talked of American racism against the Japanese) remains virtually invisible despite his egregious crime. In other words, at the precise moment of revealing the "truth" about Austin's murder—that a white man has done it and *not* a Japanese one—the film's camera moves from the boardroom screen onto which the murder is being projected to focus on the face of the unguilty *Japanese* man, thus ideologically situating him as the "real" (that is simulated) culprit.[14]

If the politics of the cyborg, to use Donna Haraway's term, reproduce Western conceptions of organic and coherent human subjectivities as fabricated and undifferentiated hybrids between organism and machine, in what way does the postmodern erasure of identifying features implicit in this film get reinvented as a highly problematic area in which borders need to be redrawn? In what way does the urge to assign "race" as it is self-consciously reproduced in Western terms signify a displaced narrative of needing to realign the politics of identity along traditional hegemonic lines? Are identities artificially invented and produced out of a technologically sophisticated culture of late capitalism in order to *guarantee* older notions of domination based on differences as natural, given, inescapable, and therefore moral? Earlier in the film, Connor remarks to Smith that while "we" come from a fragmented, MTV rap culture, "they" do not. Implicit in this remark is the problematic status of postmodernity—defined, ironically, by popular culture *as* a coherent

entity—especially in relation to a congruous and integral "other," one whose very subjectivity could end up subsuming U.S. society. "Race" is understood by the film to concentrate on the visibly marked body of the African American Smith. As a character, Smith is self-conscious of the fact that he is a signifier of U.S. histories of racism, and he alludes continually to these histories through-out the film. He mediates the American understanding of "Japanese" culture as something *marked* by color.

I would like to suggest that this form of mediation depending as it does on the production of so-called material evidence for the identification of race may articulate our cultural desire for hard copy. We need to see material instances of what's possible in order to comprehend the limits of possibility. Given an endless space for representation, it seems our first impulse is to find ways of charting, mapping, and recontaining it as discrete territories that promise phenomenological coherence. But what relation do simulations have to the hardware—or hard drives—that produce them? In a culture with increasing capacities for reinvention, hegemony has to reinvent itself as well, and it does so according to very conservative lines. Even while technological ingenuity continues to offer greater and greater freedom from the confines of identity, are there ways in which the production and deployment of those sub-jectivities replicate powerfully encoded cultural *memories* of race and gender?[15] Is there a relationship between an epistemological memory and a technologi-cal one?

Even while relishing virtuality and the erasure of boundaries that have, historically, constituted older notions of the "real," SIMS provide us with a kind of hard evidence for hegemonic positions. They are manufactured visual images that provide demonstrable testimony to that image's existence. *Rising Sun*'s representation of the Japanese man situates him in a place of racial and sexual transgression, even though that situation is entirely manipulated through computer graphics.

SIMS, however, depend on SIMMS (single in-line memory modules) for their articulation. Because they are modular units of "memory," SIMMS appear to establish a material hardness to a fluid phenomenon, but the plas-ticity of silicon also grants the capacities for infinite imprintability onto the permanence suggested by the term "hard drive." Puissant cultural fantasies about race, sex, and gender congeal as the hard materiality of ideology. Put more simply, SIMS function as the consequence of the language encoded by SIMMS. SIMS also protect us from the horrors of the ideological effects that SIMMS, as hardware, produce. SIMS provide the *illusion* of power and indi-

vidual agency while their SIMMS counterparts work invisibly to furnish the frames for those illusions, but SIMMS are entirely contingent on power: once the electricity is out, so is the illusion.

The cultural logic for examining popular film as a site of ideological investigation is compelling. Popular film functions as a popular mirror, but one that uses ideological fields for its articulation. We consume the coherent *imago* (the projection of the film) in the moviegoing process. But this imago is produced through SIMS and reproduced as SIMMS—from the fluid mechanism of filmmaking to the material film itself. Such consumption bolsters our belief in ideological fields as the only fields of "legitimate" cultural representation.

The hysteria over the necessity for national, racial, and gender discretion in *Rising Sun* may be usefully understood in both Lacanian and Marxist terms of fetishism: as subjectivities that mask the impossibility of their existences—simulations signifying simulacra—and as the reification of labor and social relations that guarantee their visible material presences as SIMMS. The fact that SIMMS can't account for themselves once the power is shut off—that is, like a calculator, their ciphers and reckonings disappear—attests to the invisibility of ideology and the necessity to make continually present and visible a memory that has no past. It may be those "memories" then that account for the reasons why films like *Rising Sun* expend so much energy putatively refashioning a future that turns out to be cast in the ideological language of the past.

Notes

1. Such settings include the conference in which I first presented this essay as a paper, the Society for Science and Literature. At issue that year (1996) was the continuing debate, formulated and conducted largely by the scientists, about the usefulness of humanities. The question that *didn't* get asked concerned the status of the term "useful." This telling absence suggests that the putative accessibility of the humanities qualifies everyone to be a judge of their "use" as service.

2. In particular, the work of Donna J. Haraway has been especially useful in providing theories and methodologies for understanding the ways in which various discourses of science, technology, feminism, and culture are articulated, but other critics have made crucial contributions to the field(s). The work of Mary Ann Doane, Jennifer González, Sandra Harding, Evelyn Fox Keller, Susan Squier, Sally Shuttleworth, and Paula Treichler to list just a few names has usefully complicated the relations between these discourses.

3. Richard Dyer's *White* (New York: Routledge, 1997) and Thomas DiPiero's "White Men Aren't" (*Camera Obscura: 30*, 1992) admirably complicate the positions of white masculinity. In relation to the language of color, for example, the position of "white" and "masculine" may be read, in Lacan's formulation, as the master discourse, or the state of "being." This particular discourse is characterized most completely by *not* understanding the capacity for "lack." To "know," ironically, is to also be aware of inadequacy and lack—the discourse of the hysteric—and so understand oneself and the construction of one's subjectivity as a supplement.

4. I am invoking the problems Henry Louis Gates Jr. identified with the term "race" (complete with quotes) in the collection he edited, *"Race," Writing and Difference* (Chicago: University of Chicago Press, 1986). Gates uses the quotes in order to make visible the complications with the term: its use often solidifies or materializes a category, rendered visually by color, as an essential entity and thus serves hegemonic structures of Western culture. However, the problem with scare quotes, especially given their association with postmodern analysis, is that while complicating the uses of the term, they may freeze those complications into another kind of orthodoxy and thus ironically perform the very kinds of ideological uses they seek to uncover.

5. It may seem contradictory that the "unmarked body" to which I refer is, in fact, very specific in terms of its perimeters. The body used to conduct airbag tests required specific heights and weights, specific genders and races. The fact that those details get consumed by culture as a "model" body, however, masks their precision and establishes this body as unmarked.

6. John Berger, *Ways of Seeing* (London and New York: Penguin, 1977), p. 32.

7. Ibid, p. 33.

8. Richard Dyer's richly complex study on the construction of racial identities, *White*, offers a very compelling argument for the distribution of race in *Rising Sun*. I am indebted to his argument; however, my own account of the film problematizes the apparently diametric positioning of race in this film as a black and white issue. The place for the unshaded "Asian," I claim, in fact enables that face-off to take place.

9. Michael Crichton, *Rising Sun* (New York: Ballantine Books, 1992), p. 394.

10. This baby as of yet has not the sufficient coordination to stand independently, is dependent on his mother for support, "what in France, we call a *trotte-bebe*." Jacques Lacan, *Ecrits*, Alan Sheridan, trans., (New York and London: Norton, 1977), p. 1.

11. Gary Peller has argued quite persuasively on the problematics of civil rights language in his article "Race Consciousness," in *After Identity: A Reader in Law and Culture*, Dan Danielson and Karen Engle, eds. (New York: Routledge, 1995).

12. It seems as if the term "Asian" is replicating the same imperial practices that its "Oriental" predecessor performed in the past. In the case of this film, "Asian" gets singled out as "Japanese" in order to make the face of corporate competition that much more comprehensible to an unknowing American public.

13. Slavoj Zizek, *The Sublime Object of Ideology* (London: Verso, 1989), p. 33.

14. In the words of Lacan and Zizek, the truth is out there; cultural fantasies about Asians come to life on the big screen, providing us (albeit tautologically) with "proof" for stereotypes.

15. I realize that other issues inform manifestations of subjectivities, but for the purposes of this essay, I am primarily interested in the formations of race and gender.

References

Berger, John. *Ways of Seeing*. London: Penguin, 1977.

Crichton, Michael. *Rising Sun*. New York: Ballantine Books, 1989.

DiPiero, Thomas. "White Men Aren't." *Camera Obscura* 30 (1992): 113–37.

Doane, Mary Ann. "Technophilia: Technology, Representation, and the Feminine," in *Body/Politics: Women and the Discourses of Science,* Mary Jacobus, Evelyn Fox Keller, and Sally Shuttleworth, eds. New York: Routledge, 1990.

Dyer, Richard. *White*. New York: Routledge, 1997.

Gates, Henry Louis Jr. *"Race," Writing and Difference*. Chicago: University of Chicago Press, 1986.

González, Jennifer. "Envisioning Cyborg Bodies: Notes from Current Research," in *The Cyborg Handbook,* Chris Hable Gray, ed. Routledge (1995).

Haraway, Donna J. *Primate Visions: Gender, Race, and Nature in the World of Modern Science.* New York: Routledge, 1989.

———. *Simians, Cyborgs, and Women: The Reinvention of Nature.* New York: Routledge, 1991.

Harding, Sandra. *The Science Question in Feminism.* Ithaca, NY: Cornell University Press, 1986.

Harding, Sandra and Merrill Hintikka, eds. *Discovering Reality: Feminist Perspectives on Epistemology, Metaphysics, Methodology, and Philosophy of Science.* Dordrecht, Netherlands: Reidel, 1983.

Hirsch, Marianne and Evelyn Fox Keller, eds. *Conflicts in Feminism.* New York: Routledge, 1990.

Keller, Evelyn Fox. "From Secrets of Life to Secrets of Death," in *Body/Politics: Women and the Discourse of Science,* New York: Routledge, 1990.

Lacan, Jacques. *Écrits,* Alan Sheridan, trans. New York: Norton, 1977.

Peller, Gary. "Race Consciousness," in *After Identity: A Reader in Law and Culture,* Dan Danielson and Karen Engle, eds. New York: Routledge, 1995.

Squier, Susan. "Reproducing the Posthuman Body: Ectogenetic Fetus, Surrogate Mother, Pregnant Man," in *Posthuman Bodies,* Judith M. Halberstam and Ira Livingston, eds. Bloomington: Indiana University Press, 1995.

Shuttleworth, Sally. "Female Circulation: Medical Discourse and Popular Advertising in the Mid-Victorian Era," in *Body/Politics: Women and the Discourse of Science,* New York: Routledge, 1990.

Treichler, Paula A. "Feminism, Medicine, and the Meaning of Childbirth," in *Body/Politics: Women and the Discourse of Science,* Mary Jacobus, Evelyn Fox Keller, and Sally Shuttleworth, eds. New York: Routledge, 1990.

6. *In Medias* Race

Filmic Representation, Networked Communication, and Racial Intermediation

David Crane

In 1995, Hollywood released four major feature films dealing with "cyber-space" in one form or another that featured African Americans in either significantly supporting or lead roles: *Johnny Mnemonic, Hackers, Virtuosity*, and *Strange Days*. The race of these characters involves more than just progressively inclusive casting, for their race itself plays a significant role in each film's narrative presentation of networked technology. Sometimes overtly, sometimes more subtly, the characters' blackness intermediates between the representational conventions of narrative film and the "new technologies" that those films depict. The one helps make the other visible, so to speak. How this is done varies from film to film; but by examining these, along with the 1986 film *Jumpin' Jack Flash* (which, despite its earlier release, shares many qualities with the later films), I will show how blackness functions to authenticate—and envision—oppositional identities and ideologies associated with cyberspace. Moreover, this authenticating function negotiates between the networked communication of cyberspace and the "reality" diegetically framed in cinematic space. I could say that blackness is the medium that makes the mediation real; but the reality, as we shall see, is not so neat.

Web Sight

It's a strange space, cyberspace, this nonplace that becomes ever more ubiquitous and ever more essential to our already mediated reality—or the reality of our many mediations. Conjoining the hard materiality of technologies and the fuzzier logics of imagination, it exists not so much as a discernable entity but as a "site," in the most metaphorical sense, of cultural, social, and, of course, technological tension. This tension is productive, to be sure: it has provided us with a seemingly endless array of gadgetry and accompanying terminology, as well as an entire new economic sector that promises national and even global prosperity—for some. Less quantifiably, but perhaps more profoundly, it has ushered in new ways of understanding agency, social interaction, and identity, an epistemological shift best examined in the writings of Donna Haraway, Sherry Turkle, Scott Bukatman, and Allucquère Rosanne Stone. Finally, this tension has, in a sense, produced itself; that is, it has given its own "site" a name, one that broadens that site into an arena where its tensions and productions can be multiplied, expanded, contested, and redefined.

But why "cyberspace"? How has this originally fictional term become the dominant signifier associated with a vast array of loosely organized and often conflicting systems of technological communication (not to mention the frequently antagonistic networks of power that struggle to use and control them)? The word itself offers some clues, as it also demonstrates the creative fabrications of communicating in natural language. Technically speaking, it is a hybrid word: the prefix "cyber" is back-formed from "cybernetics" (where it is not a prefix), itself rather newly formed (like all good technical terms) from Latinized Greek by Norbert Wiener; the root "space," derived more "naturally" from Latin, has been part of the English lexicon in some form since the Norman Invasion of England.

While the complex phenomena that "cyberspace" signifies cannot be judged solely by one word, no matter how pervasive, it seems appropriate that this hybrid word should refer to such hybrid technologies and practices. Technologically and practically speaking, cyberspace denotes a profoundly intermedial relationship among computer networks, telephony, and television. Computers and digital information are already an important part of telephonic and televisual mediation, after all, and they will become more so with the planned conversion to digital TV. The battles and alliances between telecommunications companies, entertainment conglomerates, and software firms demonstrate how this intermediation is also part of a technocapitalist marketing of territory. In fact, the ultimate importance of the term "cyber-

space" is that it encourages the abstract and obscure structures of computer and communications hardware and code to become spatialized, and, in turn, conceived of as territories, frontiers, boundaries, communities, and virtual realities. Not that the term alone has caused this to happen; rather, its popular adoption shows how it fitted already occurring phenomena and further encouraged their development.

What the term's emphasis on spatialization especially encourages, however, is visualization. Marcos Novak's idealized composite definition of cyberspace as "a completely spatialized visualization of all information in global information processing systems" (225) shows this link between space and vision as it also reveals the totalizing aspirations of this web sight—an apotheosis of graphical user interface (GUI) development in the computer industry.[1] William Gibson's coinage of "cyberspace" draws on these GUI efforts, through the immersive desires of video game interaction, to develop a visualizable narrative space through which characters and readers can maneuver (a basic element of narrative, which is itself a system for creating spatio/temporal relations out of alphanumeric representations of phonetic language—at least for print-based texts). Yet in the "real" cyberspace, as in Gibson's fiction that named it, seeing is not always believing. Even with the proliferation of webcams, the wired world carries an image of pseudonymity and deception, especially in popular discourses and narratives. From hackers' handles and MUDers' avatars to more quotidian personal webpage designs, cyberspace involves various degrees of masking, relying on the complex interplay between visibility, invisibility, and the performative representation of identity.[2]

As Gibson first showed, this interplay works well with narrative's own games of concealment and revelation—a situation made more vivid, and more "literal," when the audiovisual narrative strategies of film visualize cyberspace. On the big screen, the GUI must be made sufficiently cinematic, and the protocols of interfacing must adapt to the economies and redundancies of commercial narrative conventions (for example, speaking while typing). This intermediation has two main features: first, the film represents another electronic space, distinguished from yet also echoing the cinematic space (a *mise-en-abyme* of *mise-en-scène*); second, it uses computer-generated imagery, along with other digital and analogue compositing effects, to produce these representations.[3] While Vivian Sobchack has emphasized the phenomenological differences between the cinematic screen and the electronic one, films that screen electronically and digitally mediated space still tend to incorporate that other format of mediation into the narrative economy of film. However, visualizing

the other electronic space can still transform the dominant cinematic space/time, much like when the depiction of telephonic discourse influenced the development of cinematic narration. Indeed, a third aspect of the cinematic presentation of cyberspatial communication draws directly on the conventions of representing telephonic discourse.[4] Yet despite its conventional incorporation and transformative potential, cyberspace still generally connotes an "other" world ontologically and phenomenologically distinct from the "real" one. Its otherness, in fact, bestows upon it the capacity for transformation.

It should not surprise us, then, that representing the otherness of cyberspace might involve forms of racial and ethnic otherness—especially hybridity, with its negotiation of identity and difference. Nor is it surprising that hybridity would be privileged, celebrated, and even fetishized in the attempts to portray the shifting boundaries of an emerging postcolonial global economic structure—and especially a resistance to that structure. Hybridity figuratively envisions these geopolitical and conceptual transformations, linking them to the technological transformations with which they are implicated.[5] Haraway, in ironically manifesting the cyborg as the potentially revolutionary subject of postmodern technoculture, exemplifies this within the cultural studies imaginary. Acknowledging the importance of low-wage third-world female labor in the technology industries, she suggests that "'women of color' might be understood as a cyborg identity, a potent subjectivity synthesized from fusions of outsider identities…" (174). Extending this, Stone identifies those who participate "in the electronic virtual communities of cyberspace" with the "boundary-subject" of the Mestiza.[6] In Gibson, again, the resistant and revolutionary potential of cyberspace becomes increasingly linked to Afro-Caribbean voodoo. Bukatman emphasizes how the novelist uses the "*street* religion" of voodoo to present, "like cyberspace itself…an alternative method of conceptualizing the system…."[7] Evoking himself the traditions of African storytelling and the theories of Michel de Certeau, Bukatman notes how Gibson's cyberspace cowboys, as well as the narratives that constitute them, use "trickster tactics within the 'machineries' of cybernetic culture" (212).

Similarly, John Akomfrah's independent British documentary film, *Last Angel of History* (1995) invokes a trickster-like figure called the "data thief" to link the African diaspora to black (mainly American) science fiction and technoculture.[8] For Akomfrah, the data thief is a figure of mediation that recalls the violent displacements of the middle passage while signifying the recent creative appropriations of scratching and sampling. Also a hybrid identity and a

boundary subject, the data thief's essence is in-betweenness. Denied a home, he (the film privileges the masculine) is destined, says the narrator, to "wander between science fiction and social reality," an intermediary between symbolic mediation and the reality that resists its representation. The figure's blackness is crucial to this; enmeshed with his outlaw status, it situates him (and the film) in a cultural and historical context that authorizes—and authenticates— the film's opposition to dominant culture. Furthermore, the data thief bridges the outlaw ethics of black culture, namely hip-hop, with those used by hackers and cyberpunks to construct their own oppositional identities.

Yet Akomfrah's film (not to mention hacker identity) may not be as oppositional as it appears, especially given the growing popularity of "oppositional" (or at least alternative) identities. The data thief, for example, resembles characters in the much more mainstream *Johnny Mnemonic, Hackers, Virtuosity, Strange Days,* and *Jumpin' Jack Flash.* They, too, function as mediators while simultaneously representing, through the audiovisual mediation of their blackness (and, in some cases, star power), a "reality" at odds with its mediation. These cases, however, involve more than simply the authenticating otherness common in popular culture representations, and more than the mainstream recuperation of the subcultural—though they certainly do involve that. They also, to reiterate Bukatman, offer "an alternative method of conceptualizing the system," providing figures of resistance to the systems that they also help to configure. Blackness provides a more authentically resistant otherness than hybridity, and that authenticity associated with blackness visually enhances the intersection between cyberspace and cinematic space. Sometimes this serves to authorize the "Other" space of cyberspace; more often, it highlights the diegetically framed "reality" of cinematic space in relation to other systems of mediation.

However, as Wahneema Lubiano puts it, "'Reality' is promiscuous, at the very least" (105). The ultimate in overcoding, it can mean too much to too many (and always involves contradictions if invoked in popular mediations). Yet, invoking the "real" is always more a pragmatic act than a matter of literal semantics. This is especially true in African-American discourse, where it asserts the importance and urgency of a lived experience long denied visibility and legitimacy. And because of this history of denial, as black culture reaches a wider audience and greater popular legitimacy, it parleys this pragmatic "real" into an aura of authenticity that the dominant culture has been more than willing to fetishize in various ways. But again, the pragmatic and often performative sense of "making it" or "being real" means that those expressions

do not simply "say" something about the reality of cultural experience. What remains tacit amongst those who understand is just as important. Articulating the "real," particularly in a resistant or oppositional sense, not only describes a cultural situation—it helps establish that situation, along with its bonds, its boundaries, and the conditions of its realization.

In other words, such articulation involves aspects of what Henry Louis Gates Jr. calls "Signifyin(g)," which he derives and expands from the complexly ritualized black vernacular tradition of signifyin'. He defines Signfyin(g) as "the Other of discourse; but it also constitutes the black Other's discourse as its rhetoric" (50).[9] Estranged from the law, but nonetheless an ethical basis for communication and community, the double vocality of Signifyin(g) disrupts straight signification while its vernacular quality expressively ties it to an everyday reality. Although the conventional formalities of Signifyin(g) tend to distinguish it from discourse that is "for real," in these examples the real itself is articulated in a formal, stylized manner—as is true of any mediated representation of the real. Specifically, these films capitalize on the Otherness of Signification, drawing it into the more dominant mode of signifying. This process certainly appropriates and commodifies the Other as part of dominant culture's quest to be, as bell hooks says, transformed through the Other.[10] Yet such a transformation is potentially significant. While I will not pretend that the films discussed here offer clear examples of cultural resistance that challenges the racial hegemony of representation, they might really transform, in some way, the dominant system of signification—or at least intermediate meaningfully between the one and the Other.

Wired in the Streets

The street, in black vernacular and now even in mainstream discourse, is often posed not only as a site of the real but as an avenue of real knowledge and communication, in contrast to official information and its channels. As H. Rap Brown puts it, "The street is where young bloods get their education. I learned how to talk in the street, not from reading about Dick and Jane going to the zoo and all that simple shit" (25). In *Johnny Mnemonic*, a film based on a William Gibson story, the street also plays a role in spreading knowledge that confronts systems of power. The mean streets of the film's not-too-distant future are a vast ghetto of poverty, crime, and disease—namely Nerve Attenuation Syndrome (NAS), a fatal scourge caused by mainstream information overload. These streets are populated by those who have been oppressed,

exploited, infected, and abandoned by the corporate technocrats who control the mediation of information from the security of their towering office/hotel complexes. But the oppressed return, as the film's opening prologue tells us: "the corporations are opposed by the LoTeks, a resistance movement risen from the streets: hackers, data pirates, guerrilla fighters in the info-wars."

Both citing "the streets" and the site of the streets signify the authenticity of that resistance to technological dominance—albeit in a postmodern way. Indeed, "the street" becomes an almost literally floating signifier in the form of the bridge on (or more accurately in) which the rebel LoTeks live. Not only is this street suspended above the ground, but its approaches have been destroyed, unmooring it from the surface streets and negating its original intermediary function. What was once a means for transit has become a makeshift home, or squat, for the LoTeks, who also use it as their base for fighting the ruthlessly evil corporate high-tech system. Since the LoTeks are an underground organization, their life on the bridge is fundamentally ironic; but then, their whole floating world is one of ironic pastiche—"built with straight-world junk," according to their leader, J-Bone. This low-tech detritus is used to sample and steal straight-world data, which is then recontextualized and retransmitted on the LoTek broadband signal for everyone and for free.[11]

On a diegetic level, the LoTek pirate broadcasts offer messages of reality, telling "truths" that challenge the commodification, restriction, and distortion of the dominant order. Most tellingly, the film's climax features the LoTeks' transmission of the cure to NAS, as well as the knowledge that the straight, corporate world had been suppressing this information in the interest of profit. The inherent truth of the outlawed message is further signified, on both a diegetic and extradiegetic level, through the casting of rap and rock (and to a lesser degree, film and television) star Ice-T as J-Bone. Most obviously this marks J-Bone as black, which in itself appears to add legitimacy to his narrative position of privileged opposition. His otherness speaks for the ethical and real—and even the redemptive and sacrificial, since the character's primary function is to get the white Johnny to give up his selfish, establishment ways and save humanity, even at the risk of his own life. Moreover, the connection between blackness and ethical realness is further mediated—and further legitimized—through Ice-T's star persona. This is signified both visually (J-Bone looks like Ice-T) and, even more so, through J-Bone/Ice-T's vernacular eloquence and streetwise articulation. Somewhat paradoxically, Ice-T's star image is indistinguishable from his class- and race-based "ghetto identity, " as Todd Boyd calls it.[12] He, perhaps more than any other gangsta rapper, has built his

image on his ability to convey the word from the street and tell the "truth" repressed by dominant culture—an image enhanced by well-publicized efforts to censor his songs.

It could be, however, that J-Bone/Ice-T is just a mouthpiece for mainstream representation with his race cynically providing the film with a moral legitimacy. While his race (or race in general) is never diegetically addressed, it is recognizable through voice and image. More conspicuously, J-Bone is the only black character in the film with a prominent speaking part. This implicitly fetishizes his otherness, making him more like a cipher whose presence serves as a token of the real and whose racialized street style is more style than substance. But to say only this would be critical (and maybe cynical) self-righteousness, a moral condemnation of the mainstream for simply being mainstream. It could be, instead, that J-Bone/Ice-T functions both as a critical voice and as an appropriated other, marking an intersection as complex as any network of streets or computers—an intersection shown more vividly, and yet more contradictorily, in *Hackers*.

City streets also figure prominently in *Hackers*. In fact, they are integrated even more smoothly into that film's visual mise-en-scène, mainly through mixing computer-generated imaging with more traditionally cinematic visual effects. This slick and stylish film follows a multicultural group of data thieves—ethical ones, of course—who thwart the schemes of another unscrupulous (and white) hacker who has not only sold himself out to the corporate world as a security consultant but then steals from those he's promised to protect. As in *Johnny Mnemonic*, the street—and urban physical space in general—is linked to the good hackers' underground, alternative, and ethical outlaw status. According to the logic of the film's narration, the good hackers' street credentials mitigate any negative connotations to being outlaws because those very credentials ground their behavior in an ethical authenticity. There is virtually no moral ambiguity in this film: the good hackers are always shown to be in the right; any wrongdoing attributed to them is because they have been framed or because their computing savvy and connection to street culture is misunderstood by the ignorantly arrogant straight world.

Yet the street also functions differently here than in *Johnny Mnemonic*. Its ethical authority is not placed in opposition to the world of mediation and technology, but instead provides both an iconographic and narrative link between the "real world" and cyberspace. The film represents the latter as a city of data that echoes (and is intercut with) the physical buildings and streets of New York. The hackers glide between the virtual structures as smoothly as they

inline skate through Manhattan, and their extensive knowledge of the information superhighway is shown to be part and parcel of their street smarts. At one point, they even hack into the traffic-light system to facilitate a physical getaway. But the film not only visualizes cyberspace as a city; its vision of the "real" city owes as much to the virtual one. Real life appears more like a highly immersive and interactive video game: visually engaging, as well as abstract and highly stylized, the streets of *Hackers* are hardly what we would expect as a reference to an authentic "real." They are about as far as one can get from the "gritty" representations most commonly associated with realism.

Streets also mediate the initial movement of the protagonist from the white homogeneity and dreamy affluence of Seattle's suburbs to the multiethnic and stylized urban world of New York City. A precredit prologue shows a SWAT team intruding on the former's sun-drenched, tree-lined streets to arrest Zero Cool, an infamously precocious eleven-year-old hacker (known in real life as Dade Murphy) who had crashed a record 1,507 computers throughout the country. Following a montage sequence depicting his trial (sentence: $40,000 fine and prohibited from owning a computer or using a push-button phone for seven years) and the credits, we see an eighteen-year-old Dade (Jonny Lee Miller) flying to New York, his new home, with his mother. The extended sequence closes with an overhead shot of Manhattan that smoothly dissolves from the pattern of streets and buildings into that of a computer chip—a visual convergence of physical space into the hyperspace of a hypercard. This shot as much as any encapsulates the film's abstract fascination with stylized urban space. Even when shown up close, the streets are kept at a distance; here, they are practically shot from outer space before the shift to inner space. Perhaps this explains why many of the characters appear costumed more for outer space travel—Kate/Acid Burn even wears her hair like a Romulan from *Star Trek*.

Once actually in the city, Dade wastes no time making himself at home in the online realms of his new environment. On what appears to be his first night in New York, he takes on a racist local television show, *America First*. "So-called American Indians, Latinos, and blacks come from a genetically mediocre stock," harangues the show's host, to which Dade retorts, "Yak, yak, yak—get a job." He then hacks his way into the station's automated playback system, replacing the show with *The Outer Limits*. The explicit narrative purpose of this scene (besides showing us that Dade has not lost his computer skills) is to set up the first conflict between he—in the guise of his new online identity, Crash Override—and his hacking challenger, Acid Burn, upon whose

cyberspace territory he has infringed. Unsurprisingly, Acid Burn turns out to be his real-life antagonist and eventual love interest, Kate (Angelina Jolie). But directing Dade's first depicted hack against right-wing racism also demonstrates the film's liberal and idealized multiculturalist attitude, which is manifested in Dade's newfound hacker compatriots; particularly Phantom Phreak (Renoly Santiago), presented as a dark-skinned Latino and apparently gay; Lord Nikon (Laurence Mason), the African American who can best be called the leader of this otherwise anarchic group; Joey (Jesse Bradford), the Italian-American computer neophyte who initiates the dramatic conflict; and the more peripheral Razor and Blade (Darren Lee and Peter Y. Kim), the narratively unspecific Asian connections to the worldwide hacker network.

The film's multicultural and integrationist position gets articulated most directly—though still a bit ironically—when two Secret Service agents discuss the "hacker manifesto" while staking out Joey's apartment building. "'We exist without nationality, skin color, or religious bias,'" one reads mockingly to his partner. But the other (played by Latin crossover singer, Marc Anthony) insists it's "cool," prompting the first to more directly dismiss the text as "commie bullshit." The irony comes not only from having the hostile white agent (looking practically like a skinhead) read the text, but also from playing against racial stereotypes: whiteness is linked with irrationality and physicality, brownness with sensitivity and intelligence (Anthony's character wears delicate wire-rimmed glasses). Yet the obvious use of such racially marked characters to show "colorblindness" pushes the irony to the point of contradiction.[13]

A more complex case of colorblindness reveals further contradictions in the film's alignment of racial identification with political/ethical positions. It occurs just a few scenes later, when Dade finally reveals to his friends that he was Zero Cool. Amazed, Lord Nikon (so named because of his photographic memory) recites in clipped, almost mechanical Standard English the facts he has remembered of Zero Cool's exploits. Then he shifts into a more vernacular, "black" intonation: "I thoughya was black, man." Playing off one's invisibility on the Net, this response opens up a number of implications. From the perspective of diegetic character psychology, it implies that Lord Nikon has identified with Zero Cool enough to visualize this otherwise invisible person as like himself. His response also makes us aware, at least for a moment, that white need not be the color of normalcy, the default race.

But that possibility fades when both Lord Nikon and the film's audience do see Zero Cool's skin color—or rather, when his color gets identified with his handle. This may have been meant as another irony, but it moves even beyond con-

tradiction into a paradoxical ideological tension. On the other hand, if we look at Nikon's intratextual identification more functionally, his blackness lends some credence to Zero Cool/Dade's potential, or imaginary, blackness. Race may not vanish, as the manifesto wishes; but it—particularly blackness—gets virtually lifted from skin color to become a marker of inherent rebelliousness and natural skills—the essence of outlaw ethics. In this case, blackness, and racial identity in general, loses its essentialness; and in so doing, its essence is more easily appropriated. There is still, it seems, a bias toward skin color as color is ascribed to certain modes of behavior and cultural style. But is this Zero Cool appropriating blackness or Nikon projecting his idea of Zero Cool? Or is there a difference?

The significance of this scene is best understood in comparison to an earlier one that also links racial identity to style. It concerns the hackers' counterharassment of Dick Gill (Wendell Pierce), the African-American Secret Service agent in charge of arresting our falsely accused heroes. Gill is portrayed as an egotistical buffoon whose arrogance at press conferences reveals his incompetence. Always shown in plain dark suits and utilitarian glasses, he is in essence the Man—the *straight* man, through his identification with the law, his lack of humor, and his aversion to hacker style. He is also the sort of straight man who is the butt of everyone's jokes (including, unintentionally, his own) precisely because of his straightness. His blackness is also part of the film's joke on him. When Dade and Kate engage in a contest to humiliate him with hacker pranks, Dade creates a phony personal ad for Gill that begins "disappointed white male…." The reasons for this wording go unstated. Maybe Dade doesn't think Gill is black enough, or he doesn't want to write in virtual black-face, or he mis-identifies Gill as part of his own joke.

The underlying implication, however, is that Gill's straightness, his agency for the law, makes him white. A corollary of this would be that his blackness diminishes his authority. Actually, the film treats his visible blackness as if it were invisible or irrelevant or some strange visual accident. Yet the situation is more complicated, since Dade's ad is posted to a cross-dressing site, and his copy continues: "…cross-dresser, looking for discreet friend to bring dreams to reality. Leather, lace, and water sports. Transvestites welcome." The authenticity of Gill's straightness itself is put under question in this joke, which hinges on the intersection of "invisible" networked mediation and filmic representation. The joke plays off the incongruity between the ad's text and Gill's straight, black visual appearance—an incongruity obvious to the audience but not apparent to the respondents who overwhelm his office phone system. Of course those jokers Dade and Kate (Crash and Burn), the straight white cou-

ple, remain the primary focus of the film, with race a supporting concern. The support is more direct in the case of this contest, since the prize is a date between Dade and Kate, at which the loser has to wear a dress—intimating that their straightness has a bit of queerness, too.

Whether directly or obliquely, the isolated moments in which race is confronted contribute significantly to the film's engagement with both the mediation of cyberspace and a more "authentic" reality. Dade's whiteness and Gill's blackness visually authenticate a cinematic reality obscured in online communication, and the sight of the multiethnic and racial protagonists visibly marks their ethical authenticity. Yet, as we have also seen, the film's mise-en-scène blurs cinematic reality and computer mediation, treating race as a stylistic element of its hybrid narrative world. As part of the film's self-styled progressive (and postmodern) politics, *Hackers'* use of race does offer the possibility of utopian and popular cultural action, even challenging the popular myth. Similarly, it challenges the popular myth that race is just about "the color of one's skin" rather than the product of complex and contradictory cultural practices, knowledges, and histories. In the end, however, these remain only possibilities and potentialities, with history and cultural experience only allusions, and class not even that. Such may be an inevitable contradiction of desiring a color-blind world while also being attentive to racial, ethnic, gender, and sexual differences.[14] Besides, colorblindness is difficult in the visually dominating medium of film.

"Time to Get Real"

In *Virtuosity*, a technothriller set in the not-so-distant dystopian future, blacks are not just supporting players as they are in *Johnny Mnemonic* or *Hackers*. The film features Denzel Washington in the lead role of Parker Barnes, a former police officer unjustly incarcerated for killing some innocent people (and some reporters) during a psychotic rage. His actions were caused—and justified, according to the narrative—by the murder of his wife and daughter at the hands of a media-savvy serial killer. Parker himself lost an arm in the confrontation, and he now uses a bionic one. Obviously, his status as ex-cop turned con puts him in a dual position, at the intersection between the law and the outlaw. But with an actor so well known for his righteous characters in the role, we can trust that Parker Barnes will be an ethical—make that virtuous—outlaw. Placed outside the law by the very injustice of the law, his ethical authority is no longer derived from the policing system, portrayed as

all white and deeply corrupt (yet potentially redeemable). Rather, Parker's authority comes by virtue of his personal tragedy and, moreover, his natural skills: his virtuosity. These virtues don't make him pleasant; on the contrary, he is bitter and prone to anger, ripe for righteous Old Testament retribution. Still, those virtues—and faults—link the conventional traits of the independent, individualist hero (standard for detective narratives in the Dirty Harry mold and for Westerns) with notions of black naturalness that circulate, with different implications, in black and white cultural representations.

As if to illustrate Parker's dual position, the film opens with a doubly embedded diegesis. We first see him in a police uniform (we don't know who he is yet) with a white cop, tracking a dangerous killer into a Japanese restaurant, where they engage in a violent shoot-out that kills the white cop. Parker is the only black person that we see in the zombie-like crowd—everyone else is white or Asian—and the mise-en-scène itself appears strangely digitized. We soon realize this world is a VR simulation, and as it goes awry we cut back to the narrative reality where things, too, go all wrong. Parker and his partner convulse in the apparatus that contains them, victims of informational overload that kills the partner in this diegesis as well. Both, it turns out, were convicts selected as human guinea pigs to test the technology. Parker's visibly superior physical body, along with his observable natural skills, helps him survive the ordeal, only to be led back to prison.

Despite Washington's starring role, *Virtuosity* is not primarily about race. As with *Johnny Mnemonic* and *Hackers*, racial politics provide a subtext made explicit only at key narrative moments. Actually, there is only one such moment, but it comes at a crucial time: just after the opening virtual reality sequence and as character and plot are still being established. A white prison guard leads Parker into a fight with a white supremacist prisoner seeking vengeance for the death of the other white prisoner. The stylized artificiality of the prison setting even recalls that of the VR scene: boisterous spectators appear as silhouettes on scrim-covered cells, as derealized as the earlier digitally produced figures. "Who wants dark meat?" cries the white inmate as he attacks, emphasizing that his hatred is based on Parker's race as well as his being an ex-cop. Parker wins; but when the guards finally arrive to break up the melee, they take their sticks to him, iconically citing the Rodney King beating. This scene authenticates Parker's oppositional identity through the visual mediation of his black body, an identifiable Otherness that bears the brunt of racist and institutional violence. In doing this, the scene reinforces the power—and vulnerability—of his racialized physical presence. This is impor-

tant, since Parker will ultimately signify—embody, really—the authentic physical world against a simulated, and therefore illegitimate, physicality. And while his race will not be spoken of in the subsequent narrative, this scene insures that its significance will still be noticed.

Parker's blackness appears in sharp contrast to the whiteness of his main nemesis: Sid 6.7 (Russell Crowe), a self-learning computer program developed from the personalities of some 200 serial killers (including the one who killed Parker's family) and created for some preposterously ill-conceived high-concept reason. Sid, the amalgam of white male sociopathic murderousness, solicits the help of his white (as is virtually everyone else in the film) programmer/creator in escaping from his cyberspace prison. The creator, a stereotypical gay-coded villain who apparently uses this as a diabolically queer form of asexual reproduction, obliges by embodying Sid with synthetic nanocells that are not only of superhuman strength but can be regenerated with glass—making him, in a sense, a complex and murderous piece of fiber-optics.

Despite their contrast, Parker and Sid share some traits. Sid slyly remarks on what they have in common: both "touch the world with synthetic hands," both have been locked out of the "real world" for years—and both are multiple murderers. But any attempt at conflation only more profoundly illustrates their differences. Parker is shown to be wrongly othered and deserving reintegration into the world; Sid is further revealed as a true, irredeemable Other not of this world and deserving no place in it. All prosthesis, Sid is a false, virtual embodiment of the threat of artificial networks and autonomous technology. In the end, Parker turns the tables on Sid by conflating the virtual and real worlds in order to send Sid where he belongs; and, he uses his prosthetic arm as a tool of rescue, confirming his synthetic self as the embodiment of virtue.

Sid's whiteness is not the reason for his villainy, though it is an important aspect of it, considering serial killer demographics. Likewise, Parker's blackness itself is not explicitly tied to his virtue; but his physical embodiment is, and, because of that, so too is his race in an understated yet visually obvious way. Of course, the fetishizing of Parker's body, even for the cause of virtue, implies a racist equation of blackness with the physical—though Parker's mental ability is never questioned. Unlike the other examples we have seen, however, the "realness" that his black body invokes does not involve a vernacular street culture. Instead, it is connected to family and human companionship—again, something lacking or "perverse" with Sid.

Parker's anger is righteous anger because it is based on the murder of his family, and he redeems himself at the end of the film by saving the young

daughter of Madison Carter (Kelly Lynch), the white police psychologist and single mother who has befriended and helped him. While this does not lead to new romance or replace his lost family, it does lead to his freedom. And if this freedom doesn't lead to his reinstatement into law enforcement, it at least rehabilitates him through the law of the father. Indeed, the film's main concern seems to be relegitimizing patriarchy rather than developing a heterosexual romance or addressing racism—but one wonders if Parker and Madison would more likely be coupled if he were white or she were black. Perhaps more significantly, one might wonder about Parker's broader racial isolation. As the only black character, he recalls J-Bone/Ice-T in *Johnny Mnemonic*, but on a larger scale. Combined with his focus on his body and his charisma as a star, he becomes fetishized, re-othered as a solitary intermediary of the authentic.

Lornette "Mace" Mason, Angela Bassett's character in *Strange Days*, also functions as an intermediary between different worlds. A limo driver and bodyguard, her job takes her to and from various locations, implying both an older type of "hacking" and an upscale L.A. version of street culture—though her fighting skills make her a force on the meanest street. The film itself posits the world at a crossroads, first by setting the action during the last days of the millennium, and then by presenting a virtual, visual technology that threatens the lived experiences of reality. Mace defends and articulates this reality even more forcefully than Parker Barnes in *Virtuosity*. Her physical, material presence (like Parker's) visually and narratively authenticates the film's ideal of the "real"; she is also the only character in this film concerned with the everyday realities of paying rent and raising a child alone. Her dark, healthy, muscular physique accentuates the pasty, emaciated whiteness of the other lead characters: Lenny Nero (Ralph Fiennes) and Faith Justin (Juliette Lewis), whose physical degeneration stems from their respective addictions to the delusions of mediated representation and the deceptions of interpersonal manipulation.

Mace's guardianship of the real—and its ethical basis—extends beyond the diegetic confines of the film. Bassett describes her character as "a woman of integrity" in a promotional trailer for the film included on the commercially released videocassette. "She knows right from wrong," the actress insists forcefully and in costume, blurring the "real" star with her role by highlighting the sincerity of her performance: "she's the preservative, the moral preservative." In contrast to *Virtuosity*, Mace's relationship to the real is more directly, though complexly, articulated through her racial identity. In fact, the film as a whole is more explicit in both its scripting and visualizing of racial politics. Laura Rascaroli has observed how *Strange Days* is "fascinated by its own image

and indulges in many forms of self-reflection" (8); and the film's treatment of racial—and racist—confrontations, I would add, is tied directly to its treatment and enactment of vision and visibility. On the other hand, the film's self-reflective indulgences also implicate it in—and maybe blind it to—some of the very problems it attempts to explicate.

The main focus of the film is on Lenny, another ex-cop turned outlaw, but this time more of his own volition. He, too, is an ethical outlaw, if less virtuous and a little sleazier: he sells "clips," events recorded on disk (though sometimes called "tapes") by a quasi-fictional superconducting quantum interference device—or SQUID.[15] The clips made by the object are visualized narratively through a series of stunning, and sometimes horrifying, point of view (POV) shots. While any trade in clips is illegal (because they are made from pirated police surveillance technology), Lenny maintains some virtue by never peddling "snuff" clips—and, in the spirit of Parker Barnes, by being kind to Mace's son. Still, he is interested in the SQUID's ability to thrill through verisimilitude, a realism charged, and made marketable, by (no surprise) its connection to the streets: "You're always telling me," one of Lenny's suppliers tells him, highlighting the contradictions of realism, "bring you street life, bring you real life, that one man's mundane and desperate existence is another man's Technicolor." The appeal is not only realism, however, but the forbidden nature, the Otherness, of that reality. The SQUID shows "the stuff you can't have; the forbidden fruit," and as Lenny later cajoles a first-time user: "I'm your main connection to the switchboard of the soul."

The style with which the film renders the SQUID-based POV shots combines the televisual camerawork of shows like *Cops* (itself derived from direct cinema documentary) with certain conventions of amateur video; ultimately it harks back to André Bazin's celebration of the realistic long take in Jean Renoir and Roberto Rossellini. Actually producing these shots, explains Rascaroli, involved "a hybrid camera, that combines the stability of a steadicam and the mobility and flexibility of a hand-held camera, to simulate the agility of the human eye."[16] The SQUID technology is not merely for viewing someone else's life, however. Within the story, it offers full sensory reproduction: other people's experiences drawn, as Lenny says, "pure and uncut, straight from the cerebral cortex" and then fed back directly into the brain of a consumer. Technically, the space it kinesthetically represents (in the fiction of the film) is not a conventional cyberspace or virtual reality. The film's cowriter/producer, James Cameron, even takes the time to distinguish SQUID from VR in the previously mentioned trailer, pointing out that the latter is a

computer-generated environment. The former's workings are left so vague, however, that the distinction between the two media seems unimportant or even forced.

Besides, the SQUID stands allegorically for all "artificial" or "simulated" technological mediations, taking the discourses that surround them and screening them cinematically. Plus, it offers the ultimate in electronic telepresence—a visualized space of mental data that is not only seen but felt, befitting Marcos Novak's definition and getting as close to the real as one can get. In general, the addictive pervasiveness of this hyperreal technology recalls the "consensual hallucination" of Gibsonian cyberspace, and its operation borrows from Gibson's cyberspace decks as well (most notably by taking the term "jacking in"). At one key moment, the technology does become terrifyingly networked: when Iris, a key but peripheral character, is raped and murdered. Her attacker not only records his feelings and her image on his SQUID, but he forces another one, wired to his, onto her head, so that she sees and feels what he does. Through the POV shot, the audience sees this, too. The extradiegetic mirroring (and enhancing) of this diegetic circuiting of specularity is emblematic of the film's focus on vision; and it is indicative of how the film sees through technology to envision the sadomasochistic potential of that way of seeing. It even attempts to implicate itself. Just how race is implicated in this we will see shortly.

The film's initial main plot line—Lenny's clip dealing and his pathetically unrequited pursuit of his good-for-nothing ex-girlfriend, Faith—eventually gets intertwined with and overcome by what starts as a subplot: the murder of militant/activist black rap star, Jeriko-One (Glenn Plummer). Already dead at the beginning of the story, Jeriko-One is only shown through forms of intermediation: TV and SQUID. He and the subplot are introduced briefly in a news bulletin shown on a television in Lenny's apartment, and then more fully in a TV report playing in the bar where Lenny hangs out with his friends and customers. The latter is comprised of clips showing angry and mournful fans as well as Jeriko-One speaking at rallies, at which he adopts a messianic, millennial tone appropriate for *Johnny Mnemonic*. Denouncing a police state with dysfunctional social programs, he declares that America is "rearranging deck chairs on the Titanic.... But a new day is coming; 2K is coming; the day of reckoning is upon us."

Importantly, this fuller introduction to Jeriko-One coincides with the introduction of Mace. In fact, the clips of Jeriko-One are intercut with shots of Mace emerging (leg-shot first) from her limo and walking into the club. Once

in, she hushes the others so she can listen to the report with respect. The connection between the two becomes even more profound later in the film, and further intermediates among race, representation, and technology. Through a series of narrative machinations, Lenny gains possession of a SQUID clip showing Jeriko-One's murder at the hands of two LAPD uniformed cops, which he and Mace watch while hiding out with her relatives in South Central L.A. But while Lenny views the playback first, the film uncharacteristically refrains from cutting to his POV, dwelling instead on his externally visible, horrified reactions. Words fail Lenny, also uncharacteristically, when Mace asks him what he sees: "I—I can't tell you; you got to see it," he stammers. The film has repeatedly demonstrated her refusal to have anything to do with the SQUID, and when she refuses, he insists: "I know what you think about the wire—but you gotta see it—it's that important."

The visual content of the clip is deferred not only until Mace herself watches it, but also until she is willing to use the wire at all, thus granting her the privileged view while also forcing her to compromise her principles. Mace's viewing situation adds new meaning to Rascaroli's assertion that, in *Strange Days*, the "POV gives us a change of looking through the eyes of the Other" (7). Rascaroli's is a Sartrean view of Otherness, in which, as she puts it, "we wish we were able to look through the eyes of the Other, because the Other sees me in a way that I will never be able to see myself" (8). Considering this phenomenological circuit of identification and difference through Henry Louis Gates's aforementioned definition of Signifyin(g) ("the Other of discourse" and "the black Other's discourse as its rhetoric"), we glimpse the further significance of this doubly articulated viewing.

While seeing Jeriko-One's murder reveals to Mace the power of the SQUID, it doesn't change her overall attitude toward the apparatus. A few scenes later she chastises Lenny for his vicarious obsession with clips of Faith, signifying most clearly her role as "moral preservative" and how the unmediated real is at the heart of that moral preserve: "This is your life, right here, right now; it's real time, you hear me, real time, time to get real, not playback! These are used emotions—time to trade them in. Memories were meant to fade, Lenny. They're designed that way for a reason." She wants him to focus on the reality of the Jeriko-One clip instead, a memory that she doesn't want to see fade. And when Lenny (always the dealer) later tries to use that clip to barter for Faith, who is being held hostage by her paranoid manager, who himself wants the clip, Mace again delineates right from wrong: "This tape is a lightning bolt from God—it's worth more than you, more than me, more than

Faith, you understand? It can change things, things that need changin'…you do not have the right to use it for currency." This speech, not to mention her privileged viewership of the clip, reinforces the crosscut link established between she and Jeriko-One earlier, a link grounded in their shared blackness and emphasized through their insistence on truth telling. In Mace's case, at least, the truth should stand outside commodification and exchange—although the film itself certainly capitalizes on the "real" representational currency of the Rodney King beating (its surreptitious recording, in particular) and the L.A. riots.

Related to this discrepancy, Mace's use of the Jeriko clip to tell the truth and defend the real further compromises her antagonistic relationship to the mediating technology of the SQUID. This compromise is itself part of a more fundamental contradiction in the way the film narrates the technology's relationship to race and racialized politics. On the one hand, the extreme verisimilitude—the "wrong" reality—of the clips in general places them in Platonic opposition to the authentic, "right" reality that Mace represents and, more important, speaks for. On the other hand, this clip, because of its extreme verisimilitude, provides unimpeachable testimony (clips cannot be faked or doctored, it seems) and becomes the agent that can either incite racial unrest over Jeriko-One's murder or rectify the crime. Interestingly, this returns the SQUID to its original function of surveillance, though this time against the police, and highlights its difference from the more connected environment of the Net, where one cannot imagine this clip staying secret for long.

Compromises and contradictions are inevitable in such a spectacular critique of the specular. But the biggest compromise in the film comes when Mace entrusts the Jeriko clip to Deputy Director Palmer Strickland, the most virtuous cop on the LAPD (in the men's room, no less). This most utterly straight-laced white man has both the ethics and the authority to set the moral order right, which he does, although through a resolution that smacks of narrative contrivance. One function of this turn of events is to counter the conspiratorial thinking that the film otherwise encourages, and even poses as a red herring earlier on. When Jeriko's murder is revealed to have been committed by a couple of bad cops during a chance traffic stop, it shows a world that functions more chaotically than we may believe or desire. But this happenstance is belied by a narrative that resolves chaos with such conventional convenience and technological certainty. What makes this closure inconvenient, however, is that it shuts out the idea that racism, while not a conspiracy, can still be endemic to a police force or other structure of authority, even with a Palmer

Strickland. The main purpose of this resolution is to allow a relatively happy ending: the bad cops die, Lenny and Mace finally kiss, and instead of rioting in the streets, everyone else parties like it's the year 2000.

I Spy

The portrayal of cyberspace in *Jumpin' Jack Flash* differs from that in the previously discussed films, and not just because this film appeared nine years earlier. Less concerned with the futurist stylishness and gadget fetishism of cyberpunk, its view is more mundane. In fact, it makes no effort to visualize cyberspace through spectacular digital effects or the mise-en-abyme of virtual reality. Rather, cyberspace is part of a day at the office, and it appears primarily as text on a screen. But despite its different appearance, *Jumpin' Jack Flash* similarly uses an intermediary whose blackness helps format the film's more technological intermediations: its star, Whoopi Goldberg. More than the other characters or actors addressed above, Goldberg signifies the crossroads of cinema and cyberspace in a manner closest to Gates's sense of Signification. Her subversively skillful verbal play coordinates the visual play between the obscure world online and the observable "reality" of the film's diegesis. Her race, as well as her gender, helps demarcate the limits of each while traversing the expectations of both.

Although originally conceived for Bruce Willis, *Jumpin' Jack Flash* is most obviously a vehicle for Goldberg's comedic talents. Yet its focus on its star's charismatic personality creates a certain identity crisis for the film, as the spectacle of Goldberg's routines often overwhelms the narrative (not necessarily a bad thing). The film itself is a generic hybrid—an espionage comedy, although it does not exactly parody the action/spy thriller conventions upon which it relies.[17] But its questions of identity—and difference—mainly center around Goldberg's character, Terry Doolittle, who types transactions into the International Bank Transponder for a New York City financial institution. More significant, those questions get raised through Goldberg's vocal and visual characterization.

Terry doesn't quite fit in at work. Oh, she gets along swell with her coworkers; in fact, she's probably the most beloved of the group. But her white boss, Mr. Page, doesn't take to her unconventional demeanor or lack of professional decorum, especially in her data transmissions. Early into the film, he upbraids her over the recipes and the (sometimes apparently very) personal advice she has dispensed over the financial network—where she has garnered some international celebrity. He wants her to use her terminal only for its proper busi-

ness—"the transfer of funds between international banks"—and to follow proper protocols, such as concluding each electronic exchange by typing "end trans." This verbal exchange ensues as Terry tries to defend her actions:

Terry: "Mr. Page, I was just trying to be friendly."
Mr. Page: "Computers are not friendly, Miss Doolittle."
Terry: "I'm not a computer, Mr. Page."
Mr. Page: "From 9 to 6, five days a week, you are; you will represent this bank in a professional manner, or you will not represent it at all."
Terry: "End trans."
Mr. Page: "End trans."

Terry resists being identified with a machine. But despite her humanist protest, the film develops her identity in relation to computer technology—a terminal identity as much as anything in Bukatman. She has a natural ability with the machines in the office and is constantly helping coworkers with their technical problems. Her gifts even verge on the supernatural as when attracting Russian television exercise programs to her terminal screen, which she removes through the more natural magic of jiggling and banging the monitor.

Again, this emphasis on skills conjures up racist stereotypes of black natural ability as innate and unlearned (and, by implication, blacks as unteachable)—although those are rarely invoked for such technological ability. Yet such innate skills are common to heroes of both thrillers and comedies. Here they also establish Terry's humanizing and subversive position within the technologized and bureaucratized workplace, signifying her "individualism" and distinguishing her from the rest of the characters. Most distinct, however, is her skillful and often "inappropriate" use of "natural" language, grounded in the vernacular (and even the profane) and marking her ability for more "real" discourse. She uses this talent to signify on the film itself through her humorous running commentary on its narrative events and her double-voiced articulation that mocks straight discourse. By saying "end trans." in the above example, she seemingly conforms to her boss' demands; but actually she ridicules him and his rigid formalism by voicing the phrase in this discursive context. And while Terry's speech is not exactly of the street, it does resonate with the alternative authenticity of the vernacular, especially when confronting the standardized language of the system in which she works.

Not only do Terry's online "Signifying" skills draw the negative attention of Mr. Page, they attract more positively that of Jumpin' Jack Flash, the code name of a British spy trapped in Eastern Europe after having been betrayed by

some traitorous fellow agents. Taking advantage of the virtual mobility at his disposal, Jack contacts her through her terminal right after her confrontation with Mr. Page, using his own inappropriate communication over crossed networks. He starts with a knock-knock joke, to which she responds (speaking as she types), "'Personal chit-chat is prohibited on the International Bank Transponder.' 'Not on it,'" he returns, informing her that he has been monitoring her transmissions and has enjoyed her recipes. He then tests her mental skills by having her use the song "Jumpin' Jack Flash" to figure out the code key to his system. In her apartment, Terry sings along to it in a frustrating attempt to decipher the words, while also producing a racially mediated parody: a black woman mocking a white Englishman who has himself made a fortune imitating black American men.

The irony of this imitation game is taken a little further when Jack asks Terry to play at being a spy by taking a message to the British consulate. "Do you think they'll let me in the door?" she says to herself but does not type, acknowledging the discrepancy of her image from what he might imagine (and, for that matter, from what the film imagines of the British). This is reemphasized later when he asks her to return to the consulate during the ball for the Queen's anniversary. At this point, Jack discovers that Terry is a woman— her gender neutral name having disguised that fact—and this revelation makes him want another intermediary.[18] He relents, at her insistence (she is falling in love with him, of course), and then asks her to "be inconspicuous" at the ball. But because she realizes more than he how difficult it will be for her to fit in (and because she will be recognized from her previous visit), she chooses to be as conspicuous as possible. She dresses in a wig and red sequined dress and passes herself off as the fête's entertainment, making her way past obstacles by lip-synching to The Supremes. At another point, she eludes a confrontation with the aid of Liz (Annie Potts), a white woman she had met earlier and the wife of a spy friend of Jack's. Liz claims that Terry is her cousin— "by marriage" she adds to explain the visual incongruity. Ultimately, Terry gets access to the consulate's computer center and uses her technical skills to attach a device to the consulate's telecommunications network that will help Jack (this scene is partially lifted in *Hackers*). However, the spectacle of her presence in this setting is the main focus in this sequence; indeed, after her technological success, she catches her dress in a paper shredder, leading to an extended slapstick routine accompanied by Fontella Bass singing "Rescue Me."

Terry's blackness is the key (though not the only) element in her adventures at the consulate, crucial in what becomes an extended sight gag as she

acts out Jack's cyberspace instructions for real. And while Terry may have to bear the brunt of the physical humor, it all leads back to Jack's expectations of her based on his virtual misrecognition. While Terry does have greater access to physical "real" space in the film, Jack seems blind to the limits of her mobility. The sight gag, recognizing the intermediational misrecognition that Terry's blackness so conspicuously marks, is also a site gag. As the character through which cyberspace is diegetically integrated into filmic space, she also provides the most cinematically visual distinction between those two spaces. Yet oddly, there is little payoff to this gag in the end; or rather, it remains unspoken. Although Jack had been surprised by her gender earlier, when he does finally meet Terry in person, he is not surprised by her race. Apparently more color-blind than Nikon in *Hackers*, he never says, "I thought you were white"; he may, in fact, have thought she was black, though the consulate sequence makes this unlikely. Articulated or not, her race still emphasizes the discrepancy between the default male identity that he blindly first attributes to her and the one that we see. He is white, of course, given that the film treats Britishness as the paragon of whiteness; and any future romance between Terry and him, while possible, seems uncertain.

Terry's racial intermediation in *Jumpin' Jack Flash* is emphasized in, and indistinguishable from, Whoopi Goldberg's performance style and star power. The set pieces in the film, and the personae Terry adopts within them, recall Goldberg's early stage and comedy work, in which she created multiple characters and vignettes. This style, which mediates between characterizations and scenarios, also manifests itself in Goldberg's developing star persona. Terry, in fact, is the first of a number of "mediating" characters that Goldberg would subsequently play—the most famous being Oda Mae Brown, the phony medium who to her own surprise really channels the spirit of Patrick Swayze to Demi Moore in *Ghost* (1990). Less well-known, but more pertinent here, is her role as Vashti Blue in *The Telephone* (1988), a film recalling Jean Cocteau's 1930 play, *La voix humaine* (filmed by Rossellini in 1948). Vashti is an out-of-work actress whose existence hinges on her relationship to her telephone. In a series of single-ended dialogues (her interlocutors are neither seen nor heard), she takes on numerous performative identities, signaled most by her changes in accent. Linked to her technological dependence and her constant role switching is her confusion of fantasy and reality; it turns out that her phone has been disconnected all along, and it has actually served as the medium of her delusions.

As both Michele Wallace and Ed Guerrero have discussed, Goldberg, as her characters and as an actress/star, also functions as an intermediary

between a typically effaced black culture and a visibly dominant white one, personifying the problematic way in which the latter incorporates the former. Wallace, writing in 1989, identifies the problem this way: "Hollywood is having a difficult time coming up with a credible storyline for a black female comedian with dreadlocks, which will commodify racial 'marginality' but isn't racist enough to produce a boycott of the theatre" (219). Goldberg's blackness, in particular her hair, is too distinctive and visible for her to fit into mainstream Hollywood narratives. For Guerrero, the problem is a little different. Hollywood has been quite successful in commodifying Goldberg's marginal image, he argues, and Goldberg has fit into its narratives too well. Her role in *Jumpin' Jack Flash* (and just about anything else she's been in) typifies the situation in which "black culture is…embodied in the black star's persona and actions, surrounded and appropriated by a white context and narrative for the entertainment of a dominant or crossover audience." This practice, he continues, "amounts to dominant cinema's effective erasure of the star's identification with a black collective consciousness and sense of politics" (126–27).

While there is no denying the pervasiveness of this sort of co-optation and containment, the alternative may involve an even heavier "burden of representation," to use James Baldwin's expression (discussed later by Guerrero [189]). That is, the black star would need to convey a realer, more authentic sort of blackness, in content and context.[19] This burden may be more than Goldberg would want to bear, judging by her own provocational self-identification (or anti-identification) in her book, *Book*: "Call me an asshole, call me a blowhard, but don't call me an African American. Please. It divides us as a nation and as a people, and it kinda pisses me off." Her strangely antagonistic call for unity should not be misconstrued as a desire for a color-blind, homogeneous society; after all, she does describe herself as black as she continues her rant: "It diminishes everything I've accomplished and everything every other black person has accomplished on American soil. It means I'm not entitled to everything plain old regular Americans are entitled to" (105). Judging by this and the rest of *Book*, her desired vision of an egalitarian America is inclusionist rather than assimilationist—although the desire for one can easily mask the other. On the face of it, she advocates an American culture that fully channels black culture into the mainstream and also keeps it visible.

It is difficult to take an actor's—especially a star's—word at face value, however, even if she has a reputation for truth-telling, in-your-face honesty. What gets said signifies at too many levels, not the least being the construction and promotion of a public image. Yet Goldberg's statement also articulates a

position for herself vis-à-vis the mainstream and the marginal, a position she negotiates through her idiosyncrasies.[20] Likewise, Terry's visible eccentricities, along with her race, constitute her character and contribute to her general mediation of marginality within the mainstream, and specifically her inter-mediation of cyberspace into the dominant filmic space. Her lovable quirks compensate for any threat her blackness might convey, easing her access to the mainstream. Conversely, her blackness, as the otherness that can't help but be visible, authenticates her different, "alternative" position within the system—whether that be the system of cyberspatial communication or the system of cinematic representation.

As in all of the films I have looked at here, her blackness marks the cross-roads of those two systems. More generally, the blackness displayed in these films, along with the sense of the real that becomes attached to it, refers less to the realities of specific peoples or cultures and more to a position of identifi-able, realizable otherness—a position that reconfigures, and reinscribes, racial marginalization in order to integrate the otherness of cyberspace into the nar-rative structures of mainstream film. Blackness, in such situations, is more of a medium than a message. Or its medium is its message, one whose exact meaning is vague, though it signifies much. On the one hand, this process does signify the appropriation, commodification, and embodiment that both Wallace and Guerrero critique. On the other hand, it potentially challenges the identification of blackness with a fetishized spectacle of embodiment, thus approaching the utopian desires of the "hackers' manifesto" to abandon embodied images altogether. At the very least, it can open more channels, more possibilities for different types of black representation in popular cul-ture. But as *Hackers* (and the rest) makes manifest, Hollywood—but certainly not only Hollywood—will continue to visualize the body in order to com-modify and fetishize its appearance.

Moreover, allowing blackness to signify and be refetishized as the "real" of otherness, regardless of the ethical and progressive intentions, is as likely to restrict representations as it is to multiply them. A similar point is made by Stuart Hall when discussing tendencies in black popular culture to regard the term "'black' as sufficient in itself to guarantee the progressive character" of political action. Now mainstream culture has also become "tempted to display that signifier as a device that can purify the impure…" (131). Blackness, Hall reminds us, is never pure, never outside of representation and history. These films, in their own distorted, fantastic, co-optive, and commodified ways, reveal something about both the temptation of purity and the compromises of

representation as they intermediate cyberspace through film. As a sign of authenticity, blackness attempts to "purify" this intermediation, sometimes for the "real" against mediation, sometimes to authorize a "purer" use of technological communication against the forces that would co-opt and commodify it. It is no wonder that these are paradoxical positions to take.

Notes

I owe more than gratitude to Lisa Nakamura for her encouraging discussions about cyberspace, both online and on the phone; to all the editors for their help in improving this essay—and for their patience; to Amelie Hastie for her help in person; and to Laura Rascaroli for graciously allowing me to quote from her unpublished essay manuscript.

1. See the rest of Benedikt as well as Helsel and Roth for further theoretically foundational essays that attempt to define the visual aspirations of cyberspace while also intermediating between technical aspects of computer science and their cultural reception.
2. Lasko-Harvill (a virtual world and interface designer, formerly with VPL Research, who helped develop MicroCosm) discusses the relationship between masks and virtual reality. See Stone ("Will" and *War*), Turkle, and Nakamura for analyses of various forms of deception, masquerade, and transvestitism online related to the invisibility of a "real" interlocutor.
3. These two main methods of representing cyberspace are generally (though not always) used in consort, as pioneered by the 1982 film *TRON*. See Bukatman (especially 215–27) for an analysis of the computer-generated "potential" space of *TRON* as part of the cinematic narrative space (subverting the latter, according to him). Of course, digital visual effects are used for much more than the representation of cyberspace.
4. See Bowser 64–71, 248–49 on the role of the telephone in early film narration; the link between these two examples is partly bolstered by techno-pundit John Perry Barlow's famous claim, "Cyberspace is where you are when you're talking on the telephone" (Qtd. in Rucker, et al. 78).
5. See Shohat and Stam (41–46) for a discussion of—and more important, a critique of—"hybridity" in postcolonial (and other) discourse, done from the perspective of film studies. Here, I use the term "hybrid" to describe rather than to celebrate or stigmatize—though given the term's history, a purely neutral use is impossible.
6. Stone's analogy is worth quoting: "If the Mestiza is an illegible subject, existing quantum-like in multiple states, then participants in the electronic virtual communities of cyberspace live in the borderlands of both physical and virtual culture, like the Mestiza" ("Will" 112). She is drawing from the work of Gloria Anzaldúa.
7. Bukatman 213, 214. The "*street* religion" is quoted from *Count Zero* 91, where Gibson calls it vodou; emphasis in the original. Yet when Gibson depicts cyberspace as a site of global economic power, he invokes a techno-Orientalism (despotic and exotic) that pervades many Western narratives of new technology.
8. The film focuses mostly on music, starting with Sun Ra, Lee "Scratch" Perry, and Parliament/Funkadelic, moving to Detroit techno and, finally, jungle; it also includes interviews with writers such as Greg Tate, Ishmael Reed, and Samuel R. Delany.
9. Gates capitalizes the black vernacular practice of Signification and Signifyin(g) to distinguish the words visually from their correspondingly contrasted and "shadowed" Standard American English senses—as well as parenthesizing the "g" in the latter, to make it stand at the crossroads of the intersected signifying traditions that each sense of the word repre-

sents. In fact, he modifies his initial description of these two traditions as "parallel" to "perpendicular" to highlight this intersection (49). His capitalization could also be seen as part of his recontextualization of the vernacular sense into an academic one, placing the term at another crossroads.

10. See hooks, "Eating," especially 24–25.

11. The narrative in *Johnny Mnemonic* concerns a data courier named Johnny (Keanu Reeves), whose augmented brain is used to store information on the cure to NAS (although Johnny himself is not aware of what information he carries). He is pursued by a ruthless Japanese corporate representative and his hired assassin ("Beat" Takeshi Kitano and Denis Akiyama) who want to control and profit from the NAS cure, as well as by a demonic Teutonic "Street Priest" (Dolph Lundgren). When they free the data from Johnny's head, the LoTeks use an ex-Navy cyborg dolphin named Jones, giving their LoTek style a greenish hue as well.

12. Boyd 48. When the film was made, and even now, Ice-T was not a major star, though he would appeal to the target audience of this film. Actually, the film uses a number of stars with what could best be called "alternative" appeal: Eurotrash and Warhol cult figure Udo Kier as Ralfi; veteran punk rock singer, celebrity, and poet Henry Rollins as Spider; and ubiquitous Japanese television personality, as well as cult film auteur and star "Beat" Takeshi Kitano as Takahashi. The version released in Japan contains more scenes with Takeshi.

13. The film, which quotes more than this extract, credits this statement as "The Conscience of a Hacker" by Lloyd Blankenship. The document, in a somewhat different form, was first published in the e-zine *Phrack* under the authorial tag "The Mentor" on behalf of the hacker group the Legion of Doom. See Rucker et al. 60.

14. While the film is attentive to these differences, it completely ignores age difference, except to valorize youth—a standard prejudice in cyberdiscourse.

15. A SQUID is an instrument used to measure weak magnetic and electrical fields, and has been used to detect brain activity. The imaging device used in the film is fictitious; however, its design (by Syd Mead) visualized the acronym, making it resemble a small mechanical squid placed on top of the head.

16. Rascaroli, "Invisible," 2. She cites "Momentum and Design: Kathryn Bigelow interviewed by Gavin Smith," *Film Comment* Sept.-Oct. 1995: 55. See Rascaroli, "Steel" for more on vision in *Strange Days* in the context of Kathryn Bigelow's other films.

17. Its production troubles also contributed to its identity crisis: original director Howard Zieff was fired early on, taking the two original screenwriters with him. First-time feature director Penny Marshall was then placed at the helm, and four more writers (the ones credited) were brought on to redo the script, which was still being written during shooting (Nash and Ross 138). The supporting roles are played primarily by comic actors or comedians, such as Carol Kane, Annie Potts, Phil Hartman, Jon Lovitz, Ren Woods, and Chino "Fats" Williams. Tracy Ullman, Michael McKean, and Penny's brother Garry Marshall also make cameo appearances. Interestingly, Goldberg's next feature, *Burglar* (1987) was also originally intended for Bruce Willis (Guerrero 126).

18. What Jack had thought of Terry's seemingly feminine activities—gossiping, giving advice, and distributing recipes—is not addressed.

19. The bigger problem here is the lack of alternative forms of representations available to black stars; not just a lack of "good roles" to choose from, but a hegemonic restriction on what constitutes the options for mainstream cultural representations of blackness.

20. After all, we are in some way already dealing with the "character" Whoopi Goldberg as "performed" by Caryn Johnson (Whoopie Goldberg's birth name). And all this negotiating and positioning makes her latest role, as the center square on the new *Hollywood Squares* perhaps her most emblematic one.

References

Benedikt, Michael, ed. *Cyberspace: First Steps.* Cambridge, MA: MIT Press, 1991.

Bowser, Eileen. *The Transformation of Cinema, 1907–1915.* New York: Scribner's, 1990.

Boyd, Todd. *Am I Black Enough for You? Popular Culture from the 'Hood and Beyond.* Bloomington: Indiana University Press, 1997.

Brown, H. Rap. *Die Nigger Die!* New York: Dial, 1969.

Bukatman, Scott. *Terminal Identity: The Virtual Subject in Post-Modern Science Fiction.* Durham, NC: Duke University Press, 1993.

Gates, Henry Louis Jr. *The Signifying Monkey: A Theory of Afro-American Literary Criticism.* New York: Oxford University Press, 1988.

Ghost. Dir. Jerry Zucker. Wr. Bruce Joel Rubin. Prod. Lisa Weinstein. Howard W. Koch; Paramount (USA), 1990.

Gibson, William. *Neuromancer.* New York: Ace, 1984.

Goldberg, Whoopi. *Book.* New York: Rob Weisbach/William Morrow, 1997.

Guerrero, Edward. *Framing Blackness: the African American Image in Film.* Philadelphia: Temple University Press, 1993.

Hackers. Dir. Iain Softley. Wr. Rafael Moreu. Prod. Michael Peyser and Ralph Winter. United Artists; MGM/UA (USA), 1995.

Hall, Stuart. "What Is This 'Black' in Black Popular Culture?" in *Representing Blackness: Issues in Film and Video,* Valerie Smith, ed. New Brunswick, NJ: Rutgers University Press.

Helsel, Sandra K. and Judith Paris Roth, eds. *Virtual Reality: Theory, Practice, and Promise.* Westport, CT: Meckler, 1991.

Haraway, Donna J. *Simians, Cyborgs, and Women: The Reinvention of Nature.* New York: Routledge, 1991.

hooks, bell. "Eating the Other." *Black Looks: Race and Representation.* Boston: South End, 1992.

Johnny Mnemonic. Dir. Robert Longo. Wr. William Gibson. Prod. Don Carmody. Alliance Communications, CineVisions; TriStar (USA/Can.), 1995. Based on Gibson's story.

Jumpin' Jack Flash. Dir. Penny Marshall. Wr. David H. Franzoni, J. W. Melville, Patricia Irving, and Christopher Thompson. Prod. Lawrence Gordon and Joel Silver. Twentieth Century Fox (USA), 1986.

Lasko-Harvill, Ann. "Identity and Mask in Virtual Reality." *Discourse* 14.2 (1992): 222–34.

Last Angel of History. Dir. and wr. John Akomfrah. Prod. Lina Gopaul and Avril Johnson. Black Audio Film Collective; Channel Four (UK), 1995.

The Lawnmower Man. Dir. Brett Leonard. Wr. Brett Leonard and Gimel Everett. Prod. Gimel Everett. Allied Vision Lane Pringle, Fuji Eight; New Line (USA), 1992.

Lubiano, Wahneema. "But Compared to What? Reading, Realism, Representation, and Essentialism in *School Daze, Do the Right Thing,* and the Spike Lee Discourse," in *Representing Blackness: Issues in Film and Video,* Valerie Smith, ed. New Brunswick, NJ: Rutgers University Press.

Nakamura, Lisa. "Race in/for Cyberspace: Textual Performance and Racial Passing on the Internet." *Works and Days* 25/26 (Fall 1995 / Winter 1996): 181–93.

Nash, Jay Robert and Stanley Ralph Ross, eds. *The Motion Picture Guide, 1997 Annual.* Chicago: Cine Books, 1997.

Novak, Marcos. "Liquid Architecture in Cyberspace," in *Cyberspace: First Step,* Michael Benedikt, ed. Cambridge, MA: MIT Press, 1991.

Rascaroli, Laura. "Invisible Visions: POV, Perception, and the Self in Kathryn Bigelow's Cinema." Society for Cinema Studies Conference. San Diego, 5 April 1998. Unpublished manuscript.

———. "Steel in the Gaze: On POV and the Discourse of Vision in Kathryn Bigelow's Cinema." *Screen* 38.3 (1997): 232–46.

Rucker, Rudy, R.U. Sirius, and Queen Mu. *Mondo 2000: A User's Guide to the New Edge.* New York: HarperPerennial, 1992.

Shohat, Ella and Robert Stam. *Unthinking Eurocentricism: Multiculturalism and the Media.* London: Routledge, 1994.

Smith, Valerie, ed. *Representing Blackness: Issues in Film and Video.* New Brunswick, NJ: Rutgers University Press, 1997.

Sobchack, Vivian. "The Scene of the Screen: Envisioning Cinematic and Electronic 'Presence.'" *Materialities of Communication,* Hans Ulrich Gumbrecht and K. Ludwig Pfeiffer, eds., William Whobrey, trans. Stanford: Stanford University Press, 1994. 83–106.

Stone, Allucquère Rosanne. *The War of Desire and Technology.* Cambridge, MA: MIT Press, 1995.

———. "Will the Real Body Please Stand Up? Boundary Stories about Virtual Cultures," in *Cyberspace: First Steps,* Michael Benedikt, ed. Cambridge, MA: MIT Press, 1991.

Strange Days. Dir. Kathryn Bigelow. Wr. James Cameron and Jay Cocks. Prod. James Cameron and Steven-Charles Jaffe. Lightstorm; Twentieth Century Fox (USA), 1995.

The Telephone. Dir. Rip Torn. Wr. Harry Nilsson and Terry Southern. Prod. Robert Katz and Moctesuma Esparza. Odyssey; New World (USA), 1988.

TRON. Dir. and wr. Steven Lisberger. Lisberger-Kushner; Walt Disney (USA), 1982.

Turkle, Sherry. *Life on the Screen: Identity in the Age of the Internet.* New York: Simon and Schuster, 1995.

Virtuosity. Dir. Brett Leonard. Wr. Eric Bernt. Prod. Garry Lucchesi. Paramount (USA), 1995.

Wallace, Michele. *Invisibility Blues: From Pop to Theory.* London: Verso, 1990.

7. I'll Take My Stand in Dixie-Net

White Guys, the South, and Cyberspace

Tara McPherson

After a certain point, the subject of the public sphere must become a matter of
local investigations into particular collectivities and practices.
— Bruce Robbins, *The Phantom Public Sphere*

I. Of Neo-Confederates and Cybertheory

I do not recall *exactly* how I first stumbled upon one of the many outposts of
Dixie in cyberspace. I do know that one summer I was working on a manu-
script on race and Southern femininity in the twentieth century, and, in an
obvious (and perhaps narcissistic) ruse to avoid writing one day, I typed "tara"
into a Web search engine and started surfing sites. I visited the Tara museum
in Atlanta and several other Atlanta pages (many tied to the Olympics) and
then, with one stray click of the mouse, found myself on the doorstep of the
Confederate Embassy in Washington, D.C. Having lived the previous summer
in D.C. without ever encountering such an edifice, I was surprised to learn that
it existed as a real building in physical space in the nation's capital. Later, I
began to ponder what purpose a Confederate embassy might serve. Would I

go there to get a visa to travel to Mississippi for a conference? Perhaps I could visit it to plea on behalf of loved ones left behind in Louisiana (most of my family is still there)? At any rate, I spent many hours during the next few days following the neo-Confederate trail through cyberspace and then put these sites out of my mind.

Or so I thought. Throughout the past two years, as I read, thought, and taught about new technologies, I found myself drifting back below the virtual Mason-Dixon line, wondering how these neorebel sites might be reconciled with much of the new media theory I was reading. Such theories often maintain, in the words of Allucquère Rosanne Stone, that cyberspace functions as a kind of public theater, "a base…for…[the] cyborg" (39), suggesting that, in their play, these cyborgs are rewriting the standard of the bounded, embodied individual (43). Here, prosthetic communication enables computer users to overcome the self/body binary. Sherry Turkle likewise foregrounds cyberspace's ability "to give people the chance to express multiple…aspects of the self" making "possible the creation of an identity so fluid and multiple that it strains the limits of the notion" of identity (12). While I focus here on Turkle and Stone (whose books, in many respects, I quite like), I see their work as indicative of a larger movement within technotheory to focus on the tendency of "prosthetic living" to foster "rapid alternations of identity" in which computer users inevitably come to "cycle through different characters and genders" (Turkle, 174). In this scenario, prolonged exposure to cyberspace irrevocably produces multiple selves (or, at least more selves than one entered the Net with), though the racial identity of these "many selves" has not received much attention.

And stable, embodied identity is not the only thing transformed by cyberspace. For Turkle, "Life on the screen is also without origins and foundation" (47). Indeed, "our very rootedness to place is attenuated" (178) via virtual living, suggesting that collective as well as individual identities are uprooted when confronted by the postmodern geographies of cyberspace (though Turkle is far more interested in selves than in communities). While Turkle does briefly consider the downside to cyber-transformations of place, she generally sees this loss of rootedness as, if not positive, somehow inevitable. More utopian cybernauts like Howard Rheingold have celebrated the Internet's ability to overcome geographical boundaries, envisioning it as a kind of yellow brick road leading to a harmonious global village. Even those wary of the charms of the virtual world (like Michael Heim or Stephen Doheny-Farina) still worry about its ability to destroy one's sense of place.[1]

But the neo-Confederates guarding the portals of the Confederate embassy in cyberspace seem relatively unconcerned with the prosthetic nature of cyber-communication. Likewise, they busily continue to envision and build a very specific, if virtual, South without paying much mind to the Internet's potential to enable, in the words of Stone, "many selves to inhabit one body." Still, some of their concerns do overlap with those of contemporary cybertheory. For instance, Stone notes that the stories we tell ourselves about technologies (old or new) reveal "our deep proclivity, our deep need, to make self in the world" (83) and to "stabilize a sense of presence" in uncertain times (88). I think the work of the neo-Confederates in cyberspace reveals a very sincere attempt to make "self" in the world and to articulate a very particular (and racially natu-ralized) presence. Still, their endeavors are notably less marked by a celebration of multiplicity and of play than much of today's technotheory. For these cyber-rebels, reconstructing Dixie and its citizens is not about play at all; rather, it is a very serious battle over the demands of place, race, and identity.

Cybercommunities like those of the neo-Confederates invoke specific registers of place, yet these places, like the majority of writing about cyber-space, evade precise discussions about race or racism. Certainly race is one of the nodal points around which public discourse on the South (if not the nation) has turned throughout the twentieth century, but in the post–Civil Rights era representations of race and racism proceed via different logics than they did before the 1960s. In the first half of the century, Southern images of blackness and whiteness were often mutually interdependent, sketching the contours of whiteness (particularly white womanhood) in contrast to black-ness, if only to insist upon racial difference. (For an example of this, one need simply recall the intertwined relation of Mammy and Scarlett in Margaret Mitchell's 1936 epic *Gone With the Wind*.) By century's end, Southern racial representations are much more likely to elide race entirely or to figure white-ness as independent, as separate from blackness, particularly via a dismissal of the region's complex racial history. (In Alexandra Ripley's 1991 *Gone With the Wind* sequel, *Scarlett*, the white heroine flees to Ireland, thus skirting the issue of blackness altogether.)[2]

These two logics can be labeled "overt" versus "covert" and differ in that the former *brings together* figurations of racial difference in order to fix the categories while the latter *enacts a separation* that nonetheless achieves a sim-ilar end. Upon close examination, this separation is very much in evidence in the neo-Dixie of cyberspace, a place which is nothing if not white. This chap-ter will highlight how this "cyberwhitening" takes place via the creation of new

regional identities that refigure white Southern masculinity by borrowing from the language of the civil rights struggle. It is equally important to think through how such covert strategies might also inform our own theorizations of cyberspace.

What, for instance, does it mean to champion cyberspace as placeless or as a breeding ground for new identities when talk about race is conspicuously absent from these conversations? Rather than simply "forgetting" or "over-looking" race, these theories enable the evasion of the race question, under-writing the whiteness of cyberspace. Put differently, they revolve around and facilitate an inability to articulate the place of race and the race of place in visions of the future. Thus, when theories of the multiple-selved, unrooted inhabitants of cyberspace do not directly and explicitly engage with issues of race, racism, and racial representation, they help to construct a raceless fantasy space, free of the contradictions of life at the end of the millennium, that shares many traits with cyber-Dixie. Whether this space is filled with MUDers happily swapping gender, freed from the constraints of embodied identity and geographic origin, or neorebels dreaming of cybersecession and new visions of old places, the default setting is still all too white. Our theories of cyberspace must tackle race full on if we are to short-circuit the covert racial representa-tions which structure life in the U.S. at the end of the millennium.

Throughout the last year, when I mentioned to friends that I was doing research on neo-Confederates in cyberspace, the general reaction consisted of grimaces and inquiries about how I could stand investigating such rednecks and racists. Such an assessment is one these neorebels are fully aware of, and, as we shall see, it is an evaluation to which they try to respond. For my part, I did have to wonder why I was studying this group (beyond the recent acade-mic fascination with white trash), especially since I enjoyed sites like "The Lipstick Librarian" so much more.[3] In part, I suspect it is because their version of what is best about the South differs so radically from my own. On another level, my friends' questions highlighted for me certain issues of taste and judgement regarding academic inquiries. In what follows, I try not to reinscribe our own academic binaries and categories (progressive/reactionary, racist/nonracist) when describing these neorebels but instead attempt to understand what their virtual battles have to tell us about the self, the citizen and the public performance of white masculinity at the close of the mechanical age. In other words, what insights can an investigation into these local collec-tivities provide for our attempts at theorizing the possibilities of structuring new (and newly hued) public spheres online?

Exploring Virtual Dixie

Though I thus far have been referring to these neo-Confederates as if they were a monolithic and self-named entity, the terms "neo-Confederate" and "neorebel" are not always used on the webpages I examined, though I suspect they are titles many in the groups would embrace. I use these terms to refer to the creators and inhabitants of a fairly broad cluster of both individual- and group-authored websites, sites primarily concerned with "preserving Southern heritage." They often refer to themselves as "Southern nationalists" or as "Southrons." For the most part, these pages are designed and frequented by white men of a wide range of ages and classes, though the ages seem to cluster in the eighteen-to-thirty-year-old and the forty-five-to-sixty-year-old groups. Most are native-born Southerners as well, though a good number no longer reside within the physical borders of Dixie, and many also participate in Southern heritage groups offline. In fact, these groups have received a substantial amount of press coverage in the past few years, largely because two recent books, Peter Applebome's *Dixie Rising* and Tony Horwitz's *Confederates in the Attic*, have brought news of the neo-Confederate movement to a wide-ranging audience.

No single group or individual website embodies every aspect or member of what I call the cyber-Confederacy, but most of the pages reference a long list of links to other Confederate websites and several umbrella sites serve to introduce and catalog the variety and number of Confederate webpages that exist (I have visited well into the hundreds). Many of these are updated weekly (if not daily), and some also link to listservs and newsgroups (though not many; cyberchat does not seem to be the primary goal of many of these sites.) Three major sites, which together cover pretty much all of the cyber-Confederacy, are Dixie-net (http://www.dixienet.org), The Confederate Network (http://www.confederate.net), and The Heritage Preservation Association (http://www.hpa.org). Each of these sites contains information (or links to information) on Confederate history, reenactments, Southern merchants, and what many of the sites refer to as "heritage violations," a term that most often refers to attempts to ban or remove symbols of the Confederacy, particularly Confederate flags. Many of the sites advocate Southern separatism or nationalism, sometimes via secession.

Each of these warehouse sites also includes some type of mission statement, often in the form of a bulleted manifesto stating the group's aims. For instance, Dixie-net, the official website maintained by the Southern League (which is spearheaded by Alabama history professor Michael Hill and is in

some ways comparable to the conservative National Association of Scholars) asserts that the League's purpose is to "advance the social, economic, cultural and political independence of the Southern people by all honourable and peaceful means."[4] A fourth warehouse site, Dixieland Ring (http://www.geocities.com/BourbonStreet/2757/index.htw), addresses similar themes but stages a more inclusive appeal, defining Southernness a bit more broadly. This site does labor to reconfigure the much-heralded rhizomatic nature of cyberspace by structuring its links in a circle, creating a kind of closed mobility. The page itself proclaims that, ideally, "the [user] keeps moving forward, [and] eventually he will end up back where he started." Of course, individual visitors to the site are free to abandon the ring structure, but the physical construction of the pages encourages an orderly progression through a list of pro-Southern sites that works against the celebrated anarchy of the Internet.

During a tour of these sites, it quickly becomes obvious that they trade heavily in what might be deemed the signifiers of the Confederacy, from their frequently animated Southern flags to their structuring of a sonic Southernness via countless (and varied) renditions of "Dixie" and other Confederate battle songs. Battle itself is frequently figured as a primary frame of reference and as an originary moment, and the facts of the "war between the states" (never the Civil War; in fact, several sites ban the use of the term) constitute a large part of the historical information the sites detail. The war itself becomes the ground upon which claims to heritage are waged, though here heritage clearly functions as a universal and naturalized category which only some can lay claim to and which all "real" (read "white") Southerners would die to defend. The South's complex racial history and its relationship to the Civil War disappear as the war is rewritten in univocal terms.

Furthermore, these sites construct a phantasmagoric South via several varieties of mapping. For instance, many sites revision U.S. geography, presenting maps of the eleven states of the Confederacy floating detached and separate from the rest of the United States. The Dixienet site actually maps and literalizes the drama of secession via an animated image in which the Southern region breaks free from a map of the union and hovers inviolate (and in rebel gray) at the top of a page. This page also narrates the story of "The South as Its Own Nation," underscoring the vast demographic and economic resources of the region through a series of graphs and charts that detail the viability of the South as a separate nation. On the page, the visitor learns that "in economic power, a Southern nation composed of the eleven States would have the fourth largest gross domestic product...after the remainder of the United

States, Japan, and Germany," a precise example of the narration of nation as imagined community.

Such narratives highlight that, much like webpages, the South is still undergoing "reconstruction." They also visualize a fantasy of a new Confederacy and a virtual secession at precisely the moment that black Americans are moving to the South in greater numbers than they are leaving it for the first time since the Civil War. The carefully constructed graphs and charts of this imagined Southern nation do not offer the visitor any demographic information on the racial makeup of the South. One can only imagine that the African-American families recently relocated from Detroit or Chicago would feel none too comfortable taking up citizenship in such a Southern nation. That the neo-Confederate imagined community glosses over the heterogeneity and diversity of the actual South almost goes without saying, but it is important to highlight the elisions of these covert strategies.

Other mappings are less literal, calling upon imagery of the old South to transform the "unrooted" realms of cyberspace into particular cyberplaces that correlate to real and imagined landscapes of gentility. These cognitive mappings structure an imagined place of history and heritage by referencing the ways of the Old South. One such site is the Confederate Embassy, which first initiated me on this journey. This site presents a virtual photo album of white Southern fantasy, replete with images of modern-day dancing belles, smiling rebel gentlemen, and a luxuriant, entirely white plantation home.

To anyone familiar with Southern history, these hoopskirted images of the past, in concert with old black and white images of the Southern soldier, smack of Lost Cause sentiments. "The Lost Cause" refers to a widely-prevalent movement across the South in the late nineteenth and early twentieth centuries to "enshrine the memory of the Civil War." This included the formation of Confederate memorial associations, the celebration of Confederate Memorial Day, and the beginnings of the still-active organizations, the Sons and Daughters of the Confederacy. A crucial trope upon which Lost Cause sentiments depended was an idealized and nostalgic recasting of Southern gentility, hospitality, and manners. Today's neo-Confederates are clearly linked to this historic Lost Cause ideology, both in their defense of the memorials and statues of Confederate soldiers erected during that earlier period, and in their figurations of Southern grace and manners, suggesting that origins and foundations are not always lost in cyberspace.

I have written elsewhere about how this Southern reverence for manners functioned historically as a very particular technology of location, designed

precisely to "help" one know one's place, but this rebirth of the Lost Cause over one hundred years after its origins interests me primarily for the *differences* it displays from its original.[5] Neo-Confederate revampings of Lost Cause imagery depend heavily on their reconfiguration of two important visual registers as they rework iconic signs of both femininity and race. The Lost Cause ideology constructed a very particular figure of white Southern femininity, that of the Southern lady, and quickly installed her upon a pedestal where she served both to represent the gentility of the South and, via imagined threats to her safety, to justify a violent and prolonged attack on black masculinity. The idealized Southern lady underwrote the myth of the black male rapist and the horrors of lynching.[6]

Though crucial to the figurations of the Lost Cause at the turn of the last century, these icons have largely disappeared in the phantasmatic South the neo-Confederates have built for the new millennium, replaced as they are with a near obsession with the contours of white Southern masculinity. Several personal webpages, often created by younger white men and linked to larger clearinghouse sites like DixieNet, have names like "The Virginian Gentleman" and commit a great deal of space to delineating the Southern gentleman's finer qualities: he strives to forgo the use of power and "feels humbled himself when he cannot help humbling others." He is the descendant of the crusader and the champion of justice. But in these reconstructions, the Southern gentleman, though modeled on Lost Cause portraits of Robert E. Lee and Jefferson Davis, stands largely alone, unencumbered by the lofty version of femininity that once accompanied him.

Gone too is any overt imaging of blackness or explicit expression of racism. A concern with white masculinity and its preservation replaces representations of blackness, and almost all of the sites decry any racism, hate-mongering, or Klan or neo-Nazi activity. (Many of the webpages feature an "anti-Klan" logo, a crossed-out image of a Klansman's hood.) Often, the pages express dismay (some seemingly genuine, others less so) over the continued perceptions that protecting Southern heritage means one must be racist. Hence, these sites abandon the overt racism of the Lost Cause era for the more palatable covert racism characteristic of the post–Civil Rights era. While this turn from explicit racism can simply be an act of bad faith, understanding how covert racism works in many of these sites entails recognizing that, often, practitioners of this brand of racism (quite fervently) do not believe themselves to be racist. Labeling them and their cyberspaces "racist" does little to help us understand how they understand either whiteness or blackness. I will return to these questions shortly, but

first I want to examine how the sites deploy a doubled and particular mode of address, an address expressly structured toward a public.

At one level the sites hail fellow white rebels, enunciating a very clear address to a "you" who resembles the creators of the sites. For instance, one page opens with the promise that "preserving OUR heritage is preserving YOUR heritage." Membership pages delineate quite specifically what the "you" visiting the site must believe in (or at least agree to) in order to join the organizations. Yet, the sites are not just for consumption by like-minded individuals. Unlike, say, Confederate conventions or reenactments, these sites also stage a carefully mediated public address designed both to dissociate their actions from overtly racist causes and to educate the public on issues "of Southern civil rights."

This mode of address carefully and selectively appropriates the discursive practices of both civil rights groups and a wide-range of nationalist struggles. Thus, page after page insists on the need to reclaim history in order to end the oppression of the Southern people and offers practical tips on how to "buy Dixie" or to boycott corporations that violate Southern heritage. The Heritage Preservation Association home page labels the group "the most successful Civil Rights Organization for Southern Heritage," noting their efforts at "guarding our future by preserving our past" and inviting the viewer to "help us tip the scales of Justice for Dixie."

Sites also speak of "the cultural genocide of the Confederacy" and of campaigns of ethnic cleansing against Southerners. Several groups include links to the Homelands Page, a clearinghouse for nationalist movements worldwide. (If you visit this page from the Confederate States of America network, you are in for one of the Net's surreal juxtapositions: it is possible to view the Chiapas homepage from beneath a border extolling the benefits of Confederate secession.) Frequent comparisons are also made between the Southern independence movement and struggles in Scotland, Northern Italy, Croatia, and Quebec. While we may rightfully worry about comparisons between independence for white Southerners and the Chiapas revolutionaries, this call for a virtual Dixie does signal an attempt at reconstituting a public sphere where the finer points of citizenship and its requirements can be interrogated, debated, and lived. Though neo-Confederate organizations have existed throughout the twentieth century, these Internet communities signal a new level of awareness about public perception and battles over public spaces, and a heightened awareness of the functions of publicity. These sites understand that successful publicity now requires an evasion of questions of race and racial representation.

What I am suggesting here is that these men are fashioning a "techno-logically mediated publicness" that sustains a desire for origin and home-place. In other words, they can be seen as actively constructing what Nancy Fraser has called a "subaltern counterpublic," designed to mediate and recon-figure the boundaries between the private and public. Like other counter-publics, these men coin new languages and invest old signs (like the flag) with new meanings as they construct new access routes to the public. Fraser, of course, primarily discusses the subaltern counterpublic in terms of groups that challenge dominant ideology (her example is feminism). What does it mean that white, mostly middle-class men—the group we usually see as important players in the public sphere—feel the need to battle for alternative publics? After all, both Democrat and Republican white Southerners—from Ted Turner to Newt Gingrich to Bill Clinton—have emerged as key players on the national scene, and the neo-Confederates' own statistics indicate the South's economic growth and stability during the past few decades. Yet despite their improved economic position and the prominence of many white men from their region, these men clearly view themselves as marginalized because of their Southernness, and they actively construct spaces in which this origin can be discussed, celebrated, and protected from attacks, real or imagined.[7]

This virtual battle is being fought to defend a very specific Southern her-itage, a heritage that is undeniably white. While "whiteness" itself is rarely mentioned in these webpages, Celtic, Anglo, and European ancestry often is. Thus the Southern league proclaims it will "affirm the legacy of our precious Anglo-celtic heritage." In *White*, Richard Dyer notes that the turn to situating whiteness as ethnicity (Celtic, Polish, etc.) "tends to lead away from a consid-eration of whiteness itself" (5). Put differently, an exploration of white Southernness couched in the terms of ethnic identity is less likely to produce an understanding of the privileges whiteness confers and often functions as yet another form of covert racism. This is not to say that we shouldn't attempt to understand ethnicity's relation to whiteness but that fetishizing ethnicity is not enough. Contemporary theories of race often posit whiteness as devoid of content, as, in the words of Toni Morrison, "mute, meaningless, unfath-omable" (59). It is perhaps useful to think of these neo-Confederate appropri-ations of nationalist or civil rights struggles as precisely an attempt to give whiteness both voice and content. Without a discourse or images of blackness to delineate the contours of whiteness, these men struggle to find new ways of securing the meaning of whiteness.

Emotional defenses of the Southern flag or other Confederate symbols are closely tied to this attempt to carve out an embodied meaning for whiteness. One site included a variety of letters protesting Ole Miss's decision to ban Confederate symbols from the school's publications and sports events. Rich in sarcasm, one of the writers suggests renaming the football team (formerly the Rebels) "The Guilt" and changing the school colors to "blush red." While I was at first tempted to dismiss these letters as racist refusals to see the pain caused to many by these symbols, I recognized in this evocation of guilt a response shared by many of my white students when we study theories of whiteness or of race more generally. Many claim anger at being made to feel guilty about what they describe as a past during which they were not even alive: a response provoked as much, I think, by our theories of whiteness as by their naïveté. One of the limits of these theories is their tendency to slip between readings of whiteness as a dominant (and dominating) ideology and the various ways white people are positioned in relation to this spectrum of privilege and power. If the left is not willing to offer up a possible reading of a progressive or oppositional whiteness, conservative groups like the neo-Confederates will be happy to assign whiteness another content.

The neo-Confederate webpages replay a logic of separatism that I have elsewhere categorized as the lenticular or covert logic of post–Civil Rights discourse in the United States. Such discourses stage a new visibility for whiteness as an injured, wronged, violated whiteness and also underscore the degree to which we lack compelling narratives or theorizations of successful union (between North and South and between races).[8] This inability to think beyond separatism also permeates more "liberal" accounts of today's South. The previously mentioned popular books *Dixie Rising* and *Confederates in the Attic*, both authored by prominent, liberal journalists, offer up portraits of a still racially separate South, but they frame their tales in such a way as to suggest an equivalence between white and black separatism, overlooking the historic ways in which white separatism has been supported by state institutions and given access to and power over black bodies. In many ways, Horwitz and Applebome reinscribe the separatist attitudes about which they seem so dismayed by presenting present-day segregation as "simply the way it is," something that *all* Southerners (black and white) really want. Though these two authors hope for a South different from the South envisioned by Georgia Senator Newt Gingrich or the Southern League, the stories they provide of the South do little to challenge the vision of the neo-Confederates.[9]

Though I am clearly critical of the neo-Confederates and their narrow definition of Southern heritage as conservative, white, and mostly male, I do

think that their cyber-South expresses a real desire for some type of social or community life that is less bound by a distant and seemingly unresponsive government and more fully engaged in the local and the regional. Though their response may be to call for "states' rights" and a decrease in federal power, I wonder how the sense of dissatisfaction with public life that they express might be differently mobilized? How could we narrate other versions of Southern history and place that are not bleached to a blinding whiteness? Richard Dyer writes of the need to make whiteness strange in order to reveal its limits and its constructedness. One way to achieve this in relation to Southern culture would be to continue to tell the stories of those "eccentric" and brave Southerners, white and black, who have struggled to build a different South less seeped in the sentiments of the Lost Cause. Such stories could appeal to many Southerners who perceive their region to be marginalized without replaying the covert racial politics that neo-Confederate sites so often deploy.

I imagine websites that reclaim Southern heritage for progressive causes by reminding us of other Southern sons and daughters, including the likes of Katharine DuPre Lumpkin, Angela Davis, Martin Luther King Jr. and Morris Dees. Such sites would offer alternatives to the webpages of the neo-Confederates, reflecting a more diverse South and redefining Southern heritage. They could also point the way beyond the binary poles of covert and overt racial logics. If overt racial representation brings together black and white in order to privilege whiteness, and covert strategies repress difference to the same end, what seems necessary is an overt representation of racial difference and *its interconnections* that explores the interrelation of this difference without privileging either term. We cannot understand or learn from the South's racial history by repressing it any more than we can champion the identity-shifting potential of cyberspace without studying its racial contours.[10]

Some Final Thoughts

Beyond suggesting new ways for thinking through and negotiating the demands of white identity, I think virtual Dixie also suggests the limits of conceptualizing cyberspace as both freed from place and origin and as a "playground for nontraumatic multiplicity." Both proponents and critics of online community and culture have noted the Internet's ability to free us from physical spaces, propelling us into, alternately, freer virtual spaces or bottomless abysses of placelessness, but the constructions of the cyberrebels illustrate the

ways in which virtual life serves instead to forge new (and reactionary) relations to precise geophysical spaces.

If these virtual rebels are not willing to abandon the physical South in pursuit of virtual glory, neither do they seem very interested in experimenting with the hybridity of the self. Rather, the neo-Confederates are reformulating identity politics for the cyberrealm, intent on the construction of a fairly unified cybersubject. And he's not playing. The theories of multiplicity we have used to describe identity formation in cyberspace often rely on MUDs and game playing in sketching their models of community and identity, but such models make it hard to envision how other subaltern publics might be formulating more fixed identities via the Web, reconstructing "the old South, the new South, and the future South" as a fairly traditional and static place. They also evade questions of racial representation in cyberspace, suggesting that in the identity-swapping realms of the cyber, one identity is the same as the next. While I am as happy to engage in prosthetic communication as the next girl, I wonder what we might gain from shifting our theories of cyberspace away from tropes of "play," "multiplicity," and "theater" toward explorations of "citizens," "politics," and "publics." We might just find our way toward a Southern cybercitizen less bound by the nostalgic racial politics of Dixie and toward new theories of cyberspace less trapped in the covert racial representations that seem all too familiar today.

Notes

1. Howard Rheingold has recently become a vocal critic of the commercialization of the Internet, a development that has certainly dampened his early utopian portraits of cybercommunity. Accounts such as Doheny-Farina's also tend to suggest that Internet users leave behind their sense of history when entering the Web. He writes that virtual communities "encourage us to ignore, forget, or become blind to our sense of...place and community" as we cast off the cumbersome weight of our past lives. My examination of the neo-Confederates illustrates that the past is very much with them as they traverse cyberspace.

2. The different strategies of racial representation utilized in *Gone With the Wind* and its sequel, *Scarlett*, are further explored in my essay, "Seeing in Black and White: Gender and Racial Visibility from *Gone With the Wind* to *Scarlett*."

3. See for example, the anthology *White Trash*, edited by Matt Wray and Annalee Newitz. This recent academic turn to studying whiteness has been met with an understandable skepticism by some within the academy. Richard Dyer notes that, while it is crucial that we "come to see whiteness" (8), it is also important that our investigations of whiteness not become yet another excuse to do what we white folks have done all along, that is, talk and think only about ourselves.

4. Michael Hill has been a vocal defender of Southern nationalism and has been profiled in academic publications like *The Chronicle of Higher Education*. He describes the politics of

the group as "paleoconservative" and claims that the organization's membership is "well over four figures" (*Chronicle* A9).

5. I discuss the ways in which Southern etiquette most often worked in the service of power and also examine multiple ways in which the tropes of the old South are reworked for the present day in my *Reconstructing Dixie: Race, Place and Femininity in the Deep South*.

6. Excellent discussions of the race and gender dynamics of Southern lynching campaigns can be found in the work of Angela Davis and Jacquelyn Dowd Hall.

7. As noted earlier, many of my academic peers grimace when I describe this research project, noting their distaste for "rednecks." This reaction does suggest that the neo-Confederate perception of "anti-Southern" attitudes is not entirely imagined. To view white Southerners as inherently and irredeemably racist is about as insightful as arguing that the Civil War had nothing to do with race.

8. A lenticular image is the type of image found on what are often called "3-D" postcards, composed of two separate but interlaced images. The very structure of the card makes it almost impossible to view the two images together, enforcing a structural separatism. For more on this trope, see my *Reconstructing Dixie*.

9. It is only fair to note that, while I here draw an equivalence between the goals of the neo-Confederates and the writings of Horwitz and Applebome, neither the journalists nor the neorebels would be happy with that equation. In fact, both authors have been denounced as Yankee scalawags by the neo-Confederates, and, in an interesting interview, the Pulitizer-prize winning Horwitz comments that the neocon's "continuing sense of aggrievement and of being put down is at odds with the reality of Southern life" now that the South "is the most economically vibrant part of the country" (24). Still, neither journalist successfully imagines what a harmoniously multiracial South might look like, and neither pays much attention to historical or contemporary figures who are struggling toward such a vision.

10. As much as I think we have to learn from the neo-Confederate websites, it seems unlikely that many of these sites could accommodate this wider view of the South as racially diverse. Overt references to blackness would destabilize the carefully naturalized (i.e., white) universality of "Southern heritage" that the sites construct. What I am suggesting is that there are many ways to define Southern heritage and that we need sites that narrate these other origin stories. One might, for instance, begin with sites like those of the Southern Poverty Law Center or the Griffith IN CONTEXT project currently underway at Georgia Tech.

References

Applebome, Peter. *Dixie Rising: How the South is Shaping American Values, Politics, and Culture.* New York: Harcourt, Brace and Company, 1996.

Davis, Angela. *Women, Race and Class.* New York: Vintage Books, 1981.

Dyer, Richard. *White.* New York: Routledge, 1997.

Doheny-Farina, Stephen. *The Wired Neighborhood.* New Haven, CT: Yale University Press, 1996.

Fraser, Nancy. "Rethinking the Public Sphere: A Contribution to the Critique of Actually Existing Democracy," in *The Phantom Public Sphere*, Bruce Robbins, ed. Minneapolis: University of Minnesota Press, 1993.

Hall, Jacquelyn Dowd. *Revolt Against Chivalry: Jessie Daniel Ames and the Women's Campaign Against Lynching.* New York: Columbia University Press, 1974.

Heim, Michael. *The Metaphysics of Virtual Reality.* New York: Oxford University Press, 1993.

Hornburg, Mark W. "Tony Horwitz's Civil Wargasm: An Interview." *The North Carolina Review of Books*, Summer 1998, 8.

Horwitz, Tony. *Confederates in the Attic: Dispatches from an Unfinished Civil War*. New York: Pantheon Books, 1998.

McPherson, Tara. *Reconstructing Dixie: Race, Place, and Femininity in the Deep South*. Durham, NC: Duke University Press, forthcoming.

———. "Seeing in Black and White: Gender and Racial Visibility from *Gone With the Wind* to *Scarlett*," in *Hop on Pop: The Politics and Pleasures of Popular Culture*, Henry Jenkins, Tara McPherson, and Jane Shattuc, eds. Durham, NC: Duke University Press, forthcoming.

Mitchell, Margaret. *Gone With the Wind*. New York: Macmillan, 1936.

Newitz, Annalee and Matt Wray, ed. *White Trash: Race and Class in America*. New York: Routledge, 1996.

Rheingold, Howard. *The Virtual Community: Homesteading on the Electronic Frontier*. Reading, MA: Addison-Wesley, 1993.

Ripley, Alexandra. *Scarlett*. New York: Warner Books, 1991.

Robbins, Bruce, ed. *The Phantom Public Sphere*. Minneapolis: University of Minnesota Press, 1993.

Shea, Christopher. "Defending Dixie: Scholars in the Southern League Want To Resurrect the Ideals of the Old South." *The Chronicle of Higher Education*, 42.11 (1995): A9.

Stone, Roseanne Allucquere. *The War of Desire and Technology at the Close of the Mechanical Age*. Cambridge, MA: MIT Press, 1995.

Turkle, Sherry. *Life on the Screen: Identity in the Age of the Internet*. New York: Simon and Schuster, 1995.

8. Margins in the Wires

Looking for Race, Gender, and Sexuality in the Blacksburg Electronic Village

David Silver

The residents of Blacksburg, Virginia are wired. Over 70 percent of the town's residents congregate, communicate, and consume using the town's unique community network, the Blacksburg Electronic Village (or, as it is commonly referred to, the BEV). They come together in mailing lists, local Usenet newsgroups, and chat rooms to discuss issues both local and global. They go online to browse through the minutes of last week's city council meeting, to check which films are playing at the local theaters, and to e-mail the city to discontinue public services when they go on vacation. And with a simple point-and-click, they order a dozen roses from Wade's Flower Shop, check the weekly seafood specials at Bogen's, and download two-for-one bowling coupons for Triangle Lanes.

For obvious reasons, a number of commercial interests—including Internet service providers, telecommunications businesses, and online shopping startup companies—have kept a close watch on the BEV. Likewise, government agencies, eager to find cost-effective and convenient ways to distribute and collect information, have also followed with great interest the development and use of the BEV. Strangely, however, few scholars have paid close attention to the BEV and similar community networks.

For cyberculturalists interested in the ways in which marginality is manifested online, the BEV is a digital goldmine. Unlike virtual communities, which are based largely on users' shared *interests*, community networks such as the BEV are based on users' shared *locations*. Therefore, if the BEV claims (and it does) to be the online community for Blacksburg, one would expect a community network as culturally diverse as the town, which, in large part due to the presence of Virginia Tech, is very diverse indeed. Unlike the more anonymous cyberspace described and theorized by such cyberculturalists as Howard Rheingold, Allucquère Rosanne Stone, and Sherry Turkle, and celebrated by the (in)famous television commercial for MCI ("There is no race, there are no genders...there are only minds."), the BEV attempts to bring together a very real population of users who have very real races, ethnicities, genders, and sexual orientations.

This chapter explores the existence, manifestation, and possibilities of race, gender, and sexuality within the wires of the Blacksburg Electronic Village. This exploration is divided into three sections. First, I offer a review of the literature regarding marginality online. How have scholars approached and theorized issues of race, gender, and sexuality on and within the Internet? How does the digital architecture of an online environment influence or help to determine the kinds of cultural exchanges and interactions that take place? Next, I provide a brief history of the BEV. Who built the network? What kinds of recruitment strategies were taken to encourage participation within the network? Third, I offer an in-depth content analysis of the community network's design and offerings. How is cultural diversity represented within the network? What kinds of discussions and forums are privileged within the network's devoted listservs? Are issues of race, gender, and sexuality routed around or brought to the front?

I. Margins in the Wires: A Brief Review of the Literature

There is no race. There is no gender. There is no age. There are no infirmities. There are only minds. Utopia? No, Internet.

—"Anthem," television commercial for MCI

In the last five years, many academic and popular presses have published a number of monographs, edited volumes, and anthologies devoted to the growing field of cyberculture. During the same time period, several academic journals have addressed the topic in the form of individual articles and/or spe-

cial issues.[2] Yet while scholars from across the disciplines flock to the general topic of cyberculture, few have made their way into the margins to explore issues of race, ethnicity, and sexuality online. Although significant work in the field of online gender exists, one finds little published work on the topic of race and cyberspace and even less on sexuality and the Internet. Furthermore, when such work does appear, it usually focuses solely on issues of access. Seldom does it tackle more social and cultural dimensions.

One step in the right direction is Lisa Nakamura's influential essay, "Race In/For Cyberspace: Identity Tourism and Racial Passing on the Internet," an analysis of the ways in which race is written within the popular MUD, LambdaMOO. She notes that while users are required to specify their genders, there is no such option for race: "Race is not only not a required choice, it is not even on the menu" (444). Instead, the formation of racial identity is limited to the selection of already-established characters. Focusing specifically on Asian identity formation, Nakamura notes that the vast majority of such characters—Mr. Sulu, Bruce Lee, Little Dragon, and Akira, for example—fall within familiar discourses of racial stereotyping: "The Orientalized male persona, complete with sword, confirms the idea of the male Oriental as potent, antique, exotic, and anachronistic" (445).

In addition to the technologically determined barriers to diverse identity formation discussed by Nakamura, there are other, more social ones. In his brief essay "The Virtual Barrio @ the Other Frontier (or The Chicano Interneta)," performance artist and writer Guillermo Gómez-Peña recounts his and his collaborator Roberto Sifuentes' 1994 entrance into cyberspace, a digital frontier already largely settled by ethnocentrism:

> We were also perplexed by the "benign (not naive) ethnocentrism" permeating the debates around art and digital technology. The unquestioned lingua franca was of course English, "the official language of international communications"; the vocabulary utilized in these discussions was hyper-specialized and depoliticized; and if Chicanos and Mexicans didn't participate enough in the Net, it was solely because of lack of information or interest (not money or access), or again because we were "culturally unfit." The unspoken assumption was that our true interests were grassroots (by grassroots I mean the streets), representational or oral (as if these concerns couldn't exist in virtual space). In other words, we were to remain dancing salsa, painting murals, writing flamboyant love poetry, and plotting revolutions in rowdy cafes (178).

Along similar lines, Cameron Bailey, in his article "Virtual Skin: Articulating Race in Cyberspace," argues that shared customs such as Netiquette and acronyms constitute "newbie snobbery," producing an unwelcoming terrain for marginalized cultures. He notes, "The Net nation deploys shared knowledge and language to unite against outsiders: Net jargon extends beyond technical language to acronyms both benign (BTW, 'By the way') and snippy (RTFM, 'Read the fucking manual'). It includes neologisms, text-graphical hybrids called emoticons, and a thoroughgoing anti-'newbie' snobbery. Like any other community, it uses language to erect barriers to membership" (38).

While scholars such as Nakamura, Gómez-Peña, and Bailey examine the technological, social, and linguistic barriers to a diversely populated Internet, other cyberculturalists explore marginalized cultural groups' attempts to establish self-defined, self-determined virtual spaces. In "Virtual Commonality: Looking for India on the Internet," Ananda Mitra analyzes the discursive practices of contributors to the Usenet newsgroup soc.culture.indian. While acknowledging strong "segmenting forces," especially when users crosspost messages to soc.culture.pakistan, Mitra argues that the online community generates "centralizing tendencies" for Indian users. He notes that "these diasporic people, geographically displaced and distributed across large areas, are gaining access to CMC [computer-mediated communication] technologies and are increasingly using these technologies to re-create a sense of virtual community through a rediscovery of their commonality" (58). Similarly, David Shaw, in "Gay Men and Computer Communication: A Discourse of Sex and Identity in Cyberspace," argues that gay-themed Internet Relay Chats (IRCs) provide healthy spaces for dialogue, discussion, and discovery for gay users. He notes: "for the gay men participating in CMC, the virtual experiences of IRC and real-life experience share a symbiotic relationship; that is, relationships formed within the exterior gay community lead the users to the interior CMC gay community, where they, in turn, develop new relationships which are nurtured and developed outside the bounds of CMC" (143).

Self-definition and self-determination constitute the core of Systers, a mailing list of women in computer science and related disciplines. As many scholars, including Stephanie Brail, Maureen Ebben and Cheris Kramarae, Kira Hall, Susan Herring, and H. Jeanie Taylor have noted, males tend to dominate online discussions, regardless of the topic. As L. Jean Camp recounts in "We Are Geeks, and We Are Not Guys: The Systers Mailing List," Systers was established in response to male-dominated discussions about women taking place in Usenet newsgroups like soc.women. The solution was to "withdraw to

a room of our own—to mailing lists" (115). Able to control and moderate the list, members of Systers discuss the issues most relevant to them.

While soc.culture.indian, gay-themed IRCs, and Systers provide healthy and robust online discussion spaces for marginalized cultures, they are not, of course, the only spheres within which such discussions arise. Indeed, diverse exchanges often occur within not-so-diverse online spaces. In "Approaching the Radical Other: The Discursive Culture of Cyberhate," Susan Zickmund explores the digital domain of far-right online communities like alt.skinhead, alt.politics.nationalism.white, and alt.politics.whitepower. Well aware of the violent, racist, and misogynist discussions that take place, Zickmund argues for the importance of outsiders within the group. While the author is quick to note how such actions often provide group members with a clear target to attack, thereby strengthening internal cohesion, she also values such interactions and the "ideological dialectics" they create. Similarly, Camp stresses the need for members of Systers to travel beyond the safe contours of the list: "The very strength that Systers offers can make it a sanctuary on a hostile net. But we cannot live in a sanctuary, regardless of the temptation. It is important to go back out into the public debate and remain visible, if for not any other reason than to ensure that no woman is left truly isolated" (121).

The issues of access, discursive communities, and insider/outsider dynamics come together in an article on one of the first community networks in the world, Santa Monica's Public Electronic Networking system, or PEN. In her article "Gender Representation in an Electronic City Hall: Female Adoption of Santa Monica's PEN System," Lori A. Collins-Jarvis examines the reasons behind the relatively high (30 percent) female ratio of PEN users. Significantly, Collins-Jarvis offers three answers: PEN's public terminals, the availability of socially and politically related discussions and forums related to female interests, and the ability of females to take part in the network's design and implementation.

According to Collins-Jarvis, female users of PEN not only needed access to get involved, they also needed a reason to participate: "[C]omputing systems which appeal to women's norms and interests (e.g., by providing a channel to enact participatory political norms) can indeed increase female adoption rates" (61). Further, when faced with often hostile flaming and a dearth of "women-specific" forums, female users of PEN assumed the responsibility of reinventing rather than rejecting the network. This reinvention took the form of creating a number of conference topics and user groups devoted specifically to issues of their own.

While brief, this review of published literature offers a number of impor-
tant considerations and questions to keep in mind as we turn our attention to
the BEV. First, as Nakamura notes, many online environments contain tech-
nological barriers that *route around race*. Further, as Gómez-Peña and Bailey
argue, digital domains are often socially constructed in a manner that mar-
ginalizes users of color and, by extension, other cultural groups that do not
possess a historical involvement with advanced technologies. Do such barriers,
we must ask, exist within the BEV? Second, as Mitra, Shaw, and Camp note,
feelings of online marginality can be challenged by establishing self-defined,
self-determined online communities. Such forums can engender community
formation, relevant discussion, public debate of once-private matters, and
increased comfort and familiarity with new technologies. Does the BEV pro-
vide similar forums? This is not, of course, to suggest that such communities
should replace involvement in larger, more broad online spheres. As both
Zickmund and Camp argue, dialogic interventions within mainstream and
even hostile online environments can be both effective and engaging. Do such
interactions occur within the BEV? If so, what happens when they do? And
finally, as noted by Collins-Jarvis, to insure diverse online participation, virtual
spaces must be technologically accessible, socially relevant, and subject to rein-
vention by the most diverse of users.

II. A Brief History of the Blacksburg Electronic Village

> From the start, the Blacksburg Electronic Village was promoted as a people
> project, not a technology project.
>
> —Cortney Martin, former assistant director,
> Blacksburg Electronic Village

Throughout the 1990s, Internet applications have exploded in dozens of
directions. One of the fastest growing areas is community networks. In the
simplest terms, community networks incorporate Internet technologies to
connect residents of a specific place—a town, a city, or a municipality—with
one another and with local institutions, services, and businesses. For exam-
ple, the Boulder Community Network was established to connect the resi-
dents, institutions, and businesses of Boulder, Colorado, just as the
Blacksburg Electronic Village attempts to wire the residents of Blacksburg,
Virginia. While virtual communities such as listservs, mailing lists, news-
groups, bulletin boards, IRCs, MUDs, and MOOs are constituted by mem-

bers' shared *interests*, community networks are based on members' shared *location*. Although community networks vary significantly in form, they are similar in function. As Steve Cisler notes in his online essay "Community Computer Networks: Building Electronic Greenbelts," the "key word is local. They [community networks] provide electronic mail and discussion groups for local users. Local civic groups and local businesses provide information from the town or region in which the system is located such as…job opportunities, city or county legislation and regulations, calendar of events, school lunch menus, homework help lines."

One of the earliest community networks is the BEV. As I've noted elsewhere (Silver 1999), the origins of the BEV are found in a particularly wired university campus.[3] In 1987, long before the Web, Yahoo!, and Jennicam, Virginia Tech invested $16 million to construct a campus-wide telecommunications system which, when completed, effectively placed a 19,200 baud modem on the desk of every Virginia Tech student, faculty, and staff member.[4] By 1993, the network became so popular that students living off campus approached Virginia Tech administrators about providing online access from home. Soon after, university officials struck a deal with the Bell Atlantic Company of Virginia and the town of Blacksburg to build a true community network.

Working primarily with ISDN lines and Ethernet, Bell Atlantic immediately set out to "wire the city." They installed internal wiring in approximately 450 individual apartment units, providing occupants with a T1 line to link directly to the network. Further, they connected the Blacksburg Public Library with high speed network connections. In all, Bell Atlantic invested $7 million in building the infrastructure of the BEV, while Virginia Tech took on the task of developing and managing the network. Essentially serving as project manager, the university designed the network, maintained its servers, packaged software and user support information, and handled user registration.

Finally, in addition to Bell Atlantic and Virginia Tech, the town of Blacksburg contributed significantly to the network's development and accessibility. They began by establishing off-campus connection fees of $8.60 a month, a relatively inexpensive rate for unlimited Net access. Next, they assembled a series of free workshops, seminars, and lectures tailored towards the needs and interests of Blacksburg residents, classrooms, and community groups. Further, the town of Blacksburg served as the project's chief publicist and published *About Town*, a print and online newsletter charting the progress and possibilities of the BEV.

It was not until late 1994, however, that the network began to take off. At that time, the town of Blacksburg began its three-phased plan to increase community participation in the BEV. As Andrea L. Kavanaugh and Andrew Michael Cohill note in "Conducting Business in a Community Network," the first phase was a concerted effort to put government-related information online. This included directories of Blacksburg boards, commissions, and town officials, extensive transportation guides, emergency response documents, and the agendas and minutes for a number of government meetings. The second phase began in spring of 1995 and included providing online access to various civic services and setting up channels through which citizens could communicate with the town council. This process allowed citizens to use the network to request police reports and vacation monitors, to reserve picnic shelters and camping grounds, and to notify the Department of Public Works of a dead animal or the need of a special pickup. Further, it allowed citizens to send their ideas and opinions regarding civic plans and ordinances to town officials via e-mail.

The third phase occurred in the summer of 1995. In an attempt to "spur the development of new business services offerings," the town of Blacksburg offered grants of up to $500 to local businesses interested in establishing World Wide Web sites. Significantly, in order to qualify, both the business being advertised and the Web service provider/consultant had to be local, thereby promoting local, "in house" Web development. Faced with over seventy applications, the town of Blacksburg awarded forty-seven grants, totaling approximately $15,000.

In addition to the town's three-phased plan to increase community involvement, the BEV introduced Community Connections (http://www.bburg.bev.net/civic) in the spring of 1998. For a small annual fee, local non-profit groups and organizations can apply for a Community Connection. This includes a private mailing list or listserv for up to one hundred subscribers, 2.5 megabytes of storage space for the group or organization's website, and two flexible, devoted e-mail accounts for administrative purposes. Since its inception, nine groups, including the Newcomer's Club, the Blacksburg High School Band, and the Blacksburg Christian Fellowship, have signed up for such accounts.

As one of the earliest community networks in the world, the BEV was guaranteed its share of publicity. Yet a strategic combination of community outreach, early recruitment of businesses, and the "wiredness" of Virginia Tech and its students produced national fame. During the spring of 1995 alone, the

Philadelphia Inquirer called Blacksburg "perhaps America's most wired municipality" (Farragher D1), the *Los Angeles Times* described Blacksburg as "the most connected town in the world" (Harrison A4), and the *Washington Post* noted emphatically that Blacksburg is "without a doubt, the most computer-connected place, per capita, on the planet" (Chandrasekaran A1).

III. Looking for Margins within the Interface

> What we're re-creating is the old village square where people get together with their neighbors.
>
> Andrew Cohill, project director, Blacksburg Electronic Village

In the 1989 film *Field of Dreams*, Ray Kinsella (played by Kevin Costner) is driven by a voice—"If you build it, he will come"—to construct a baseball diamond in an Iowa cornfield. In Kinsella's case, "he" meant Shoeless Joe Jackson as well as seven other baseball players banned from the game for throwing the 1919 World Series. Substituting the residents of Blacksburg for Shoeless Joe Jackson and his gang, the designers of the BEV sought to adopt a similar ethos when developing their community network. In other words, instead of designing the network to privilege particular interactions, discussions, and dialogues, the BEV's designers built the network and let the users determine the course of the community.

This is not to suggest that the developers of the BEV entered the project without clearly defined goals. Indeed, they had two: to foster an electronic town square and to develop an online shopping mall. As noted in the June 1995 Vision Statement (http://www.bev.net/project/vision95/Goals.html), "the goal of the project is to enhance the quality of people's lives by electronically linking the residents of the community to one another." Besides being linked to one another, BEV users are linked to Blacksburg institutions such as the local government, community service groups, schools, the public library, and businesses. According to BEV developers, this integration between communication, community, and (online) contact constitutes an electronic town square.

The second major goal of the BEV is to develop the Village Mall, an online shopping mall. As mentioned in the Vision Statement, "in essence, the Blacksburg Electronic Village offers companies interested in 21st century information services an opportunity to test new products and delivery mechanisms in a real-life community laboratory prior to their large-scale introduc-

tion." Thus, the Village Mall is an integral part of the BEV, both as an online mall for BEV users and Blacksburg businesses and as a "real-life community laboratory" for telecommunication developers and Internet investors. As John Knapp Jr., a spokesman for Bell Atlantic, notes, the "Blacksburg Electronic Village has proven to be and will continue to be a test bed of services that will be demanded by customers in the future" (Farragher A1).

With these two goals in mind, I now turn to the site itself (http://www.bev.net) in order to look for online elements of race, gender, and sexuality. The deep and sprawling BEV site offers three different opportunities for user communications and community-building: interactive websites, informational websites, and discussion groups. The first of these is contained under the site's "Education" (http://www.bev.net/education) and "Community" (http://www.bev.net/community) wings. Here, users can virtually visit Blacksburg Middle School and view student-constructed projects or browse through the online catalog of the Blacksburg branch of the Montgomery-Floyd Regional Library. They can also get a voyeuristic glimpse into Virginia Tech's Cyberschool, a collection of online courses, syllabi, lecture notes, and student projects.

Similarly, the "Community" wing—divided into four sections: Arts and Entertainment, Organizations and Clubs, Religion, and Sports—offers a number of rich websites with which users can interact. In addition to browsing through online exhibitions featuring local artists, BEV users can visit the websites of over thirty individual artists, download digital reproductions of those artists' works, and inquire about the work's location, history, and price. They can also go online to look for religious communities: among the over thirty local institutions with a virtual presence on the BEV are the Blacksburg Baptist Church, the Blacksburg Jewish Community Center, the Islamic Center of Blacksburg, and the Mennonite Church. Finally, the "Community" wing offers an extensive listing of websites for locally-based organizations and clubs. The listing ranges from general interests and health to volunteer groups and agencies and includes, among others, Blacksburg Area Darters; Kiwanis Club of Montgomery County-Blacksburg; the American Red Cross, Montgomery County Chapter ("make your donation appointment online!"); and the Virginia Special Olympics.

Interestingly, the one link that could be safely considered "alternative," the Alliance of Lesbian and Gay Organizations of Western Virginia, is dead. It is unclear whether this is the fault of a downed server on the part of the Alliance or an incorrect hyperlink on the part of the BEV. What is clear, however, is that

the community listings are not as diligently updated and edited as those found in the online shopping mall, a point I will return to later.

Significantly, communities—geographic and online—are defined not only by who and what are included but also by who and what are excluded. Although the designers of the BEV allot online space for communities revolving around Blacksburg art, sports, and religion, they *route around* communities based on the more volatile issues of race, gender, and sexuality. As mentioned above, the link to the Alliance of Lesbian and Gay Organizations of Western Virginia is dead, and there are no links whatsoever to race- or gender-based communities of any kind. Similar to the absence of race in LambdaMOO, the lack of race-, gender-, and sexuality-based communities within the BEV helps to code its participants as the digital default: white, male, and heterosexual.

In addition to the BEV's interactive websites, informational websites contribute to both online and physical community building. Under the "Government" section (http://www.bev.net/government), for example, there is a listing of local, regional, and federal civic and political institutions. A number of federal resources—a link to the White House, to the United States Postal Service, and to various branches of the Armed Forces, for instance— are preceded by state sites which, in turn, are preceded by local institutions. In this manner, local sites and resources are privileged over federal and more global ones.

What kinds of community building do such resources provide? A quick click to the Montgomery County Home Page offers a brief history of the region, a description of its geography and recreational offerings, and various employment opportunities. More important, the site provides up-to-date minutes for the Board of Supervisors meetings. Using a free software program called Adobe Acrobat Reader, interested visitors can download the minutes and send comments and suggestions directly to the County Administrator.

The "Health" wing (http://www.bev.net/health) of the BEV is designed similarly to the "Government" section and also attempts to facilitate community building on both an online and physical level. Thus, local (or local chapters of national) support groups such as Emotions Anonymous and the New River Valley Celiac Disease Support Group have established informational websites. Likewise, under the BEV Cardiac HealthWeb, a campus-community collaboration dedicated to the promotion of cardiovascular health in the New River Valley, visitors will find extensive resources, including "Dr. Wilder's Cardiology Database."

Significantly, the lines between community and consumption often blur within the BEV. For example, on a page devoted to health-related facilities and organizations, links to the Public Health Department and the Free Clinic of the New River Valley are placed side-by-side to the Weight Club, a commercial fitness gym. Likewise, a page entitled "Health Professionals" serves as an online Yellow Pages for private, Blacksburg-based practices.

Discussion groups (http://www.bev.net/news) are a third technique used to facilitate community-building within the BEV. The groups take two forms: local Usenet newsgroups and e-mail-based mailing lists. In all, there are fourteen newsgroups and four mailing lists. They include:

Discussions about Blacksburg:
- bburg.announce—announcements of Blacksburg events;
- bburg.general—general talk about Blacksburg;
- bburg.business—information about businesses in Blacksburg;
- bburg.config—configuration of Blacksburg Usenet groups;
- bburg.environment—environmental issues;
- bburg.forsale—items for sale, wanted to buy, exchange, etc.;
- bburg.k12—discussion of K-12 education;

Discussions about BEV:
- bburg.bev.announce—announcements of BEV events;
- bburg.bev.general—general discussion about BEV;
- bburg.bev.questions—questions about software, using the net;
- bburg.bev.volunteers—discussion of BEV volunteer activities;

Special Interest Groups
- bburg.auto.repairs—getting auto repairs in the area;
- bburg.hobbies.brewing—the art of zymurgy;
- bburg.sports.general—discussions of local sports teams;

BEV Mailing Lists (e-mail):
- BBURG-L—Blacksburg topics;
- BEV-NEWS—the BEV Project - past, present, future;
- BEV-SENIORS—for local senior citizens;
- NEWCOMERS-L—Blacksburg Newcomers Club members.

Although a comprehensive discussion of the newsgroups and mailing lists begs for an ethnographic investigation, an approach briefly touched upon later in this chapter, it is important to record a few cursory observations. First, it is interesting to note that a third of the lists are devoted to discussions regarding

technical questions and the network itself. This seems to contradict the observation of Cortney Martin, the former assistant director of the BEV, who, in an essay titled "Managing Information in a Community Network," notes, "From the start, the Blacksburg Electronic Village was promoted as a people project, not a technology project" (235). Moreover, three of the lists are devoted to business or commercial activities.

Second, it is disconcerting to note that none of the remaining nine newsgroups and lists revolve around issues of race, gender, or sexuality. Although the developers included a forum for senior citizens, BEV-SENIORS, they did not do the same for, say, African Americans or women, which begs the question: where are bev-diversity, bburg.gender, and bburg.bev.questions.sexuality? Significantly, when special interests are included within the BEV, they revolve more around hobby-oriented discussions such as brewing beer and local sports teams than they do around more politically charged issues such as gender and race.

This absence, I believe, is telling. Similar to the lack of links to race-, gender-, and sexuality-based sites within the Community pages, the absence of discussion groups based on the traditional cultural identifiers of race, gender, and sexuality does not necessarily reflect racism, sexism, and homophobia, but rather signals a missed opportunity to foster a more diverse community network. Unlike Santa Monica's PEN, which actively recruits and encourages participation from marginalized residents, the designers of the BEV try their best to route around such marginality.

This is not, of course, to suggest that more political discussions cannot take place in less-than-political online spheres. Such an argument would suggest a dangerously limited notion of public spheres, a limitation that scholars such as L. Jean Camp, Nancy Fraser, and Susan Zickmund warn us not to accept. A brief look at a particularly volatile thread that took place throughout June and July of 1998 in bburg.general reveals that serious yet problematic political debate is indeed alive and kicking in the BEV.

The thread got started, as so many do, with a particularly offensive subject line: "ugly female in treasurer's office." The poster, Jeff,[5] couched a perfectly understandable rant against a day of bureaucracy in the town's Treasurer's office with pointed hostility at the manager, a "red-dressed fat bleached blonde," whom Jeff believed lied to him. Soon, governmental bureaucracy took second stage to the manager: "I was halfway back to Blacksburg when I remembered an adage cruel but often true: 'never trust a fat person', and I will add 'especially not one so layered in makeup.'" Finally, Jeff concludes, "I nominate the short fat bleached blonde red-dressed manager for BIg TwitCHing Ugly Female Person of the Day."

An interesting onslaught ensued. One poster called for Jeff's immediate expulsion from the BEV: "Opinion is one thing, but blantant [*sic*] attacks on someone here in bburg.general are uncalled for. As I say when I send off spam complaints, 'Please terminate this user (and disable his account while you are at it).'" Another poster hand-delivered Jeff's rant to the Treasurer's office and noted: "I hope all your [Jeff's] taxes are paid up to date." Various posters called Jeff's message "garbage" and "pretty offensive stuff" and Jeff was labeled "an asshole" and "a vitriolic village idiot."

The word "sexist," however, never appeared. Instead, Jeff got even more offensive:

> I have it from a seemingly reliable source that the ugly woman, Miss Piggy, has referred the matter of her fatness and ugliness to the Commonwealth's Attorney. Of course it goes w/o saying, that she has probably failed to render to him her account of how she lied. I would like to suggest to her, so my little communications-go-between can relay it to her again, that she go on a diet, get a face lift, and best of all quit being a bitch about her public duties. That will get her much more results than whimpering about someone's reaction to her perfidity [*sic*].

At this point, the discourse shifted. One poster, Tim, argued that Jeff's language violated U.S. Internet Accepted Use Policy, thereby establishing grounds for Jeff's expulsion. Tim signed his message, "Tim, annoyed electronic citizen of bburg.general/bburg-l." Another poster, Greg, in a message with a subject line "let's reflect on the 'censorship mob,'" replied:

> [Tim], why don't you, and all the other self-appointed Gatekeepers of Public Speech (e.g., Ms. xxxx) who have been trying so vigorously and self-righteously to "silence" Mr. xxxx from participating in this public forum just take a little "quiet time" and reflect on things a bit? I was having a discussion with someone the other day: they were claiming that in THIS country it was not possible that we could ever have the kinds of attacks on civil liberties that occurred in the axis countries during WW2. I disagreed, and in my opinion the comments seen from you and the others in the "censorship mob" that has formed on this newsgroup-list over the past few weeks provide compelling evidence in support of my position.

The result: a long, arduous, and, in many ways, predictable thread debating the importance and limitations of free speech on the Internet, the merits and perils

of online censorship, and the familiar technolibertarian rants that inevitably populate so many online discussions. No postings regarding sexual harassment, sexist speech, or the use of the word *bitch* appeared throughout the thread. Within two months and dozens of postings, the word *sexism* never appeared.

One can argue that the developers of the BEV are not responsible for "ugly female in treasurer's office" messages and the threads they produce. Indeed, through the BEV–as–*Field of Dreams* lens, the developers merely built the field, leaving the playing of the game up to the residents of Blacksburg. Who are they to determine who plays the game and how it is played?

Yet I wish to argue the opposite. It is clear that the developers of the BEV have worked hard to foster *particular kinds of* diversity within the network. By offering Blacksburg senior citizens a series of ongoing workshops, a prominent Web presence, and a devoted listserv (BEV-SENIORS), developers of the BEV have succeeded in fostering active and engaged participation on the part of the town's older residents. Likewise, through a series of projects with local K-12 schools and libraries, they have been able to bring younger users within the digital fold. Finally, by working closely with Virginia Tech, the developers have succeeded in getting university students involved. In other words, with respect to age, the BEV's population is extremely diverse, an element that can and should be credited to the developers of the BEV.

The same can be said for commercial diversity. The Village Mall (http://www.bev.net/mall/cat.html) is populated by large, nationwide chains and local, independently owned shops. In other words, the website for Subway appears alongside that for Wade's Grocery; Kinko's is nestled next to Katie's Custom Clocks. While much of this scenario can be attributed to the growing Internet budgets of chain companies and restaurants, it is also a product of the nearly $15,000 of grants awarded to local businesses. Clearly the investment paid off. Currently, the Village Mall contains nearly as many pages as *the rest of the entire BEV site*. Further, unlike the pages found under the Community wing, the Village Mall enjoys continuous attention and diligent online editing. Indeed, the developers of the BEV sought and succeeded in building a healthy and robust Village Mall.

The same, however, cannot be said for the more common and much more controversial issues of diversity: race, gender, and sexuality. While the developers of the BEV do an admirable job of reaching out to one historically marginalized cultural group, senior citizens, they do not take similar measures towards others. Indeed, in many ways, especially within the Community pages and discussion groups, issues of race, gender, and sexuality are not only ignored, but rather

routed around. Such absences speak volumes. They also beg a number of "what if?" questions. What kinds of discussions would occur if the network included bburg.diversity? What kind of participation would a wing devoted to women and gender issues promote? And how much use (or abuse?) would an online resource center devoted to sexuality and sexual orientation receive? Unfortunately, these questions cannot be answered, for such forums do not exist.

As community networks continue to grow throughout the world, their developers and participants must set aside the popular myth that race, gender, and sexuality are magically nonexistent online. Indeed, to insure diverse community networks they must not only acknowledge the presence of users' races, genders, and sexualities, but also build that presence directly into the network.

Notes

The author wishes to thank John Caughey for his useful prodding and helpful suggestions.

1. See, for example, Lynn Cherny and Elizabeth Reba Weise, editors, *Wired_Women: Gender and New Realities in Cyberspace*; Steven G. Jones, editor, *CyberSociety: Computer-Mediated Communication and Community, Virtual Culture: Identity and Communication in Cybersociety*, and *CyberSociety 2.0: Revisiting CMC and Community*; William J. Mitchell, *City of Bits: Space, Place, and the Infobahn*; David Porter, editor, *Internet Culture*; Allucquere Rosanne Stone, *The War of Desire and Technology at the Close of the Mechanical Age*; and Sherry Turkle, *Life on the Screen: Identity in the Age of the Internet.*
2. While dozens of journals address various aspects of cyberculture, several lead the way. These include *Information Society, Journal of Communication Inquiry,* and *Critical Studies in Mass Communication*, as well as the online, peer-reviewed journal, *Journal of Computer-Mediated Communication* (http://jcmc.huji.ac.il/).
3. For a more extensive history of the BEV, see Andrew Michael Cohill and Andrea Lee Kavanaugh, editors, *Community Networks: Lessons from Blacksburg, Virginia,* and David Silver, "Parameters and Priorities: The Formation of Communities in the Blacksburg Electronic Village."
4. Jennicam (http://www.jennicam.org) is the brainchild of Jennifer Ringley, one of the newest members of the growing rank of "Net celebrities." Combining a self-imposed online paparazzi with an updated cyber-version of Hitchcock's *Rear Window*, Ringley has set up a camera in her Washington, DC apartment that snaps her picture every day, 24 hours a day, and then transmits it onto her website. While guests can receive a new image every thirty minutes for free, paying customers receive updated images every three minutes.
5. All names have been changed.

References

Bailey, Cameron. "Virtual Skin: Articulating Race in Cyberspace," in *Immersed in Technology: Art and Virtual Environments*, Mary Anne Moser, ed. Cambridge, MA: MIT Press, 1996. 29-49.

Bowden, Philip (Theta), Earving Blythe, and Andrew Cohill. "A Brief History of the Blacksburg Electronic Village." *Community Networks: Lessons from Blacksburg, Virginia*, Andrew Michael Cohill and Andrea Lee Kavanaugh, eds. Norwood, MA: Artech House, 1997.

Brail, Stephanie. "The Price of Admission: Harassment and Free Speech in the Wild, Wild West," in *Wired_Women: Gender and New Realities in Cyberspace*, Lynn Cherny and Elizabeth Reba Weise, eds. Seattle: Seal Press, 1996.

Camp, L. Jean. "We Are Geeks, and We Are Not Guys: The Systers Mailing List," in *Wired_Women: Gender and New Realities in Cyberspace*, Lynn Cherny and Elizabeth Reba Weise, eds. Seattle: Seal Press, 1996.

Chandrasekaran, Rajiv. "In Virginia, a Virtual Community Tries Plugging Into Itself." *Washington Post,* 11 April 1995, A1.

Cisler, Steve. "Community Computer Networks: Building Electronic Greenbelts." 1994. Online. http://www.sims.berkeley.edu/impact/s94/speakers/cisler/cisler-talk.html.

Cohill, Andrew Michael, and Andrea Lee Kavanaugh, eds. *Community Networks: Lessons from Blacksburg, Virginia.* Norwood, MA: Artech House, 1997.

Collins-Jarvis, Lori A. "Gender Representation in an Electronic City Hall: Female Adoption of Santa Monica's PEN System." *Journal of Broadcasting & Electronic Media* 37:1 (Winter 1993): 49–66.

Ebben, Maureen and Cheris Kramarae. "Women and Information Technologies: Creating a Cyberspace of Our Own," in *Women, Information Technology, and Scholarship*, H. Jeannie Taylor, Cheris Kramarae, and Maureen Ebben, eds. Urbana, IL: Women, Information Technology, and Scholarship Colloquium, 1993.

Farragher, Thomas. "Electronic Village, U.S.A." *San Jose Mercury News,* 1 May 1995, A1.

_____. "In Blacksburg, Va., There's No Wired Place Like Home." *Philadelphia Inquirer,* 14 May 1995, D1.

Fraser, Nancy. "Rethinking the Public Sphere: A Contribution to the Critique of Actually Existing Democracy," in *Habermas and the Public Sphere*, Craig Calhoun, ed. Cambridge, MA: MIT Press, 1992.

Gómez-Peña, Guillermo. "The Virtual Barrio @ the Other Frontier (or The Chicano Interneta)," in *Clicking In: Hot Links to a Digital Culture*, Lynn Hershman Leeson, ed. Seattle: Bay Press, 1996. A considerably altered version of this essay is available online at: http://www.telefonica.es/fat/egomez.html.

Hall, Kira. "Cyberfeminism," in *Computer-Mediated Communication: Linguistic, Social and Cross-Cultural Perspectives*, Susan C. Herring, ed. Amsterdam: John Benjamins, 1996.

Harrison, Eric. "Virtual Village Opens Up Alternate Reality for Townspeople." *Los Angeles Times,* 16 May 1995, A4.

Herring, Susan. "Posting in a Different Voice: Gender and Ethics in CMC," in *Philosophical Perspectives on Computer-Mediated Communication*, Charles Ess, ed. Albany: State University of New York Press, 1996.

———. "Two Variants of an Electronic Message Schema," in *Computer-Mediated Communication: Linguistic, Social and Cross-Cultural Perspectives*, Susan C. Herring, ed. Amsterdam: John Benjamins, 1996.

Kavanaugh, Andrea L. and Andrew Michael Cohill. "Conducting Business in a Community Network," in *Community Networks: Lessons from Blacksburg, Virginia*, Andrew Michael Cohill and Andrea Lee Kavanaugh, eds. Norwood, MA: Artech House, 1997.

Kramarae, Cheris and H. Jeanie Taylor. "Women and Men on Electronic Networks: A Conversation or a Monologue," in *Women, Information Technology, and Scholarship*, Jeannie Taylor, Cheris Kramarae, and Maureen Ebben, eds. Urbana, IL: Women, Information Technology, and Scholarship Colloquium, 1993.

Martin, Cortney V. "Managing Information in a Community Network," in *Community Networks: Lessons from Blacksburg, Virginia*, Andrew Michael Cohill and Andrea Lee Kavanaugh, eds. Norwood, MA: Artech House, 1997.

Mitra, Ananda. "Virtual Commonality: Looking for India on the Internet," in *Virtual Culture: Identity and Communication in Cybersociety*, Steven G. Jones, ed. London: Sage, 1997.

Nakamura, Lisa. "Race In/For Cyberspace: Identity Tourism and Racial Passing on the Internet," in *CyberReader*, 2nd ed. Victor J. Vitanza, ed. Boston, MA: Allyn and Bacon, 1999. This essay first appeared in the journal *Works and Days* 13.1-2 (1995): 181–93. It is is also available online at: http://www.iup.edu/en/workdays/Nakamura.html.

Rheingold, Howard. *The Virtual Community: Homesteading on the Electronic Frontier*. Reading, MA: Addison-Wesley, 1993.

Shaw, David F. "Gay Men and Computer Communication: A Discourse of Sex and Identity in Cyberspace," in *Virtual Culture: Identity & Communication in Cybersociety*, Steven G. Jones, ed. London: Sage, 1997.

Silver, David. "Localizing the Global Village: Lessons from the Blacksburg Electronic Village," in *The Global Village: Dead or Alive?* Ray B. Browne and Marshall W. Fishwick, eds. Bowling Green, OH: Popular Press, 1999.

_____. *Parameters and Priorities: The Formation of Communities in the Blacksburg Electronic Village*. Unpublished M.A. thesis, University of Maryland, 1996.

Stone, Allucquère Rosanne. "Will the Real Body Please Stand Up? Boundary Stories About Virtual Cultures," in *Cyberspace: First Steps*, Michael Benedikt, ed. Cambridge, MA: MIT Press, 1991.

_____. *The War of Desire and Technology at the Close of the Mechanical Age*. Cambridge, MA: MIT Press, 1995.

Turkle, Sherry. *Life on the Screen: Identity in the Age of the Internet*. New York: Simon & Schuster, 1995.

Zickmund, Susan. "Approaching the Radical Other: The Discursive Culture of Cyberhate," in *Virtual Culture: Identity & Communication in Cybersociety*, Steven G. Jones, ed. London: Sage, 1997.

9. Language, Identity, and the Internet

Mark Warschauer

I ka 'ōlelo no ka 'ola, i ka 'ōlelo ke make.
In language there is life, in language there is death.

—Ancient Hawaiian proverb

Language has always played an important role in the formation and expression of identity. The role of language and dialect in identity construction is becoming even more central in the postmodern era, as other traditional markers of identity, including race, are being destabilized. In this chapter, I will first explore the relationship of language to race and identity in the age of information. I will then examine the particular role that language plays in cyberspace. Finally, I will illustrate these issues by examining the experiences of native Hawaiians' use of the Internet as a tool for promoting language revitalization.

Language and Identity in the Age of Information[1]

The informational revolution that has begun in the last several decades, accompanied by the process of international economic and media integration known as globalization, has acted as a battering ram against traditional cor-

nerstones of social authority and meaning. Throughout the world, shifts of economic and political power have weakened the role of the state, new forms of industrial organization have decreased the possibilities for long-term stable employment, and women's entry into the workforce has shaken up the traditional patriarchal family. The political, economic, cultural, and social shifts that are occurring in the wake of the informational revolution are almost as profound, and far more compressed, than those that occurred as a result of the first industrial revolution some two hundred years ago.

But every action brings a reaction. The last quarter century has also witnessed a worldwide surge of movements of collective identity that challenge globalization and cosmopolitanism on behalf of people's control over their culture and their lives. These differ from earlier social movements, which in many parts of the world were based on struggles of organized workers. As Alan Touraine explains, "In a post-industrial society, in which cultural services have replaced material goods at the core of production, *it is the defense of the subject, in its personality and its culture, against the logic of apparatuses and markets, that replaces the idea of class struggle*" (Touraine, 1994, emphasis in original).[2] Manuel Castells (1996) further explains the central role of identity:

> In a world of global flows of wealth, power, and images, the search for identity, collective or individual, ascribed or constructed, becomes the fundamental source of social meaning. This is not a new trend, since identity, and particularly religious and ethnic identity, have been at the roots of meaning since the dawn of human society. Yet identity is becoming the main, and sometimes the only, source of meaning in a historical period characterized by widespread destructuring of organizations, delegitimation of institutions, fading away of major social movements, and ephemeral cultural expressions. People increasingly organize their meaning not around what they do but on the basis of what they are (3).

Within this situation, the dynamics of race and ethnicity are also altered. On the one hand, race and ethnicity matter as much as ever as a source of oppression. On the other hand, as globalization and economic change blur traditional racial and ethnic boundaries, race and ethnicity increasingly intersect with other identity markers, related to religion, nationality, gender, and language in stimulating social struggle (Appiah and Gates, 1995). This is illustrated by an analysis of ethnic politics in the United States.

Ever since the institutionalization of slavery brought about the racialization of society in the sixteenth century, the principal divide within American

society has been between black and white. African-American identity was forged through a collective history of racism and Jim Crow, and expressed in music, literature, and social struggle. European immigrants, whether indentured servants or wealthy industrialists, were socialized within a generation or two into the "white race." Native Americans, Mexicans, and immigrants from Latin America, the Caribbean, and Asia were socialized as nonwhite, with their inclusion in that category enforced through antimiscegenation laws.

The last thirty years, however, have witnessed a major reshaping of this dynamic. The success of the civil rights movement and affirmative action programs has allowed an African-American middle class to emerge and make significant inroads into economic and political power structures. At the same time, changes wrought by the informational economy—such as the transference of low-skill manufacturing jobs from the U.S. to developed countries—have severely worsened the social and economic conditions of the majority of African Americans by every conceivable measure (West 1993). The failure of the civil rights movement to improve the lot of most African Americans, and the increasing gap between the black "talented tenth" and a large "underclass" have weakened black racial unity and caused many blacks to seek out other identities. Whereas the black struggles of yesterday were symbolized by the 1965 March on Washington—with its powerful call for racial equality—the black struggles of today are symbolized by the 1996 Million Man March, with its strong religious, nationalist, and gender-based character (which caused it to be opposed by many established civil rights groups).

Within this new mix of black politics, the role of language and dialect has emerged as a critical issue. The dialect spoken by many African Americans, Black English Vernacular (also called Black English, African-American English, African-American English Vernacular, or Ebonics) has existed for centuries, but has apparently diverged in recent decades from Standard American English due to increased racial and economic segregation and cultural resistance in the ghetto (Labov and Harris 1986). Yet the African-American community is bitterly divided over the significance of the black dialect. This is witnessed by the controversy over the Oakland School Board's 1996 resolution on Ebonics, which asserted that African Americans faced educational discrimination stemming not only from their race, but also from their language. The resolution was immediately attacked by prominent African American leaders such as Jesse Jackson, Maya Angelou, and Kweisi Mfume. Whereas the Oakland School Board chose to emphasize the linguistic differences between blacks and whites, these spokespersons from the black "talented

tenth" chose to reject the language of the ghetto and emphasize the unity of (middle-class) blacks and whites in speaking Standard American English.

The U.S. racial dynamic has been transformed not only by changing identity politics among blacks, but also by shifting immigration patterns. The large number of immigrants from Latin America and Asia, as well as the relatively high intermarriage rates between those immigrants and whites, has further blurred the U.S. color line. In recent years, the number of Latin Americans has surpassed that of blacks. Contrary to earlier expectations, quasi-racial ethnic identities such as "Chicano" or "Latino" have not taken strong hold, with Latin American immigrants divided by class, nationality, and race. To the extent that a U.S. Hispanic identity has emerged (or that national identities such as Mexican/Mexican American have been preserved), it is once again largely due to language, with Latin American immigrants united by their use of either Spanish or "Spanglish." Paralleling and even overshadowing the controversy over Ebonics, the main political struggle that emerged in 1998 in California was over bilingual education. This struggle emerged not only between Hispanics and whites, but also within the Hispanic community. While the majority of Hispanic groups and voters supported the initiative, a substantial minority did not. Apparently, a Spanish-language-based identity remains important for a certain section of Latin American immigrants, while a faith in English immersion as a vehicle to American middle-class life overrides that identity for others.

While the above examples are drawn from the United States, the infusion of language into ethnic struggles is by no means a local phenomenon. South African students' battle to learn English rather than Afrikaans helped carry forward the antiapartheid movement and, a few years later, speakers of Zulu launched a counterrevolution in Natal province. Canadians deal with separatist movements from both French speakers in Quebec and Native American groups who seek to revitalize their languages. Lithuanians, Latvians, and Estonians broke away from the Soviet Union and made language a central component of citizenship only to face revolt from the Russian speakers in their midst. Yugoslavs who previously spoke a single language, Serbo-Croatian, divided into Croats and Serbs who formed new identities based in part on their efforts to forge two distinct languages, Croatian (with a roman alphabet) and Serbian (with a Cyrillic alphabet). Catalans work to build a language-based nation within a nation, while small numbers of Basque speakers wage armed struggle for independence. Speakers of Maori, Hawaiian, Navajo, Mohave, Quechua, and Gaelic work to revive their languages as a way of pre-

serving their culture. And throughout the world, from France to Hong Kong to Malaysia to Kenya, movements have arisen to defend national languages against the encroachment of global English.

It is not surprising that language and dialect have assumed such a critical role in identity formation. The process of becoming a member of a community has always been realized in large measure by acquiring knowledge of the functions, social distribution, and interpretation of language (Ochs and Shieffelin). In most of the world, the ability to speak two or more languages or dialects is a given, and language choice by minority groups becomes "a symbol of ethnic relations as well as a means of communication" (Heller 1982, 308). In the current era, language signifies historical and social boundaries that are less arbitrary than territory and more discriminating (but less exclusive) than race or ethnicity. As Castells (1997) notes,

> If nationalism is, most often, a reaction against a threatened autonomous identity, then, in a world submitted to culture homogenization by the ideology of modernization and the power of global media, language, the direct expression of culture, becomes the trench of cultural resistance, the last bastion of self-control, the refuge of identifiable meaning (52).

Language-as-identity also intersects well with the nature of subjectivity in today's world. Identity in the postmodern era has been found to be multiple, dynamic, and conflictual, based not on a permanent sense of self but rather the choices that individuals make in different circumstances over time (Henriquez et al. 1984; Schecter, Sharken-Taboada, and Bayley, in press; Weedon 1987). Language, though deeply rooted in personal and social history, allows a greater flexibility than race and ethnicity, with a person able to consciously or unconsciously express dual identities by the linguistic choices they make—even in a single sentence (e.g., through code-switching; see Blom and Gumperz 1972). Through choices of language and dialect, people constantly make and remake who they are. A Yugoslav becomes a Croatian, a Soviet becomes a Lithuanian, and an American emphasizes his African-American linguistic and cultural heritage.

Language in Cyberspace

If language is becoming an increasingly important identity marker in the age of information, what then is the role of language in cyberspace? On the one hand, the Internet highlights the role of language while simultaneously mask-

ing the role of other identity markers such as race, gender, or class. As the saying goes, nobody on the Internet knows that you're a dog, nor can they easily determine if you're black or white, male or female, gay or straight, or rich or poor. But they can immediately notice what language and dialect you are using—and that language is usually English. As of 1996, some 82 percent of the webpages in the world were in English (Cyberspeech), and most of the early nationally oriented Internet newsgroups (e.g., soc.culture.punjabi) conducted their discussions in English as well (Graddol 1997).

This state of affairs causes great consternation for many people around the world, whose concerns are well expressed by Anatoly Voronov, director of the Russian Internet service provider, Glasnet:

> It is just incredible when I hear people talking about how open the Web is. It is the ultimate act of intellectual colonialism. The product comes from America so we either must adapt to English or stop using it. That is the right of any business. But if you are talking about a technology that is supposed to open the world to hundreds of millions of people you are joking. This just makes the world into new sorts of haves and have nots. (cited in Crystal 1997, 108)

The early dominance of English on the Internet was due to several factors. First, a high percentage of early users were North Americans. Second, the computer scientists who designed personal computers and the Internet did so on the basis of the American Standard Code for Information Interchange (ASCII) Code, which made computing in other alphabets or character sets inconvenient or impossible. Finally, at a more basic level, by bringing together users in many countries, the Internet has furthered the need for people to communicate in an international lingua franca and strengthened the position of English in that role ("The Coming Global Tongue" 1996).

As it turns out, though, the fears of an English-dominated Internet were premature. Recent analysis indicates that the number of non-English websites is growing rapidly and that many of the more newly active Internet newsgroups (e.g., soc.culture.vietnamese) extensively use the national language (Graddol 1997, 61). Indeed, by one account the proportion of English in computer-based communication is expected to fall from its high of 80 percent to approximately 40% within the next decade (Graddol 1997).

Underlying this change of direction is a more general shift from *globalization* to *relocalization*. The first wave of globalization—whether in economics or in media—witnessed vertical control from international centers, as witnessed

for example by the rise of media giants such as CNN and MTV. But in more recent waves, a process of relocalization is occurring, as corporations seek to maximize their market share by shaping their products for local conditions. Thus, while CNN and MTV originally broadcast around the world in English, they are now producing editions in Hindi, Spanish, and other languages in order to compete with other international and regional media outlets.

A similar process is occurring with the Internet, although via a more spontaneous and bottom-up process. Whereas more than 90 percent of the early users of the Internet were located in North America, the Net is now growing fastest in developing countries; in China and India alone, Internet access is expected to multiply fifteen-fold over a two-year period to reach 5.5 million users by 2002. In response to this situation, Web browsers are being adapted for an increasing number of languages and character sets. Thus, while Internet users around the world still must use English for global communication, today they are increasingly turning to their own language to reach websites or join discussions in their own country or region.

This process is furthered by an important feature of the Internet, which is its multichannel capacity. While producing a bilingual television show or newspaper raises costs dramatically, producing a website in two or more languages is relatively simple and inexpensive. This allows the Web to support English as an international lingua franca while simultaneously facilitating the use of other languages, including languages spoken by small numbers of people. Indeed, speakers of a number of languages—from the Maori in New Zealand to the Navajo in North America—have already started to make use of the Internet's capacity to connect isolated groups of small numbers of speakers and to allow low-cost archiving and publishing as a way to promote language maintenance and revitalization (Benton 1996; Bernard 1992; Office of Technology Assessment 1995).

In summary, the Internet is on the one hand a highly restrictive medium, based on the cost of access to computers and connections as well as its historical domination by a white, well-to-do, English-speaking North American community. On the other hand, the Internet is potentially the most democratic media yet developed, in that it places powers for broadcasting, research, and interaction into the hands of greater numbers of people than ever before. Because of this basic contradiction, the Internet can both magnify existing inequalities in society while also facilitating efforts to challenge these inequalities. This is certainly seen in relation to race, where unequal access to information technology is an important factor in heightening the economic divide between whites and blacks (Castells 1998; Novak, Hoffman and Project 2000

Vanderbilt University 1998), yet at the same time, well-crafted educational programs that take advantage of telecommunications have become an important element of antiracist curricula (Cummins and Sayers).

A similar situation exists in regard to language. Until now, the Internet has been thoroughly dominated by English. Demographic factors are starting to weaken this domination, while language rights activists throughout the globe are finding ways to use the net to defend and promote minority languages.

The Internet and Hawaiian Language Revitalization

One of the most developed cases of the use of the Internet to preserve and strengthen an indigenous language has occurred in Hawai'i. This example is also illustrative of the complex interrelationship between language, ethnicity, and race addressed earlier in this chapter. For this reason, I will discuss this case in depth, beginning with an introduction to language and race issues in Hawai'i, and then discussing data from an ethnographic study about Internet use in a Hawaiian language program.

Hawai'i is an excellent example of the demographic process of globalization, with high degrees of influx and intermarriage among people of European, Polynesian, and Asian descent. Together with smaller numbers of African Americans and Latin Americans, Hawai'i is one of the most ethnically diverse places in the world. The first U.S. state with a majority nonwhite population, Hawai'i represents the demographic future of the rest of the United States. With expanding Asian and Latin American immigration combined with interracial marriage, first California and then other states will eventually reflect the sort of multiracial ethnic blend now present in Hawai'i.

When people have ancestors of two or three "races" and several nationalities, it is natural that other factors besides race become important in constructing identity and meaning. In Hawai'i, language and dialect are critical factors. This takes place in two ways. First, there is a strong demarcation between those who have "local" origins and values, no matter what their race or identity, and those identified as coming from outside the Hawaiian islands. The most important identity marker of "locals" is the ability to speak Hawaiian Creole English (HCE), more commonly referred to as Pidgin (Sato). HCE grew out of the language of communication between plantation owners and workers in Hawai'i, and soon became the native language of the children of those workers. Though its vocabulary is largely based on English, its syntax, intonation, and some of its vocabulary all reflect Hawaiian language influences

(and perhaps origins; see Roberts). Though HCE has converged with standard English over the course of the twentieth century, it remains a markedly distinct dialect with strong sociocultural connotations. For example, a white person who speaks HCE will be viewed as a local; a white person who speaks Standard English will be viewed as a *haole* ("outsider" in Hawaiian). Many locals have the same love-hate relationship that African Americans have with Black English Vernacular: they use it enthusiastically as a mark of group identity, but feel uneasy about it not really being "correct" English.

A second important marker of identity in Hawai'i is *ka 'ōlelo Hawai'i*, the native Hawaiian language. Hawaiian is a Polynesian language in the same family as Maori and Tahitian. It was the national language of Hawai'i until the sovereign Hawaiian kingdom was violently toppled by American colonists in 1893. The Hawaiian language was forcibly repressed for some eighty years, resulting in its near complete extinction.

By the 1970s, "pure" Native Hawaiians had been reduced to about 2 percent of the population. Native Hawaiians of mixed ancestry constituted some 20 percent of the population, and were generally found in dire social and economic circumstances. Globalized economic development led first to the monopolization and then to the downfall of the agricultural economy on which Hawaiians had long sustained themselves. The development of long-distance communication and transportation systems, especially the jet aircraft, led to the transformation of the Hawaiian economy from agriculture to tourism, relegating most Hawaiians as little more than "exotic" tourist attractions in an economy dominated by major U.S. corporations (Kent 1982). Then, in the 1970s and 1980s, Japanese capital flowed into Hawai'i, drastically effecting real estate values and taxes and making small-scale farming or home ownership increasingly impractical for all but the wealthy.

In these circumstances, Hawaiians organized to defend their culture, land, and values. A Hawaiian identity movement emerged in the 1970s, parallel to similar movements for minority and indigenous rights which developed elsewhere in North America and throughout the world (Wilson 1998). The Hawaiian movement was active on several fronts, from a political struggle for land and sovereignty to a cultural revival of Hawaiian traditions such as hula, oral chanting, and canoeing. But within this array of efforts, language revitalization has played a key role. Hawaiian activists were able to overturn legal bans on teaching Hawaiian, make Hawaiian an official language of the state together with English, and achieve the creation of a group of Hawaiian immersion elementary and secondary schools within the Department of Education.

These schools were launched in 1987 and have recently graduated the first high school class educated in the Hawaiian language in nearly a century.

The impact of the Hawaiian language revitalization movement extends far beyond the few thousand people who speak or are learning Hawaiian. As of twenty years ago, only a few hundred people, mostly elderly and dying, spoke the Hawaiian language. By successfully reviving the language and preventing its extinction, the revitalization movement has sent a powerful signal that the Hawaiian language, culture, and people are alive and are an important force to be reckoned with on the archipelago. This has served as a stimulus not only for the twenty percent of the population that is of part Hawaiian ancestry, but for politically progressive people of all races and nationalities in Hawai'i who seek to control the islands' development for local needs rather than for the needs of transnational corporations.

For the past two centuries, Hawaiian leaders have proven to be pioneers at making use of Western technology to serve Hawaiian ends. Printing presses were brought to Hawai'i by missionaries in the nineteenth century to propagate the Bible. Hawaiians made use of the presses to establish more than one hundred different Hawaiian language newspapers and by the end of the century Hawaiian-language literacy rates were among the highest in the world (Schütz 1994).

Today, Hawaiians are similarly trying to take advantage of the Internet for language propagation. In 1994, Hawaiian educators established Leokī (Powerful Voice), a graphic bulletin board system entirely in the Hawaiian language. The system has been installed on computers throughout the immersion school system and includes components for electronic mail, live chat, public and private conferences, announcements, dictionaries, and an online newspaper.

In colleges and universities, where the Leokī system is not yet universally installed, Hawaiian educators are making use of other software and Internet tools such as Daedalus Interchange, electronic mail, and the World Wide Web to connect students of Hawaiian language with each other and with the broader community.

From 1996 to 1998, I conducted an ethnographic study of the uses of online technologies in the Hawaiian language revitalization effort (Warschauer 1998, 1999). I observed classrooms and interviewed parents, administrators, teachers, and students throughout the state of Hawai'i, focusing in particular on one computer-intensive Hawaiian language class at the University of Hawai'i, "Hawaiian 201." Thirteen of the fourteen students in Hawaiian 201 were Native Hawaiians, as was the teacher, and Hawaiian-

language computer-mediated communication—including real-time discussions via Daedalus Interchange, an e-mail exchange with a Hawaiian class at a community college, and the development of Hawaiian language webpages—was a central part of the course.

Through the study, I found that interacting in cyberspace in the Hawaiian language provided students an opportunity to explore and strengthen their sense of individual and collective Hawaiian identity. This seemed to be due to several factors.

First, it gave the multiracial students in the class an opportunity to fully engage in their Hawaiian selves. An excellent example of this is seen in Onaona, a female student in her early twenties.[3] Onaona, of mostly European ancestry, was aware that she had one Hawaiian great-grandparent, but this did not have a profound effect on her early life. Like many people in Hawai'i, she chose Japanese as a foreign language in high school due to its occupational value as a language of communication with Japanese tourists to the islands. Yet, as she told me, she "began to hate [studying Japanese] because it wasn't something I could relate to in terms of heritage or nationality."

As a university student, she switched to Hawaiian language classes, but she found that her fair skin and European features made it difficult for her to present herself as a Hawaiian and she was sometimes challenged by other students when she attempted to do so. In the class I observed, she was quite shy and didn't interact much in face-to-face discussion with other students. She participated much more freely, however, in the computer-mediated discussions and, like the other students, did so entirely in the Hawaiian language.

It was in the webpage research and publishing project, however, that she really shone. Each of the students in the course was to conduct research on a topic of relevance to Hawaiian life and culture and create a webpage on it. The pages would then be linked in a class website. In the first semester of the course, Onaona created a very attractive and nicely written webpage on the life of one of Hawai'i's last princesses. In the following semester, she produced a web page on the history and nature of Hawai'i Creole English (Pidgin), including sound files and sophisticated graphics. Both webpages were entirely in Hawaiian.

Her Web work allowed her to project herself as a Hawaiian not only online, but "in real life" as well. She explained to me that she showed her webpages to her friends at work, even though they couldn't read it, as a way of signaling to them the importance of Hawaiian language in her life and in the life of the Hawaiian people.

Onaona's excitement about communication in Hawaiian in the online realm far exceeded her earlier enthusiasm for spoken Hawaiian, in part because it allowed her to overcome her shyness, in part because it allowed her to try out a new image, but most important because it allowed her to combine her growing enthusiasm for Hawaiian with the creative expression facilitated by the Internet. By the end of her year in the Hawaiian language classes, she changed her major to education and decided to become a Hawaiian immersion teacher and dedicate her career to Hawaiian-language revitalization.

Onaona's case also indicates an interesting twist on the example of "race-passing." Lisa Nakamura illustrates how whites often assume racial minority identities in cyberspace for the purpose of acting out racial stereotypes. In this case, Onaona used the Internet for an entirely different kind of race-passing. She was able to more fully explore and express a part of her real ethnic heritage that had been partially denied her in real life because she didn't look the part.

Culturally Appropriate Interaction

Though Onaona's case was in some ways the most dramatic of the students in the class, it was not unique. Many of the other students had very positive experiences in exploring and expressing their Hawaiian identity. Of course, this was not entirely due to their Internet communications. Many college students explore their ethnic identity, and students in Hawai'i are not exceptions to this trend. Yet there seems to be something particular to the Internet experience that proved helpful to students' exploration and expression of being Hawaiian. Many of the students commented to me that they found Internet-based communication and learning consistent with Hawaiian ways of interacting and learning.

An extensive body of literature exists on the cultural mismatch between patterns of interaction in Hawai'i's public schools and universities and traditional Hawaiian ways of communicating and learning (see, for example, Au 1980; Boggs 1985; D'Amato 1988; Martin 1996; Sing 1986; Watson-Gegeo 1989). A number of patterns of Hawaiian interaction have been identified, and these patterns are often at odds with how classroom education is organized. First, Hawaiians learn best through extensive informal social interaction, or what has been referred to as *talking story* (Au 1980). Second, Hawaiians are motivated to learn not for individual aggrandizement but to contribute to a broader community network. As Scott Whitney (1987) explains, "it is the feeling of being a member of extensive and untangled net which represents security and

coherence to Hawaiians of all ages" (9). Finally, Hawaiians have traditionally passed on knowledge through a variety of media, including chanting, hula, and hands-on activity, rather than principally through text-based instruction.

The teacher of the Hawaiian 201 class, herself a native Hawaiian and strongly involved in Hawaiian cultural and political affairs, made every effort to make use of the Internet in ways that enhanced its potential for informal interaction, community networking, and multimedia learning. In particular, the e-mail exchange and the Web publishing project gave students a sense that they were doing something of benefit for the broader Hawaiian community. As a female student named 'Iolani told me,

> It's really good to put our papers on the Web. Maybe now if other Hawaiian classes need research, maybe they can look on the Web for research that they need and they can learn how to read it in Hawaiian and get the information in Hawaiian. 'Cause we got all ours from English books and we translated it, and so maybe now instead of looking at English books they can look at our Web pages and they can add on their own.

The other element of culturally appropriate learning was the integration of different media. Though many college teachers would blanch at the sight of their language students spending time on graphic work and design, the Hawaiian 201 teacher gave students full range to explore uses of different media in enhancing their work. For example, Malina was a Hawaiian studies major in her forties. Even though she had a strong commitment to the culture and language, she was having great difficulty learning Hawaiian and had failed a previous class. Malina also had no previous experience with computers and was quite afraid to work with them in the beginning. Yet she began to feel more comfortable with both computers and the Hawaiian language when she seized the opportunity to engage in multimedia design in her final project. She produced a beautifully designed page on Hawaiian wetlands, incorporating a combination of poetry, text, drawings, and photos. She spent a great deal of time in the laboratory perfecting both the text and the overall look. She received a top grade in the course and at the end of the semester shared her feelings with me about multimedia web design:

> Even if you don't speak the language, you want to press down and go further because something is happening on that page, you know it's some kind of *mana* [spirit] coming out of that page. And so, the people

in the class wanting to put their stuff on there, that's part of their expression, it's part of their *mana*. It says not in words, but it says in a different way what they're trying to convey in a piece....You know, Hawaiians weren't a written culture, and I think there's a reason for that, you know they were very alive with everything, so if [we're] gonna be writing I think this is a great medium because [we] can be alive here.

The match between Hawaiian culture and computing was far from seamless. The students in Hawaiian 201 faced many technical, personal, and cultural obstacles in entering the realm of cyberspace. The English-language and ASCII interfaces of the university's computers caused many obstacles in Hawaiian language computing, and forced the students to resort to complicated procedures to produce and view their work in the full Hawaiian alphabet. Moreover, when the students ventured out into English-language websites to gather information for their research projects, they often came across racist stereotypes about Hawaiians. For example, when 'Iolani found a page of Hawaiian photography and went to sign the guest book, she found a comment in the guest book from someone on the U.S. mainland who asked "Hey, where are the girls in grass skirts?" She decided to politely inform the person about the situation in Hawai'i, while at the same time showing him that Hawaiians have their own language:

Date: Wed, 23 Oct 1996 14:11:47 -1000
From: 'Iolani Smith <iolan@hawaii.edu>
To: jonathon@waycon.net

Aloha!

Noho au ma Kane'ohe Hawai'i ma ka mokupuni 'o O'ahu.. (I live in Kane'ohe Hawai'i on the island of Oahu). There aren't any ladys [*sic*] walking around here in grass skirts. It really isn't the total paradise that people make it out to be. Of course there are beautiful mountains, beaches, and waterfalls, however due to western contact, much of the original native beauty is gone. Take care. A hui hou! (Until we meet again) Write back if you want to! =) I just wanted to share a little bit about Hawai'i with you.

Perhaps the most interesting cultural challenge was faced by a young male student named Kamahele. A talented hula dancer and chanter, Kamahele decided to create a webpage about Hawaiian chants, including explanations of

the history and meaning of chants as well as sound files of chants that he would record for the page. However, he felt conflicted about his desire to share chants through this medium. As he explained to me,

> The Hawaiians have a saying, "I ka ʻōlelo no ke ʻola, i ka ʻōlelo ke make"—And that's "In the language there is life, in the language there is death." That's like there's so much power in the word.... And when you just give away power and knowledge so easily, then there's no respect for it. But when you actually have to work and earn and go through life experiences to attain that knowledge, then you have more of a deeper understanding and you're more cautious and careful and you'll retain that knowledge. And that's why I was kind of scared to just do some of the traditional chants on the World Wide Web—it was just like, O.K., here, well take our things that we've been holding really carefully and sacred for all this time and passed down and then, O.K. world, here it is!

In the end, Kamahele did decide to put his chant on the webpage and share it with the rest of the class. Soon, however, the file became corrupted and no longer worked. Kamahele took this as a sign of what was meant to be, and he didn't replace the file.

What relevance do these issues have for broader questions of race in cyberspace? Many ethnic and racial groups, and not just native Hawaiians, have suffered from education that is culturally inappropriate (see, for example, Delpit 1988). Some assert that educational computing will exacerbate this situation by reinforcing mainstream ways of communicating and knowing at the expense of alternate frameworks (Bowers 1988). Others imply that the Internet is by its nature congruent with non-Western patterns of interaction (Fowler 1994). I prefer to see the Internet, like other domains of literacy, as a site of struggle between different ideological and political forces. In this particular class, the Internet proved to be a very useful medium for students' cultural exploration and expression—but only because the students and teachers actively struggled to make it so. They struggled to overcome difficulties imposed by the ASCII interface, to overcome racist stereotypes of Hawaiʻi and Hawaiians expressed both in commercial websites and by individual correspondents, and to express themselves in a way that was congruent with their own cultural values rather than with what is normally expected in a college foreign language class. Their results were for the most part successful, though certainly not preordained, and based on the fact that they were willing to bend

the rules of education to fit the particular cultural patterns of the Hawaiian community. Successful uses of the Internet by blacks, Latinos, and other minority groups must also build from cultural patterns of interaction and learning in those communities.

The Internet and Language Revitalization

Finally, I would like to return to the issue of the Internet and minority language revitalization. There are currently some six thousand languages spoken around the world. It is estimated that some 90 percent may die out within the next century (Krauss 1992), representing a loss of stunning magnitude to the cultural heritage of humanity. An individual culture need not die out with its language—witness, for example, the cultural survival of groups like the Jews and the Yaquis, who have shifted languages several times (Spicer 1980). Yet the death of a language does entail the eclipse of certain voices, perspectives, and ways of life. Languages are threatened by "destruction of lands and livelihoods; the spread of consumerism, individualism, and other Western values; pressures for assimilation into dominant cultures; and conscious policies of repression" (Crawford 1994, 5). For Hawaiians, as for many peoples around the world, defense of language means defense of community, autonomy, and power. It is a way of asserting that "we exist" in a postmodern world where the most important question is no longer "What do you do?" but rather "Who are you?" (Castells 1997).

According to sociolinguists, the survival of languages depends not so much on numbers of speakers but rather on *will* and *transmission*. Simply put, languages will survive if the speakers of the language have the desire to maintain the language and the means to transmit it to the next generation (Fishman 1991). Transmission has traditionally occurred through tight-knit communities passing the language on to their children. In places such as Hawai'i, where globalization and economic change have dispersed native speakers, communities are experimenting with new media (such as electronic bulletin boards which can bring together widely dispersed groups of speakers) to assist in language transmission.

It appears, though, that the most important role of the Internet is not its impact on *transmission*—which must continue to occur through oral interaction in families and schools—but its impact on *will*. As noted by Nancy Hornberger (1997), "language revitalization is not about bringing a language back, it's about bringing it forward." People will struggle to maintain their language when they see it as not only an important part of their grandparents'

past, but also of their own future. And herein lies the main significance of Hawaiian language computing. As Kamahele explained,

> We're learning how to use new technology and new tools, at the same time we're doing it in Hawaiian language—it looks as if it's a thing of the future for Hawaiian, because maybe there's [only] a few Hawaiian language papers. But you have something that might be just a little bit better, like the World Wide Web.

Kamahele began the semester with a strong sense of commitment to the Hawaiian language. He ended it with an appreciation of how his commitment could be extended via new media. Malina began with an interest in Hawaiian but a personal history of failure in learning it. Multimedia computing helped her draw on her own cultural resources to overcome her fears of both language and technology. Onaona began with an emerging but unexpressed sense of her own identity as a Hawaiian; she ended the academic year prepared to dedicate her life to revitalize Hawaiian language as a Hawaiian-language educator. For each of them, Hawaiian-language computing took on an important symbolic value, allowing them to say to themselves and to the world that they are Hawaiian and proud of it.

Conclusion

In the postmodern era, traditional cornerstones of authority and meaning—from family to job, from nation to race—have been shaken up. While race still matters as a source of oppression, the dynamics of race have been altered by the fast-paced social and economic changes of the informational era. New patterns of immigration, marriage, employment, and interaction mean that the ethnic dynamic in the U.S. is no longer principally black versus white, but rather a complex web of multiple and conflicted identities shaped by nationalism, religion, gender, race, and culture. Language plays an important role within this new mix, as it represents a powerful and flexible medium for assertion of identity against cultural homogenization.

The Internet does not introduce totally new ethnic dynamics, but rather magnifies those that already exist. New immigration patterns and increased interracial marriage make racial identity more subjective and multiple; the anonymous, multi-channeled communication facilitated by the Internet deepens this trend toward multiple subjective identity (Turkle 1995). Globalization heightens the role of English as an international lingua franca while relocal-

ization creates space for other national and local languages to reassert themselves; the broad mix of international, national, regional, and local discussion channels on the Internet first accelerated the spread of global English and now provides opportunities for those who challenge English-language hegemony.

Hawai'i in some ways represents a special ethnic dynamic, but in other ways is not unique. The multiracial ethnic mix that exists in Hawai'i, where no single racial group dominates and large numbers of people have interracial backgrounds, will likely become the norm soon in California, Washington, New Mexico, Texas, New York, and other states. The increasing prominence given to language issues in North America is seen by the recent battles over bilingual education and Ebonics as well as the ongoing conflict over Québecois sovereignty. Just as Hawaiians have sought to assert their language rights in the online realm, other groups will increasingly do so. Indeed, Native American groups are already bringing their own language revitalization efforts into cyberspace (Office of Technology Assessment 1995), and there are signs that Internet contact with Latin America is creating opportunities for language-based identity formation among U.S. Hispanics (Lillie 1998). One important area of research in the future will be the use of Black English Vernacular and other nonstandard dialects of English in cyberspace.

Sherry Turkle suggests that the identity question posed by cyberspace is "Who am we?" If Hawai'i is an indication of future trends in America, and I believe it is, then "we" is increasingly someone who uses standard English in certain Internet forums but chooses alternate languages or dialects in other online domains, and that the exercise of this choice represents an act of cultural resistance against the homogeneity of a white, monolingual America.

Notes

I would like to thank the Hawaiian students and teacher discussed in this chapter for their openness in inviting me into their class and community. I also would like to thank Richard Kern, who provided very helpful comments on a previous version of this paper.

1. My analysis in this and the following section draws heavily on the work of Manuel Castells (1996, 1997, 1998).
2. Translation of this quotation from the original French is provided by Castells (1997).
3. The names of the students have been changed for the sake of anonymity.

References

Appiah, Kwame Anthony, and Henry Louis Gates, Jr., eds. *Identities*. Chicago: University of Chicago Press, 1995.
Au, Kathryn. "Participation Structures in a Reading Lesson with Hawaiian Children: Analysis

of a Culturally Appropriate Instructional Event." *Anthropology and Education Quarterly* 11.2 (1980): 91–116.

————. *Principles for Research on the Early Education of Hawaiian Children.* Los Angeles: Asian American Studies Center, UCLA, 1980.

Benton, Richard. "Making the Medium the Message: Using an Electronic Bulletin Board System for Promoting and Revitalizing Mäori," in *Telecollaboration in Foreign Language Learning,* Mark Warschauer, ed. Honolulu: Second Language Teaching and Curriculum Center, University of Hawaii, 1996.

Bernard, H. Russell. "Preserving Language Diversity: Computers Can Be a Tool for Making the Survival of Languages Possible." *Cultural Survival Quarterly,* Fall 1992: 15–18.

Blom, Jan-Petter and John J. Gumperz. "Social Meaning in Linguistic Structures: Code-switching in Norway." *Directions in Sociolinguistics,* John J. Gumperz and Dell Hymes, eds. New York: Holt, Rinehart & Winston, 1972.

Boggs, Stephen. *Speaking, Relating, and Learning: A Study of Hawaiian Children at Home and at School.* Norwood, NJ: Ablex, 1985.

Bowers, C.A. *The Cultural Dimensions of Educational Computing: Understanding the Non-neutrality of Language.* New York: Teachers College Press, 1988.

Castells, Manuel. *The Power of Identity.* Malden, MA: Blackwell, 1997.

————. *The Rise of the Network Society.* Malden, MA: Blackwell, 1996.

————. *End of Millennium.* Malden, MA: Blackwell, 1998.

"The Coming Global Tongue." *Economist,* 21 December 1996, 75–77.

Crawford, James. "Endangered Native American Languages: What Is to Be Done and Why?" *Journal of Navajo Education* 11.3 (1994): 3–11.

Crystal, David. *English as a Global Language.* Cambridge: Cambridge University Press, 1997.

Cummins, Jim, and Dennis Sayers. *Brave New Schools: Challenging Cultural Illiteracy through Global Learning Networks.* New York: St. Martin's Press, 1995.

"Cyberspeech." *Time.* 1997. 149: 23.

D'Amato, J. D. "'Acting': Hawaiian Children's Resistance to Teachers." *The Elementary School Journal* 88 (1988): 529–42.

Daedalus Inc. *Daedalus Integrated Writing Environment.* Austin: The Daedalus Group, 1989.

Delpit, Lisa. "The Silenced Dialogue: Power and Pedagogy in Educating Other People's Children." *Harvard Educational Review* 58.3 (1988): 280–98.

Fishman, Joshua. *Reversing Language Shift.* Clevedon, U.K.: Multilingual Matters, 1991.

Fowler, Robert. "How the Secondary Orality of the Electronic Age Can Awaken Us to the Primary Orality of Antiquity." *Interpersonal Computing and Technology* 2.3 (1994): 12–46.

Graddol, David. *The Future of English.* London: The British Council, 1997.

Heller, Monica. *Language, Ethnicity and Politics in Quebec.* Unpublished doctoral dissertation, University of California, Berkeley, 1982.

Henriquez, Julian, et. al. *Changing the Subject.* New York: Methuen, 1984.

Hornberger, Nancy. *Language Policy, Language Education, and Language Rights: Indigenous, Immigrant, and International Perspectives.* American Association for Applied Linguistics Annual Conference. Orlando, March 1997.

Kent, Noel, *Hawaii: Islands under the Influence.* New York: Monthly Review Press, 1982.

Krauss, Michael. "The World's Languages in Crisis." *Language* 68.1 (1992): 4–10.

Labov, William, and Wendell A. Harris. "De Facto Segregation of Black and White Vernaculars." *Diversity and Diachrony,* David Sankoff, ed. Amsterdam: John Benjamin, 1986. 1–24.

Lillie, Jonathon James McRadie. *Cultural Uses of New Networked Internet Information and Communication Technologies. School of Journalism and Mass Communications.* Chapel Hill: University of North Carolina at Chapel Hill, 1998.

Martin, Darlene Emiko. *Towards an Understanding of the Native Hawaiian Concept and Manifestation of Giftedness*. Unpublished doctoral dissertation, University of Georgia, 1996.

Nakamura, Lisa. "Race in/for Cyberspace: Identity Tourism and Racial Passing on the Internet." *Works and Days 13.1–2 (1995)*. http://acorn.grove.iup.edu/en/workdays/Nakamura.html.

Novak, Thomas P., Donna L. Hoffman, and Project 2000 Vanderbilt University. "Bridging the Digital Divide: The Impact of Race on Computer Access and Internet Use." http://www2000.ogsm.vanderbilt.edu/papers/race/science.html. 1998.

Ochs, E., and B. Shieffelin. "Language Acquisition and Socialization: Three Developmental Stories and Their Implications," in *Culture Theory: Essays on Mind, Self, and Emotion*, Richard Shweder and Robert Levine, eds. Cambridge: Cambridge University Press, 1984.

Office of Technology Assessment. *Telecommunications Technology and Native Americans: Opportunities and Challenges. Report No. OTA-ITC-621*. Washington, DC: U.S. Government Printing Office, 1995.

Roberts, Julian M. "Pidgin Hawaiian, a Sociohistorical Study." *Journal of Pidgin and Creole Languages* 10.1 (1995): 1–56.

Sato, Charlene. "Sociolinguistic Variation and Language Attitudes in Hawaii," in *English around the World: Sociolinguistic Perspectives*. J. Cheshire, ed. Cambridge: Cambridge University Press, 1991.

Schecter, Sandra, Diane Sharken-Toboada, and Robert Bayley. "Bilingual by Choice: Latino Parents' Rationales and Strategies for Raising Children with Two Languages." *Bilingual Research Journal* 20 (1996): 261–81.

Schütz, Albert J. *The Voices of Eden*. Honolulu: University of Hawaii Press, 1994.

Sing, David K. *Raising the Achievement Level of Native Hawaiians in the College Classroom through the Matching of Teaching Strategies with Student Characteristics*. Unpublished doctoral dissertation, Claremont Graduate School, Claremont, CA, 1986.

Spicer, Edward H. *The Yaquis: A Cultural History*. Tucson: Tucson Arizona Press, 1980.

Touraine, Alan. *Qu'est-ce que la démocratié?* Paris: Fayard, 1994.

Turkle, Sherry. "Who Am We." *Wired*, January 1996, 158+.

———. *Life on the Screen: Identity in the Age of the Internet*. New York: Simon & Schuster, 1995.

Warschauer, Mark. "Technology and Indigenous Language Revitalization: Analyzing the Experience of Hawai'i." *Canadian Modern Language Review* 55.1 (1998): 140–61.

———. *Electronic Literacies: Language, Culture, and Power in Online Education*. Mahwah, NJ: Lawrence Erlbaum Associates, 1999.

Watson-Gegeo, Karen Ann. *The Hawaiian Language Immersion Program: Classroom Discourse and Children's Development of Communicative Competence* (ERIC Document FL 018 681). 1989.

Weedon, Chris. *Feminist Practice and Poststructuralist Theory*. London: Blackwell, 1987.

West, Cornel. *Race Matters*. Boston: Beacon Press, 1993.

Whitney, Scott. "'I Would Always Take Care of My Net': Self-esteem and the Assumptive World of Local Youth." *The Journal of the Hawaii Community Education Association* 1.1 (1987): 7–13.

Wilson, William H. "I ka ʻōlelo Hawaiʻi ke ola, 'Life is found in the Hawaiian language.'" *International Journal of the Sociology of Language* 132 (1998): 123–37.

10. Babel Machines and Electronic Universalism

Joe Lockard

And the whole earth was of one language, and of one speech.

And it came to pass, as they journeyed from the east, that they found a plain in the land of Shinar; and they dwelt there.

And they said one to another, Go to, let us make brick, and burn them thoroughly. And they had brick for stone, and slime had they for mortar.

And they said, Go to, let us build us a city and a tower, whose top may reach unto heaven; and let us make us a name, lest we be scattered abroad upon the face of the whole earth.

And the Lord came down to see the city and the tower, which the children of men builded.

And the Lord said, Behold, the people are one, and they have all one language; and this they begin to do: and now nothing will be restrained from them, which they have imagined to do.

Go to, let us go down, and there confound their language, that they may not understand one another's speech.

So the Lord scattered them abroad from thence upon the face of all the earth: and they left off to build the city.

Therefore is the name of it called Babel; because the Lord did there confound the language of all the earth: and from thence did the Lord scatter them abroad upon the face of all the earth.

<div align="right">Genesis 11: 1–9, King James Version</div>

The Internet world of the 1990s has been preoccupied with the invention of virtual communities and rearticulation of an historical concept of insubstantial community. These ideas, which rely heavily on Howard Rheingold's popularizing net theory,[1] require uncritical acceptance of enabling predicates, entail erasures of group culture, and rely upon a division between material self-conceptions and an ideal community form. "Virtual community" is an appeal for a transcendent communitarianism, one where race and ethnicity have been left behind as remnants of an Old World Order. In this emergent electronic ethos, the specificities of origin and ethnicity are irrelevancies that characterize an exterior, increasingly antique world. Virtual uncertainty and unknowability have promised to annul the particularistic atavisms of "race" and ethnicity, introducing instead an universalitic community instrumentalized by shared online access.

In the three sections of this essay I shall argue first that the current conceptual transit into the Internet's techno-universalism relies upon repetition of deep-rooted cultural models of metacommunity. Techno-universalism, a belief in the existence of an open, available Internet in permanent revolutionary expansion, provides an intellectual faith for Internet nationalism. Second, a globalistic "electronic nation," which relies on cyber-English as its foundational standard, asserts an elite transnational class commonality implicitly based within J. G. Fichte's early-nineteenth-century equation of language and nation.[2] Third, an ideology of online nationalism restates racialism (positing Tzvetan Todorov's definition of "racialism" as ideologies of "race")[3] through its transformative identity omissions that emphasize unidentifiability and mutability. The initial organizing paradigms of "virtual community" derive substantially from the language of faith and faith in language, from narratives of religious belief and imperial common tongues. Racialized and ethnic communities, as persistently antagonistic alternatives to dominant and unificational worldviews, represent contradictions to these current paradigms. They challenge the monotonal and monolithic self-conception embedded in virtual whiteness.

Heavenly Techno-Universalism

Incorporation of ever-broadening user networks is undermining the universalistic models of early Internet theory, and the "virtual community" concept is already in the midst of confrontation with its unacknowledged exclusionary premises. Net culture has encountered global poverty culture. The social archi-

tecture of the nets is far from the liberationism claimed, and the Internet's access, information and speed hierarchies have become more obvious as the nets have spread. Universalism is simply not there: it remains a future faith.

"Virtual community" incorporates a noncorporeal presence not simply in order to assert a new cybernetic transcendence, but to lend positive and benign formulation to the dominance of an elect. By shifting the source of authority into an immaterial realm, the discursive use of "virtual community" shifts the political focus away from the material power bases of social elites. Under this metaphysical paradigm of virtuality, a social articulation has been translated into a natural order beyond human challenge.

An annunciatory formulation of a metacommunity participates in a tradition that stretches back to Saint Augustine, who undertook "to write about the origin, the development, and the destined ends of the two cities. One of these is the City of God, the other the city of this world; and God's City lives in this world's city, as far as its human element is concerned; but it lives there as an alien sojourner."[4] Augustine's bifurcation of material from immaterial *communitas*, where a metacommunity coexisted within (but separate from and elevated above) the mundane, provided the basis for a pan-national and transethnic ideal in the canonical Western intellectual tradition. This religio-egalitarian idealism was, of course, hollow in practice and arguably facilitated the cultural self-elevation of racialist hierarchies. Of equal importance, it enabled the rationalization of ideological authority in pursuit of a superior and unquestionable civilizational stage, founded on a community of belief rather than immediate communal interests. The same divorce from immediate local culture and assimilation into a greater ideological collectivity, asserted to be part of an integrative submission into an unalterable historical progression, has found its latest iteration in virtual communities.

Augustinian salvation, eminently visible in *Wired*'s open-armed and worshipful electronic triumphalism, relies on social physicality as confirmation of an overarching communicative antimaterialism. Ethnicity, found in shared social physicality, becomes irrelevant; thus, the perpetuation of material racism via access and ownership issues remains absent from the discussion.[5] The online world is the new City of God, an anti-identitarian world where Macintosh and Linux users are the definition of ethnic minorities. Where ethnicity and virtual community do attempt to merge, their union creates unconscious commercial parody or mega-ethnicity, as at the Asian Avenue website, where demographic targeting defines a combinatory pan-Asian ethnicity.[6] Online ethnicity remains parodic because it cannot translate physicality.

In the electronic city, race, class and gender aren't governing elements of worklives lived daily; rather, they are nothing more than facilitators or impediments to technological diffusion and market expansion. They have become dematerialized signifiers for the electronic market, or hazily mirrored interpretations of social particularisms subsumed into the constructions of techno-universalism. Access language is no less a condition than race, ethnicity, class or gender in virtual communities.

In its technological organization, the Internet is a distributed rather than a centralized entity: it is a contemporary Babel machine, one that propagates a diversity of languages even as its originating code lies in the English language. Babel machines produce many out of one; they render monolingualism into its native pluralist components. Although rationalistic digital descendents of the Enlightenment, Babel machines incorporate and express a longing for the unrationalized familiarity of tongues spoken by the heart, not only by the mind. As linguistic centrifuges, Babel machines emerge against the background of a centuries-old faux history that posited an originary cultural center. In a discussion of medieval Europe's fascination with the Babel story, Umberto Eco writes, "Even when thinkers dreamed of a new language of universal reason, the model for that language was based on a theoretical idea of the possible aboriginal Hebrew of Adam."[7] Babel machines arise from and are surrounded by an impossible-to-realize unificational impulse, one that seeks to impose order in a world where, in Paul Auster's words, "Names became detached from things; words devolved into a collection of arbitrary signs; language had been severed from God."[8]

The obsessed character of Peter Stillman in Auster's *City of Glass*, an elderly man who traces the incomplete letters of "Tower of Babel" during his walks through New York City and seeks absent singularities of understanding, provides a fictional analogue for large-scale natural-language technologists who construct software programs that plod toward a nonexistent horizon of universal intertranslatability. Auster's postmodernist vision of a "neverland of fragments, a place of wordless things and thingless words" is recognizable webspace,[19] one whose fragmentation seduces technologists into metaphysical and global sewing projects, stitching together words and meaning as much as languages and diverse peoples. Rationalism has gone wild here—software is not divine expression.

The universalistic project of machine language, as science fiction writer Neal Stephenson suggests in *Snow Crash*, drives towards Edenic understanding and inter-linguistic perfection. But, in the cautionary words of Hiro Protagonist

in that novel, "Maybe Babel was the best thing that ever happened to us."[10] The Babel myth, after all, engenders the human freedom not to be all alike.

An understanding of the Internet as Babel minus the Tower, the Tower representing monocultural and Microsoft-driven singularization of locus and architecture,[11] contests the neo-Augustinian vision of the Internet as a civilizationally unified, elevated, immaterial, and ultimately monolingual discourse field. Augustine, who believed that humanity's languages emerged from a divine Hebrew monolingualism, argued that social decline, corruption, and ethnic divisions dated from the mythical disaster at Babel.[12] Linguistic diversity, for Augustine and for Internet globalists, is a human handicap that can be overcome in order to establish a common enlightened human condition.[13] At the remove of centuries, Jeffrey Shapard argues in an essay on Japanese-global net interaction that "Language separation leads to isolation, and communities require a shared common language" (264). Shapard concludes with neo-Augustinian sentiments when he writes, "[A]s we sail electronic seas and explore, settle, and develop the virtual world online, we face many of the same issues that our ancestors faced" and enjoins against machine-language biases that defeat greater connectivity.[14] However, a language-defined absence of immediate human communication or mechanical interconnectivity does not equal isolation, since—save rare instances—humans and computer-mediated communications function in networks. In both of these examples, classical and contemporary, the final purpose of language lies in convertible expression and universalism.

Augustine's version of human history is that of a post-Babel human reconvergence towards a world society no longer divided by the trivialities of mundane physical separations, a world that joins in pursuit of its collective redemption. What for Saint Augustine was eschatology is now central to the raison d'être so frequently proclaimed by Internet triumphalism, the establishment of a medium of full human interintelligibility—the Internet as the new Tower of Babel. Henry Miller observes, "In his highest flights, musical and architectural above all, man gives the illusion of rivalling the order, the majesty and the splendor of the heavens."[15] The work of building an electronic Tower has the aspect of humanity merging toward collective self-elevation, towards heavenly vistas over a world of newly comprehensible information. In this uncritical purpose, with its increasing millions of acolytes and devotees, the Internet approaches a universalistic religious mission.

Yet linguistic fragmentation within the Internet has begun, as the growing number of World Yahoo! portals (Spanish, French, German, Danish,

Norwegian, Swedish, Chinese, Korean, Japanese) make clear. In early fall 1998, Yahoo! keyword searches in the English language began returning results with English-to-other translating options. Even earlier, the BabelFish webpage enabled translation of websites between English and major European languages.[16] Internet anglocentricity continues to provide the organizing language principle,[17] but fractures are spreading and creating marginal non-anglophone spaces on the Internet. The Internet, born and nurtured in cyber-English, is in the process of market segmentation and gradual maturation. Whether as a consequence of its origins within monolithic cyber-English or despite them, an Internet Babel machine has begun to operate.

For me, the diversity of babble is far more interesting than the Babel megalith. Several months ago I stood looking at an Arras tapestry that features a depiction of the Tower of Babel. The artists had an especially difficult time in framing such a massive imaginative structure within the conventions of perspective: the Tower was unrepresentable due to its mythic size. Although quite large, the tapestry could, at best, provide only a very modest visual framework. This perspectival condundrum is analogous to the problem of racial representation on the Internet, which is simultaneously one of unrepresentable linguistic diversity. As we *see* people, we have some expectation of language, whether common or different, that derives from human signs.

Raciality is one of those signs, and a major one. Racialism and language have been constant companions since the emergence of consistent, solidified racial theory during the Enlightenment. The Internet removes accustomed everyday perceptual frameworks that previously made this language/race nexus possible, and we find ourselves looking at the Babel without the Tower, at the babble of humanity in its unidentifiable diversity. We lack the scale of previous cultural measures.

Racialized language itself is another form of babble: word meanings dry into stereotypical husks. Gerald Vizenor's surreal short story "Mother Earth Man and Paradise Flies" retells these colonial takeovers of language from a Native American perspective. "The tribal pilgrims, wandering from the woodlands to the desert for the winter, were escorted to a large room in the word hospital where the central computers were housed."[18] In Vizenor's word hospital, tribal observers see that rational scientific analysis founders on the irrational chromatisms of "race." Since "race" has no defensible intrinsic meaning, neither can the words that emerge from racializations. This begs a question: If racialism is demonstrably fraudulent in the physical world, what possible analytic validity might it possess in a virtual world?

Internet users have been translated into an online a-racial transcendence, yet we all continue to use the language of racialism because it underlies contemporary history and because we lack another language. This echoing referentiality arises because we live in a physical world still defined by the forever obsolescent but unnegated history of race, race, and race. At best, the online world is ignoring rather than unlearning—or better, *undoing*—the social catastrophes created by racialism.[19] It retreats to the asylum of virtual whiteness,[20] where the now-challenged privileges of phylogenetic whiteness have been reformulated as online "honorary whiteness" or "default whiteness."

Online and Offline Languages

> I am always falling
> toward that dark, swollen
> river filled with tongues
> drunk and baptized…
>
> —Haunani-Kay Trask, "Pax Americana: Hawai'i, 1848"[21]

Language remains the least-examined component of online identity, and anglophone monologism remains a basic linguistic feature of the Internet. The technouniversalism of emergent Internet ideologies creates global assumptions about online language. But as Tom Paine observed when contesting false universalisms two centuries ago, "Human language is local and changeable and is therefore incapable of being used as the means of unchangeable and universal information."[22] Even as nonanglophone electronic discussions proliferate and multilingual browsers are introduced, English supplies the indispensable universalistic glue for the global "virtual community." However, in order to adapt technology to users, rather than adapt users to online monolingualism, a nonanglophone Internet must be supported and developed. Reconceptualizing the nets as a set of linked human languages that actualize heteroglossic norms, not simply as a domain of market segmentation and software localization from an English norm, will aid in propelling minoritarianism from out of the electronic shadows.

Insofar as it cannot—and does not wish to—recognize the historic material bases of community, "virtual community" constitutes an increasingly shallow theoretical understanding in the midst of this redistributive communicative fragmentation. Instead, the analytic task becomes one of understanding the operation of the Internet as a system of languages, where economic and class privileges accrue with gross differentials in the midst of racial and ethnic geographies.

Online language use cannot simply be equated with raciality: black and white British, for example, are indistinguishable as online speakers. There are no accurate means to estimate online raciality, unless we search out the electronic version of racial culture—but how many of those gangsta-talking websites are being run by rebellious, back-talking, suburban white kids looking for some model, any model? Online racial language is far easier to emulate than front-and-center real-world raciality. This sort of domestic American white-to-black speech paradigm is an ironic and paradoxical echo of life and resistance to colonial metalanguages that forcibly enacted colored-to-pseudowhite transformations, such as those that, as R. K. Narayan suggests, left Indians "strangers to our own culture and camp followers of another culture, feeding on leavings and garbage."[23]

Major international languages, especially those with a colonial history and diverse speaker populations, do not correlate with "race." The cultural adaptability of language betrays the inflexibilities and spuriousness of "race." With this caveat clearly understood, cyberlanguage statistics nonetheless provide a gross understanding of the Internet's constitution as a Euro-American sociolinguistic phenomenon, just as a hypothetical eight-tenths Wolof Internet might sign a primarily African cultural origin.

Some 6 percent of the world population are mother-tongue English-speakers, while over 82 percent of the World Wide Web's contents are lodged in English.[24] Approximately 15 percent of the global population are native Spanish-speakers, whereas only 1.1 percent of the Web's contents are in Spanish. Over 90 percent of the Web is in English and other European languages, compared with 2 and 3 percent, respectively, in Asian languages (Japanese primarily) and at hispanophone/lucophone sites.

Given that the Internet may be understood as a distributed information machine, where continental presence or absence indicates function in a worldwide symbolic processing order, this blatant cyber-language skew echoes and restates, at a multigenerational remove, Immanuel Kant's and G. W. F. Hegel's beliefs that the Western mind was uniquely adapted to the perception, manipulation, and production of abstract knowledges. Kant and Hegel both argued that Western philosophical systems represented the ne plus ultra of abstraction and originality, and both suggested that Oriental and African thought was iterative and incapable of symbolic sophistication.[25] Similar claims have been made throughout the twentieth century. José Ortega y Gasset claimed, for example, that Asian and African use debased a common language culture. In non-Roman mouths, he wrote, Latin became "a puerile language that allows for neither the fine edge of reason nor the shimmer of lyricism, a sad and groping language,

soulless, without warmth or light."[26] This Kantian/Hegelian prejudice that Ortega y Gasset imported is but one instance of the effects of racialized historiography in confirming the power of hegemonic language systems: many more might be cited. Under racialism, unificational languages have been argued to hold an abstract power available to a core racial stock and unavailable to others. The second- and third-class nonwhite English that constitutes the bulk of cyber-English become the locus of such race/language fallacies that equate difference with inferiority (viz. common flame-war insults over English language command).

In its current language formation, the Internet recapitulates uninformed Kantian and Hegelian prejudices toward distant cultures of Asia and Africa. Preexisting economic disadvantages translate into a new electronic differential, which in turn reinforces the old symbolic order through a new structural racism of limited or absent Internet access. Because the Internet additively re-enunciates the languages of power that have dominated the economic existence of entire nonwhite continents, it electronically amplifies and reproduces the modern history of capital.[27]

The equality that has been asserted as a major cultural product of the Internet is largely a figment of advertising imagination. An ideology of presumptive equality within a society of users pervades the Internet, but this ideology does not withstand empirical evidence on differential access and user-ship rates, or evidence concerning geographic regions of nonaccess. Internet usership reflects patterns of offline social power, and these patterns substantially reflect ethnic/racial hierarchies. Internet use largely functions under an ideological illusion of oneness-as-users, of a common and indivisible status as a global bourgeoisie. In this anti-ethnic mass electronic regime, online users, whatever their offline ethnicity, confirm each other's online subjectivity in preference to an originating ethnicity that must perforce remain unverifiable.

Within an immaterial and noncorporeal online environment, race/ethnicity become an external commodity, one that is a valueless commodity online. An unverifiable online ethnicity is a fiction that has no meaning beyond its pretense and its actor. In this postmodern exorcism of the ethnic, assertions of "race" or "ethnicity" sign an unemancipated consciousness, a consciousness that is either parochial or incapable of morphing. Online ethnicity itself becomes a performance rather than a lived experience.[28] That performance is indistinguishable from reality; indeed, the delineation of ethnicity as reality becomes a continuous challenge to the ethnicity/raciality of Internet users.

Such technological regimentations of identity arise from the separatisms, distances, and alienations of Internet media. Prevailing Internet ideology resists

the divisions of race/ethnicity, not as minoritarianism per se, but rather as a rejection of controlling fictions of homogeneity and proportionality. The presence of the cultural counterassertion—race and ethnicity—is anathema to believers in a liberational Internet universalism. Elevation of the public sphere to a communicative meta-world is the electronic City of God; the racial and ethnic spheres are the historic, unaesthetic and provincial cities of social sin. In this new and sightlier world, a "freedom to be" is an unchallengeable ontology, whatever contradictions arise from the earthly city.

Techno-universalism camouflages gross social inequalities and the global economic effects of racialism by announcing the advent of a new historical era, but this is no more than the means through which universalistic ideologies have advanced prophetic social claims for centuries. Realities are vastly more decisive than illusory claims. In a reality where some densely populated regions of China are served at the rate of one telephone per 100,000 people, online identity play is an unimaginable luxury for the remaining 99.99 percent of the population.[29] Whatever the Westernized consumerist desires that emerge in technologically less-developed countries, we shall continue to live in a material world where "freedom to be" is an assertion of superior privilege over those who, for reasons of poverty and education, will never have the ability to advance assertions of such freedoms. Two different public spheres are emerging, the online and the offline, together with a struggle between privileged universalism and unprivileged particularism. Freedom to speak in the new electronic world, let alone the global language with which to speak, remains unattainable because of international economic orders built upon centuries of colonialism and racialism. Only a very few projects, like Project Oxygen, seek to redress this order through construction of a fully global Internet access network.[30]

The offline public sphere constitutes itself in that still-haunting world of racialism never undone; the online sphere speaks the languages of the past even as it attempts to enunciate a future.

Internet Nationalism

> There is no race. There is no gender. There is no age. There are no infirmities. There are only minds. Utopia? No, Internet.
>
> —"Anthem," television commercial for MCI

Sitting in Davos in 1996, John Perry Barlow wrote "A Declaration of the Independence of Cyberspace,"[31] an angry response to passage of the Telecommunications Reform Act in the United States. Barlow's much-noted

declaration voices the rise of Internet nationalism,[32] an assertion of online sovereignty that refuses to accept the tyrannies of "weary giants of flesh and steel," or the governments of the industrial world.[33] Barlow's vision of cyberspace is one that originates in an absent electronic Lockean "consent of the governed,"[34] and avers that cyberspace "is an act of nature [that] grows itself through our collective actions." Thus the declaration invokes an aggregate formation of general will on the Internet, one whose organizing principle lies in a defense of individual liberty, but which can simultaneously be understood in mass terms as a defense of self-privilege.

The declaration encapsulates a growing strain of defiant and global electronic separatism generated by government efforts at control of the Internet. As political separatism, this declaration relies on a constitutional separation of mind and body, or a reiteration of Augustine's heavenly and earthly cities. For Barlow, "Cyberspace consists of transactions, relationships, and thought itself.... Ours is a world that is both everywhere and nowhere, but it is not where bodies live." Like the original U.S. Declaration of Independence, which paraphrased Locke in its "consent of the governed" clause but ignored the disenfranchisement of women and black slaves, Barlow's reinvocation of the phrase suffers from the same omission. In both declarations, a privileged minority parades as an auto-liberating majority.

Online nationalism is a deterritorialized and diasporic cultural nationalism, one that participates in a tradition that includes such predecessors as nineteenth-century haskalitic literature, Leopold Senghor's mid-twentieth-century elaborations of transoceanic pan-Africanism, and late-twentieth-century gay and deaf nationalisms.[35] Like online nationalism, each represents an intellectual effort to achieve cultural sovereignty and interlinkage for a diverse source population that shares a defining condition. As an ideological formation, online nationalism emphasizes unificational issues (advocacies for public encryption and information privacy, opposition to censorship)[36] and a hacker ethos. Whether their economics include orthodox capitalism, Silicon Valley libertarianism, or support for a gift economy, online nationalists consistently represent these intellectual positions as most favorable for an electronic economy. Such common and shared online values, linking netizens from otherwise heterogenous offline cultural systems, create a distinct nationalism. This cybernational formation encourages systemic expansion and Internet access, and views itself as an open ideological system that encourages broad participation. Online nationalism might be more cynically analysed as a form of consumer libertarianism focused on fullest value realization of small capital hold-

ings (personal computers and software) and mutual self-protection of the expressive potential achieveable through such investments. Such cynicism, though, would discount the very deep passions and beliefs of online nationalism.

As a class-based phenomenon, online nationalism embraces a nonracial and nonethnic openness, yet replicates social and ethnic hierarchies of its constituent and originating societies. One recent U.S. government report notes not only that this hierarchy is a pronounced one, but that the "digital divide" has significantly increased in the last several years.[37] Identity mutability and interchangeability, rather than access egalitarianism, are more central issues for online nationalists. Such concerns help situate the crucial importance online nationalist culture places on electronic privacy rights: rights that enable nonidentification, anonymity, or the free reinvention of self without relation to a "real" or grounded existence.[38] The proliferations of neo-identities and elaborate pseudonymous personae, born and dying in the ether alone, often seem no less than an effort to escape materialist gravity.

User identity disguises and encrypted digital capital flows arise from the same ethos, even the same data streams. As Jonah Peretti argues, "[L]ate capitalism not only accelerates the flow of capital, but also accelerates the rate at which subjects assume identities.... The Internet is one of many late capitalist phenomena that allow for more flexible, rapid, and profitable mechanisms of identity formation."[39] Online nationalism not only celebrates the arrival of distributed and multiple identities, whose collective population it represents, but further embraces this schizophrenic fragmentation as a liberation from old identitarian confinements. The modernist political world of "one man, one vote" has disappeared in the politics of online nationalism,[40] where distributed identities and consumer marketing have become mutually reinforcing phenomena.

This online identitarian ambiguity locates the thematics of the body that recur repeatedly in Barlow's cyberspace declaration. It states on one hand that prior legal concepts of property, expression and identity are inapplicable because they are based on matter.[41] On the other hand, Barlow accepts a bifurcation between powers of sovereignty: "We must declare our virtual selves immune to your sovereignty, even as we continue to consent to your rule over our bodies." The independence of cyberspace thus gains assertion as conditional and partial, one that is forced to confront and acknowledge an originating physicality, making it at most a mixed earthly/heavenly city.

Such preoccupation with definition of persona and consciousness across a material/immaterial spectrum joins the literatures of Internet politics with

those of adventist theologies. They share both the specification of an imminent critical transmutation of material and immaterial identities, and a belief that the material half is of far less importance to the future. Echoing the beliefs of many electronic triumphalists, when Barlow writes that "We are creating a world that all may enter without privilege or prejudice accorded by race, economic power, military force, or station of birth," his voice resonates with both political idealism and metaphysical salvationism. Race and class are to be banished as irrelevancies in this new bodiless world. While online nationalism locates itself in reference to an electronic expansion of the American frontier, its faithful can be better understood as new Millerites standing on a high prospect to celebrate a millennial arrival and translation into a new immaterial existence. But as tens of thousands of nineteenth-century New York "burned-over district" Millerites discovered, to their great disappointment, existence remains mundane. Online immaterialism ends with the on/off switch.

In a conceptual economy where old ideas are being recycled as new postmodern discoveries, the efforts by online nationalism to evade racialist histories through sheer dismissal stand out as especially striking. Such an evasion attempts to supplant material history with hopeful immaterial metahistory, where wishful decree eliminates the legacies of racialism at a stroke. Internet nationalism, in its early integrative stage, offers an inclusivity that disregards the operations of race, gender, class and language/class in online life, even as indisputably they provide the Internet with formative boundaries.

Notes

1. Rheingold; for examples of the expansion of Rheingold's analytic trope through the decade, see Brown; Bryant; Howard; Holmes; and Hagel. Since their first popularization early in the decade, such terms as "virtual community," "electronic community," and "online community," with all their variations, have continued to gain in usage.

 For a strong critique of the "virtual community" concept, see Fernback and Thompson. Fernback and Thompson conclude that "the likely result of the development of virtual communities through CMC will be that a hegemonic culture will maintain its dominance" and will serve mass catharsis more than democratic community-building.
2. Fichte; see "Seventh Address."
3. Todorov, 90–96. Also see Miles, 41–68, chapter 2: "Conceptual Inflation."
4. Augustine, 761.
5. There are exceptions. See Schön, Sanyal, and Mitchell; Civille; and Baldwin, 137–53.
6. See http://www.CommunityConnect.com/AsianAvenue.html.
7. Eco, 30.
8. Auster, 52.
9. Auster, 87.
10. Stephenson, 279. Auster's and Stephenson's preoccupations with originary pure language also appear in Byatt, 191ff. A reductionist metaphor of Babel as a structure rising above

polyglot social complexities appears in the form of a four-hundred-floor apartment building in Castel-Bloom. Beyond parallels with the Internet, Babel appears to serve as a convenient metaphor for cultural crisis in international postmodernist fiction.

11. I refer here to the present market situation and Microsoft as the current leading purveyor of techno-monoculturalism, not to agency or any suggestion of permanance. Thanks to Geoff Sauer for his comment on this point.

12. Augustine, 667–70.

13. As illustration of this comparative point, Augustine asserts that "[T]he diversity of languages separates man from man. For if two men meet, and are forced by some compelling reason not to pass on, but to stay in company, then if neither knows the other's language, it is easier for dumb animals, even of different kinds, to associate together than these men, although both are human beings. For when men cannot communicate their thoughts to each other, simply because of difference of language, all the similarity of their common human nature is of no avail to unite them in fellowship" (861). Augustine proceeds to argue that Roman imperialism imposed the common language of Latin at an intolerable cost in warfare and human suffering, a predecessor argument to the present advancement of cyber-English as an elite transnational language in a global economy characterized by widespread impoverishment, intense capital concentrations, and winner-takes-all market rules. The civilizational advantages of a shared language are, in Augustine's intelligent view, inadequate rationale or compensation for massive social wounds. Despite the means by which Latin spread, Augustine accepts the results as beneficial.

14. "Islands in the (Data) Stream: Language, Character Codes, and Electronic Isolation in Japan," in *Global Networks: Computers and International Communication,* Linda Harasim, ed. (Cambridge: MIT Press, 1993), 270.

15. Miller, 103.

16. See http://babelfish.altavista.digital.com/cgi-bin/translate?

17. By way of example, all the World Yahoo! portals are organized to mirror the originating English site. Since human cultures organize information and rubrics very differently, this American-standard organization of the Yahoo! portals reflects a fundamental anglocentricity even as minimal language diversity has been introduced.

18. Vizenor, 92–94.

19. The general preference to ignore these historical lessons found repetitive expression when the Clinton administration proposed transferring Internet governance to a new nonprofit entity, the Internet Corporation for Assigned Names and Numbers (ICANN). Governments in Latin America and Africa protested that the corporation's proposed international board would not have representatives from their continents. Amy Harmon, "U.S. Expected to Support Shift in Administration of the Internet," *New York Times,* 20 October 1998, C1.

20. See Lockard, 1997.

21. Trask, 11.

22. Paine, 39.

23. Narayan, 178.

24. For demographic estimates of English-speaking, see Crystal, 53–61. For demographic estimates of Internet languages, see http://babel.alis.com:8080/palmares.en.html. The rank list of web languages runs as follows: English (82.3 percent); German (4); Japanese (1.6); French (1.5); Spanish (1.1); Italian (.8); Portugese (.7); Swedish (.6); Dutch (.4); Norwegian, Finnish, Czech, and Danish (.3); and Russian and Malay (.1). The survey was published in June 1997. No accurate survey data are available on language prevalence in other portions of the Internet. For an expanded argument concerning the online presence of English, see Lockard, 1997, 161–74; also available at http://eserver.org/bs/24/lockard.

25. See Kant, 97–116; Hegel, 152–96.

26. Ortega y Gasset, 69.

27. Slavoj Zizek and Immanuel Wallerstein advance similar suspicious analyses of capitalist technocultural progress and universalist ideology. Zizek writes, "[W]hile cyberspace ideologists can dream about the next evolutionary step in which we will no longer be mechanically interacting 'Cartesian' individuals, in which each 'person' will cut his or her substantial link to his individual body and conceive of itself as part of the new holistic Mind which lives and acts through him or her, what is obfuscated in such a direct 'naturalization' of the World Wide Web or market is the set of power relations—of political decisions, of institutional conditions—which 'organisms' like the Internet (or the market or capitalism…) need in order to thrive" (36–37). See "Multiculturalism, Or, the Cultural Logic of Multinational Capitalism," *New Left Review* 225 (1997): 28–51. In interview material, Zizek suggests, "The so-called 'virtual communities' are not such a great revolution as might appear. What impresses me is the extent to which these virtual phenomena allow us to discover to what extent our self has always been virtual." See Kroker, 68. The immediate point stated here on Internet language as ideological articulation derives more explicitly from Wallerstein. In "Culture as an Intellectual Battleground," Wallerstein rejects cultural universalism (which would be, in the present discussion, cyber-English) as a conservative argument that seeks to obscure the particularisms that originate global inequalities. Wallerstein, 158–83.

28. See Nakamura. The performance of ethnicity, which Nakamura theorizes as "identity tourism," cannot be separated from "reality" in a profoundly political or economic sense. As Michael Hobart and Zachary Schiffman point out, "Nothing is fixed in today's information. The continuous flux of symbols collapses our usual distinction between information processing and its products. They are one and the same, mutually embodying power and play" (203). Digital convertability levels ethnicity and economics into a shared mathematical paradigm where, according to *Business Week*, "the Net's cool anonymity proves an advantage to minority business owners, allowing them to bypass real-life tensions by masking their racial identity." Roger O. Crockett, "Black Entrepreneurs: Invisible—And Loving It," *Business Week*, 5 October 1998.

29. Overall national teledensity in the People's Republic of China is less than 10 percent; in urban areas it reaches 30 percent [http://www.bupt.edu.cn/camnet/97telcom/eng/E3.html]. By 1997 China's twenty-two provincial capitals had gained new Internet connections, but only 55.7 percent of administrative villages in the country had telephone service [http://www.bupt.edu.cn/camnet/97telcom/eng/E2-1.html]. By July 1998, approximately 1.2 million Chinese were online in a national population of 1.2 billion [http://www.nua.ie/surveys].

30. Dumett, 36. Also see Project Oxygen at http://www.oxygen.org.

31. For complete text, see http://www.eff.org/~barlow/Declaration-Final.html.

32. Various essayists have employed "libertarian" or "cyberlibertarian" to characterize Internet politics that emphasize online freedom, radical individualism, and autonomist resistance to regulatory intervention by the state. See, for example, Langdon Winner, "Cyberlibertarian Myths and the Prospects for Community" [http://www.rpi.edu/~winner/cyberlib2.html] and Jay Kinney, "Anarcho-Emergentist-Republicans" [http://www.well.com/user/jay]. The term "libertarian" and its variants do not suffice to encompass the variety of political philosophies that may adhere to these principles.

33. The body of Internet nationalist literature, characterized by assertions of a separatist electronic autonomy, is large and growing. A limited review of declarative political texts professing electronic nationalism might include the original 1986 hacker's manifesto, Mentor's "The Conscience of a Hacker" [http://pages.prodigy.com/freeside/hacker.html]; Andy Hawk's 1993 statement, "Maniphest Destin-E: What is FutureCulture?" also known as the "bubble manifesto" [http://www.eerie.fr/~alquier/Cyber/fc-manifesto.html]; Cencebaugh and Aquarian's antimaterialist "Virtual Surrealist Manifesto" [http://www.emf.net/~

estephen/manifesto/aum00040.html]; the influential 1994 "Magna Carta for the
Information Age," [http://www.feedmag.com/95.05magna1.html], a call by electronic tri-
umphalists Esther Dyson, George Gilder, George Keyworth and Alvin Toffler for "the over-
throw of matter"; Al Schwartz's attitude-encrusted, less-than-thoughtful "Cybernaut
Manifesto" [http://www.ultra.net.au/~wisby/manifest.htm]; J. Richard Wilson's "Techno-
Rebel Manifesto" [http://pages.prodigy.com/freeside/techreb.html]; the Australian group
VNS Matrix's radically poetic 1996 "Cyberfeminist / Bitch Mutant Manifesto"
[http://sysx.apana.org.au/artists/vns/ manifesto.html]; and Christian Kurtchev's 1997
autonomist "Cyberpunk Manifesto" [http://www.trailerpark.com/phase1/madbyte/
INFOBASE/MANIFEST.HTM]. Like John Perry Barlow's declaration, all of these state-
ments propound a transcendant electronic public sphere and despite vast political differ-
ences, they share a common refusal to address ethnicity or race.

34. See Locke, 330–32, sections 95–97. Howard Frederick's excellent and recommended essay
"Computer Networks and the Emergence of Global Civil Society" also invokes Locke and
briefly proposes global cooperatism in a "Charter of Communication Independence."
Frederick employs the same originating civil philosophy towards democratic international-
ization rather than electronic self-privilege. In Harasim, *Global Networks*, pp. 283–95.

35. Senghor, 117–53.

36. The consociation of anonymity, cryptography and online nationalism emerges especially in
Timothy May's "Crypto Anarchist Manifesto"
[http://spunk.etext.org/texts/comms/sp000151.txt]. For a broader review of these formative
issues of online nationalism, see "Identity, Privacy, and Anonymity on the Internet"
[http://eng.hss.cmu.edu/cyber/identity.txt].

37. "Falling Through the Net II: New Data on the Digital Divide," National Telecommunications
and Information Administration [http://www.ntia.doc.gov/ntiahome/net2/falling.html],
August 1998. The report describes, among other things, a striking divide between races for
PC ownership and online access: "While the ownership of PCs have grown most signifi-
cantly for minority groups since 1994, Blacks and Hispanics still lag far behind the national
average. White households are still more than twice as likely (40.8%) to own a computer
than Black (19.3%) or Hispanic (19.4%) households. This divide is apparent across all
income levels: even at incomes higher than $75,000, Whites are more likely to have PCs
(76.3%) than are Blacks (64.1%). Similarly, the rates for on-line access are nearly three
times as high for Whites (21.2%) as for Blacks (7.7%) or Hispanics (8.7%). Significantly,
the digital divide between racial groups in PC-ownership has increased since 1994. In 1997,
the difference in PC-ownership levels between White and Black households was 21.5 per-
centage points, up from 16.8 percentage points in 1994. Similarly, the gap in PC-ownership
rates between White and Hispanic households in 1997 has increased to 21.4 percentage
points, up from 14.8 percentage points in 1994. This gap has increased at almost all income
levels, including at incomes above $75,000, where some might have expected computer-
ownership rates to converge." This study demonstrates the resiliance of racial hierarchies in
online culture. The 9th GVU WWW survey confirms the overall whiteness of the nets,
reporting that 87.4 percent of users are white (although the self-selection GVU survey tech-
nique diminishes its reliability). See http://www.cc.gatech/gvu/user_surveys/survey-1998-
04/reports/1998-04-General.html.

38. For discussion of the legal issues of online anonymity under the Telecommunications Act
of 1996, see David G. Post, "Pooling Intellectual Capital: Thoughts on Anonymity,
Pseudonymity, and Limited Liability in Cyberspace," 1996 *University of Chicago Legal
Forum* 139 [http://www.cli.org/DPost/paper8.htm].

39. Jonah Peretti, "Capitalism and Schizophrenia: Contemporary Visual Culture and the
Acceleration of Identity Formation/Dissolution," *Negations*, Winter 1996
[http://www.mii.kurume-u.ac.jp/~levers/Links.htm]).

40. The "one man, one vote" concept failed most notably on the Internet when Turkish admirers sent millions of multiple e-mails supporting Mustafa Kemal Ataturk in *Time* magazine's contest to select the most influential person of the twentieth century. Winston Churchill narrowly defeated Ataturk. "Who Will Be Time's 'Person of the Century'?" 7 November 1997 [http://europe.cnn.com/US/9711/07/people.of.century.ap/].

41. Barlow aligns his argument here with atoms-to-bits future theorists, most notably Negroponte, 3–85, and Mitchell, *City of Bits: Space, Place and the Infobahn* (Cambridge, MA: MIT Press, 1995).

References

Print

Augustine. *City of God*, Henry Bettenson, trans. London: Penguin, 1984.

Auster, Paul. *City of Glass*. New York: Penguin, 1985.

Baldwin, George. "Public Access to the Internet: American Indian and Alaskan Native Issues," in *Public Access to the Internet*, Brian Kahin and James Kellar, eds. Cambridge: MIT Press, 1995.

Brown, Alison Leigh. *Fear, Truth, Writing: From Paper Village to Electronic Community*. Albany: State University of New York Press, 1995.

Bryant, Wanda. *Virtual Music Communities: The Folk Music Internet Discussion Group as a Cultural System*. Ph.D. dissertation, UCLA, 1995.

Byatt, A. S. *Babel Tower*. New York: Vintage, 1998.

Castel-Bloom, Orly. *Dolly City*, Dalya Bilu, trans. London: Loki Books, 1997. Originally published by Zmora Bitan, Tel Aviv, 1992.

Civille, Richard. "The Internet and the Poor," in *Public Access to the Internet*, Brian Kahin and James Kellar, eds. Cambridge: MIT Press, 1995.

Crockett, Roger O. "Black Entrepreneurs: Invisible—And Loving It." *Business Week*, 5 October 1998.

Crystal, David. *English as a Global Language*. Cambridge: Cambridge University Press, 1997.

Dumett, Susan. "O2: Net Lifeline—Project Oxygen Plans to Infuse 200 Remote Countries with Digital Vitality." *Inter@ctive Week*, 31 August 1998, 36.

Eco, Umberto. *Serendipities: Language and Lunacy*, William Weaver, trans. New York: Columbia University Press, 1998.

Fichte, Johann Gottlieb. *Addresses to the German Nation*, George Armstrong Kelley, ed. New York: Harper and Row, 1968.

Frederick, Howard. "Computer Networks and the Emergence of Global Civil Society," in *Global Network: Computers and International Communication*, Linda Harasim, ed. Cambridge, MA: MIT Press, 1993.

Hagel, John. *Net Gain: Expanding Markets through Virtual Communities*. Boston: Harvard Business School Press, 1997.

Harasim, Linda, ed. *Global Networks: Computers and International Communication*. Cambridge, MA: MIT Press, 1993.

Harmon, Amy. "U.S. Expected to Support Shift in Administration of the Internet." *New York Times*, 20 October 1998, C1.

Hegel, Georg Wilhelm Friedrich. *Lectures on the Philosophy of World History*, H. B. Nisbet, trans. Cambridge: Cambridge University Press, 1975.

Hobart, Michael E. and Zachary S. Schiffman. *Information Ages: Literacy, Numeracy, and the Computer Revolution*. Baltimore: Johns Hopkins University Press, 1998.

Holmes, David, ed. *Virtual Politics: Identity and Community in Cyberspace*. Thousand Oaks, CA: Sage, 1997.

Howard, Tharon W. *A Rhetoric of Electronic Communities*. Greenwich, CT: Ablex, 1997.

Kant, Immanuel. *Observations on the Feeling of the Beautiful and Sublime*, John Goldthwait, trans. Berkeley: University of California Press, 1960.

Kroker, Arthur and Marilouise. *Digital Delirium*. New York: St. Martin's Press, 1997.

Lockard, Joe. "Resisting Cyber-English," in *Bad Subjects Anthology*, Bad Subjects Collective, ed. New York: New York University Press, 1997.

Locke, John. Peter Laslett, ed. *Two Treatises of Government*. Cambridge: Cambridge University Press, 1960.

Miles, Robert. *Racism*. London: Routledge, 1989.

Miller, Henry. *The Colossus of Maroussi*. New York: New Directions, 1941.

Mitchell, William J. *City of Bits: Space, Place and the Infobahn*. Cambridge: MIT Press, 1995.

Narayan, R. K. *The English Teacher*. Chicago: University of Chicago Press, 1980.

Negroponte, Nicholas. *Being Digital*. New York: Knopf, 1995.

Ortega y Gasset, José. *History as a System*. New York: W. W. Norton, 1941.

Paine, Tom. *The Age of Reason*, Daniel Wheeler, ed. New York: Vincent Parke, 1908.

Post, David G. "Pooling Intellectual Capital: Thoughts on Anonymity, Pseudonymity, and Limited Liability in Cyberspace." *University of Chicago Legal Forum* 1996, 139.

Rheingold, Howard. *The Virtual Community: Homesteading on the Electronic Frontier*. Reading, MA: Addison-Wesley, 1993.

Schön, Donald, Bish Sanyal, and William J. Mitchell, eds. *High Technology and Low-Income Communities*. Cambridge: MIT Press, 1999.

Senghor, Léopold Sedar. *Ce Que Je Crois: Négritude, Francité et Civilisation de l'Universel*. Paris: B. Grasset, 1988.

Shapard, Jeffrey. "Islands in the (Data) Stream: Language, Character Codes, and Electronic Isolation in Japan," in *Global Networks: Computers and International Communication*, Linda Harasim, ed. Cambridge, MA: MIT Press, 1993.

Stephenson, Neal. *Snow Crash*. New York: Bantam, 1985.

Todorov, Tzvetan. *On Human Diversity: Nationalism, Racism, and Exoticism in French Thought*, Catherine Porter, trans. Cambridge, MA: Harvard University Press, 1993.

Trask, Haunani-Kay. *Light in the Crevice Never Seen*. Corvallis, OR: Calyx Books, 1994.

Vizenor, Gerald. *Wordarrows: Indians and Whites in the New Fur Trade*. Minneapolis: University of Minnesota Press, 1978.

Wallerstein, Immanuel. *Geopolitics and Geoculture: Essays on the Changing World-System*. Cambridge: Cambridge University Press, 1991.

Zizek, Slavoj. "Multiculturalism, Or, the Cultural Logic of Multinational Capitalism." *New Left Review* 225 (1997): 28–51.

Online

Asian Avenue. [http://www.CommunityConnect.com/AsianAvenue.html].

Babel Fish. [http://babelfish.altavista.digital.com/cgi-bin/translate?].

Barlow, John Perry. "A Declaration of the Independence of Cyberspace." [http://www.eff.org/~barlow/Declaration-Final.html].

Beijing University of Posts and Telephony. [http://www.bupt.edu.cn/camnet/97telcom/eng/E3.html] and [http://www.bupt.edu.cn/camnet/97telcom/eng/E2-1.html].

Cencebaugh and Aquarian. "Virtual Surrealist Manifesto." [http://www.emf.net/~estephen/manifesto/aum00040.html].

Chinese Internet. [http://www.nua.ie/surveys].

Dyson, Esther, George Gilder, George Keyworth, and Alvin Toffler. "Magna Carta for the Information Age" [http://www.feedmag.com/95.05magna1,html].

Fernback, Jan and Brad Thompson. "Virtual Communities: Abort, Retry, Failure?" [http://www.rheingold.com/texts/techpoliti/VCcivil.html].

Georgia Tech University. "9th GVU WWW Survey" [http://www.cc.gatech/gvu/user_surveys /survey-1998-04/reports/1998-04-General.html].

Hawk, Andy. "Maniphest Destin-E: What is FutureCulture?" [http://www.eerie.fr/~alquier/Cyber/fc-manifesto.html].

"Identity, Privacy, and Anonymity on the Internet" [http://eng.hss.cmu.edu/cyber/identity.txt].

Kinney, Jay. "Anarcho-Emergentist-Republicans" [http://www.well.com/user/jay].

Kurtchev, Christian. "Cyberpunk Manifesto" [http://www.trailerpark.com/phase1/madbyte/INFOBASE/MANIFEST.HTM].

Lockard, Joe. "Virtual Whiteness and Narrative Diversity." *Undercurrent* 4 (Spring 1996) [http://darkwing.uoregon.edu/~ucurrent/uc4/4-lockard.html].

May, Timothy. "Crypto Anarchist Manifesto" [http://spunk.etext.org/texts/comms/sp000151.txt].

Mentor. "The Conscience of a Hacker" [http://pages.prodigy.com/freeside/hacker.html]

Nakamura, Lisa. "Race in/for Cyberspace: Identity Tourism and Racial Passing on the Internet" [http://www.hnet.uci.edu/mposter/syllabi/readings/nakamura.html].

National Telecommunications and Information Administration. [http://www.ntia.doc.gov/ ntiahome/net2/falling.html].

Peretti, Jonah. "Capitalism and Schizophrenia: Contemporary Visual Culture and the Acceleration of Identity Formation/Dissolution" *Negations* (Winter 1996) [http://www.mii.kurume-u.ac.jp/~levers/Links.html].

Schwartz, Al. "Cybernaut Manifesto." [http://www.ultra.net.au/~wisby/manifest.htm].

"Who Will Be Time's 'Person of the Century'?" *Time Magazine*, 7 November, 1997. [http://europe.cnn.com/US/9711/07/people.of.century.ap/].

Wilson, J. Richard. "Cyberfeminist / Bitch Mutant Manifesto" [http://sysx.apana.org.au/artists/vns/manifesto.html].

Winner, Langdon. "Cyberlibertarian Myths and the Prospects for Community" [http://www.rpi.edu/~winner/cyberlib2.html].

11. The Computer Race Goes to Class

How Computers in Schools Helped Shape the Racial Topography of the Internet

Jonathan Sterne

Origins of the Present Crisis

This chapter rests on a basic assumption: that considerations of race and the Internet must account for the relationship between the politics of race online and the politics of race as such. Many utopic visions of the Internet conceive of it as a raceless space, a space somehow beyond the politics of race, a frontier where people can remake themselves in their minds' chosen images. Yet the vast majority of Internet users are still white (Hoffman); the very idea of cyberspace's "racelessness," the belief in its separation from the racial politics of other spaces of everyday life is, as Joseph Lockard puts it, "unmistakably signed with Euro-American whiteness" (227). How did race get written out of computing? How did whiteness become a default setting for online culture?

A consideration of the history of computers and schooling in the 1980s can help clarify these issues. My reasoning is simple: if white people in the United States had a distinct advantage over people of color in learning computing and gaining access to computers, then that would go a long way toward explaining why the Internet remains predominately and presumptively white (though it is far from entirely white). A history of computers in schools offers

a fresh perspective on the Internet because it places modem use and Internet activity within the broader context of the history of computing. Though it should be blandly obvious to readers that access to a computer and the skills to make use of it are prior conditions for a person or a group of people to go online, surprisingly little Internet research follows through on this basic premise.

This essay traces the history of computers in schools as a way of tracing the problem of differential access. As I will show below, both educators and computer industry executives believed that children should first encounter computers in elementary and secondary schools. For educators, computers became a literacy issue, and "computer literacy" emerged as an education buzzword in the 1980s alongside "math literacy," "science literacy," and of course the fundamental kind of literacy that allows you to understand the words printed on this page. The basic concerns of computer literacy of the 1980s have fed into larger concerns about connecting schools with the National Information Infrastructure; students, it is said, will need new "high-tech" skills for the changing economy of the future, even though the purported "high-skill" economy is more myth than inevitability (Neill 183). For the computer industry, on the other hand, exposing children to computers was considered good long-range marketing. Like fast food, the idea was that if children were exposed to a product at an early age, there was a greater potential that they would become loyal consumers for life. Instead of carrying a neutral valence or even a positive one, the very idea of computer literacy is conflicted at its core: while educators clearly intended computer literacy as the ability to to control machines, the language of literacy can easily degenerate into the project of creating consumer populations for communication technologies. As I will show below, major computer companies actively pursued this agenda in their policies on schooling.

Moreover, even a superficial comparison of computer literacy with language-based notions of literacy demonstrates the weakness of the analogy. Literacy with a pen traditionally means being able to write as well as read. Yet this strange species of curriculum known as media literacy has more often than not stopped short of being able to "write" in any other medium but print. Computer literacy usually means being able to make use of programs, but means little in the way of programming skills. While more people are able to use computers as tools for performing writing tasks—such as the writing I am doing now for this essay, or building a webpage—the vast majority of end users have relatively little control or understanding of computing beyond the

use of programs for specific tasks. In other words, computer literacy is a completely functionalist approach to what it means to be literate or competent in a particular idiom. The analogy between writing literacy and computer literacy as it is currently conceived breaks down: if writers were literate like they were computer literate, they would be able to put words and sentences together in "wizardized" order, but they would not understand the basic rules of grammar or syntax. The print analogue of computer literacy standards would be filling out a contract, and in fact, contracts were some of the first printed documents to make it into many people's everyday lives in the late 1700s: many people were literate enough to fill out a contract, yet unable to write something on their own (Warner 31–32).[1] One can hope that computer literacy would take, over the next two centuries, the same path as mass literacy did, but at present, that remains just a hope.

The focus on schools as the agents of this new literacy meant that unequal conditions of schooling would have a significant impact on children's access to computers and computer experience. Already significant race-based inequalities in schooling were exacerbated in the 1980s, exactly when computers were first entering American public schools. Over the course of the 1980s, and especially in terms of differences such as white and black or poor and rich, federal social policy on public schooling had been "turned back almost one hundred years" (Kozol 4). Federal defunding of public schools led to greater inequalities in resources and funding between white and nonwhite schools within districts, and greater inequalities among different school districts, depending on their location and local tax base. With less federal funding to balance resources between richer and poorer schools, school districts relied more heavily on funding from sources like property tax revenue, a form of revenue completely dependent on property values and thus susceptible to existing inequalities in housing (and this had a cyclical effect as well, since the quality of an area's schools affects property values within the district). School *location* remains a primary issue because the quality of children's educations is strongly tied to where they live.

This suggests that the social space of schooling and the imagined space of cyberspace are not nearly so far apart as technophilic pundits would have it. The politics of region return as the repressed: the topology of cyberspace mimics the racial and economic topology of housing and schooling. Fiber optic cable, phone jacks in classrooms, and other "on-ramps" to the NII are more frequently found in wealthier and whiter areas. Maybe cyberspace isn't so removed from the materiality of social life after all. Maybe cyberspace is a

misleading concept for framing the problem of race and the Internet. Discussions of cyberspace that abstract it from computer culture more generally risk mistaking the experiential for the ontological. Concepts of cyber-"space"—and I think the term deserves scare quotes—mystify the phenomenology of consumption. From inside netsurfers' minds or Microsoft commercials, we can imagine "traveling" to other places. From outside the netsurfers' bodies, we see people sitting still at computer terminals in their homes, schools, libraries, and places of work, clicking mice and occasionally typing in responses or commands. People need access to and basic skills with a computer to get online. They need a reason or a motivation to go online. The desire to use a modem is not present in human beings at birth. The idea that cyberspace is purely about people's experiences online is a mystification of the medium itself—it reduces a whole set of social relationships and cultural problems to the experience of using a computer hooked into the Internet.

Academics have too easily accepted this kind of commercial discourse on computing as somehow external to computer culture, as an accurate description of it. Technological determinism has its roots in commodity fetishism: the belief that computers can change our lives is based on the widespread belief in the transformative power of commodities. This is probably the most coherent and insistent message present in twentieth century advertising (see, e.g., Ohmann). This kind of thinking pushes together many different registers of discourse and activity. The technology, the techniques of using computer technology, the culture that has arisen around computing, and the everyday language used to describe computing are all collapsed into a metadiscourse that simply mimics the commercial language. The very idea of "cyberspace" is a cultural artifact, an element *of* computer culture, and not a description from outside it. If our goal is a critique of the Internet's status quo, then we have to begin by checking our language: we should choose our metaphors deliberately, questioning our own predispositions toward certain ways of describing online life. The alternative is to unthinkingly universalize a very particular set of meanings and experiences of computing.

This kind of solipsism—applied to the question of race—is an important and pernicious element of Internet discourse. My own experience supports Lockard's assertion that the Internet's "nullness" slips quite easily into whiteness. In my research for this article, I scanned the archive for CYHIST—a listserv devoted to the "history of cyberspace"—for terms like "race," "minority," and "ethnic," finding very few hits at all. One participant commented,

Personally, I think the detachment that an indirect, online venue provides, is EXACTLY the "buffer zone" the human psyche has always needed. When you're online, you're the only person who's "real" to you; everyone else is just a bunch of words expressing thoughts. Personalities come through sufficiently to "like" or "dislike" someone, but if THEY DON'T BRING IT UP, you're NOT going to even have to DEAL WITH issues such as age, race, nationality, gender, religion, etc.—in short, most of the differences that are sadly, and so unnecessarily, responsible for so much of the pain and suffering in the world. We've all had the experience of meeting someone online, liking him/her, deciding to "meet in person," and being sorely disappointed to find that that person is so much LESS, in person, than he/she is online! (Chiesa)

While the poster clearly understands himself as antiracist, the notion lying behind the post is clearly that difference—and knowledge of difference—is an obstacle to equality. As a listserv participant, I have repeatedly seen this kind of gesture made online: the introduction of discussions of race into a discussion is cast by a white list participant as the act which produces racial inequality by referencing it. Yet, as Lisa Nakamura has pointed out, people also will take on racialized identities (their own or others') in multiuser chat domains; and there are alt.sex usenet groups dedicated to the discussion of sex with people of particular races. She calls these and other practices of selective racial naming "identity tourism." The net effect of these practices, when coupled with the white ideology of racelessness, is to produce an online atmosphere of racial voluntarism—where race is seen as something that can simply be chosen or forgotten at will.

The functions of primordial racelessness and racial voluntarism, while firmly based in a humanist ethos (i.e., "we're all the same under the skin"), risk dismissing the very real effects of race on people's lives. In fact, I would argue that such vacillation between the fluidity and marked absence of racial identity in the limited context of "online culture"[2] is a significant part of the larger structures of racial inequality on which that online culture is based. One does not choose the color of one's skin, and though racial identity is *constructed*, it is never simply chosen (Dimitriadis).

If today the Internet remains a largely (though not entirely) white space, this may well have something to do with the history of access to computers and existing racial differences offline, and schooling is a key site. People of my generation often first encountered computers as children through their schools, and

that differential access to computing in the 1980s is a structuring element of today's online culture. Though I knew of computers' existence through my parents' work, my first experiences were on an Apple II in fifth grade, playing rudimentary games and doing rote exercises. As I went through school I was required to take several basic computer literacy courses; I did well in them, but I was by no means a whiz kid. By the time my family bought a computer in 1984, I understood all of its basic functions including the use of the modem, I could program it in BASIC and DOS, and I easily learned the software that we purchased with the machine. Within days of my family's purchase of a computer, I logged into local bulletin boards and began an online life under several aliases. My experiences using the computing resources of a white, moderately affluent suburban school district thus helped shape my attitude toward computers, and gave me an opportunity to learn and use them in a supportive context.

Over the course of the 1980s, students' encounters, attitudes toward and access to computers were shaped by the racial and class differences in quality of schooling—differences that were amplified by the cuts in federal spending on education discussed above. What are the root causes of these inequalities? Why the interest now? The very existence of this collection speaks to race as a central and salient issue in Internet studies and also points to Internet scholars' relative inattention to the problem of race thus far. Is cyberspace special in some way, or are the inequalities online simply extensions of a more general state of social inequality and political domination?

The category of race itself also requires some reflection in the context of computing: race is not simply a placeholder for class when it comes to computers and the Internet. While economic class certainly impacts people's access to computers, it does not entirely explain it. *American Demographics* has reported that low income families (white and nonwhite) are willing to spend money on computers for their children if the children have access to computers in schools (Larson). Although computer marketing tended to aim for what Eileen Meehan has called the "consumer caste"—those people with the most apparent money to spend—we cannot assume that economic status (beyond a certain baseline) and the cost of the computer proportional to family income are determinant factors in a family's decision to purchase a computer. It is entirely possible that the race gap online would be narrower today if nonwhite children—especially African American, Latino/Latina, and Native American children—had the same access to computers in schools that their white counterparts did. The racial and class dimensions of computer access through schools are clearly linked, but not simply as a matter of reflection of cause and

effect. Instead, they operate in a "nonsynchronous" fashion (McCarthy 66–67), where categories may overlap and emphasize one another, as is often the case in school funding, or they may operate in contradiction, as is apparently the case in families' dispositions toward buying computers.

Even considered nonsynchronously, race as an academic problem suffers from many of the same problems that academics have had with respect to discussions of cyberspace (or perhaps it would be more accurate to say that academic discussions of cyberspace have fallen to the same habits of thought that can obscure academic discussions of race): they use terminology that is an artifact of a relationship, that has a function in that very relationship, as a metadiscourse that purports to "objectively" describe the relationship from outside. For the purposes of many of my sources here, it is the white/black dichotomy that structures racial discourse. Yet it is just as fallacious to make "black" a placeholder for "raced" as it is to make "white" a placeholder for "race-less." Much of my source material operates on this dichotomy, and therefore it informs this essay more than I would like it to. Still, discussions of differential race relations cannot go forward until there is a clear recognition that racial difference is as nonsynchronous internally as it is externally. In other words, if the experience of class does not have a predetermined relationship to the experience of race, then neither does the experience of African Americans necessarily reflect the experience of, for instance, Asian Americans. Readers should bear this in mind when generalizing from the history and the materials herein.[3]

Bringing the Computer Race to Class

The notion of the transformative power of computing needs to be read against actual social relationships external to computing. While the rhetoric of social and cultural transformation-by-computer was well established by the 1980s, it retained an uneasy relationship with both the facts and the representation of race. As a result, early computer discourse—when it did actually address race—elaborated the belief in social transformation through better management and training of students—technophilia and paternalism went hand in hand. This was, perhaps, part of the larger attitude toward differential access: it was somebody else's problem, and best solved through simple administrative adjustments of one sort or another.

At the time of my own school-based computer education, scholarship and popular writing on computers was almost unanimous: get computers into schools, get kids involved in computing, and the earlier the better. The main-

stream news media and businesses were flooded with stories about the arrival of computing and the importance of getting computers into schools. A *Time* magazine feature from 1982 entitled "Here Come the Microkids" focused primarily on kids' encounters with computers in schools. When it did talk about race, it was largely in paternalistic tones:

> Lewis Stewart, 14, a black ninth-grader at Manhattan's P.S. 118, reads at a fifth-grade level, yet mastering his school's computer was literally child's play for him. Recognized by students and teachers alike as his school's best computer programmer, Lewis works afternoons as an instructor for a computer consulting firm, introducing younger children to the machines. Last year his employers sent him to Chicago, where he displayed his special teaching gifts before a meeting of educators. As Lewis told *Time* Correspondent Peter Stoler, "I love these machines. I've got all this power at my fingertips. Without computers, I don't know what I'd be. With them, I'm somebody" (Golden).

The message here is clear: even dumb black kids can master a computer. No other student's reading aptitude is mentioned anywhere in the article; nowhere is a student's self-esteem deemed an important issue to report on. Later, the piece makes itself a little clearer: though computers are largely to be found among affluent schools, the machines are also found "in the unlikeliest of places. On a Chippewa Indian reservation in Wisconsin, computers are being used by young members of the tribe to learn their ancient and nearly forgotten language" (Golden). The unspoken assumption here is that computers are for white people: the reporter's expressions of surprise and concerns for students' self-esteem appears limited to students of color. The disparity between rich and poor, white and nonwhite is here written off as a minor glitch that can easily be overcome, while expressions of surprise serve as a placeholder for a larger tacit understanding about who is expected to be using computers.

Business reporting featured stories about schools as the next big market for computer companies. The earliest reports featured schools using computers as on the cutting edge. *Fortune* ran a piece on an elite school requiring computers for its students as early as 1980 (Tracy, Brown, and Pillsbury). A 1982 *New York Times* article on the growing popularity and dropping prices of home computers credited school use with children's interest in the machines (Pollack). Later that same year, the *Times* ran a story on schools being a key market for both current and future computer sales. A slew of other pieces followed (Morrow; Rowe; Waters). A *Forbes* piece in 1984 reported,

According to Talmis, a Chicago-based market research firm, there will be 720,000 personal computers in schools by year-end. That number pales before the almost 6 million business computers or over 6 million home machines. But consider the potential. The 50 largest school districts in the U.S., with over 9,000 schools, average only one computer for every 170 students. Ideally, educators agree, that ratio should be more like one for every three or four students. At even $500 a computer, that's $15 billion of potential demand (Wiegner).

Unsurprisingly, differential access was hardly a concern for the business press in this period. While writers frequently noted that wealthier children tended to get an advantage in terms of computer access, little more was said than to note the disparity (AP; Wiegner). Race and class were collapsed together as a single kind of difference, and then relegated to an afterthought, an additive; "how do we include these other people?"

During this same period, education scholars were flooded with book after book on how to integrate computers into schools and curricula, and how to decide which computers to buy. Similarly, the theory behind getting kids to computers was being elaborated: educators were calling computers "an integral part of the comprehensive K-12 school of the 1980s" (LaFrenz). Even the purportedly critical work at this point doesn't get beyond mentioning inequality. For instance, an anthology on computer literacy lists "the presence of computers for instruction in all schools and all students" as a prerequisite for nationwide computer literacy, and then claiming that "it is believed that we are now at a point where such a recommendation is both economically and technologically feasible" (Deringer and Molnar 6). Similarly, an edited volume entitled *The Computer in Education: A Critical Perspective* contained all manner of critiques of computers from the perspective of pedagogical theory and practice, but not a single discussion of limited resources or access. Douglas Sloane writes in his introduction that perhaps people feel the computer "revolution" is inexorable, and therefore there is nothing for them to do but adapt to it. The critique begins from that point:

> Chances are, this is all quite true. Hidden in this assumption, however, is often another, altogether different premise: namely, that human beings have no responsible choices whatsoever in shaping, restraining, and directing this revolution, that coming to terms with it means going along with it on its own terms [...] (Sloane 2).

While Sloane is concerned about the connections between the computer, defense, and pharmaceutical industries having a negative impact on academic

freedom and on students, his main critique of computing is that it stifles children's emotional and image-based learning (7–9). While he acknowledges that "the warning signs of increasing social, economic and cultural inequalities and disruptions arising from the growth of high technology call for the best critical thought from those concerned with the career and vocational dimensions of education" (3), the book offers no such social, cultural, or economic critique.

In the same volume, Harriet K. Cuffaro offers a very insightful critique into the notion that "earlier is better" when it comes to getting computers to children. She argues that based on current knowledge of the psychology of education, that

> It is when children are more firmly into functioning at the concrete operational level, at about age eight, that they are better able to take true advantage of the challenges that computers and programming may offer. Much adult eagerness to have young children use computers is based on the belief that it will be impossible to function or to be employed in the future without such expertise or knowledge (27).

Once again, the critique already accepts the parameters of the debate. Here, the best age is interrogated, but the assumption once again is that computers are essentially an administrative problem: how, when, and where to best use them is considerably more at the forefront of educators' minds than how and whether to get computers in the first place. As Cuffaro herself points out, many children who grew up without computers were able to use them intelligently and creatively when the time came for them to compute (27). Though writing at a time when computer access is severely limited for large sectors of American society, these academic writers bracket this fundamental problem, as if universal access is simply an inevitability; simply a matter of waiting for the rest of the world to catch up with them.

Yet from the very outset, writers had an acute sense of social difference, whether across the borders of nation or just neighborhood and school district. As in the *Time* article, an unspoken set of assumptions about race pervaded the discussions of computer literacy and the future of computing. Occasionally, in particularly outlandish examples, such assumptions might become visible:

> In human history it is always those who were able to develop and use new technology adroitly who in the long run not only survived better, but also came to dominate others. Homo sapiens cerebus will survive

and prosper, and in due course dominate all those who do not partake of the new intellectual technology. Among higher organisms, new behavior patterns, rather than new anatomical features, set the stage for a revolution as profound as the hominid revolution of half a dozen, or so, million years ago. Will we be able to cope with it? (Stonier and Conlin 196)

As Robins and Webster point out, while this integration of social Darwinism with high-tech ideology is a particularly strident instance of technological ideology, it nevertheless emerges from a very large body of literature where technological innovation and social progress are one and the same thing (106). The reasoning underlying this kind of "compeugenic" rhetoric is purely tautological: as if those who have superior intelligence will develop it, while those races lacking it won't. It biologizes intelligence in the most cliched fashion possible, while laying bare the implications of a mythos of technological progress more generally: "you get what you deserve." It is easy to be critical when the eugenic language is trotted out to support this kind of thinking, but technophilic discourse in general bears the trace of this kind of categorical thinking: as if the people with the better gear are the better people, more advanced, more developed.

Enfranchising Minorities through Enriching Elites: The Technology Act of 1982

Computer manufacturers were of course quite interested in rectifying the lack of computers in schools. To this end, corporations donated computers (as a tax write-off) to programs they thought would be particularly useful or successful. But in 1982 the stakes were raised when Steve Jobs, CEO of Apple Computer, convinced California representative Pete Stark to introduce a bill greatly increasing the tax break for corporate donations of computers to schools. The case of H.R. 5573 provides an interesting example of where and under what conditions "race" was deployed in early computer discourse; race was clearly blurred with class in discussions of the bill. The bill, which advocates called "The Technology Act of 1982" and was popularly known as "the Apple Bill," would have temporarily loosened corporate tax regulations to allow an unusually high level of corporate donations of computers to schools. Apple had announced that if the bill was passed, it would give a computer to every single school in the country. Lawmakers seemed divided. While the

House passed the bill by a vote of 323–62 with 47 abstentions, the Senate passed a slightly different version of the bill less favorable to equipment donations. The bill died in conference committee when the ninety-seventh Congress adjourned.[4]

While H.R. 5573 is not a key turning point in the history of computing in schools, the hearings on the bill mark an important moment in the racial history of computing. The hearings show quite clearly how and on what terms questions of race and differential access were framed in discussions of computing in the early 1980s. This also shows the degree to which the vision of corporations was allowed to set the terms of the debates around computing.

The bill itself contained some precautions against corporate abuses. For instance, corporations could not donate product over six months old, thereby guaranteeing that they wouldn't try to flood the educational market with equipment that wouldn't sell otherwise. Similarly, the tax write-off was good for only a year, meaning that this would be a one-time effort to get computers into schools. Nevertheless, there were some serious objections. Apple was already a leader in the educational market, and it, along with several of the other big computer companies—most notably Hewlett-Packard—stood to gain a lot from this legislation. The bill clearly favored larger corporations that could afford to build and move the extra stock in a short time period. While Apple was offering to donate a single computer to every school in the country, other corporations like Hewlett-Packard and Tandy focused on the possibility of training programs for teachers and the development of educational support software. Additionally, the bill left many questions unanswered: What would happen after this one year period? Were Apple's computers purely for student use or could they be put to administrative use as well? What kinds of ongoing support could schools expect after the initial donation?

The Department of the Treasury adamantly opposed the bill on the grounds that it did not foster "disinterested charity" and that it could double or even triple corporate tax deductions (see House 4–5, 15–16). Had the bill become law, its effect would have been notable, but not revolutionary by any means. At the time, it was well known among educators that a single computer in a school was of almost no pedagogical use. A survey from 1982—the same year the Technology Act was considered by Congress—showed that junior high and high school students often didn't even know they had access to a computer in their schools (Anderson 13–14). Reporters were also clear that entire computer labs were necessary to provide effective computer education to students (Wiegner).

Yet the debate characterized the bill as providing needed computers to students who otherwise would not have access; and race was a key issue just beneath the surface of these debates. Race was an explicit theme in talking about corporate philanthropy—as a way of talking around class issues. Emery Rogers, Chairman of the National Grants Review Board of Hewlett-Packard, proudly announced,

> We have observed a situation in our own neighborhood where H-P made a grant of ten personal computers to a high school in an area with largely minority enrollments. It is exciting to hear those kids after they have stepped into that program and have developed a sense of self-confidence. They will get the summer jobs; they are going to be able to work at Apple or Hewlett-Packard or some other computer oriented company; and equipped with useful knowledge they can step out of the frustration loop. These young people have confidence in themselves, and, furthermore, they find that nobody at the school teases them. There is a widespread desire to get into these programs (House 31).

Rogers's rhetoric here is interesting in its sleight of hand—computers bring "minority" kids self-esteem that they wouldn't otherwise have. Once again, computer access was about self-esteem for "minorities": the implication being that they were expected to have less self-esteem, and maybe needed a little help from the white people in the corporations. Thanks to corporate beneficence, "minorities" can step out of the so-called frustration loop. Here, Rogers uses race as a euphemism for the double injuries of race and class. The unspoken assumptions here should be clear but are worth mentioning: that schools with minority enrollments are poor schools; that largely white schools are better off; that minority kids need help to get out of poverty (what Rogers metonymizes as the affect of frustration). While I have no doubt that Hewlett-Packard did in fact donate computers to a relatively poor school, it is clear that part of Hewlett-Packard's claim is that they bridged a racial—or at least racialized—difference between ostensibly white computer culture and "minority" students.

Though many white organizations had benefited from Hewlett-Packard's charity over the years, Rogers focused on race:

> We think literacy in science is crucial to this country. We lend smart people at H-P to minority colleges and to a high school or two to help those organizations generate and implement science and engineering courses. [...] (31).

The quote counterpoises smartness and "minority"—the smart people move from Hewlett-Packard to minority schools, and not the other way around.

Race also figured in the hearings on H.R. 5573 as an external threat, and here the coding moved from African American or Native American to Asian. Other speakers, while more clear on class issues, used invocations of racial difference as a foil; Tennessee Representative Albert Gore, testifying in favor of the bill as the head of the Congressional Clearing House on the Future, invoked class as an issue in the legislation, making racial difference a kind of external threat to the nation:

> We must remember that our high school students are able to pursue an elective education only so far—often only as far as the school's resources.
>
> In the case of computer hardware and instruction, those resources are nil.
>
> We occasionally read about an exciting new effort by a progressive—and usually affluent—high school to develop a computer oriented curriculum. I wish I could tell you today that such programs abound in my State of Tennessee.
>
> Unfortunately, among the 295 public secondary schools with more than 260,000 students, there are no more than a small handful of courses in computer literacy, much less actual hands-on computer hardware opportunities (20).

Gore invoked the specter of the "Japanese"—"we are constantly made aware of our need to catch up with the Japanese," but that education is not allowing the United States to maintain its entitled dominance:

> Our secondary schools and educational planners recognize this problem, and they are capable of planning for it but their hands are often tied by budgetary constraints.
>
> The purchase of a $2000 computer and maintaining the instructor to use it is simply out of reach for most public schools, certainly those in my district and through the State of Tennessee.
>
> The modest tax deduction allowed in H.R. 5573 may be one answer—and I believe it is—a very limited impact on revenues with a clear long-range benefit for schools throughout the Nation and for our society (21).

There is a slippage between nation and race in the nationalist rhetoric the advocates for the bill used: while the sentiment was nationalist, there were

clearly racial undertones in the way that nationalism was articulated. Similarly, Rogers pointed out that "I have just read an editorial in *Science* magazine which says that because of the deplorable state of equipment in many of the teaching situations in America, the students are going to be trained as if they had graduated from a school in a developing country" (31).

Yet for all the allusions to economic inequality, there was no questioning of corporate sponsorship of computer literacy, the dependency on corporations' beneficence to get computers into schools. Apple CEO Steve Jobs described Apple's promise to donate a computer to every school in the nation as "enlightened self-interest," in that a generation of kids who grow up using computers are more likely to buy one, and that Apple hopes to help other states "duplicate the success of the State of Minnesota" in developing training programs and software applications for donated computers (25–26). Jobs also anticipated the critique of corporatizing education:

> This brings me to what is truly important about H.R. 5573. While the Bill may someday benefit any company which donates computers under its provisions, the important point is that the Bill is clearly good for the United States. Hopefully we have not come to the point in this country where any law that may be even remotely good for business automatically is perceived as bad for the country. In the area of technology particularly, that perception is fatal to the long term well being of America (27).

Similarly, Representative James M. Shannon of Massachusetts claimed that corporations giving schools computers directly was "simply the most efficient way" to help fill the need for technology education (18–19). In this rhetoric, corporate interests *became* universal interests. Jobs' hyperbolic warning that an "antibusiness" sentiment was behind criticism of the bill reads as simply ludicrous when considered in the broader context of federal legislation at the time: the loosening of regulations on industry after industry and the increasing tax breaks for wealthy individuals and corporations that characterized American lawmaking in 1982 could hardly be read as antibusiness. Jobs was essentially red-baiting his opposition.

Alongside these appeals to the immutability of the interests of technology business, appeals to racial difference and inequality were clearly used as a kind of rhetorical lever to help propel the bill through committee, but H.R. 5573 would have hardly begun to address real inequalities in access to computer education. Instead, it would have simply accelerated the proliferation of com-

puters in schools but upheld existing inequities. The racial topology of computers is thus at least as much structured by race relations external to it as it is an agent in transforming those relationships. While the hearings claimed that computers could change students, the hearings show that the stratification of students had already shaped computer culture.

Race Reclassified: Into the 1990s

Though H.R. 5573 never made it into law, computer companies increasingly began to target nonwhite and poor populations for their educational computer grants (Apple, for instance, touted this through their public relations department; see Business Wire).[5] Still, the criteria for educational donations are telling. According to the 1986 *Taft Corporate Giving Directory,* Apple made equipment donations that would "stimulate software development and produce important models of educational software." In the terse, fragmented language of the directory, Apple:

> Currently supports model educational computing projects that use microcomputers to enhance teaching and learning. Favors programs in every major discipline that are jointly planned and implemented by school districts, colleges, and universities in different communities throughout the country. Among recent priorities are courseware development in the areas of teacher training; vocational education, microcomputer maintenance/training; simulations (emphasizing the process of learning, problem solving, and practical living skills); and authoring aids (Taft 46).

Clearly, Apple's philanthropic goals were complementary to its commercial goals. It favored educators who were already plugged into larger professional networks (i.e., "jointly planned"), and who already had some access to computing resources and some basic computer knowledge. As a result, these philanthropic goals helped perpetuate already existing stratification of access to computers. Apple's decision-making criteria are even more instructive. Applications for educational-affairs grants were decided on the bases of uniqueness of application; potential for widespread use or interest in resulting product; adequacy of procedures specified to complete the project; degree of potential benefit to education or training; capability of achieving expected results; reality of time estimates; evidence of cooperation/coordination; and potential for future support and maintenance of the project (47). As Kenneth Jackson has shown with

respect to the criteria for Federal Housing Administration (FHA) loans, apparently "objective" standards can hide racial biases.[6] Any FHA loan guarantee had to have an "unbiased professional estimate" beforehand that would rate the property itself, the mortgagor or borrower, and the neighborhood. FHA criteria like "relative economic stability" of the area and "protection from adverse influences" were the deciding factors, and as Jackson points out, both carried implicitly white, middle-class assumptions (Jackson 206–207). The same can be said for Apple's criteria: uniqueness of application, potential for widespread use or interest, and potential for future support could all be read against the existing differences in school funding and district profiles. In short, the criteria could have done at least as much to reward the beneficiaries of existing inequalities as they could have to ameliorate those inequalities.

By 1991, however, Apple's philanthropic priorities had changed. Taft reported that

> the most recent awards were made under grant cycles called "next Steps" and "equal Time." These grants support 80 projects serving student populations that historically have had limited access to computer technology in traditional classroom settings. These groups include linguistic and ethnic minorities, the economically disadvantaged, the disabled, and female students studying math and science (42).

Apple had clearly developed an interest in traditionally underserved populations. But this was not simply an attempt to rectify previous imbalances in their corporate giving. On the contrary, it was part of a larger shift in industry attitudes concerning racial and other differences for the purposes of marketing.

In recent years, nonwhite users have been targeted by manufacturers as the next hot market for computers and Internet services. Race has moved from a question of access to a question of niche marketing. In 1993, Matrix Communications of Pittsburgh made a name for itself selling black-positive clip-art for word processing and desktop publishing programs (Creedy). By the mid 1990s, the mainstream press was reporting on nonwhite groups actively using computers and the Internet while publications specifically geared at particular racial and ethnic audiences urged their readers to go online. While black leaders held congresses and workshops to get African Americans more involved online, articles began to appear encouraging nonwhite audiences to go online and providing guides to nonwhite sites on the World Wide Web (Akst; Fitten; Jenkins; Moore; Poole). At the same time, more and more computer and Internet businesses specifically targeted nonwhite

consumers and especially African Americans. While Microsoft and Black Entertainment Television (BET) formed a joint venture online (MSBET), survey researchers were outlining new marketing directions. One article quoted Edward Sarpolus, vice president of a midwest market research firm, claiming that "among minorities, such as urban African-Americans, computer expertise is seen as a path to self-improvement. [...] The African-American population is younger as a whole. As it reaches prime earning and family years around age 35, a pent-up demand is not being met" (Maurer). Another article touted the Internet for its ability to reach "niche audiences, including minorities that mainstream media often miss" (Messina). Other services like American Visions Society Online sought to lure more African American users on to the Internet by providing a service geared toward that audience (Tran).

It would seem, then, that race is becoming an increasingly important marketing issue for Internet service providers and hardware and software manufacturers. Yet this booming interest in nonwhite audiences is strikingly unsatisfying. To begin with, there remains a significant racial gap in frequency and extent of computer use: white Americans are still considerably more likely than Americans of Hispanic or African descent to have and use a computer at home or at work (Tran). The *Education Technology News* reported in August 1996 that a wide, race-correlated disparity in the quality of computer education at schools still exists; Thomas Novak and Donna Hoffman's controversial study also reported a serious black-white gap in Internet use (Novak and Hoffman). Similarly, Kelly Gates has found in a study of indigenous people's websites that many are entirely run by relatively elite, white webmasters acting as surrogates for the groups online (Gates).

Although a growing nonwhite presence online is something to applaud, we should also be wary of unquestioned adoption of marketing mindsets and frames of reference. Clearly, the issues of access that began to emerge in the 1980s as whiter schools gained more access to computers are still with us today. The legacy of the deep federal cuts in public education over the course of the 1980s and corporations' preference for elite, innovative schools still leaves its mark on computer access and attitudes. Marketing to niche audiences will help, but teaching their children would be a better approach.

Conclusion: E-Raced

Important questions remain about differential access to the Internet across racial lines. Even if there weren't significant racial gaps in Internet access in the

United States, they would continue to exist worldwide. Of an estimated 107 million Internet users, about 62 million are in the United States and another 20 million are in Europe. As more people get telephones and Internet access, there are an increasing number of people without even basic sanitation (Crossette). Moreover, the treatment of Africa by global media conglomerates is worth some consideration:

> Aside from the business and affluent classes in South Africa, [sub-Saharan Africa] seemingly has been written off by global media firms as too poor to develop. It does not even appear in most discussions of global media in the business press. Global media firms tend to break the world down to North America, Latin America, Europe, and Asia. When the *Financial Times* published a world map to highlight MTV's global expansion, it simply removed Africa and replaced it with the names of the thirty eight European nations that carry MTV. [...] Left to the global media market, sub-Saharan Africa's media and communication systems will remain undeveloped, and even wither (Herman and McChesney 65).

If "the market"—that mythic, supposedly godlike driving force of capitalism—even appears to be offering alleviation to racial injustice in the United States, a global perspective should clarify our vision: free market capitalism extends racial injustice; it doesn't alleviate it. Partly, these trends can be read as a result of capitalist self-interest, since Africa does have a relatively weak infrastructure and a somewhat proportionally smaller consumer class than other continents, but it is also circular reasoning: "Africa doesn't have infrastructure, therefore we won't build it there." Inequality is perpetuated and intensified through the rationales of capitalist technological development.

For some, as Lewis Mumford has argued, technology is a "way of reaching heaven" (283). The Internet represents so many of the hopes and dreams of a professional-managerial class: instantaneity, interactivity, community, agency. In fact, the power, significance, and impact of the Internet is perhaps exaggerated because of its centrality to the social groups most likely to write assessments of its importance—academics, journalists, executives (Herman and McChesney 128). No doubt that the existence of the Internet shapes the politics of race in new and interesting ways; but we should be equally attentive to the ways in which the politics of race and class have shaped the very character of the Internet and computer culture at large. The politics of access are not simply a matter of getting more people online. It is also a matter of how, when, and on what terms people are coming online, and what they discover upon arrival.

Notes

1. In fact, actual control over computer function even at the programming level is decreasing for the average user and the average programmer. As more and more functions become automated, as more "wizards" become available, more decisions about the nature and function of any given program are made before the programmer or user ever sits down to the terminal (Ullman).

2. It is, I think, ill-advised to think of "online" culture as an autonomous or coherent cultural domain apart from "offline" culture. To begin with, it separates the Internet from a whole media environment—telephones, televisions, fax machines, clocks, print, and so forth, that work *together* in the production of subjectivity and experience. Further, the notion of an autonomous "online" is to uphold a very rigid Cartesianism: the mind is firmly split from the body. For instance, is the office worker or academic who sits in an office and moves from a word processing document to e-mail and back again participating in "online" culture or "office" culture? The answer, of course, is both—and that consciousness of simultaneity is sorely lacking in most accounts of online experience.

3. Gender is also largely absent from my analysis here, though clearly there is a gender politics of computing that would similarly interact with race in important ways. It remains an open question as to whether, for instance, specifically African American, Hispanic, or Asian American notions of masculinity and femininity affect the gender dynamics of computing in a manner substantially different from white notions of masculinity and femininity.

4. California did pass a bill similar to H.R. 5573, and Apple did donate computers all over California.

5. Corporate giving, however, is by no means a panacea. Companies still resist full disclosure of their charitable giving. Many companies cited "special interest groups" as a threat to corporate giving, though the problem groups for corporations appear more often on the right than on the left. Merck & Company's $20 million donation (over ten years) to the United Negro College Fund met with some resistance from shareholders. Similarly, AT&T ended a 25-year relationship with Planned Parenthood because of a letter-writing campaign and threatened boycott by antiabortion groups.

6. The National Housing Act of 1934 established the Federal Housing Administration in an effort to stimulate the moderate-cost housing market. The FHA was designed to encourage improvement of housing standards, to stabilize the mortgage market, and to provide low-interest long-term loans for the purchase of new housing. In fact, FHA loans for improving existing structures were small and for short durations, thus encouraging the purchase of new homes over modernizing old ones. FHA loans were widespread after the Second World War, enabling a whole generation of people to move out into the suburbs.

References

AP. "Computer Gap Widens for Poorer School Kids." *Chicago Tribune,* 13 August 1985, C6.

Akst, Daniel. "How to Stay Connected with Ethnic Roots While Cruising the Internet." *Los Angeles Times,* 11 January 1995, D4.

Anderson, Ronald E. "National Computer Literacy, 1980," in *Computer Literacy: Issues and Directions for 1985,* Robert Seidel, Ronald Anderson, and Beverly Hunter, eds. New York: Academic Press, 1982.

Bryant, Adam. "Companies Oppose Idea of Disclosing Charitable Giving: Bill Requires Reporting: Backers Say Shareholders Have Right to Data, but Critics Fear a Chilling Effect." *New York Times,* 3 April 1998, A1, C3.

Business Wire. "Apple Computer Supports Disabled and Minority Students with Grants of Computer Equipment." 1986.

———. "Apple Schools: Apple Donates $2 Million in Computers to Schools; Grants Target 23 Schools to Help At-risk Students." 1989.

Chiesa, Christopher F. "Re: CYHIST Digest—8 Oct 1996 to 9 Oct 1996." 1996.

"Computers: Focus on Schools." *New York Times*, 23 November 1982, D1.

Creedy, Steve. "Local Firm's African-American Computer Graphics Fill Void." *Pittsburgh Post-Gazette*, 23 August 1993, B8.

Crossette, Barbara. "A New Measure of Disparities: Poor Sanitation in Internet Era." *New York Times*, 12 May 1998, A11.

Cuffaro, Harriet K. "Microcomputers in Education: Why Is Earlier Better?" in *The Computer in Education: A Critical Perspective*, Douglas Sloan, ed. New York: Teachers College Press, 1982.

Deringer, Dorothy, and Andrew Molnar. "Key Components for a National Computer Literacy Program," in *Computer Literacy: Issues and Directions for 1985*, Robert Seidel, Ronald Anderson, and Beverly Hunter, eds. New York: Academic Press, 1982.

Dimitriadis, Greg. "Duelling Narratives: Some Thoughts on Menace II Society and Boyz N the Hood." *Bad Subjects #33*. Online. http://eserver.org/bs/33/dimitriadis.html (1997).

Fitten, Ronald F. "Test Drive on Hi-Tech Highway—African Americans Look to Future." *Seattle Times*, 2 May 1994, B1.

Gates, Kelly. "Can the Subaltern Speak Online?" Unpublished work in progress, University of Illinois Urbana-Champaign, 1998.

Golden, Frederic. "Here Come the Microkids; By Bits and Bytes, the New Generation Spearheads an Electronic Revolution." *Time*, 3 May 1982, 50.

Herman, Edward S. and Robert W. McChesney. *The Global Media: The New Missionaries of Global Capitalism*. Washington, D.C.: Cassell, 1997.

Hoffman, Donna. "The Digital Divide." Online. http://www2000.ogsm.vanderbilt.edu/papers/pdf/digital.divide.pdf (1998).

House, U.S. *Hearings before the Subcommittee of Select Revenue Measures of the Cimmittee on Ways and Means, House of Representatives, Ninety-Seventh Congress, Second Session*. Washington, D.C.: U.S. Government Printing Office, 1982.

Jackson, Kenneth T. *Crabgrass Frontier: The Suburbanization of the United States*. New York: Oxford University Press, 1985.

Jenkins, Timothy. "An Interactive Niagara Movement, American Visions and Congressional Black Caucus Foundation Sponsor African-American Computer Culture Symposium, January, 1994, to Address How the Projected Information Superhighway Will Contribute to Addressing Social Issues and Problems." *American Visions*, April 1994, 4.

Kozol, Jonathan. *Savage Inequalities: Children in America's Schools*. New York: HarperPerennial, 1991.

LaFrenz, Dale. "Educational Computing: An Integral Part of the Comprehensive K-12 School of the 80s," in *Microcomputers in Educations*, Pierre Barrett, ed. Rockville, MD: Computer Science Press, 1983.

Larson, Jan. "Computers in School Can Be Habit Forming." *American Demographics*, October 1991, 12.

Lockard, Joseph. "Progressive Politics, Electronic Individualism, and the Myth of Virtual Community," in *Internet Culture*, David Porter, ed. New York: Routledge, 1997.

Maurer, Michael. "Not Everyone's On-Line: Senior Citizens, Minorities Seen as Best Bet as PC Buyers." *Crain's Detroit Business*, 17 July 1995, 10.

McCarthy, Cameron. *The Uses of Culture: Education and the Limits of Ethnic Affiliation*. New York: Routledge, 1998.

Meehan, Eileen. "Why We Don't Count: The Commodity Audience," in *Logics of Television*, Patricia Mellencamp, ed. Bloomington: Indiana University Press, 1990.

Messina, Judith. "Minorities Find Perfect Medium on the Internet: Web's Low Costs, Eager Audiences Lure Entrepeneurs on a Shoestring." *Crain's New York Business*, 28 July 1997, 19.

Moore, Wavenly Ann. "Some Blacks Tapping Into Information Age." *St. Petersburg Times*, 27 February 1995, 1B.

Morrow, Christopher. "The Struggle to Go to the Head of the Class." *Business Week*, 20 June 1983, 68.

Mumford, Lewis. *The Myth of the Machine*. London: Secker and Warburg, 1967.

Nakamura, Lisa. "Race in/for Cyberspace: Textual Performance and Racial Passing on the Internet." *Works and Days* 25/26 (1996).

Neill, Monty. "Computers, Thinking, and Schools in 'the New World Economic Order,'" in *Resisting the Virtual Life: The Culture and Politics of Information*, James Brook and Iain Boal, eds. San Francisco: City Lights, 1995.

Novak, Thomas, and Donna Hoffman. "Bridging the Digital Divide: The Impact of Race on Computer Access and Internet Use." Online. http://www2000.ogsm.vanderbilt.edu/papers/pdf/digital.divide.PDF (1998).

Ohmann, Richard. *Selling Culture: Magazines, Markets, and Class at the Turn of the Century*. New York: Verso, 1996.

Pollack, Andrew. "The Home Computer Arrives." *New York Times*, 17 June 1982, D1.

Poole, Shiela. "Common Ground: African Americans Find More on Web to Grab Their Interests." *Arizona Republic/Phoenix Gazette*, 18 November 1996, E1.

Robins, Kevin, and Frank Webster. *The Technical Fix: Education, Computers, and Industry*. New York: St. Martin's Press, 1989.

Rowe, Peter. "Computers Open Door of Knowledge; Kids Reach Out and Greet Their World." *San Diego Union-Tribune*, 18 March 1985, C1.

Sloane, Douglas. "Introduction: On Raising Questions about the Computer in Education," in *The Computer in Education: Critical Perspectives*, Douglas Sloane, eds. New York: Teachers College Press, 1982.

Stonier, Tom, and Cathy Conlin. *The Three Cs: Children, Computers and Communication*. Chichester: Wiley and Sons, 1985.

"Tandy Aims at Schools." *New York Times*, 23 March 1983, D4.

Taft. *Taft Corporate Giving Directory*, 7th ed. Washington, D.C.: Taft, 1986.

———. *Taft Corporate Giving Directory, 1991*. Rockville, MD: Taft, 1991.

Tracy, Eleanor Johnson, Andrew C. Brown, and Anne B. Pillsbury. "Compulsory Computers; Stevens Institute's New Role." *Fortune*, 20 September 1980, 14.

Tran, Mark. "Black to the Future: African Americans Are Being Courted by the Internet." *The Guardian*, 27 February 1997, 10.

Ullman, Ellen. "Programming Under the Wizard's Spell." *Harper's*, August 1998, 15–20.

Warner, Michael. "The Public Sphere and the Cultural Mediation of Print," in *Ruthless Criticism: New Perspectives in U.S. Communication History*, William S. Solomon and Robert W. McChesney, eds. Minneapolis: University of Minnesota Press, 1993.

Waters, Craig R. "An Apple a Day." *Inc.*, August 1983, 51.

Wiegner, Kathleen. "Stumbling into the Computer Age: The Purchasing Power of America's Classrooms Could Make Schools the Next Great Market for Small Computers." *Forbes*, 13 August 1984, 35.

12. Erasing @race

Going White in the (Inter)Face

Beth E. Kolko

Technology engages. It transfixes eyes to a screen, draws fingers to a keyboard, focuses attention on the output of processes. But plugging in, configuring, turning on, and programming bring us in small steps closer to the technological artifact without, somehow, ever allowing us direct contact. Our interactions are with the representation of the machine rather than with the wires and circuits themselves; we meet technology at the interface. And while the technology that is the Internet brings us a cyberspace of multiple machines, multiple users, and multiple locations brought together in apparently seamless conversation, the interfaces that govern our interaction with such a cyberspace are responsible for multiple translations and accommodations. Within interactional realms such as virtual worlds and chat rooms, where people construct identities and personae for themselves in active and interactive ways, cyberspace requires one of the more intense kinds of engagement; in the cyberspace of virtual worlds, experience is defined by taking action, including deciding explicitly who you are, or who you want to say you are. Consequently, the design of such spaces—the interface that users access—has significant power to affect the interaction expressible at such sites.

This essay examines the relationship between interface and race within virtual worlds. The explicit engagement with identity in text-based virtual worlds makes them fertile ground for exploring how identity and interface interact, and as it happens, in the case of textual virtual worlds, race tends to be missing as an element of virtual identity. This chapter questions how race as a category has been elided in such media through various design choices, and it further investigates how the construction of "raceless" interfaces affects the communicative possibilities of virtual worlds. Finally, while the history of online communities demonstrates a dropping-out of marked race within cyberspace, this chapter chronicles in part an effort to create an online community that reintroduces race as an articulated notion; the goal of the community—MOOScape—is to ask how an explicit marking of race online might affect the social environment.

Text-based virtual worlds have generated a substantial amount of analysis in recent years. Generically referred to as MUDs, these worlds are built upon a relatively simple mode of plain text input. There are many kinds of virtual worlds; some are text-based descendants of the old Adventure game ("You are in a maze of twisting tunnels. You see a light in the distance ahead of you. There is a small passage to your right."); others are three-dimensional graphical worlds that provide customizable, viewable avatars and detailed visual environments; still others are business environments that contain a whiteboard, integrated video technology, and other trappings of the contemporary business world. Textual worlds, though, retain a discursive core; although many textual worlds are merging into hybrid environments with extensive World Wide Web gateways and, in some cases, simultaneous 3-D components, the premise of MUDs remains a text interface where the descriptions of rooms and objects are created by (sometimes select) participants and then examined by other users. The amount and kind of contributions players can make to a world differ somewhat depending on the environment. In the original MUDs, users navigated a predetermined world and prewritten narrative. In modifications to MUDs known as TinyMUD and MOO,[1] individual users can build rooms and objects, customize the environment, and further customize their character.

One way to conceptualize these worlds is to imagine three arenas of engagement with the environment. The first is the architecture of the world; this consists of the rooms that are described and the objects within them, the actual geography of the space that gets navigated. A second arena consists of the identities that populate the landscape of the MUD. When a participant logs on, she must create a character with which to explore the world. This vir-

tual representation of the self is given a name and numerous other character-
istics, and the user adopts an avatar—a virtual representation of the self. The
final aspect of the MUD is the interaction among the customized characters.
Since these environments are designed for simultaneous multiple users, a sig-
nificant part of the appeal lies in the conversations one can have with other
users—the interactional component of the world.

The second area—creating the avatar—is the initial substantial task of new
users. This character will be the agent of communication and action within the
MUD, and anyone who attempts to join a community (rather than visiting as a
guest, or temporary character) must assemble a virtual self. While the elements
of identity that are offered to users vary from world to world, the general act of
creating a persona within the world does not change. These characters, which
can also be thought of as *discursive* avatars, are how participants engage with
the mediating space of the interface and interact with other users. Characters
have a series of properties, most of which reflect "real life" elements of identity.
By filling in these properties, users customize their avatar and define their vir-
tual self. How you decide to fill such properties ultimately forms the extent of
the non-conversational cues you will provide to other characters. Properties
that can be defined include elements like gender, age, e-mail address, and lan-
guages spoken. In professional and educational virtual worlds characters can
fill in property values for their research and general interests.

The crafting of a virtual identity is important because your representation
in cyberspace will guide others' interactions with you. In text-based worlds
this means how you describe yourself—language choices—are of central
importance. A good deal of work has been done on how gesture and aural cues
affect our ability to decipher the meaning of actual conversations. Facial
expression, hand gestures, tone of voice, etc., play pivotal roles in helping us
make meaning of interpersonal communication.[2] These cues are, obviously,
absent in text-based virtual spaces. And while in face-to-face communication
we rely extensively on gesture and aural cues to decipher actual conversations,
as a less explored corollary to this idea—especially with regard to work on vir-
tual worlds—visual cues about *identity* occupy just as crucial a space (if a
more contextual one) as communicative cues. We look at the person who
approaches from down the street, who stands across the room at a cocktail
party, who looks back at us during a whispered exchange, and we observe
characteristics like age, gender, and race. Without these cues, within a textual
virtual world we have to depend on the described avatar for such conversa-
tional context cues. And so, a few lines of often hastily written description

stand in for the complex information about identity we receive in other modes of interaction. Depending on the type of interchange, this can be variously successful.

One of the largest social MUDs is LambdaMOO, the object of various scholarly and popular writings. LambdaMOO is a sprawling virtual world of several thousand inhabitants who interact in real-time and asynchronously via text. In this MUD you can set properties for your age, your hometown, your timezone, your webpage, your pals, your gender, your online home, your feature objects, and your e-mail address.

But not your race.

As a user you can force a racial identity into the system by adding such information to the description property, choosing a name that has particular associations, or programming messages that broadcast specific information to other users upon entrances, exits, or responses. But the system has no category for race and provides no moment of reading or writing race. After you have set your gender with the @gender command, your age with @age, your interests by inputting @interests, there remains no correlative @race property. Importantly, as documented interactions of community members show, the default race of the MUD is assumed to be white; attempts by users to mark race otherwise tends to result in confrontation (see the opening paragraphs of this volume's introduction). Because of the context of the world and the cultural position it occupies, the default race of the environment is assumed to be white; given a default, why choose to mark the "property"? An attitude that race is one of those things that purportedly can stay behind in the "real world" prevails; marking race online comes to be read as an aggressive and unfortunate desire to bring the "yucky stuff" into this protoutopian space.[3]

During a 1997 graduate seminar on subjectivity and cyberspace, I posed a question to my students: why is there no @race property in a MOO? It was a question that was very much grounded in the dynamics of that seminar, but once I asked, the question came back, in the context of that class and in later conversations and research. Why, indeed, did multiuser worlds present options for gender, sometimes age, always description, but never race?

In approaching this question the class discussed the supposed purpose within the MUD of different identity-based properties. In the worlds where users can set research interests, for example, these are compiled into an online searchable database so users can find others whose interests they share. For a professional world this customizable component of online identity has a clear purpose. Similarly, the @gender property has a clear significance in a text-based

world. Gender is communicated via pronouns, and there are small programs that run inside the MUD that replace a character's name with the appropriate pronoun when presenting such things as exit messages (what others see when you leave a room) or second references in page alerts (i.e., You sense Bek is looking for you in the Arboretum. She pages, "Do you have time to go over that article?"). In addition, MUDs encourage "emoting" as well as speaking, a kind of third-person narrativized expression of behavior rather than direct dialog. For example, I can say "Hello," or I can emote "Bek waves hello." I write myself into the action in the third person, and this means that any use of pronouns to narrativize myself requires some sort of gendered reference. For example, "Bek waves hello to all in the room, even the people she has never met before." In these examples it becomes clear why gender is a necessary component of a virtual identity—unless everyone is simply referred to as "it."[4]

As the students in that seminar analyzed the components of virtual identity, our rationales were all focused initially on the technical. We then began to explain the social reasons for the different properties. The database of research interests helped players network and strengthened the social bond of the environment. @gender, in addition to resolving technical issues easily, also provided a strong contextual communicative cue for users. As our investigation progressed and it became clear that social interaction was affected by the identity properties available, the absence of @race seemed more notable.

In fact, for several reasons the missing @race property is related to much more than a simple what-if graduate seminar question. The components of identity govern how one is able to self-present online, and they consequently help construct the communicative environment; ultimately, @race—and @gender, @research, and so on—establish the parameters of how users interact with the online world. Such parameters of interaction can also be thought of as constructing an interface—the point of interaction within an environment where a user comes into mediated contact with a technological artifact. In other words, the lack of an @race property means that the MUD is an environment where racial identity is presumed to be either irrelevant or homogenous. In asking precisely how the interface of virtual worlds came to efface @race and create a default whiteness for the worlds, it is helpful to consider why a missing @race property merits investigation, particularly when considering text-based environments. The assumed homogeneity within cyberspace studies and cyberspace itself is staggering, as is the prevalence of "we" vocabulary. And, quite simply, the lack of a writeable @race speaks volumes about the assumptions designers have, assumptions that tangibly affect the trajectory

of technological development. In this case we have an instance when the design of interface—the point of interaction with technology—reflects a series of cultural and political perspectives.

In her early 1990s work *Computers as Theatre*, Brenda Laurel began a conversation about interface design that broadened the disciplinary base for design questions. Asserting that psychology, which is the determining intellectual frame for interface design, has much to do with theater, she argued that both disciplines "concern themselves with how agents relate to one another in the process of communicating, solving problems, building things, having fun—the whole range of human activity" (6). This study served as a significant step toward opening what had been a rather closed circuit of technological development. By arguing that a user's interaction with a computer was a theatrical moment, that human-computer interaction was performative, Laurel attempted to rescript the narrative of interface design and foreground the social factors involved. The metaphor around which a particular technological artifact was designed was worthy of more attention; *Computers as Theater* was one of the first transdisciplinary works to call attention to the ideology of the interface.

As Laurel writes, "The interface becomes the arena for the performance of some task in which both human and computer have a role. What is represented in the interface is not only the task's environment and tools but also the process of interaction—the contributions made by both parties and evidence of the task's evolution" (7). It is a viable move from considering the process of interaction to examining the parameters and constraints of that interaction. Laurel's argument is related to the questioning beginning to surface in fields as disparate as human-computer interaction and composition and rhetoric regarding the politics of interface design. What this line of inquiry seems to represent is a growing awareness that technology interfaces carry the power to prescribe representative norms and patterns, constructing a self-replicating and exclusionary category of "ideal" user, one that, in some very particular instances of cyberspace, is a definitively white user.

Cynthia Selfe and Richard Selfe further Laurel's discussions about interface by examining the explicitly political ramifications of interface design. In their article, "The Politics of the Interface," Selfe and Selfe, writing as teachers who use computers in their classrooms, begin to see their computer-based teaching as a process "contributing to a larger cultural system of differential power that has resulted in the systematic domination and marginalization of certain groups of students, including among them: women, non-whites, and individuals who speak languages other than English" (481). Selfe and Selfe pay much

needed attention to how technology constructs the experiences of users; concurrently, they point to how the experiences of designers affect the construction of technology. It is common to hear pundits declare that technology is neither inherently good nor bad; what matters is the *use* to which the technology is put. Such a perspective denies the cultural matrix within which invention and consumption are embedded. Selfe and Selfe articulate this complex relationship between technology and culture, and they ask us to consider the

> political and ideological boundary lands associated with computer interfaces…the ways in which these borders are least at partly constructed along ideological axes that represent dominant tendencies in our culture, about the ways in which the borders evident in computer interfaces can be mapped as complex political landscapes, about the ways in which the borders can serve to prevent the circulation of individuals for political purposes. (481–482)

While their analysis is conducted from within a particular disciplinary perspective, their argument applies to technological progress generally. And their characterization of "computer interfaces as linguistic contact zones" emphasizes the way an interface mediates between two locations—that of the user and that of the technology. What you see via the interface relates the components of the technology that you may access.

Interfaces themselves garner less attention than their influence perhaps deserves. Quickly reified, interfaces are a technological version of a poststructuralist's language: they construct our experience and leave few traces of their power. When you use a word processing program or play solitaire on your computer, you encounter what the program produces, not the program itself. The interface—in these two examples the computer screen, your keyboard, and mouse—is the point at which your experience is grounded. As the essays in this volume explicate with regard to technology policy, video games, and other products of the computer industry, interaction with technology is far from apolitical. Selfe and Selfe articulate the relationship poignantly when they write, "Within the virtual space represented by these interfaces…the values of our culture—ideological, political, economic, educational—are mapped both implicitly and explicitly, constituting a complex set of material relations among culture, technology, and technology users. In effect, interfaces are cultural maps of computer systems" (485). Like all maps, interfaces are important for what they do not show as well as what they show; they are similarly powerful for how they choose to represent the terrain to users.

When Laurel published *Computers as Theater* close to ten years ago, she discussed interface in precisely these sorts of terms—the human interaction with the computer. Since publication of her study, however, technology, particularly the kind of computer technology she discusses, has changed substantially. Concurrently, the substance of an individual's interaction with a computer has also changed. No longer are computers seen as stand-alone machines that will play games and make manuscript preparation monumentally easier. Computers are now about networks, and the expanding market for personal computers has been closely tied to the growth of the Internet. Similarly, games that tout 3-D graphics are increasingly no longer considered cutting edge if they do not include some kind of multiuser component that allows players to compete against others. From *Quake* to *Ultima Online*, games have become increasingly collaborative. More than writing memos on a computer, or carefully word-processed letters, users e-mail notes to others, moving business and personal communication online. These changes require a revision—although certainly not a repudiation—of Laurel's formulation regarding human-computer interaction. That is, such changes are evidence of a shift from human-computer interaction as Laurel describes it to a more interactive notion of human-computer-human interaction—what might be termed HCHI in contrast to Atari-era HCI.

HCHI is a concept that foregrounds the networked components of technology. HCHI is also an idea that forces us to consider the presence of others within these networked technologies. If, as information systems researcher Donald L. Day claims, "Too frequently, people must adapt to technology rather than adapting it to their needs" (35), in a technological schema of HCHI, technology design forces users to adapt their interactions with other people to the construct of the machine. That intermediary space, then, no longer dictates a user's relationship to the computer program and any data that is associated with the program, but that mediating space also controls how users interact with one another—a more disturbing relinquishing of control over our experiences. Indeed, in a world of HCHI—interactional rather than informational cyberspace—the control that the interface exerts is magnified. To Laurel, analyzing a world of HCI, the graphic designer of an interface is like a theatrical scene designer because "[b]oth create representations of objects and environments that provide a context for action" (9). The dynamic I am interested in highlighting here, however, speaks to more than the representation of objects and environments; it is the representation of people in interactional circumstances.

Allucquère Rosanne Stone, picking up on such a problematic, has written extensively on problems of identity and the changes in social conventions within cyberspace. Her critiques have most often dealt with the realm of gender, particularly the possible representations of gender that are likely to be preloaded into a system. She writes, "Bodies in cyberspace are also constituted by descriptive codes that 'embody' expectations of appearance. Many of the engineers currently debating the form and nature of cyberspace are the young turks of computer engineering, men in their late teens and twenties, and they are preoccupied with the things with which postpubescent men have always been preoccupied. This rather steamy group will generate the codes and descriptors by which bodies in cyberspace are represented" (103–4). There has been a range of critiques leveled at Stone's work generally, but I'd like to look at her passage above in the interests of considering the power of the interface within HCHI. Stone's concerns are with how bodies can be presented, how the self can be represented. She does not mention here that those representations will be seen by others sharing the virtual space. That is, many critiques of representation in cyberspace have focused on the issue of how users can represent themselves as a matter of integrity of identity, or a more romanticized freedom of expression. Such characterizations implicitly address a single-user rather than multiple-user—an interactional version—of cyberspace.

I have chosen to use the term *interactional* rather than *interactive* because of the way the latter gets deployed in current conversations about technology, particularly multimedia. Purportedly, an e-commerce site is interactive if you can order from a catalog; a website is interactive if you can click on links. This dynamic is essentially a recapitulation of HCI, wherein the user and the program meet at a mediated (if attractively designed) site and transact their work. But conceptualizing HCHI—substantively different than computer-mediated communication because it places the emphasis on the presence of others—requires a term that denotes more than pointing and clicking within the intermediary space of the interface. Interactional cyberspace demands that rather than simply determining our relationship to the technological artifact, we examine technologized *interactions*. Multi-user virtual worlds provide a space to examine such dynamics. Unraveling the ontological and epistemological ramifications of online identity has occupied the attention of numerous scholars in recent years, but more than questions of identity, virtual worlds foreground the issue of online interaction. And at a variety of levels, not just identity, but also worlds and realities are constructed by interface

designers. Designer Meredith Bricken delineates the power of such construction as she argues,

> In a virtual world…We can create any imaginable environment and we can experience entirely new perspectives and capabilities within it. A virtual world can be informative, useful, and fun; it can also be boring and uncomfortable. The difference is in the *design*.
>
> …the most important component in designing comfortable, functional worlds is the person inside them (363).

Bricken leaves no doubt as to the pivotal role played by the designer in creating a virtual world. Whether a virtual workplace or an electronic singles scene, building a virtual world is about creating spaces for people. Although not a specific explication of HCHI (and in fact her essay focuses primarily on immersive single-user environments), her discussion lays the groundwork for considering the power of design choices to delineate possible experiences.

When she continues, saying, "Cyberspace technology couples the functions of the computer with human capabilities. This requires that we tailor the technology to people and refine the fit to individuals. We then have customized interaction with personalized forms of information that can amplify our individual intelligence and broaden our experience" (363), Bricken is not referring to MUDs. She is, however, making clear that we create interfaces for virtual worlds that dictate the kinds of interactions we can have with the underlying technology. The mediation of these virtual worlds is scripted in the image of the designer, and the coder really does become god, delimiting the kinds of representations and interactions the universe will acknowledge. The design of the interface concretely affects the uses to which technology can be put, and in a technologically HCHI environment, the exchanges users can have with one another.

In the case of MUDs, then, I would argue that the effaced @race is a component of the interface that helps construct the kinds of experiences users can have online—with the environment and with one another. The question of the @race property in social text-based worlds is made even curiouser by the fact that some MUDs *do* allow characters to mark race. MUDs can be divided into numerous categories, but one of the simplest and most common ways to categorize a text-based world is as either a role-playing or a social world. Worlds that host role-playing games (RPGs), are tied closely to the dungeons and dragons history of MUDs, while so-called social worlds usually do not contain quests, and the like. This is not to say socializing doesn't occur within an RPG

MUD, or that there is no game-playing on social MUDs; however, such a division accommodates many of the primary technological and misson-statement differences among online worlds. Within this schema, then, it is the social MUDs that generally exist without @race. With RPG worlds, on the other hand, race is often presented, albeit along the lines of elf, wizard, troll, or Vulcan, Romulan, Human. In addition to its actual presence, the race variable in RPG worlds can affect characters' abilities, social strata, and other elements of the social experience. Meanwhile, in concurrent and later incarnations of text-based worlds, when the RPG aspects drop out and the world becomes "merely social," so too does the @race property disappear.

In order to better understand the relationships among these different MUDs, some history is helpful; in particular, familiarity with the lineage of text-based worlds clarifies the independent decisions by designers to either include or exclude @race.

Social MUDs like LambdaMOO are descended (admittedly less than linearly) from a game originally created by Richard Bartle and Roy Trubshaw at the University of Essex (Aarseth, Carlson et. al.). The original system, on which Bartle continued to work, is known as MUD1. An electronic adventure game that allowed multiple users to connect remotely and play in conjunction with one another, MUD1 provided a narrative core within which users did usual adventure-related activities—killing dragons, collecting gold, and so on. The scope of the world was relatively defined as an adventure game rather than a social world, but MUD1 served as the original inspiration for later kinds of text-based worlds. Looking around at current text-based worlds quickly leads to the realization that there are numerous large and small variations within this genre; elements of the first games persist throughout the branching descendent tree, while other elements were eliminated at one or more points. In fact, the actual history of MUDs is difficult to trace, in part because different servers were programmed by individuals scattered around the globe rather than by a central entity, and so simultaneous worlds were (and are) often in the works. There are numerous branches, lineages that die out, and recursive revisitings of servers. There does seem to be, however, a main trajectory of virtual world development. Across these worlds, many characteristics reappear—the multiple users, the textually-described environment, and so on. But other elements differ, most notably for the purposes of this argument, the presence of that @race property.

The earliest MUDs were all related to RPGs. From the MUD1 game came Abermud, and from Abermud came several servers, one of which was

LPMUD, another DIKUMUD. The histories available provide competing versions, but sources generally concur that the development of TinyMUD after Abermud provided a significant break from earlier text-based worlds (Carlson et. al.; Aspnes). These histories also note that TinyMUD, written by James Aspnes, allowed building and was designed to facilitate social interaction. In Espen Aarseth's version of this history, "Unlike MUD1, Aspnes' MUD had no existing objects, intrigues, or world structure but instead let the players build...whatever they liked. Because of the relatively small size of the initial code and database, [Aspnes] named his MUD TinyMUD" (150). According to three long-term MUD programmers, when Aspnes curtailed the system, he dropped out elements that took up space and that seemed geared to the role-playing and adventure aspects of the game rather than the social functions of TinyMUD (Carlson et al.). And according to Aspnes himself, "TinyMUD did not have an @race command." Those three programmers—when asked to speculate on the history of @race—imagined it was possible that the predecessor(s) of TinyMUD, as RPG worlds, might have indeed contained @race, and that in the move to a social MUD @race could have been eliminated to save server space, since marking race might not have been seen as integral to the social function of TinyMUD. As the author of this essay I found that a compelling narrative, and one that certainly would have been convenient for the purposes of this chapter. However, as Aspnes says, "TinyMUD did not have an @race command. As far as I know, neither did either of the programs that inspired it (AberMUD and Monster)....So I'd say that rather than it [@race] having been taken out, it was never put in because it never occurred to anybody that it might be useful for anything" (Aspnes).

When exactly @race first appeared (or disappeared) is impossible to say at this point. It seems possible that @race was present in some early RPG MUDs, but since servers and databases change perpetually in large and small ways, it is difficult to pinpoint an exact date at which @race (of the troll/elf variety) first appeared. Participants' recollections differ, and without the original virtual world to check, any estimate of a date would be guesswork at best. What can be said unequivocally, though, is that many contemporary RPG worlds have the ability to set race. While this race is tied to the fantasy of the game, participants familiar with the genre know that upon login to a new game they often will have the opportunity to choose a race for their discursive avatar. This race, in turn, will help guide their interaction in the world, providing other players with cues as to how to best approach another character and respond to actions, as well as reveal something (what, I'll not say) about how

players conceptualize their virtual selves. That is, the interface of these worlds, the cultural map in Selfe's and Selfe's formulation, allows for the expression of marked race in cyberspace; rather than assuming homogeneity among participants, the political landscape of such virtual worlds take on particular characteristics. And whether or when @race got dropped from MUD cores, what is most interesting is that in the recent years of growing popularity of social MUDs, particularly the generations of MOOs, @race has remained effaced.

All kinds of changes have been made to the MUD core known as MOO. New properties like @research have been added to accomplish the professional networking that occurs online. New generic objects (the building blocks of the MOO universe) have been added to facilitate the educational needs of increasing numbers of teachers bringing their students online. Web interfaces have been added, in-MOO gopher browsers and ASCII maps have also changed the internal shape of MOOs. In all these changes, though, the interface has remained that cultural map of assumed whiteness.

The purpose of this essay is not to argue for articulated intent on the part of designers who shaped the evolution of text-based worlds. However, the missing @race verb speaks volumes about the assumptions technology designers carry with them as they create virtual environments—especially when we consider that @race appears within some adventure and role-playing cores and is yet absent from worlds conceptualized as social spaces. And since virtual worlds contain numerous properties tied to identity, the invisibility of race as a variable contrasts with how MUDs approach identity generally. Ultimately, erasing race in a social world means the database is unable to accommodate the marking of race. This is not to say that race has to be incorporated into every world, or that every user of a social virtual world would want to mark race; however, eliminating the possibility affects the shape of the world and the interaction that occurs within it.

And so, having erased the @race property and effacing race as a component of identity within the virtual world, the interface also represents the technology to the user as raceless, and provides only unraced representational gestures for the user. But as Selfe and Selfe explain with respect to class, and Day argues about cultural difference, the construction of the interface doesn't just influence users and the uses to which the technology is put; it essentially constructs a world. Interfaces, after all, are where we exist when we use technology, the interface is the point at which our experience takes place; a de-raced interface forces upon the user the experience of a de-raced environment. There are consequences of such a gesture.

It seems only appropriate that after making such claims about conse-
quences I actually do something to investigate @race and social worlds. In
1998, with the help of a grant from the University of Texas at Arlington, I
began a project to construct a text-based virtual world that incorporates an
@race property. The world is called MOOScape, and it is currently in its earli-
est stages. For close to a year, technical research assistant Rusty Bourland,
graduate research assistant Jennifer Bay, and I have worked on changing the
interface of a MOO to see what changes in interaction might follow. Not yet a
thriving community, but gently moving away from the development stage,
MOOScape, through its construction, has provided something of a workshop
in the issues surrounding racial representation online.

In developing MOOScape, we faced a number of design choices that help
clarify the significance of interface. When we first began discussing the inclu-
sion of @race, our initial decision focused on how to express the value of the
race property. We examined the extent to which other properties were
expressed in a manner consistent with the face-to-face world. For example,
gender is displayed when you consciously "look" at a character, and mood is
expressed whenever someone enters the room. Would race be something we
wanted to mark every time a character spoke? Would we want it appended to
every typewritten comment? If this were the "real world" and you were turned
away from a speaker, or on the telephone, you wouldn't have the visual marker
of race. You would have discursive markers of identity, but we imagined those
should carry into the MUD conversation itself.

The options were numerous, but the decision hinged on how prominent
the property would appear in the environment and what effect the property
would have on the conversational flow of the world. Individual properties in
the MOO—@gender and @mood for example—are used differently by the
server and database. Each property has a series of technical parameters that
define how and when it will be reexpressed in the environment. For example,
when a character selects a gender, and uses @gender to fill the property with a
particular value, that value (i.e., the gender, he/she/plural etc.) is expressed
when that character sends a page, uses selected verbs, and performs other
actions. As an integral part of such messages produced within the world,
@gender appears repeatedly, automatically attached to a character every time
that character performs a basic function. However, this repeated expression of
gender is tied to the necessity of pronouns, and so its constant appearance
remains relatively unobtrusive. An example is the "page alert." Paging is how
characters communicate when they are in different rooms. Like a person-to-

person intercom, a character can page anyone logged on with a message. Within MOOScape, if I am in a room called the Living Room and I page someone in the Yard with the message "Come join us," that person will receive the following message: "You sense Bek is looking for you in the Living Room. *She* pages, 'Come join us.'" The *she* is automatically indicated because of the value the character has declared for the property.

Page alerts, then, reexpress the gender property with every exchange. If characters are paging back and forth, they cannot escape the nature of their conversational partner's gender. As we worked on changing the MOO core to include @race, we considered how using the data of the @race property like the MOO uses @gender would affect interaction. Would constantly restating a property that is not discursively required (as pronouns are) overwhelm participants? Certainly such a choice wouldn't replicate face-to-face interaction, and so we also needed to address our goals in including @race. If we were trying to replicate the information one would receive in a face-to-face conversation then certain strategies would need to be adopted. On the other hand, there was also the possibility of making @race so often expressed and so prevalent within the communicative structure of the MOO that participants would be forced to confront it. One method of accomplishing the latter would have been to adopt the way the MOO expresses the property of @mood.

In some MUDs you can set @mood. The value for @mood is expressed in two primary ways: when a character enters a room and when a character speaks. If the character of Bek has set @mood to *surprisingly anxious*, when she enters a room the automatic entrance message reads: "Bek (surprisingly anxious) enters." Also, when a character speaks, the @mood value is automatically inserted after the speaker's name so that the MUD outputs "Bek (surprisingly anxious) says, 'Has anyone seen the keys to the lab?'" to all other players' screens. There are other ways @mood is expressed, but the exact details will depend on the MUD. However, @mood, like @gender, is difficult to ignore in conversation. A particularly long @mood property has even been known to cause mini flame wars within a MUD since the data is included with every comment or action attached to a character. Expressing @race like @mood was a way to ensure that the members of MOOScape could not ignore @race values, and we discussed the likely ramifications of such a design choice.

Another option presented itself, and that was related to the nonconversational expressions of @gender and @mood already programmed into the MOO. The "look" command calls up the value for several of the properties attached to a character—gender, description, and mood (if set). For example,

using Bek as an example again, if this character had a description of *Yet another academic littering the virtual landscape*, a gender of female, and no mood set, and another player typed "look Bek," the computer would display:

> Bek. Yet another academic littering the virtual landscape.
> She is awake.

The "She is awake" means the character is logged on and active. If Bek set her mood to *surprisingly anxious*, after the description the computer would display "Bek looks surprisingly anxious." The advantages of expressing properties in this manner are clear, particularly the way in which related properties are automatically assembled in a non-intrusive manner.

We spent a considerable amount of time weighing the advantages of the different mechanisms already in place. The options for expressing @race in the environment carried differing implications, and we especially grappled with the question of whether to allow interaction without foregrounding (as in @mood) the value for race. Ultimately, we decided to express @race in the same way @gender and @mood are nondiscursively expressed—as a value that gets automatically appended to the @description property, and as a value that does not intervene directly into the conversational exchange among characters. And so, it is only when one character "looks" at another—makes that explicit move of invoking the visual—that @race is expressed, along with @gender and @description. We did, however, leave a default @race message in place so that the description of a character that has not yet set race will indicate such. A character named RJK that had not been customized, then, would look like:

> You see a player who should type '@describe me as …'.
> RJK hasn't set its race yet.

Particularly because participants from other social worlds will not be accustomed to an @race variable, we wanted to have a prompt in place. Eventual plans for MOOScape include a scripted description aid that reminds users to set @race.

Another central issue as MOOScape was constructed concerned the question of whether we would give participants a set of data from which they would choose their @race property, or whether we would use an open-ended data set. With @gender, many MUDs give users a list from which they can choose; items include male, female, royal, plural, spivak. In many MUDs as well, however, users can also create a gender of their choosing by simply typ-

ing in a different value. For example, during a particularly troublesome evening several years ago I typed "@gender pretenure" into a MUD, and my character thus became narrativized as pretenure in gender (although the server simply inserted gender-neutral pronouns where necessary).

The issue of the open or closed data set was a thorny one. Coincidentally, at the same time we discussed this question the United States government was discussing whether to change the instructions for marking race on federal forms and allow individuals to "check all that apply." We were aware that if we left the data set completely open, we would likely have people using the property in a manner reminiscent of an RPG world. On the other hand, the consequences of narrowly defining the identity variables in a world that was designed to specifically expand the possibilities of virtual (if text-based) representation were unsettling. Indeed, MOOScape was designed to reintroduce race into the virtual world, not *define* race. In the end, then, we decided on the open data set. MOOScape makes clear this characteristic of the property. The online help text, which you receive if you ask for help on either "race" or "@race" reads:

Showing help on 'race':

Syntax: @race <race> property
 This form, with an argument, defines your player to have the race <race>.
 Your race is defined by the lines that the player inputs.
 Please note that because the value for the <race> property chosen by the player does not correspond to a preset string of options, you can expect to see a variety of approaches to setting that property.

This help text is an attempt to acknowledge that not all users will approach the race variable with the same perspective. As both a guide and a warning, the help entry defines the open-endedness of @race as envisioned within MOOScape. This is a first attempt, and there is little doubt that as the world continues to grow we will modify and refine the @raced interface.

These relatively brief descriptions of the design choices in the creation of MOOScape are intended to provide an indication of how supposedly technical decisions can construct communicative possibilities. If interfaces control experience, it is important that we experiment with them, if only to broaden the range of human interaction with technology.

MOOScape is a work in progress. The world is still too new and under-populated to provide data from which one can draw any conclusions. The

scattered inhabitants have chosen a variety of strategies with the @race property; some have gone back to the species-like @race category of RPG worlds; others have been fanciful with their use of the property, filling in such elements as "academic" or "pastry" for their race; there are also characters who have chosen "white," "Asian," and "American." The world is slowly growing, but for now MOOScape is largely an empty data set, waiting for its inhabitants to shape the environment.

It is my contention that bringing race to the forefront in a text-based virtual world will provide information that can be useful in graphical worlds and other computer-mediated communication systems as well as tell us something about how users bring perceptions and patterns into cyberspace. How much will users work to replicate racial categories in cyberspace? Which terms will be invoked and which ignored? Given the explicit invitation to mark race in the world, will participants choose to do so? And if they do, will the conflicts of other MUDs where foregrounding of race within a character's description are often taken as aggressive acts be replicated? How can users' choices help us better understand the way identity might be effectively expressed in cyberspace? If interfaces do help determine the kind of experiences available with technology, how will changing the interface affect interaction? These are some of the most very basic questions we hope MOOScape can help us better understand. But right now it is a world in the making, and we invite you to come to the world, and make it with us.

An invitation to MOOScape, found at scape.uta.edu port 7777:

$telnet
telnet>scape.uta.edu 7777

Welcome to MOOScape!

This space is devoted to rethinking the social and educational landscapes of virtual worlds.

Commands:
connect <character-name> <password>—To connect to your character
connect guest—To connect to a guest character
@who—just to see who's logged in right now
@quit—to disconnect either now or later
Connect guest

The InterScape Highway

You've landed just left of center of an impossibly broad concrete ribbon.

As you look around and notice lanes too numerous to count and dizzying traffic swerving around, you realize you're in the middle of the Interscape Highway.

A sign reads "I-way East."

An exit ramp beckons, and to your right you see the shadows of what appears to be a deserted town. Off to the left of the ramp is a rest area, and you can see clusters of strangers talking animatedly amidst the trees.

Just ahead you see a white sign marked "University" in black block letters. You are reminded of the generic aisle at your local grocery store.

To the west, the shadows of ramshackle buildings stretch out from an old grove of weeping willow trees. Dust hovers in the air, swirling in the occasional gust of wind, blurring the outline of the town.

You see News here.

Obvious exits: [East] to Rest Area, [West] to Global Village, [North] to University Complex

Notes

The author would like to thank the University of Texas at Arlington Research Enhancement Program for the grant that funded MOOScape.

1. There are numerous databases, many of which have cores that users can customize. Because MUDs did not start as a commercial venture, there is no central point of development, and the "family tree" is constantly branching.
2. In graphical spaces these can be represented somewhat, but the technical question of how to translate the multimodal interaction we experience in face-to-face interaction is a daunting one. Hannes Vilhjalmsson, for example, has done work exploring how to best correlate the movements of bodies—gestures—with the context of language. In other words, graphical virtual worlds currently allow users to signal emotions by smiling, frowning, etc., but these gestures require a specific act; currently, while typing and indicating words, a user cannot simultaneously indicate a smile. As Vilhjalmsson describes in his Master's thesis, in some worlds, body movements like looking at a watch or glancing around the room, are automated, meaning that you might be saying something intense to another person while your avatar looks away, or glances distractedly at her watch. In his work, Vilhjalmsson has striven to find ways to join discursive and nonverbal communicative acts precisely because of how closely each relates to the other.
3. As several essays on LambdaMOO interaction chronicle, marking a race other than the assumed white tends to generate uneasy responses that range from confusion to outright hostility. Cf. essays by Jennifer Mnookin, Lisa Nakamura.
4. James Aspnes, creator of one of the MOO's forebears, says he added @gender "in a fairly late version" of his world TinyMUD "because users were complaining about not being able to have grammatical gender in descriptions of actions" (Aspnes).

References

Aarseth, Espen. *Cybertext: Perspectives on Ergodic Literature*. Baltimore: Johns Hopkins University Press, 1997.

Aspnes, James. E-mail exchange with the author. February 8, 1999.

Bricken, Meredith. "Virtual Worlds: No Interface to Design. In *Cyberspace: First Steps*, Michael Benedikt, ed. Cambridge: MIT Press, 1991.

Carlson, Jay, Ken Fox, and Erik Ostrum. Interview with the author. 30 May 1998, Gainesville, Florida.

Day, Donald L. "Cultural Bases of Interface Acceptance: Foundations," in *People and Computers XI: Proceedings of HCI '96*, M. A. Sasse, R. J. Cunningham and R. L. Winder, eds. London: Springer-Verlag, 1996.

Keegan, Martin. The Mud Tree. Online. http://userweb.cyburbia.net.au/~martin/mudtree.html (1996, 1997).

Laurel, Brenda. *Computers as Theatre*. Reading, MA: Addison-Wesley. 1993.

Selfe, Cynthia L. and Richard J. Selfe Jr. "The Politics of the Interface: Power and Its Exercise in Electronic Contact Zones." *CCC* 45.4 (1994): 480–504.

Stone, Allucquère Rosanne. "Will the Real Body Please Stand Up? Boundary Stories about Virtual Cultures," in *Cyberspace: First Steps*, Michael Benedikt, ed. Cambridge, MA: MIT Press, 1991.

Vilhjalmsson, Hannes Hogni. "Autonomous Communicative Behavior in Avatars." Unpublished Master's Thesis. Learning and Common Sense Section. MIT Media Lab. Online. http://hannes.www.media.mit.edu/people/hannes/msthesis/thesis_html.html (1997).

Contributors

David Crane (dwcrane@cats.ucsc.edu) recently earned his Ph.D. in modern studies from the English Department at the University of Wisconsin-Milwaukee with the dissertation, "The Paranoid Text: Thought, Narration, and Technologies of Communi-cation." He has taught numerous courses in film and media studies at UWM and is now teaching in the Film and Video Department at the University of California, Santa Cruz.

Jennifer González (jag@cats.ucsc.edu) is assistant professor of art history and visual culture at the University of California, Santa Cruz. Her essay "Envisioning Cyborgs Bodies" appeared in *The Cyborg Handbook* (Routledge, 1995).

Beth E. Kolko (bek@uta.edu) is assistant professor of English at the University of Texas at Arlington, where she is also the codirector of an advanced technology lab. Her work on technology and culture has appeared in a number of journals and anthologies. She is the founder and administrator of MOOScape, a virtual world dedicated to exploring race online. MOOScape can be reached via telnet at scape.uta.edu port 7777.

Joe Lockard (lockard@uclink2.berkeley.edu) is a doctoral candidate in American literature at University of California, Berkeley. Together with Melinda Micco, he coedited *Pretending to Be Me: Ethnic Transvestism and Cross-Writing* (forthcoming) and has published an historicized reedition of Mattie Griffith's *Autobiography of a Female Slave* (University of Mississippi Press, 1998). He is a member of the Bad Subjects collective.

Tara McPherson (tmcphers@usc.edu) is assistant professor of critical studies in the University of Southern California School of Cinema-TV. Her writing has appeared in *Camera Obscura, The Velvet Light Trap, Discourse*, and *Screen*. She is currently at work on two manuscripts, one on southern femininity, race, and place, and another tracing the impact of new computer technologies on our understandings of place and of home, and is also coeditor of an anthology of cultural studies essays. She still hasn't finished her webpage.

Lisa Nakamura (nakamurl@sonoma.edu) is assistant professor of English at Sonoma State University, where she teaches postcolonial literature and theory and literary theory. Her work on cross-racial role playing in cyberspace appears in *CyberReader, 2nd Edition* and she is currently working on a book chapter on Orientalist imagery in cyberpunk fiction.

Jeffrey A. Ow (jeffow@OCF.Berkeley.edu) is a doctoral candidate in the University of California Berkeley's Comparative Ethnic Studies Program, where his research focuses on Asian-American history and cultural studies. Although his dissertation work investigates the transformation of memory and meaning within Asian-American historical sites, he spends much of his free time consuming and critiquing Asian-American imagery in such media as *X-Men* comics, Rodgers and Hammerstein's *Flower Drum Song,* and 3D Realms' Shadow Warrior computer game. His e-zine, *(fool's) Gold Mountain,* can be found at http://www.saber.net/~paperson/.

Gilbert B. Rodman (gbr@kcii.com) is assistant professor of communication at the University of South Florida. He is the author of *Elvis after Elvis: The Posthumous Career of a Living Legend* (Routledge, 1996) and manager of the CULTSTUD-L listserv.

David Silver (googie@wam.umd.edu) is a doctoral student in American studies at the University of Maryland and the founder and director of the Resource Center for Cyberculture Studies, located at: http://otal.umd.edu/~rccs. His work on cyberculture, online marginalities, hypertext, and teaching with technology has appeared in *American Quarterly, Computers & Texts,* and the *Journal of Popular Culture* as well as a number of academic anthologies. He is currently working toward his dissertation, an ethnographic exploration of issues of participation, politics, and power within two online cities.

Jonathan Sterne (jsternet@pitt.edu) is an assistant professor of communication at the University of Pittsburg. He has been online since 1984, and is a member of Bad Subjects, an online publishing collective located at http://eserver.org/bs. He researches communication history and technology, and he is currently completing a book on the cultural history of sound reproduction.

Rajani Sudan (sudan@utarlg.uta.edu) is assistant professor of English at the University of Texas at Arlington. Her work has appeared in *Camera Obscura, Eighteenth-century Theory and Interpretation, Criticism,* and *Genre.* She recently coedited a special issue of *Camera Obscura* entitled "Angels, Aliens and Dinosaurs."

Mark Warschauer (markw@hawaii.edu), formerly a researcher at the University of Hawaii, is currently based in Egypt, where he is consulting with universities and the Ministry of Education on effective and culturally appropriate uses of technology in education. He is editor of the international online journal *Language Learning & Technology.* His most recent book is *Electronic Literacies: Language, Culture, and Power in Online Education* (Lawrence Erlbaum, 1999). His homepage is at http://www.lll.hawaii.edu/markw.

Index